Alligators

The
Illustrated
Guide to
Their Biology,
Behavior, and
Conservation

Alligators

Kent A. Vliet

PHOTOGRAPHS BY
Wayne Lynch

Johns Hopkins University Press
Baltimore

Johns Hopkins University Press
2715 North Charles Street
Baltimore, Maryland 21218-4363
www.press.jhu.edu

Library of Congress Cataloging-in-Publication Data

Names: Vliet, Kent A., 1956– author. | Lynch, Wayne, photographer.
Title: Alligators : the illustrated guide to their biology, behavior, and
 conservation / Kent A. Vliet ; photographs by Wayne Lynch.
Description: Baltimore : Johns Hopkins University Press, 2020. | Includes index.
Identifiers: LCCN 2019013418 | ISBN 9781421433370 (hardcover : alk. paper) |
 ISBN 1421433370 (hardcover : alk. paper) | ISBN 9781421433387 (electronic)
 | ISBN 1421433389 (electronic)
Subjects: LCSH: Alligators. | Alligators—Behavior. |
 Alligators—Conservation.
Classification: LCC QL666.C925 V55 2020 | DDC 597.98/4—dc23
LC record available at https://lccn.loc.gov/2019013418

A catalog record for this book is available from the British Library.

All photographs were taken by Wayne Lynch except for those listed on the last
printed page of the book.

*Special discounts are available for bulk purchases of this book. For more information,
please contact Special Sales at 410-516-6936 or specialsales@press.jhu.edu.*

Johns Hopkins University Press uses environmentally friendly book materials,
including recycled text paper that is composed of at least 30 percent post-
consumer waste, whenever possible.

Contents

Alligators

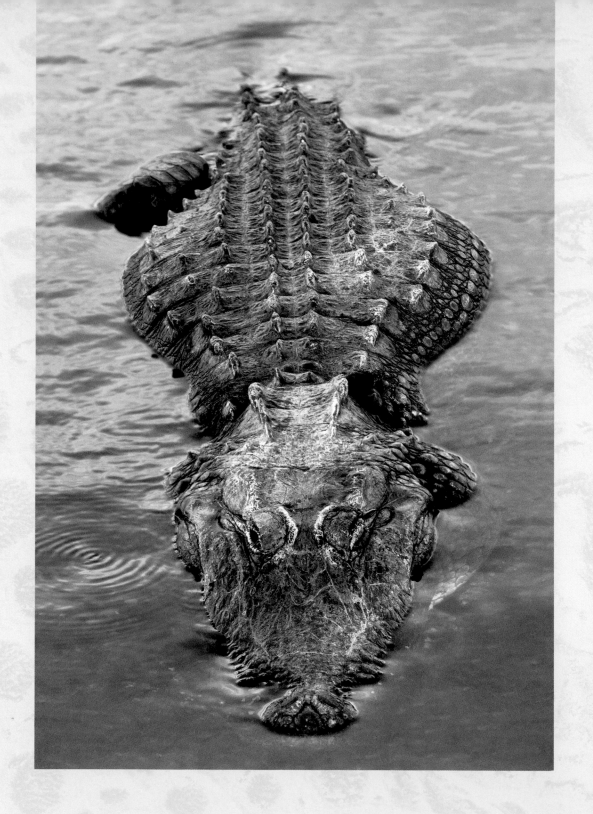

A Dragon among Us

It was my first true day as an alligator biologist. The weather was mild, typical of a November morning in Florida. I was a new graduate student at the University of Florida, and the core of my research was centered on studying courtship behavior of *Alligator mississipiensis*, the American alligator. My research site was not what I had envisioned in exotic youthful dreams. It was a tourist destination, the St. Augustine Alligator Farm, which has been in existence since 1893. When I arrived in 1980, it was a popular spot, and remains so to this day. Few who pass through St. Augustine can resist the opportunity to witness up close the nearest thing America has to a dragon.

On that morning my task was to attach large, yellow, numbered tags to the tails of each of the 165 alligators in the lake. Adopted from livestock identification, the tags would allow me to easily identify each individual.

Like most young graduate students, and newly minted medical doctors for that matter, I was not quite experienced enough for the task at hand. The largest alligator I'd handled up to that point was just under 4 feet (1.2 meters) long from snout to the tip of the tail. The beasts before me now ranged from about 6 feet to just over 10 (2–3.2 m). The largest weighed in excess of 400 pounds (180 kilograms). As reckless and carefree as youth makes most of us, they still caught my attention.

I had come prepared with very little in the way of tools—I had the tags and the tag applicator, and that was it. Luckily, I was not alone. My new best friend, whom I gladly called my mentor, was Tim Williams, a manager at the Alligator Farm. He took one look at me, and I'm sure he smiled inside at the thought of turning this greenhorn into a "gator wrangler." But he was too nice to ridicule me, and I did my best to feign bravery. Perhaps in the back of his mind he thought his mission was to not let me get mangled or killed—and take him down with me.

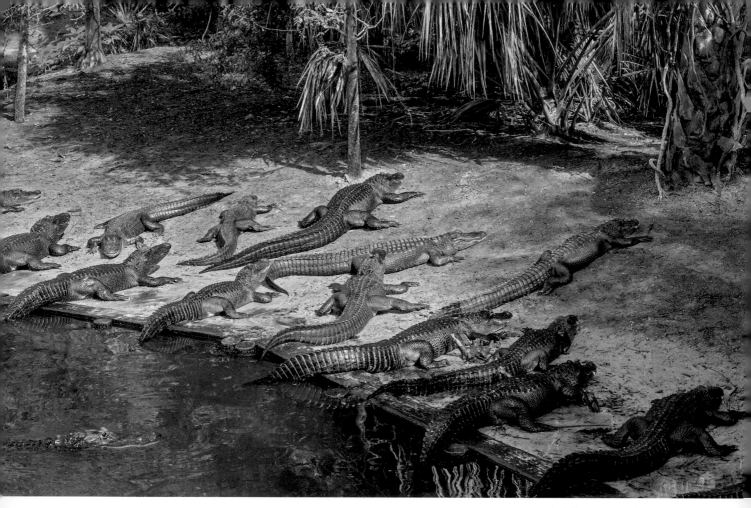

Group of adult American alligators lounging on a basking beach at the St. Augustine Alligator Farm Zoological Park.

On that first day we caught, restrained, measured, and determined the sex of thirty-one alligators. Each was fitted with a uniquely numbered tag that could be read at a distance. The tags were clipped to one of the sawtooth-like crest scales about halfway down the tail. For added security, we also put a small numbered metal tag through the webbing on each of the hind feet, just in case the tail tag was lost.

This was down-and-dirty field biology at its core. It might seem a bit rough, but most field biology is. We did try to work as quickly and humanely as possible. Even as a young graduate student in 1980, I was aware that being captured and having a tag attached was probably pretty unpleasant for an alligator. My own mixture of fear and inexperience made that secondary, but sympathy was in the mix of my emotions. So I handled it then as I've handled it since: be quick, be respectful, and avoid mistakes. As for the alligators, after release they looked a bit ticked-off but soon appeared oblivious to what had happened. The scene was reminiscent of children getting vaccination shots.

The day started easily enough. The lake had an elevated walkway running down the length of it. From that safe and lofty perch, we could drop a rope lasso

over the heads of alligators below. Once that was accomplished, we'd pull the alligators to the shoreline and get to work. This went well enough for the first ten alligators. The St. Augustine Alligator Farm boardwalk was typically filled with tourists, and the alligators learned to ignore humans, so they ignored us. At least, they ignored us for a while. But the alligators, or "gators" as they are often called, began to avoid us. They recognized the pattern: "They're not here to feed us or to gawk. They're dragging us up on shore and doing something weird to us!"

When Tim or I approached, the alligators decidedly moved away. We had to throw the rope in an attempt to lasso a gator, which was remarkably harder than our previous method of more or less dropping it on them. This took a bit of practice, but I shocked myself by how quickly I mastered the skill. Soon we were back to catching and tagging alligators.

By early afternoon, our lassoing luck had run out. When the rope would land just right, the alligators would immediately freeze. They would come to a dead stop in the water. After a few seconds, they would slowly back up. The drag of

Very little of an alligator's body is generally visible when in water, making it difficult to assess just how big it may be.

the rope in the water would pull it off their head. They had watched our chess game and seen their neighbors fooled by two techniques, so they developed a new counterstrategy. I began the day looking at these "lazy animals" who were lounging around, soaking up rays, totally oblivious to us. I was struck by how passive the gators were to the goings-on of the early morning. It was almost too easy—like shooting fish in a barrel. Then they began to move away. It was pretty basic stuff. But this new move was sophisticated, and it marked the first time I began to see alligators as having their own kind of intelligence. They were able to assess the situation, see a problem, and come up with a solution.

By midafternoon of that first day, we couldn't get a rope on a gator. Tim said the Alligator Farm had a boat we could use to get to the center of the lake. It was a 12-foot (3.7 m) aluminum johnboat, which is basically a low-hulled rectangle. I was in back with a paddle; Tim was up front with a rope. We approached a few alligators, but they quickly eluded us. Finally, we spotted a gator in the deepest part of the lake that didn't seem too concerned about us. He looked quite big, but we could only see the top of his head. As I paddled toward him, I could see some hints of hesitation on Tim's part. He finally turned and said, only half-joking, "He's pretty big, are you sure you want to do this?" With naïve determination, I said we had to mark all of them, so we might as well catch him now.

Tim slipped the rope over the alligator's head and tightened the noose. It was at this point that the obvious flaw in our plan became evident to us—the alligator turned and headed for the other end of the lake at top speed. We experienced the Florida equivalent of a Nantucket sleighride, a term whalers used to describe being towed by a harpooned whale. Tim was holding onto the rope up front and I was holding onto the boat in the back.

We both expected the alligator to affect our boat, but I don't think either of us anticipated his power. The entire front half of his body was out of the water as he pulled the boat and us; his tail was churning madly behind him. Much of the lake was shallow and I expected I'd be able, at some point, to step out and take the rope from Tim. But at the speed we were moving, nothing like that was possible.

A new problem quickly presented itself: the boardwalk. It was constructed with heavy lumber elements running along from post to post about a foot (30 centimeters) above the water surface. We would be scraped right out of the boat if the alligator swam under. There were two places along the length of the walkway where arches had been constructed for the purpose of allowing boats to pass under. Thankfully, the alligator was aiming for one of the two arches. As we passed under the boardwalk, I reached up and grabbed the wood.

The alligator was unimpressed and pulled the boat forward until I was stretched between boardwalk and boat with only my heels holding onto the back of the boat. With all the effort I could muster, I managed to pull enough of the boat back under me to allow Tim to tie the rope to the walkway. Exhausted, we were able to gain sufficient control to get him tagged. He turned out to be the biggest alligator in the study population that year. He was number thirty-one, the last one of that day.

I was left wet, cold, and exhausted. But I also knew I was hooked. Feeling that power at the other end of the rope, and sensing so much exhilaration from what was supposed to be work, made me more full of life than I'd ever felt before. I had a purpose, and since that day I've dedicated my life to the study of alligators and other crocodilian species.

First Impressions

The American alligator is a prehistoric creature living in the modern world. It's the largest species of aquatic wildlife most Americans will ever see in a natural habitat. Millions of alligators live among sixty million people. In fact, the alligator's range includes four of the top ten most populous states in the United States. Alligators are often found living in close association with people, in lakes and rivers, roadside ditches, canals of housing developments, and water hazards on golf courses. They are neighbors throughout the South.

How the Alligator Got Its Name

The name "alligator" was probably derived from the Spanish *el lagarto*, meaning "the lizard." In 1568, Job Hortop wrote in *The Travailes of an English Man*, "in this river we killed a monstrous Lagarto or Crocodile." Shakespeare's *Romeo and Juliet*, written sometime between 1591 and 1596, contains the following: "in his needie shop a Tortoyrs hung, / An Allegater stuft." It seems Shakespeare added the "r" to the end, moving us closer to the name we know today. Through countless recitations, productions, and readings of *Romeo and Juliet*, the word "alligator" came into common use and was widely recognized by 1730.

The scientific name for the American alligator is *Alligator mississippiensis*. In the scientific world, the genus name *Alligator* is pronounced as if Latin: Al-i-gi-tore, as opposed to the American pronunciation of Al-i-gate-er. Scientific names of species are binomial, that is, consisting of two words: the genus name, *Alligator*, and the species name, *mississippiensis* (by convention, both are italicized). The species name refers to the fact that the American alligator specimen early scientists used to describe and name this species was thought to have come from the banks of the Mississippi River (which is questionable). The only other living member of the genus *Alligator* is the Chinese alligator, *Alligator sinensis*. In addition, there are extinct (fossil) members of the genus *Alligator*.

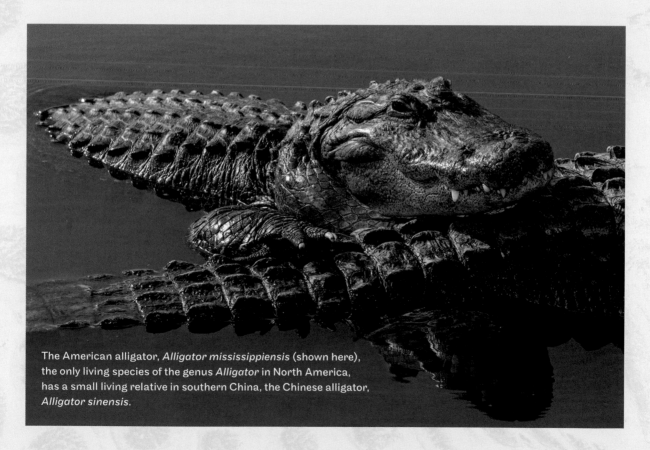

The American alligator, *Alligator mississippiensis* (shown here), the only living species of the genus *Alligator* in North America, has a small living relative in southern China, the Chinese alligator, *Alligator sinensis*.

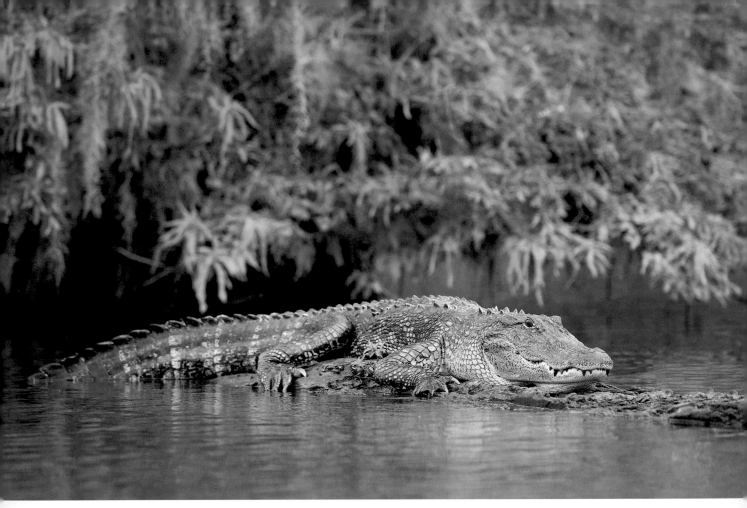

Alligator pulling out on a log in a Louisiana swamp. The alligator's very size and form invokes mental images of ancient times when giant reptiles dominated the terrestrial world.

For many who live outside the range of the alligator, the animal is more of an abstraction than a reality. Impressions are formed from news stories of unusual events, or from movies. Families who have lived side by side with alligators for generations are accustomed to their presence and accept them as part of the environment. For those moving south from places without alligators, the first sight of one in the neighborhood can be unnerving, even otherworldly.

The alligator's size and appearance provoke mental images of ancient times when giant reptiles dominated the terrestrial world. With its huge head, thick white teeth embedded in powerful jaws, body covered in leather and bony scales, large flat feet equipped with sharp claws, and long, heavy tail dragging behind, the alligator seems as if a dinosaur has survived the end of the Cretaceous some sixty-six million years ago.

It is natural, probably innate, to fear predatory beasts—a hereditary wariness borne of survival. It must certainly be the most primal of all fears: fear of being

snatched by teeth and held in crushing jaws. The fate of most prey in the grip of an alligator is to be slowly dragged into dark, deep waters to certain death. Paradoxically, we are drawn to such beings: their power enthralls us. It's like an emotional roller coaster, with conflicting emotions of both fear and fascination.

Balance

Alligators were here first. They were joined by the first human settlers around fifteen thousand years ago when Paleo-Indians spread across North America. Later, waves of immigration brought millions of humans in contact with millions of alligators. Alligators have come to accept the human invaders as part of the environment, and they seem to live comfortably in close proximity to us. We humans, on the other hand, have had some difficulties adjusting to this relationship. In the past we expended enormous effort trying to destroy as many alligators as possible, as we did with many other species we considered dangerous. More than a century of intense, unrelenting slaughter reduced alligator numbers from untold millions during the times of the first European settlers to rarity by the 1950s and 1960s.

The overall persecution of alligators, which lasted hundreds of years, provided humans with many hides but drove alligators to the edge of extinction. Then we woke up. We protected them, studied them, and developed plans that allowed alligators to survive in our world. And alligators responded, increasing rapidly in numbers once the pressure was removed. The return of the alligator to its rightful place as the monarch of the southern wetlands is one of the great success stories of modern conservation biology and wildlife management.

The alligator can now be found in numbers large enough for it to perform the valuable role that top predators play in an ecosystem. We have achieved a fine balance between an ever-growing human population and a large, healthy alligator population. But balance can be difficult to maintain. It will require people who advocate on behalf of the voiceless alligators. People like you.

Science Meets the Alligator

The American alligator was formally described to science by the French zoologist François Marie Daudin in 1802. Daudin named the American alligator *Crocodilus mississipiensis* and listed its type locality as "les bords du Mississipi"—the banks of the Mississippi River. Daudin's original spelling, with a single "p," was how the name of the river was spelled at that time. The species name was changed in 1957 to *mississippiensis* to reflect the modern spelling. Daudin included the alligator in the genus *Crocodilus*, that of crocodiles, as only one genus was recognized for all crocodilians at that time (today most scientists recognize eight genera in the order Crocodylia).

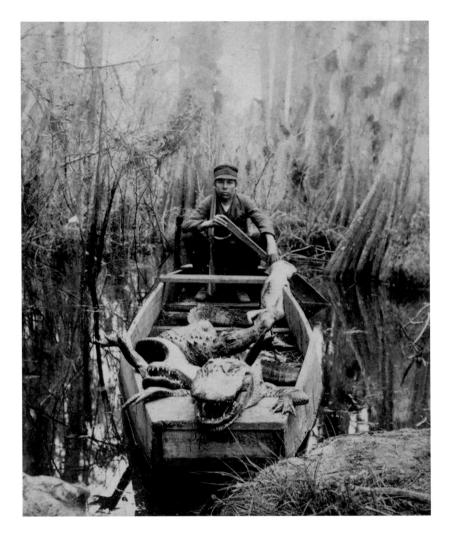

Historic photo of an alligator hunter in Florida returning to camp with the spoils of his night's work.

Daudin himself never visited the United States. His legs were paralyzed by a childhood disease, so he relied on the writings of other scientists and naturalists, as well as his own observations of preserved specimens in collections of European museums. The single alligator specimen mentioned by Daudin in his description was donated to the Muséum National d'Histoire Naturelle (the National Museum of Natural History) in Paris by the French botanist and explorer André Michaux.

Michaux was a royal botanist appointed by King Louis XVI to study plant specimens from North America that might be of economic importance. Michaux had already studied and collected plants across Europe and had ventured as far as Persia before making his way to North America. He was a very capable botanist who traversed eastern North America, often under very grueling conditions, collecting and describing plants as well as some animals. From 1785 to 1792, Michaux sent more than ninety enormous collections of specimens to France,

including more than sixty thousand live trees he had nurtured in his nurseries in Bergen, New Jersey, and outside of Charleston, South Carolina. Michaux and his son, François, produced several books on North American flora that were standard botanical references well into the 1800s.

When a species new to science is first described, a single specimen is usually selected as the definitive representative of that species and labeled the "type" specimen. A little alligator supposedly collected by Michaux, described as a mutilated hatchling, was sent back to France and deposited in the museum in Paris where Daudin saw it and described it. Unfortunately, the type specimen of the American alligator was apparently never entered into the catalogs of the museum. It may simply have been discarded or sent to another collection. Museum science at the end of the eighteenth century was not well organized like it is today. The origins of the type specimen remain somewhat unclear. Daudin wrote that Michaux killed the alligator along the Mississippi, but Michaux's journals suggest that the Mississippi locations he visited were not within the range of the alligator.

Spanish moss hangs from the branches of old cypress trees in a swamp along the Mississippi River.

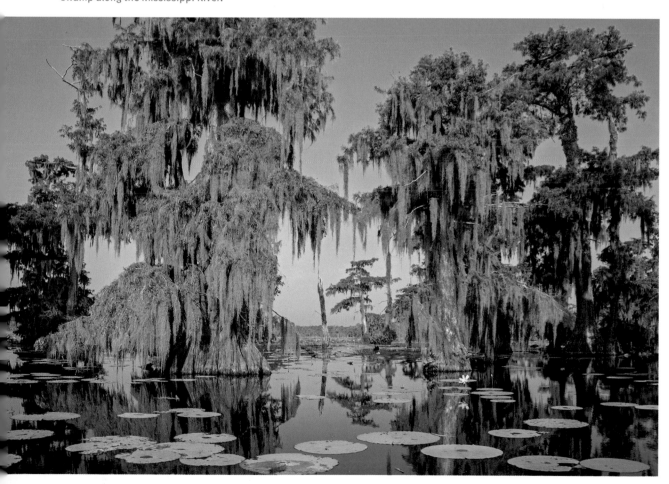

During the years Michaux was living in the United States, the social unrest in France was building and ultimately boiled over, leading to the French Revolution. Louis XVI, the last King of France, was guillotined in January 1793. This posed an immediate problem for Michaux, as he was a royal botanist and the King was his employer. The money to continue his work in North America dried up almost immediately. Michaux needed new financial support and found some in Thomas Jefferson, with some additional assistance from then president George Washington, through the American Philosophical Society. Jefferson had long been interested in encouraging exploration of North America beyond the Mississippi River. In April 1793, Michaux was hired to lead such an expedition. It was, perhaps, a precursor to Jefferson's funding of Lewis and Clark, whose expedition began a decade later.

Prior to setting off on his expedition (and without Jefferson knowing), Michaux met with the French Minister to the United States, Edmond-Charles Genêt. Michaux agreed to carry messages between Genêt and George Rogers Clark, a Revolutionary War hero and former general of the Virginia militia, who was living in Louisville. Genêt was attempting to recruit and finance an army to attack the Spanish in New Orleans and thus open the Mississippi River to trade. Michaux's journals indicate that he did quite a lot of botanizing along the way, but he also spent much of his time contacting people and delivering messages from Genêt. By the time Michaux made contact with Clark, France had decided not to pursue the attack.

Rather than continue his expedition to cross the Mississippi and explore the West, Michaux turned back to Philadelphia to further Genêt's mission. Jefferson found out about Michaux's involvement with Genêt and withdrew financial support for the expedition. Michaux returned to Kentucky again in 1795–1796. He reached the Mississippi on this trip, but he was near St. Louis and too far north to have collected an alligator.

Michaux was based for many years in Charleston, South Carolina, and traveled widely through the Southeast in areas where alligators were common, including Georgia and Florida. So it's possible he collected the type-specimen hatchling alligator somewhere other than the Mississippi, or perhaps he was given the specimen during his travels to Kentucky or Illinois. Whatever its origins, the poor little alligator met an early end but also marked the start of science's formal relationship with the species and forever associated the name Mississippi with the species.

Alligators in the White House

According to lore, alligators have lived in the White House three times. As the first story goes, France's Marquis de Lafayette made a gift of a small alligator to President John Quincy Adams in 1826. Lafayette had himself received

the alligator as a gift as he toured the country in the years after the American Revolution. He apparently decided to "regift" the alligator when he visited the White House (then called the President's House). The alligator lived for several months in the East Room of the White House, which was unfinished at the time. The gator often occupied a nearby bathtub.

Adams reportedly enjoyed showing off the alligator to surprise, startle, and possibly frighten his visitors. The alligator was eventually moved to a different house. The story of President Adams's pet alligator is widely told, even used in school lesson plans. However, there is too little documentation from the time to verify that most of the events actually occurred.

In 1889, President Benjamin Harrison's daughter, Mary, brought a small alligator home with her from a trip to Florida. Not much more about that alligator is known. In the early 1920s, Herbert Hoover's son, Allan, kept two small alligators as pets. They apparently escaped repeatedly from the bathtub in which they were kept. Allan would also allow them to wander about on the White House grounds from time to time. In 1921, Allan and the President constructed a pond for the two alligators at their South Street residence. The alligators reportedly spent their first winter at the zoo in Washington, but Allan recovered them the next spring. Because the alligators continued to escape their confines, they were eventually donated permanently to the Smithsonian National Zoo.

Alligator versus Crocodile

Perhaps the most common question I get is, "How do you tell the difference between an alligator and a crocodile?" In the United States, we only have two native species of crocodilians: the American alligator and the American crocodile. To differentiate these two, the simple answer is that alligators have broader, more parallel-sided, and more rounded snouts. With a view from above the snout, alligators have a fairly U-shaped look. The snout of a crocodile is more narrow, tapered, and pointed. Viewing it from above, a V shape is seen.

A second feature is a difference in the appearance of the teeth when the mouth is closed. The fourth tooth from the front on the lower jaw is enlarged in both alligators and crocodiles, but this tooth fits into a groove in the upper jaw of crocodiles. This difference gives crocodiles a sort of a bulldog look, with two big canine teeth visible and sticking up. These same teeth in alligators fit snugly into pits in the upper jaw when the mouth is closed and cannot be seen.

Crocodiles also look much "toothier" than alligators because most of the crocodile's teeth interdigitate—that is, teeth from the upper and lower jaws slide in between each other the same way your fingers do when you clasp your hands. Alligators have an overbite, so the teeth of the lower jaw are tucked inside those of the upper jaw when they close their mouths.

Myths and Misconceptions

Alligators are a favorite subject of written and oral folklore. Myths, exaggerations, and misconceptions abound because the species is so attractive to storytellers. Here are ten common myths I have tried to clear up over the years.

10 Alligators are not green, but they can look that way when covered with algae or duckweed. Green alligators are depicted in most cartoons, caricatures, plush toys, painted signs, logos, mascots, and Mardi Gras floats. Alligators are generally very dark gray or black with tan, bronze, and yellow patterning above and creamy to yellowish-white below.

9 Alligators are not lizards, nor are they dinosaurs. They belong to another distinct group of reptiles called crocodilians. Other crocodilians include caimans, crocodiles, and gharials.

8 Alligator hides are not bulletproof. In the early days of discovery, when firearm muzzle velocities were much less than that of modern weapons, adult alligators may have had hides thick enough and hard enough to offer sufficient protection, but most of today's firearms can penetrate the hide at any location.

7 Alligators can be fast, but they cannot "outrun a racehorse" for the first 100 feet (30 m) of a race. Alligators achieve their highest speeds when they are running away, and their top speed is somewhere around human running speed, which is much slower than a horse (even out of the gate).

6 You should *not* run in a zigzag fashion to get away from an alligator. Just run as far and as fast as you can.

5 The tail is not the most dangerous part of the alligator. The jaws are the most dangerous part hands down. If cornered on land, an alligator will slap you with its tail and, I can attest, it does hurt. I've even had my toes broken a couple of times from the force of a tail—it's like being slammed by a 100-pound (45 kg) piece of timber. But I'll take that shot anytime over a bite.

4 The lower jaw is not fixed. I've often heard that an alligator can only move its upper jaw. It certainly may seem this way if you watch one out of water, lower jaw resting on the ground and mouth agape. In reality, an alligator is able to drop its lower jaw and also lift its head.

3 Alligators don't weep for their prey. You may have heard of the phrase "crocodile tears" to infer false sympathy or insincerity. It is derived from ancient notions that crocodiles weep for their victims while devouring them. Alligators and crocodiles have glands near the back of the eye as well as in the lower eyelid. These glands produce tears to lubricate their eyelids. When they bite down on large or dense food, tears may be forced out.

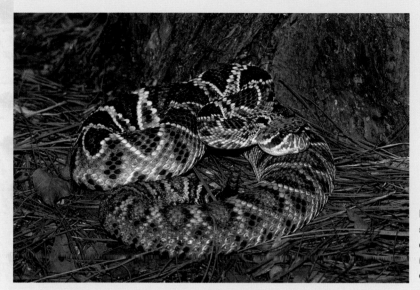

Eastern diamondback rattlesnake, a large, venomous snake that occupies much of the alligator's home range and on which the alligator occasionally feeds.

2 Alligators are not immune to snake venom, as is often claimed. Although alligators eat a lot of water moccasins, and an occasional rattlesnake, they can be bitten while doing so. Larger alligators may survive a severe bite because their size dilutes the impact, but small and moderate-sized gators can be killed by water moccasin bites. The fangs typically cannot penetrate the bony skull or the back of the alligator, and possibly not the rest of the hide in adults. But alligators are occasionally bitten inside the mouth and on the tongue during an attack. Fangs can penetrate those tissues.

1 Alligators don't live in New York City's sewers. The often-told story may have originated with a short piece in the *New York Times*, published February 10, 1935, of three teenage boys shoveling snow into an open manhole when they saw, captured, and killed an alligator. It's possible that some small alligators have turned up in New York over the years after being released by humans. Similar events occur in many parts of America. But there is no free-living alligator population in New York City, or anywhere else outside the southern United States and lower Mississippi River valley.

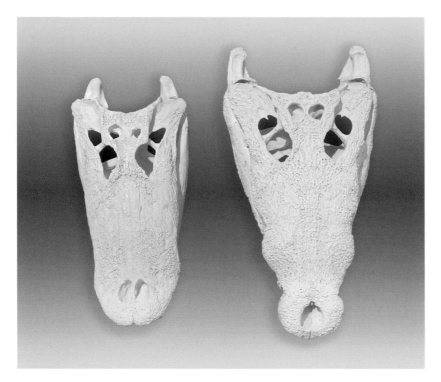

Side-by-side comparison of the skulls of an American alligator (*left*) and an American crocodile (*right*). In profile, the snout of the alligator is broadly rounded, forming something of a U shape, while that of the crocodile is tapered, suggesting more of a V shape.

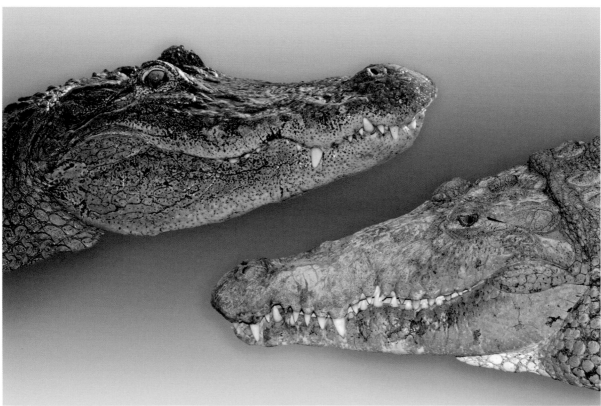

The teeth of the lower jaw of alligators (*left*) are covered by the upper jaw when the mouth is closed. In crocodiles (*right*), the teeth of the upper and lower jaws interdigitate, giving them a much toothier appearance.

Icon of the South

It is impossible to think of the American South absent the alligator. Both the history and culture of the South are tied to the species. Alligators are a symbol of the Everglades, Okefenokee Swamp, Mississippi Delta, and southern most areas from the Atlantic to East Texas. Albert Alligator, the alligator character in Walt Kelly's classic comic strip, Pogo, lived in the Okefenokee. Louisiana adopted the alligator as its official state reptile in 1983. Florida followed suit in 1987, as did Mississippi in 2005. If you ask any of the one hundred million annual visitors to Florida what they came to see, you will find that alligators rank second only to Disney World. The gator has been the mascot of the University of Florida teams since 1911. For a long time, the University had actual living gators as their mascots, but today they're represented by Albert and Alberta, both stylized green alligators.

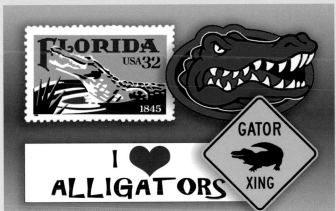

The alligator is an iconic part of the South. Images of alligators appear in all sorts of places. Those depicted here include (*clockwise from upper left*) a 1995 US postage stamp, the mascot of the University of Florida Athletic Association, a traffic sign, and a bumper sticker.

Another difference is that crocodiles have highly specialized, tiny sensory organs distributed ubiquitously on their skin called "integumentary sense organs," or ISOs. ISOs are extremely sensitive to touch and vibrations in the environment. Alligators have ISOs distributed densely all over their heads but nowhere else. The ISOs are quite easy to see. They are minute, domed swellings, almost like pimples, usually darkly pigmented unless they are on a light-colored portion of the body. When looking at fine leather products made from crocodiles, it is not hard to see the impression in each scale that was formed by the presence of an ISO.

Unlike alligators, crocodiles have salt-excreting glands in their tongues. On the surface of crocodile tongues, twenty to forty large pores are visible. These salt glands are capable of actively removing excess salt ions from the blood and excreting them through these pores. This allows crocodiles to easily drink salt water and eat marine fish and other foods laden with salt. The glands simply remove the excess salt load. Alligators lack these glands and must limit their activity in salt water, having only kidneys to help remove salt.

Rooted in the South

The distribution of the American alligator covers more than 300,000 square miles (800,000 square kilometers) of the American South (or the southeastern United States, if you prefer). Their range occupies the coastal plains of the states bordering the lower Atlantic coast and the Gulf of Mexico and extends up into the lower Mississippi River valley. The exact northern and western limits of the alligator's range have long been subject to debate. The northern-most point of their distribution is generally considered to be Albemarle Sound on the northeast coast of North Carolina, above latitude 36° N. They range along the coast, south through the Carolinas and Georgia, and through all of Florida. To the west they extend through Alabama, Mississippi, Louisiana, eastern Texas, and north into the neighboring states of Arkansas and Oklahoma (where they just cross the border). American crocodiles, on the other hand, are located in southern Florida, parts of Mexico, the Caribbean, Central America, and northern South America.

Alligators are mostly found in low elevations, generally below 250 feet (76.2 m) above sea level. In the southeastern United States, coastal plains habitats extend inland until the land rises into the Piedmont. This change in elevation is delimited by what geologists refer to as the "fall line." The soils of the coastal plains are composed of young, soft, sedimentary deposits that date to the Cretaceous and Cenozoic. The underlying geology of the Piedmont consists of older, harder, metamorphic rocks. The term fall line refers to the water falls and rapids associated with the change of elevation across the line as water flows from the harder rocks of the Piedmont down onto the soft substrates of the coastal plain. The rapid change in elevation prevents alligators from moving upriver, so the fall line pretty much demarcates the inland limits of the alligator's distribution along the southern Atlantic seaboard. On occasion, alligators are found in the Piedmont, but these seem to be stray animals, or perhaps escaped or released captive animals.

The areas that alligators occupy today essentially encompass all of the known historical range of the species, and perhaps a bit more. It is impossible to say with certainty what the precolonial range of alligators looked like because no records were left by the tribes that inhabited the alligator range. We also have only scattered local and anecdotal observations from the earliest European explorers and pioneers.

The first academic attempts to summarize what was known of the species occurred in the 1840s and came after many decades of widespread slaughter. Alligator populations at the extremities of the range may have already been eliminated, or they were so reduced that they were overlooked. At that time, the northern limit in North Carolina was thought to be the mouth of the Neuse River, though there were indications that sparse numbers of alligators lived north of

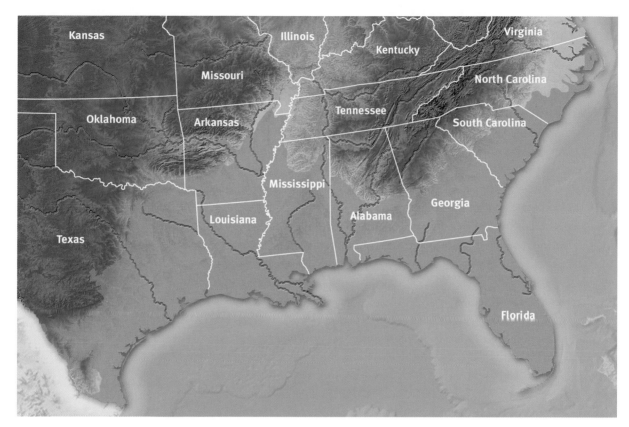

Distribution of the alligator in the southeastern United States, shown in yellow. Alligators are slowly expanding their range to the north and west. Stray individuals may be found outside the margins indicated.

there. The limits of the alligator's range in the Mississippi River drainage was said to stop at the mouth of either the Red River or the Arkansas River. I will summarize the range of alligators alphabetically by state to give a better sense of "the natural range."

Alligators occupy all of the coastal plain in the lower portion of Alabama. Their range extends up the Mobile, Alabama, and Tombigbee Rivers. In 1979, the US Fish and Wildlife Service released alligators into northern Alabama. Fifty-six alligators were introduced into more remote sections of Wheeler National Wildlife Refuge along the Tennessee River. This release occurred at a time when state wildlife management agencies were restocking depleted alligator populations in the Gulf states with alligators from the Rockefeller Refuge in Louisiana. This stocked population has persisted for almost four decades and alligators have spread along the river. Scattered sightings may occur anywhere along the Tennessee River from at least Guntersville in the east to the Mississippi-Tennessee state lines in the west. Alligators are also found in small numbers in Tennessee's adjacent counties. There is a tiny isolated group of alligators known in northern Alabama, with one group occurring about 70 miles (113 km) southwest of Chattanooga, Tennessee. It is most likely they were released there. The

elevation is about 880 feet (268 m), which is high for alligators, but this group has persisted for many years.

Alligators range across the lower lowlands of Arkansas and extend up the Mississippi, St. Francis, and White Rivers on the east side of the state almost to the Missouri border. The range follows the Arkansas River narrowly to the west as far as Pope and Yell Counties. In efforts to reestablish the species into parts of its former range, alligators were transported from Louisiana's Rockefeller Refuge to Arkansas starting in 1972. The Arkansas Game and Fish Commission released a total of 2,800 alligators between 1972 and 1984.

Alligators are found throughout the state of Florida, including many islands of the Florida Keys. Historically, alligators were found as far south as Key West.

Alligators occupy the southern half of Georgia, from near Augusta on the east across to Columbus on the west. The greatest concentrations are found in the coastal marshes and associated barrier islands, and in the Okefenokee Swamp, which overlaps the state's border with Florida. Although alligators were hunted in the Okefenokee, this massive swamp was something of a refuge for alligators when hunting pressures were most intense, much in the same way that the interior reaches of the Everglades offered some measure of protection.

It is never a surprise to see an alligator in Florida, nor is it a surprise to see one in Louisiana. Alligators are most numerous in the southern portions of Louisiana, in the coastal parishes, but they call most of the state home. In the east, they occur up through Lakes Pontchartrain and Maurepas, and they extend up along the Tangipahoa River.

In the west, the southern-most parishes, which contain the Sabine, Cameron Prairie, and the Rockefeller Refuges, are all prime alligator habitat. This remarkable system of coastal wildlife refuges was instrumental in preserving the alligator in Louisiana prior to state and federal protection.

The primary alligator range in Louisiana extends up through the center of the state, along the Atchafalaya River before it splits. The range extends into the northwestern portion of the state along the Red River and its tributaries. To the northeast, the range follows the Black River and its tributaries, the Tensas and Ouachita Rivers, and continues up through Bayou Bartholomew.

The Mississippi Game and Fish Commission (as it was known at the time) released about four thousand alligators between 1970 and 1978 in their effort to restore the species. Many private landowners requested that alligators be released on their properties because they wanted to help control beaver, snake, and turtle populations. Today the Mississippi Wildlife, Fisheries, and Parks Department estimates that over four hundred thousand acres (162,000 hectares) are known alligator habitats. Jackson, Hancock, and Rankin Counties seem to have the highest alligator densities. Alligators have rarely been found as far north as Oxford.

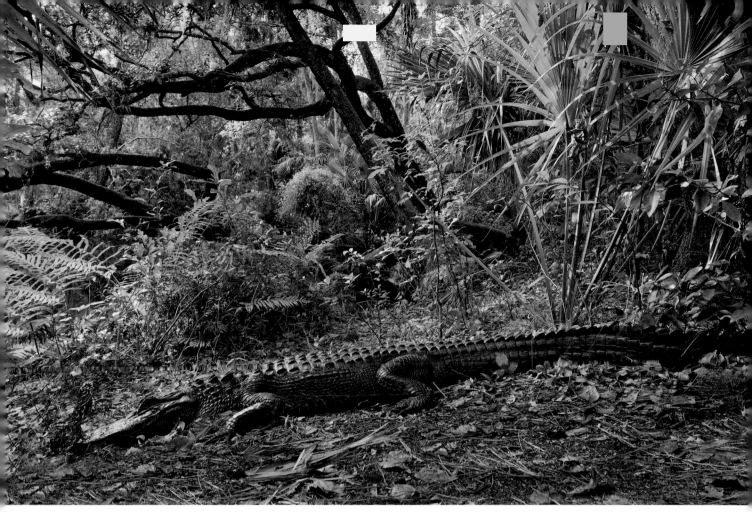

Alligators are found in many different habitats throughout the Southeast. This alligator rests on the bank of a pond in an oak hammock in Central Florida.

In North Carolina, alligators are generally found along the coast in the southern half of the state. To the north, alligators become very rare and are restricted to a narrow band of coastal marshes, tidal rivers, estuaries, and barrier islands. Albemarle Sound, in the extreme northeast at about 36° N latitude, is generally considered to be the northern limit of the American alligator's natural range. However, a small number of alligators can be found north of the Sound. A population of alligators is found in and around Merchants Millpond State Park, which is just north of Gatesville at a latitude of about 36°25' N. The population has been in the area for at least three decades and breeds there. At least one fairly large male, 9–10 feet (2.75–3 m), has lived there for more than a decade. There is another small group of North Carolina alligators even further north and a bit east of the Merchants Millpond alligators in the Pasquotank River near South Mills. This locality is within the portion of the Great Dismal Swamp that extends southeast into North Carolina. The locale is within 5 miles (8 km) of the Virginia border. This group has been in the area at least a decade and a half, but there is no evidence of reproduction.

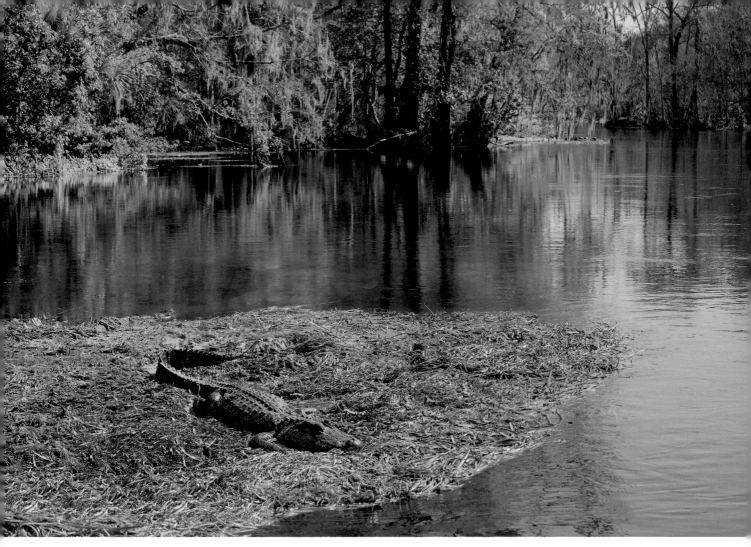

Alligators, such as this one in the Okefenokee Swamp in southern Georgia, often use dense mats of floating vegetation for refuge or as places to lay in the sun.

Alligators range to the extreme southeast counties of Oklahoma. The majority of the existing population is found in Choctaw, Pottawatomie, and McCurtain Counties. Scattered individuals may be found along the Red River, which forms the southern border of the state with Texas. Early historical accounts suggest alligators were at one time numerous in the Red River, as well as the Little River. But alligators were virtually exterminated in Oklahoma by 1900. Over time, a few small populations have become reestablished. The historic range seems to have extended west along the Red River to perhaps present-day Lake Texoma.

Alligators extend across the lower two-thirds of South Carolina. Populations can be quite dense in the coastal marshes, especially in impoundments created for migratory waterfowl and at abandoned rice production plantations. The large portion of the coastal plain and the coastal environments in South Carolina provide ample habitat for alligators, as do certain barrier islands. The range pretty much ends at the fall line, which runs close to the capitol of Columbia, South Carolina.

The alligator's range is difficult to define in Texas, in part because the historic range is somewhat in doubt, but also because the distribution seems to currently be expanding and has been for the past twenty-five years. Alligators occur in the lowlands to elevations of perhaps 300 feet (about 90 m) along the Gulf Coast. Some authors in the 1890s suggested alligators reached the San Antonio River, and others, including famed zoologist Edward Drinker Cope, said they extended south as far as the Nueces River, at Corpus Christi. Several authors in the early 1900s indicated that alligators extended the length of Texas to the Rio Grande River. There are published reports of alligators in the Brownsville area from the mid-1800s. Another reliable report from the early 1900s told of an alligator shot about 20 miles (32 km) south of Fort Clark. Fort Clark is about 110 miles (177 km) west of San Antonio and quite close to the Rio Grande. So there is good reason to believe that alligators once extended to the lower Rio Grande valley. If so, they were hunted to extinction in the area during the first half of the twentieth century.

Today alligators range down the entire Gulf Coast of Texas into the lower Rio Grande valley. It is possible that the initial sources for South Texas alligators were released captive animals. Alligators first appeared, or reappeared, around 1980 and began to spread through the region. They first showed up in Bayview in the early 1980s. Within the next twenty years, they began to appear all over the Brownsville area. They are now common in the oxbow, or U-shaped, lakes off the Rio Grande near Brownsville.

This new arrival of alligators in the Brownsville area was quite a surprise to many of its residents, most or all of whom had never known of alligators in the area. This same situation has occurred in more northern portions of Alabama, Mississippi, and Arkansas. Hide hunters wiped out native alligator populations so long ago that current residents never thought of alligators as part of the environment.

Alligators have a habit of wandering, which, combined with the possibility of warming climates, means we may see alligators move into more states. Virginia has regular sightings of a few alligators already, and these animals seem to be sticking around. Alligators are found in the extreme southwest corner of Tennessee near the Arkansas-Mississippi border at McKellar Lake, just west of Memphis. They have been in this location for at least thirty years. A small alligator was spotted in Indian Creek just over the Tennessee border, close to the northern Alabama population. This animal may have been a released pet, but the proximity to the Tennessee River population at least hints at the possibility that the alligator migrated there on its own. So far, neither Tennessee nor Virginia hosts a breeding alligator population.

There is some debate as to whether alligators occurred historically in Virginia. There are a few historical anecdotal references, some from the 1700s. They discuss alligators in the Great Dismal Swamp (possibly confused by the

fact that a part of the Great Dismal extends into North Carolina). Virtually all maps of the historical distribution of alligators indicate Albemarle Sound as the northern edge of the range. One exception is a 1971 range map in Wilfred T. Neill's *The Last of the Ruling Reptiles*, which extends the alligator range into southeastern Virginia, in the area of the Great Dismal Swamp. Neill states that alligators ranged into the Dismal Swamp in colonial days and cites as evidence an old place name, Alligator Sink, which is in southeastern Virginia. He further remarks on the decline of alligator numbers throughout its range, associated with historical settlements, and specifically notes the extirpation, or complete destruction, of alligators in some regions, including those "north of Albemarle Sound."

Individual alligators have been found in recent years in Virginia's Dismal Swamp and elsewhere in the state. Whether these alligators migrated up into the region on their own, or were dropped there by well-meaning pet owners, is impossible to determine in most cases. There is a well-regarded report of alligators being released outside of their natural range in North Carolina in several counties, including Gates County in which Merchants Millpond is located. So, it's conceivable that even the Merchants Millpond population was established by human intervention rather than a natural invasion of the area by alligators.

The Dismal Swamp Canal, which is part of the Atlantic Intracoastal Waterway system, was first opened in 1805. It runs along the eastern edge of the swamp very near where alligator populations exist. The canal cuts north to the Chesapeake Bay. This canal could provide alligators with easy access north into Virginia. There are persistent, unconfirmed reports of alligators east of the Dismal Swamp in the Cavalier Wildlife Management Area, along Route 17, and in the Atlantic Intracoastal Waterway itself. However, a herpetologist for the Virginia Department of Game and Inland Fisheries vehemently denies that alligators are naturally immigrating into southeast Virginia. Only time will tell.

Range maps of alligator distributions almost always show the range stopping abruptly at the border with Mexico. There are definitely alligators on the north side of the Rio Grande, but are there any "Mexican" alligators? I know of only a single published reference that indicates alligators extend over the border into extreme northeastern Mexico, along the Rio Grande valley in Tamaulipas. But even the authors of that report admit they have no conclusive evidence of alligators in Mexico. That said, it seems inconceivable that they are not on both sides of the border. Still, there have been some concerted efforts to search for Mexican alligators, and there is no strong evidence so far.

Much of northern Mexico is simply too arid to support alligators. There is some apparently acceptable habitat there, if only in the small patches of flooded swamp and cane brakes along the Rio Grande. There is certainly suitable habitat about 75 miles (121 km) south of the border, on the Gulf Coast where the Rio San Fernando empties into Laguna Madre.

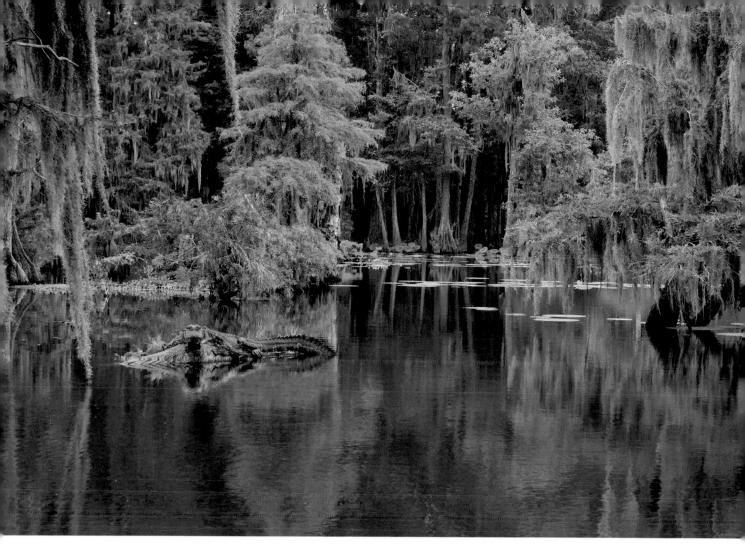

Any wetland will do for an alligator, but large stretches of slow-moving, permanent water, such as this swamp in the Atchafalaya River basin of Louisiana, are ideal for alligators.

There are at least three specimens in European museums of alligators reportedly from Mexico. I've seen two of these specimens and can confirm they are alligators. All three were collected in the mid- to late 1800s and all indicate they were collected in Mexico, but with no further locality data. There is a single small specimen of an American alligator preserved in the National Museum of Natural History in Paris labeled "Mexique," but also with no other data. Whether this specimen was indeed collected in Mexico, or was an animal captured in Texas while that region was still the possession of Mexico, will never be known.

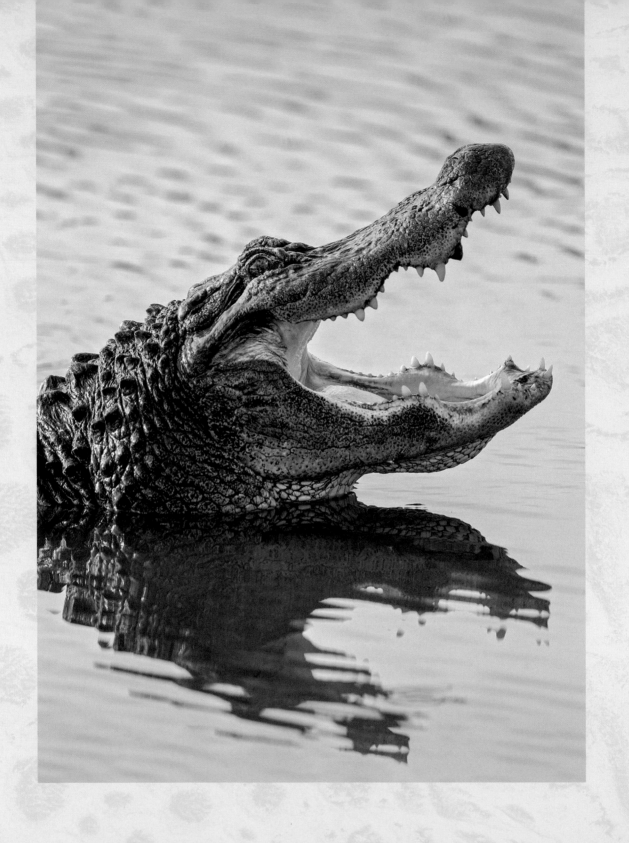

First Encounters

What was the realm of the alligator like before the first European explorers and colonists set foot on the shores of the New World? How many alligators might there have been in the rivers, lakes, marshes, and swamps? It is so difficult to imagine what this continent was like 550 years ago that these simple questions are hard to answer. One thing we do know for sure is that the environment has been massively altered, depleted, and modified for our own uses. But that won't prevent us from trying to travel back in time, connecting the filaments of information that we have in order to weave a tale that tries to accurately reveal a forgotten history.

Travelers to the New World from European countries included many who sailed from societies that had tamed their beasts centuries earlier. There were still dangers of predators in Europe, in the form of bears and wolves, but the first sight of a large alligator would have been foreign to all but those few who had ventured to Africa and Asia. George-Louis Leclerc, Comte de Buffon, the great French scientist and natural historian, conveyed it this way: "Of the history of all the ravenous or savage tribes of animal nature, the inhabitants of Europe are least interested in that of the crocodile; for it is placed at a happy distance from cultivated society."

America was a scary and dangerous place to newcomers, full of dangerous animals that, beyond alligators, included panthers, rattlesnakes, and an abundance of bears and wolves. Although alligators were not known to the earliest European explorers, Nile crocodiles, or at least tales of them, were well known in Europe. Crocodiles were featured in Greek and Roman literature that extended back close to two thousand years. So it seems probable that early observations of alligators by explorers may have been tainted by preconceptions they had about Nile crocodiles. In fact, numerous early stories of alligators begin by describing them as being exactly like crocodiles of the Nile.

It is apparent to me, from reading very early narratives, that some authors are recounting tales reported in earlier works, rather than their own observations. Numerous accounts mention attacks by alligators on people, but some of these contain racist rhetoric that is strikingly similar to tales that were told for hundreds of years in Europe.

There are, however, some early written accounts that give us a sense of the natural state of the alligator before widespread settlement and exploitation. From 1497 to the middle of the next century, the Spanish explored Florida and adjacent regions. They were joined along the way by the French. Some records include notes about alligators, though only tidbits can be learned from these accounts.

In 1513, Spaniard Juan Ponce de León, who landed somewhere near present-day St. Augustine, Florida, wrote that there were "many alligators and crocodiles that practically frighten me as much as they intrigue me." He returned to Florida in 1521, landing somewhere along the Gulf Coast, but was soon attacked by the indigenous Calusa tribe. He was wounded, possibly by a poison arrow to the thigh, and later died in Cuba from his wounds.

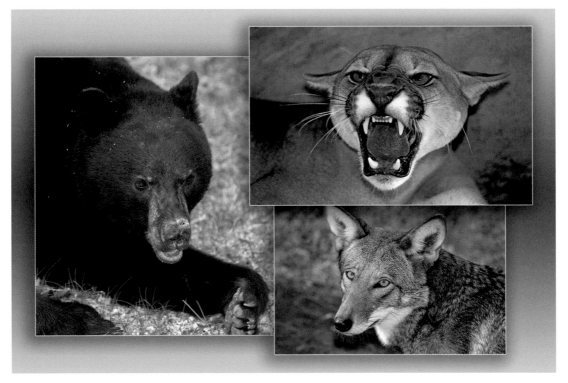

Early explorers to the New World encountered a wilderness teeming with wildlife, including many large predators like the black bear (*left*), the Florida panther (*above right*), and the red wolf (*below right*).

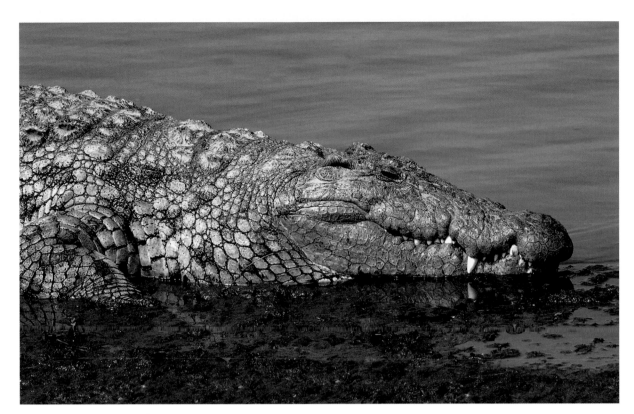

Nile crocodile, a large and dangerous species of crocodile known to Europeans venturing to the New World. Fears of the aggressive nature and man-eating tendencies of this crocodile biased the opinions of Europeans to the alligator.

Hernando de Soto landed in what is now called Tampa Bay on May 25, 1539. Soon after arriving, de Soto's patrol encountered Juan Ortiz, one of the few survivors of the ill-fated Pánfilo de Narváez expedition of 1528. After eleven years living among the native tribes, Ortiz understood some of the local languages and de Soto used him as a translator.

Ortiz introduced de Soto to his chieftain, who warned de Soto that it was too dangerous to venture inland any further because of alligators and insects. But de Soto and his men paid no heed and traveled up through North Florida, Georgia, the Carolinas, and Tennessee in search of gold and other wealth. They then moved south to Alabama to meet supply ships near present-day Mobile. They turned back inland through Mississippi, crossing the Mississippi River in 1540—the first Europeans to do so. They wandered all over Arkansas, even reaching Oklahoma, before returning to the Mississippi where de Soto developed a serious fever and died in 1542. His men then ventured into east Texas before returning to the Mississippi River, traveling down the river to the Gulf of Mexico and then along the coastline to Mexico. They spent a lot of time in alligator territory.

Among the written records of the de Soto expedition, there are scattered mentions of alligators. It is often impossible to know where they were when

they made these observations. In fact, they often did not know their location themselves, and the course the de Soto expedition actually took is still strongly debated. They mention seeing "monstrous" alligators sunning themselves and hearing their bellows. There is a report of Native American breast shields made of bony alligator hide being no match for the Conquistadors' tempered blades. Another note describes a medicine man's necklace strung with alligator teeth. De Soto himself referred to alligators as "esbirros del Diablo," the Devil's minions.

Two decades later, in 1562, Jean Ribault led a group of French Huguenots (Protestants fleeing religious persecution in Europe) to the New World. They made landfall in Central Florida and then sailed up the coast, inspecting each bay and river. They reached the mouth of the St. Johns River and made contact with local bands of the Timucua Nation. The Huguenots continued northward along the coast, eventually stopping at present-day Parris Island in Port Royal Sound, South Carolina. They constructed a small settlement called Charlesfort and were welcomed by the Timucuan peoples. In terms of alligators, the Huguenots wrote this about one of the freshwater rivers just inland from their settlement: "They found therein a great number of crocodiles which in greatness surpass those of the river Nilus."

The second Huguenot expedition to Florida was led by René Goulaine de Laudonnière, who brought along artist Jacques Le Moyne de Morgues. Le Moyne was there to draw maps of the Florida coastline, but he also made illustrations of the plants, animals, and peoples he encountered in his travels. By the time of their arrival, the small Charlesfort settlement had been abandoned. So Laudonnière built a small fort, which he named Fort Caroline, near the mouth of the St. Johns River (close to present-day Jacksonville, Florida). Le Moyne made numerous drawings illustrating the life and customs of the Saturiwa Timucuans near the fort, providing the most detailed view of the lives of any indigenous group in the Southeast. In his *Indorum Floridam provinciam inhabitantium eicones*, published in 1591, Le Moyne includes the first published illustrations of alligators actually drawn from life. These now-famous engravings include a depiction of a group of Timucuans killing what appears to be an extremely large alligator by driving a long, sharpened log into its mouth and as far down the throat as possible. They then flipped the alligator on its back and killed it with clubs and arrows. Another drawing illustrates the Timucuans smoking and drying the carcass of an alligator and other game animals over a fire.

Le Moyne wrote that the Timucua thought alligators were "such a menace that a regular watch has to be kept against them day and night. The Indians guard themselves against these animals just as we guard ourselves from our most dangerous enemies."

Europeans continued to flood into the New World as the decades passed. Books about travel experiences were published by explorers, military men, poli-

How Many Alligators Were There?

Unlike our estimates of the thirty to sixty million bison that once thundered across the open plains, or the flocks of billions of passenger pigeons that darkened the skies, an early census of the often submerged American alligators was never possible. In fact, even the estimates for the aforementioned mammal and bird are probably only in the ballpark.

Alligators were something to be avoided or killed by early settlers, not counted and recorded. Travel in those times was too difficult and dangerous to have assessed alligator populations, and science was just developing. Even today, with our modern techniques, it is still very difficult to count alligators. A reasonable guess, based on the extent of available habitat and our current estimates of typical alligator densities, is that somewhere between ten and twenty million American alligators lived in the American South when European colonization began.

Personally, I am comfortable with something closer to the upper limit of this guesstimate. Observation of hundreds of alligators lining a riverbank two hundred years ago hint at the tremendous abundance that once existed. Nothing close to such an observation is possible today, with the seasonal exceptions of a few places like Paynes Prairie Preserve.

Single alligator hangs motionless in open water in Paynes Prairie Preserve State Park, near Gainesville, Florida. In times of drought, when water levels recede, hundreds of adult alligators can be seen in the La Chua sink area within the prairie.

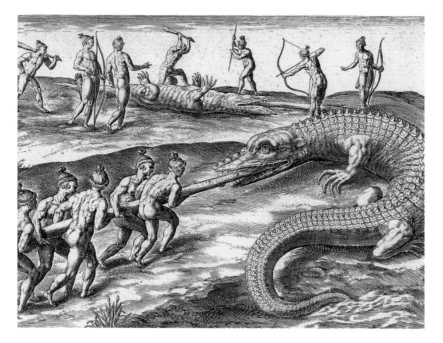

Famous etching, produced by Flemish engraver Theodor de Bry, of Jacques Le Moyne de Morgues's 1564 drawing of Saturiwa Timucuans killing large alligators along the St. Johns River near present-day Jacksonville, Florida. Le Moyne's images were the first published illustrations of the American alligator.

ticians, boat captains, travelers, surveyors, and settlers. Some were widely read and influential in Europe, shaping impressions of the New World—its natural resources, native peoples, cities, settlements, wilderness, and fertile, untilled soils. The images highlighted the potential richness of the New World and served to entice Europeans, especially those of limited financial means. Alligators were discussed in a number of these books, particularly those published during the late 1600s and early 1700s. By this time, almost two centuries after Columbus, European settlements were widespread along the Atlantic seaboard. Forests were felled for lumber and habitats were converted to agriculture. Many marshes in the southern states had been drained, plowed, and planted, or terraced into rice paddies.

All sorts of vessels plied the southern rivers, trading and transporting as commerce spread among settlements scattered along the banks. The European settlement of the Atlantic states was well underway throughout the seventeenth and eighteenth centuries, with the English, French, and Spanish governments controlling most of North America. Much of the continent was still under the control of the original tribes—a situation that changed dramatically in the 1800s.

Alligators were not the primary focus of early European settlers, nor were they a primary fear. But many authors of the old books left tidbits about alligators that make for some very interesting reading. The French explorer René-Robert Cavelier de La Salle traveled the entire length of the Mississippi drainage from the Great Lakes to the Gulf of Mexico, claiming the entire region for France. La Salle's men report killing several alligators on the Arkansas River as they trav-

eled downriver during 1681 and 1682. In 1686, on his second voyage to the New World, La Salle's chamber valet, a man named Dumesnil, was killed by a large alligator while crossing the Colorado River in Texas. Henri Joutel, the historian on the expedition, occasionally shot alligators and "never spared them when [he] met them near the house" (the house being La Salle's settlement on Garcitas Creek near Lavaca Bay in Texas). Joutel wrote that he once shot an alligator near the settlement that was about 20 feet (6.1 m) long.

Jean-Baptiste Le Moyne de Bienville, appointed the governor of French Louisiana several times, visited the Ascantia River area (now called Bayou Manchac and near what would become New Orleans). He wrote that it was filled with fish and crocodiles, some of which he shot and ate. He mentioned that the meat of alligators is not unpalatable "when liberated from its musk." New Orleans was founded by Bienville in 1718 and quickly became the center of French commercial interests in the region. From New Orleans, the French controlled access to the Mississippi River and its many tributaries for travel and trade through the entire region. The writings of New Orleans's residents and visitors made frequent references to the alligators in the region.

Pierre François Xavier de Charlevoix, a Jesuit priest who arrived in Quebec in 1720, was instructed to seek a western passage to the Pacific. Searches for such a passage were a recurring theme undertaken by many explorers of the time and for most of the next century. For his quest, Charlevoix was given two canoes and eight companions. He traveled through New France and reached New Orleans. Of course, he found no passage to the Pacific. The priest reported large numbers of "cayman" in the New Orleans area in 1721. He also commented, with surprise, that the local residents bathed without fear in the river surrounded by alligators. His observations match those of naturalist John Bartram, who wrote that Florida's inhabitants were unafraid of alligators.

In the early eighteenth century, the Royal Society of London sent English naturalist and painter Mark Catesby to Carolina to study the biology of the New World. Catesby spent four years, from 1722 to 1726, traveling throughout the South and the Bahamas. He wrote an acclaimed, heavily illustrated, two-volume book of his travels, *The Natural History of Carolina, Florida and the Bahama Islands*, an effort that took him twenty years to complete. Although he was typically a keen observer of nature and a talented artist, Catesby provided only a crude illustration of a hatchling alligator and an egg. He mistakenly considered the American alligator indistinguishable from the Nile crocodile. As a result, he recited a number of elements about crocodiles from previous writings. Catesby did provide some useful observations, noting that alligators were quite numerous in Carolina, that they became inactive in the colder months (when they occupied caverns and hollows in the banks of rivers), and that upon their emergence in spring they made a "hideous bellowing noise."

William Bartram, one of naturalist John Bartram's sons, provides us with

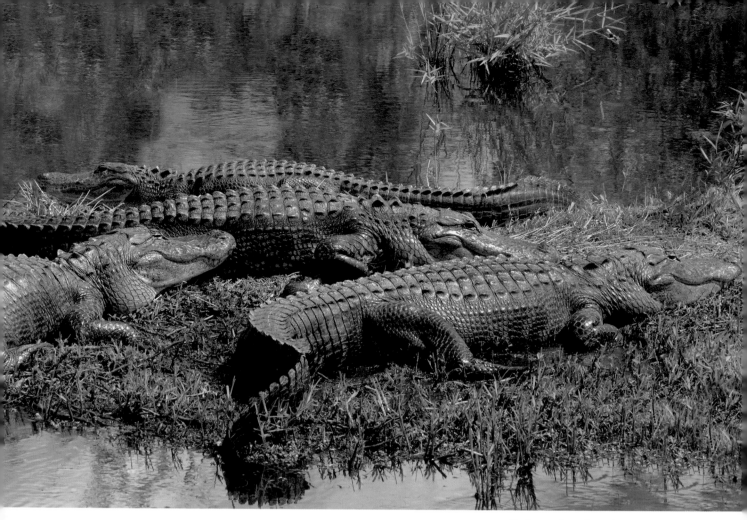

some of the most thorough, though possibly biased, early accounts of alligators. He accompanied his father to East Florida in 1765 and then returned on his own several years later. He traveled through the southeastern states and colonies in the mid-1770s, just as America was gaining its independence from Britain. His journals from this exploration, now referred to as *The Travels of William Bartram*, were very widely read in Europe and translated into several European languages. His flowery descriptions of the Southeast, especially his imagery of eastern Florida, had a great impact in Europe. It has been suggested that his writings stimulated interest in settlement in Florida.

Bartram's journals provide a first-hand account of the natural history of this area prior to extensive settlement by people of European descent. He told stories that some have called woefully exaggerated or even fanciful. However, Bartram's writings about alligators do match some scientific observations. As such, this account could be considered the earliest detailed record of natural behaviors in these creatures:

Early travelers along the waterways of the South often encountered alligators in very large numbers. Many were surprised that local residents and indigenous peoples bathed in alligator-filled waters without fear or incident.

Behold him rushing forth from the flags and reeds. His enormous body swells. His plaited tail brandished high, floats upon the lake. The waters like a cataract descend from his opening jaws. Clouds of smoke issue from his dilated nostrils. The earth trembles with his thunder. When immediately from the opposite coast of the lagoon, emerges from the deep his rival champion. They suddenly dart upon each other. The boiling surface of the lake marks their rapid course, and a terrific conflict commences.

One of Bartram's most famous passages, and the one most often used to exemplify his gift for exaggeration, is his account of a congregation of alligators on the upper reaches of the St. Johns River in Florida during what seems to be a run of fish:

> The prodigious assemblage of crocodiles at this place exceeded everything of the kind I ever heard of. The river in this place from shore to shore, and perhaps near half a mile above and below me, appeared to be one solid bank of fish of various kinds, pushing through the narrow pass of St. Juans into the little lake on their return down the river, and the alligators were in such incredible numbers, and so close together from shore to shore, that it would have been easy to have walked across on their heads, had the animals been harmless.

Alligator lunges at an intruder. When cornered by people, alligators will gape and hiss and even lunge forward, but usually only a few feet. Continued harassment may evoke a more vigorous response.

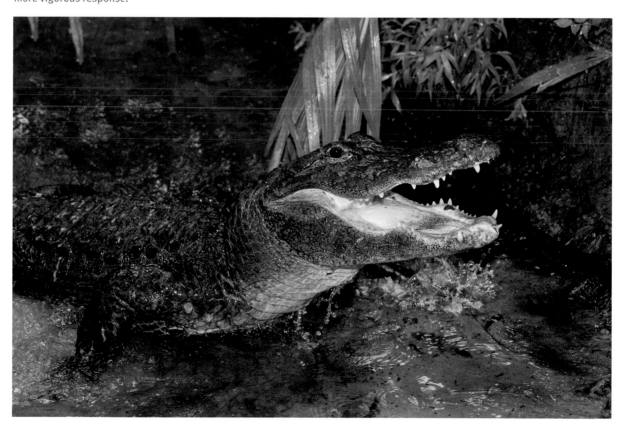

John James Audubon, the great naturalist and artist best known for his detailed and accurate paintings of birds, wrote of his observations of alligators in a letter dated 1827. He begins, "One of the most remarkable objects connected with the Natural History of the United States, that attracts the traveller's eye, as he ascends through the mouths of the mighty sea-like river Mississippi, is the Alligator." Audubon wrote that the alligators along the river were accustomed to the river traffic and were not shy. He also commented that they were not the dangerous animals that many travelers described and were plentiful anywhere there was sufficient water and food. He saw large numbers of alligators all the way up the Mississippi to the mouth of the Arkansas River. He reported that alligators had been very abundant in the Red River, with hundreds along the banks "at a sight." The Red River crosses Louisiana diagonally from the northwest corner of the state until it joins the Mississippi River near the southwest border of Mississippi. Audubon lived for several years in Bayou Sarah, a shipping port near the confluence of the Red, Mississippi, and Atchafalaya Rivers. He wrote that thousands of the largest alligators were killed for the hide industry to produce boots, shoes, and saddle seats. Many settlers and squatters, as well as some tribal members, hunted alligators as their only profession.

Alligators and Native Americans

Many of the original North American tribal nations lived within the range of the American alligator when the first European expeditions arrived. Humans first arrived in the southeastern region of the United States somewhere between twelve thousand and fifteen thousand years ago. Many European accounts mention that alligators were an important source of meat for Native Americans. The meat of the tail and the hind part of the belly seem to have been strongly preferred. Middens and shell pits (which contained trash disposed of by Native American settlements) found adjacent to the Gulf of Mexico often contain alligator bones, indicating that alligators were a normal part of the human diet. The size of the bones found suggest that large alligators were more commonly consumed.

The Key Marco Calusa, an early Florida Native American culture, produced wood carvings depicting alligators. These carvings took the form of wooden plaques and figureheads, but did not seem to represent deities. In fact, many Native American cultures across what is now the southeastern United States do not seem to have worshipped or deified alligators; rather, art and folktales seem to depict them as dangerous or villainous. That said, some cultures consider alligators to be more benevolent, depicting them as sharing their hunting skills with humans. The Seminoles and the Muskogee (Creek) peoples both had alligator clans. The Seminole alligator clan is extinct, but the Creek alligator clan, the Halpadalgi, still persists. The Seminole still have a traditional alligator dance.

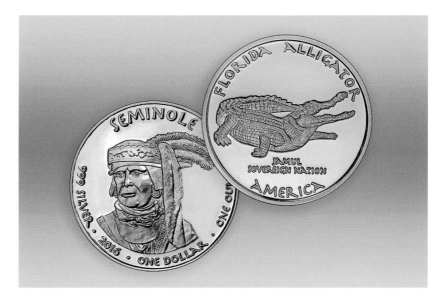

The Jamul tribe of Southern California is recognized as a sovereign nation by the US government and is legally authorized to issue its own commemorative coins. The one dollar coin pictured was commissioned by the tribe in 2016 to celebrate the Seminoles and their connection to the American alligator.

When Major Stephen H. Long explored the Texas panhandle and Oklahoma in 1820, he interacted with a migratory village of Kaskia (Kiowa-Apaches). The Kaskia were walking north up the Canadian River near present-day Amarillo, Texas. The home of this band was near the headwaters of the Platte and Arkansas Rivers in present-day Colorado, outside the natural range of the alligator, but most members of the band wore ornaments depicting alligators. Their alligator amulets were first carved of wood, then wrapped in leather, and finally decorated liberally with white and blue beads. The amulets were apparently worn for the prevention, or cure, of disease and for luck. The chief of the band, Red Mouse, had an open wound on his upper arm, seemingly from an arrow. While talking with Major Long, Red Mouse took out a small wooden alligator figure and pressed it repeatedly against the wound. He then put it away and did nothing else to address the wound. The alligator fetishes worn by this group suggest their migratory movements included areas populated by alligators.

From Persecution to Profit

The colonization of North America by European settlers was accompanied by the wholesale destruction of large predators. The great mammalian apex predators, such as bears, wolves, and cougars, were hunted for hides and meat, and to protect livestock and families. In some cases, they were simply persecuted, being seen as undesirable co-inhabitants of the continent.

Alligators had a mixed reputation during their early encounters with Europeans. Many people considered them benign, as attacks on humans were rare and alligators typically retreat when humans approach. But for other people, they were objects of fear or disdain. Alligators did regularly kill dogs, pigs, and

poultry, even coming onshore to do so. As settlements grew, alligators became the bane of some farming communities. Persecution soon began in earnest, with any alligator in the vicinity of a farm being shot, clubbed, or axed to death. Although the persecution began around farms and homesteads, it spread to any place alligators were encountered, similar to the way some people treat rattlesnakes today. Historical accounts include descriptions of people who, when encountering alligators for the first time, reflexively picked up a firearm and shot them as if it was a natural response.

Alligators were often shot from boats as they lay on the banks along rivers or other bodies of water. Corpses were usually left to rot. This type of persecution continued into the early 1900s. Numerous articles in popular magazines of the day included stories of "alligator shooting" from steamboats that carried both residents and tourists along the rivers of the South. No attempts were made to recover the carcasses. Some writers at the time even considered alligator shooting a "sport," though contemporary sportsmen made derisive comments about the practice in sporting magazines and books.

Skill in this "sport" took on a gruesome form as alligators had to be shot in the brain. Hitting them anywhere else caused them to writhe about violently and spook other alligators basking on the riverbank. A clean shot through the eye, or preferably just behind the eye, would strike the brain, leaving the alligator in place, and leaving the other alligators, unaware of the goings-on, ready as targets for the next hunter. The practice of shooting from steamboats was so common along the primary river routes that these "sportsmen" often shot alligators that were already dead on the bank from a previous passing boat.

Alligator hunting as a commercial enterprise first appeared in the very late 1700s, and soon a market developed for alligator skins for men's shoes and boots. The belief was that alligator leather must be waterproof because the animals spent all of their time in water. In truth, the fibers making up the leather are too loosely arranged to be waterproof. Still, thousands of skins were harvested in the lower Mississippi River valley, especially in the lower Red River. At about the same time, demand for oil produced by rendering alligator fat increased. The oil was an effective lubricant for industrial machinery and remained in use until about 1870.

The desire for alligator skins waxed and waned over the years but became highly fashionable around 1855. For a few years, thousands of hides were sent to Paris to make shoes, boots, and other products such as saddlebags. The pattern of scales and the high luster of the tanned hides made for elegant footwear. The trend faded, as had happened before, because water damage destroyed the original shine so easily.

During the American Civil War, when leather from cattle and pigs became rare for Southern troops, alligator became a substitute. All manner of alligator leather goods was produced in the South at this time—boots and shoes,

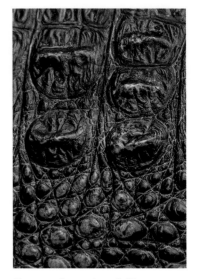

Closeup of a section of alligator hide, showing the enlarged, keeled scales of the dorsal armor above, and the smaller scales of the upper flank below. Flank and belly hides are the most prized for high-end alligator-skin products.

of course, but also holsters and bags, as well as saddles, bridles, and other horse tack. With the end of the Civil War in 1865, alligators enjoyed a very brief respite from the endless slaughter for their hides. But soon one hundred years of unsustainable hunting began, the scale of which was unlike anything alligators had withstood before. Demand for alligator hides began to rise in about 1870, driven again by the European fashion industry. Alligator hide was back on the market in the form of purses, pocket books, travel bags, and trunks. Elegant accessories, such as gloves, wallets, card cases, and belts, were also made from alligator hides.

By 1880, the value of a large tanned hide had risen to $1.50, while an average skin was worth about $1.00 (well over $1,000 today). Sale of alligator skins became so lucrative that men took up hunting alligators as their sole profession. These "gator scalpers" may have caused alligators to become wary of humans, for soon alligators had to be hunted at night. With light from torches

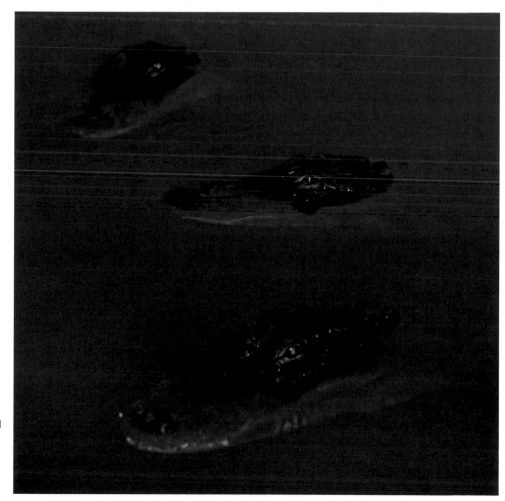

Glowing red eyes, produced when light shines deep into the interior of the eye, are visible through the pupils of these alligators. Alligator hunters, using head lamps and hunting at night, located alligators in the dark by means of this eyeshine, resulting in the demise of millions of alligators.

or lanterns, the scalpers illuminated the alligator's reflective eyeshine to find its position. They then shot the gators between the eyes or used shotguns to destroy the back of the head. Once they had shot the alligator, the scalpers used long-handled hooks to snag the body before it sank and was lost. Small groups of men, equipped with one or two boats, lamps, and a shotgun, could kill ten to fifty alligators in a single night. The alligators were skinned, and the skins were then salted to preserve them. The carcasses were dumped in the swamps.

Demand increased dramatically as the twentieth century arrived. Alligators in Florida bore the brunt of this assault, as the state had the crown for being the primary producer of skins. Commercial centers for buying raw, salted hides were concentrated in South Florida along the periphery of the Everglades—places like Cocoa, Melbourne, Kissimmee, Fort Pierce, and Miami. In areas where alligators were once common, passengers could travel by boat from Jacksonville to Miami without seeing a living alligator. One naturalist estimated that, by about 1905, the alligator population in Florida had been reduced by 98 percent from what it was two decades earlier. Even in the face of scarcity, the value of the alligator's hide was enough to encourage hunters to persist.

Demand for other alligator products had increased as well. Eggs were emptied and offered for sale to tourists as souvenirs by the thousands. Teeth in good condition were worth one to five dollars per pound wholesale in the 1880s, and perhaps ten times that amount in retail sales. Oil produced from the alligator's fat was selling for twelve to twenty-five cents per gallon. Hatchling alligators were shipped to the northern states to be sold in curio shops. In the 1890s, live hatchling alligators were being sold for twenty to thirty-five dollars per hundred.

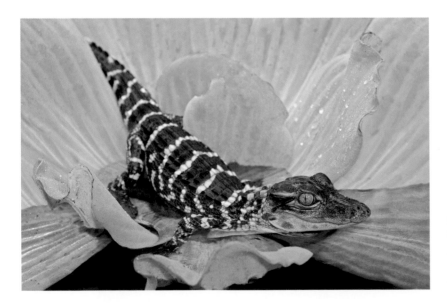

Hatchling alligator resting on water lettuce. Hatchlings like this were sold as pets or stuffed as curios or souvenirs by the hundreds of thousands in the decades following the Civil War.

The number of alligators killed from 1870 to the early 1900s would have varied widely from year to year, influenced by price and dwindling population sizes. Records of hides purchased by tanneries, bills of lading for transport of the skins, tax records, newspaper accounts, private journals, and business ledgers are the best sources of information. Based on these sources, we have a rough idea of the extent of the slaughter.

In the 1880s, an estimated 250,000 adult and juvenile alligators were killed each year in Florida alone. If you add in all of the other range states, you can probably double that number as a reasonable guess for the entire United States. For a time, large numbers of alligators likely remained in the most remote, secluded parts of swamps. But by 1890, people were invading these areas to hunt not just alligators, but also egrets for their white plumage, which had become fashionable for women's hats.

In Louisiana, an estimated 3–3.5 million alligators were harvested for their hides between 1880 and 1933. In 1899, from just one section of Louisiana, 186,000 skins were shipped to northern tanneries. In 1902, the US Fish Commission estimated that 280,000 "crocodilian skins" were sold in the United States. By their (probably low) estimate, alligators accounted for 120,000 of the hides. The rest were crocodile hides from Mexico and Central America.

By 1905, alligators were severely reduced in Georgia, Alabama, and Mississippi. There were still viable populations in Louisiana and Florida, but hunting was proceeding at an alarming rate. Alligators near human habitation, or along easily accessible waterways, were gone. Hunters were forced to penetrate ever deeper into more remote wetlands. Calls to protect alligators finally sounded in earnest, but efforts to pass laws protecting the alligator were met with complete indifference on the part of most legislators. The alligator's reputation was one of an ugly and dangerous monster, and lawmakers were mostly in favor of its extermination. War (in the form of World War I) was the only thing that slowed the onslaught. The fashion industry demand eased dramatically, and the hunters had to find new work.

By the 1920s, the number of skins taken each year had dropped to about fifty thousand. Alligator populations in Louisiana and Florida were thought to be less than one-fifth of their very reduced numbers from twenty years before. Old trappers in Louisiana reportedly told of times when reflected eyeshine of alligators in the bayous was as dense as the stars in the heavens. In the 1920s, canals were dug into the remote parts of the coastal bayous of Louisiana primarily to allow hunters access to fur-bearing mammals—beavers, muskrats, raccoons, foxes, and mink. The mammals were trapped during the winter months when their pelts were at their finest, and alligators were hunted the rest of the year. Soon the stars were extinguished.

A severe and prolonged drought that struck southern Louisiana in 1925 and 1926 forced alligators out of their dens and from the thick marshlands. They

Handbag made from the skin of a brown caiman, a close relative of the alligator. The intricate scale patterns, texture, and high luster of tanned crocodilian skin products have made them attractive to the high fashion industry.

concentrated in canals, setting up a situation that depleted their numbers dramatically. Hunters set fire to the dry marshes, further leaving alligators no place to hide. State records indicate taxes were paid on 21,885 belly skins in 1925, a total of 197,295 linear feet of hides—more than 37 miles (60 km) if laid end to end. That number went up to 36,041 hides in 1926, according to tax records. Soon alligators, a common sight in most southern wetlands just a quarter of a century before, were no longer seen. Scientists and, more importantly, the general public expressed increasing concern about the alligator's impending extinction. Yet it would still be decades before those concerns stopped the slaughter.

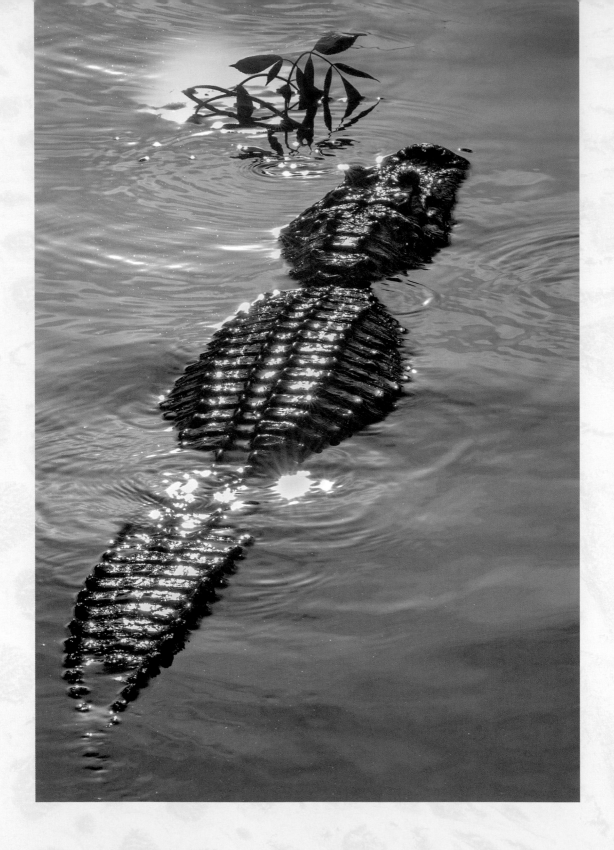

Alligator Adaptations

As we watch an alligator swimming almost effortlessly through the water, it is easy to marvel at the perfect, languid oscillations of its tail. Alligators move gracefully through the water, in sharp contrast to their lumbering movements on land. Yet the less-than-graceful terrestrial alligator can walk long distances cross-country, run when they must, and even climb trees and fences.

My long history of alligator watching has led me to the conclusion that the alligator leads a double life as an aquatic creature fully capable of swimming, diving, and remaining underwater for long periods of time and a land dweller that knows its way around on shore. The alligator lives at the interface of these two very different worlds. And it has a body that is adapted to the rigors and requirements of both. Many scientists believe that it was the double life of amphibious existence that helped the ancestral crocodiles survive at the end of the Cretaceous, a time when the non-avian dinosaurs disappeared.

The alligator has a body similar in some ways to a large lizard, but the comparison only goes so far. Alligators have a bulky torso, a back studded with keeled rows of bony scales, four short, heavy legs that end with webbed feet, a thick neck, large head, and a long, stout tail. The tail alone is about half of the total length of the animal. The tail is extremely muscular, compressed on the sides, and crested with elongate scales. This shape increases the tail's surface area and allows for the serpentine undulations that quietly and quickly propel the animal through the water. Holding an alligator side by side with a lizard, you'll see some similarities, but many of the characteristics I just mentioned are not seen in lizards.

The head and neck of an alligator are massive and muscular. The broad, parallel-sided snout is bluntly rounded in front and lined with dozens of robust teeth. Both the head and neck are swollen with muscles that allow an alligator to exert a debilitating, crushing bite that can overpower its desperate, struggling prey.

Skin Deep

Alligator skin is very leathery, as it is made up largely of bundles of collagen fibers in the underlying dermis. The skin has a hard, stratified epidermal covering made of beta-keratin, similar to what one sees in bird feathers. Keratin adds rigidity to the skin surface and makes an alligator water-resistant. That same rigidity also prevents water loss when on land. The skin on most of the alligator's head is attached directly to the bone below it, with the blood supply passing through small channels in the skull.

The skin that forms the alligator's hide covers the neck, body, legs, and tail. It is broken into patterns of scales. Scales are named for the region of the body on which they occur—those on the throat are called gular scales, on the belly are the ventral scales, the sides have flank scales, and the tail has concentric rings of scales called caudal whorls.

On many parts of the crocodilian body, especially the back, there are regularly arranged rows of enlarged, keeled scutes (enlarged, thickened scales). These keeled scutes have elements of bone embedded in the dermis of the skin, called osteoderms, and are covered by very heavy keratin. The cluster of keeled scutes over the neck are called nuchals, the line of small conical scales between the nuchals and the back of the head are called post-occipital scutes, and the scales forming regular rows down the back are called dorsals. Other scales on the body may develop bony inclusions with age, but these structures are not as large, heavy, or keeled as those of the dorsal scale rows. In larger alligators, "buttons" of embedded bone may form in the gular scales under the neck, the ventral scales, and even in the scales on the side of some caudal whorls. The presence of buttons in the ventral scales can reduce the value of a hide in the commercial market.

A bony skin serves multiple functions, but a primary one is defense. The large osteoderms of the nuchal and dorsal scale rows, as well as smaller buttons in the gular and ventral scales, act as body armor during aggressive encounters with other alligators, blunting the impact of bites. In dominant/subordinate interactions between adult male alligators, the subordinate male rotates its torso to direct more of its bony armor toward its opponent.

The colors and patterns seen on an alligator's skin are produced by combinations of pigments. The most common of these pigments is melanin, which gives the alligator its dark gray to black background color on its back and sides. In areas where melanin is absent, light yellow-orange and brown stripes or bands are produced by other pigments. Hatchling and juvenile alligators are generally much more boldly marked than older animals, with four or five bands of yellow or brown across the torso and nine to eleven bands down the tail. These bands may help camouflage the young in grasses and other heavy emergent vegetation in shallow waters. As alligators age, they darken because of added melanin-producing cells.

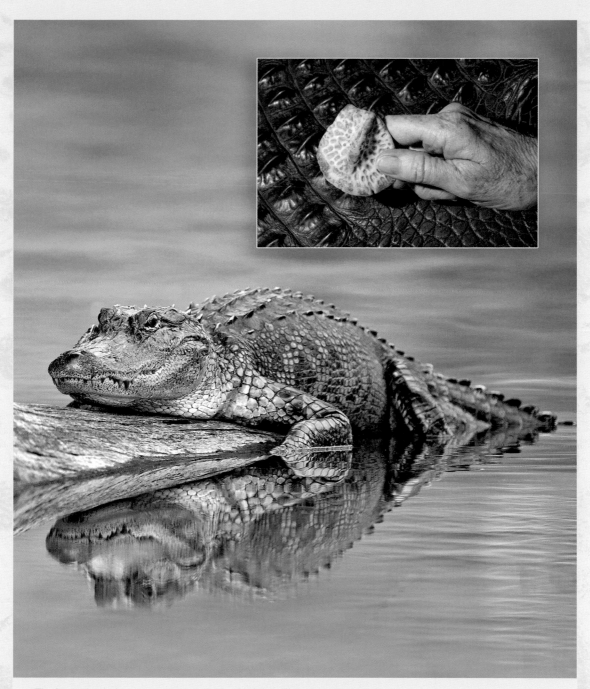

The large, keeled scutes covering the back of the alligator's torso each contain an osteoderm (*inset*), a bony plate embedded in the skin.

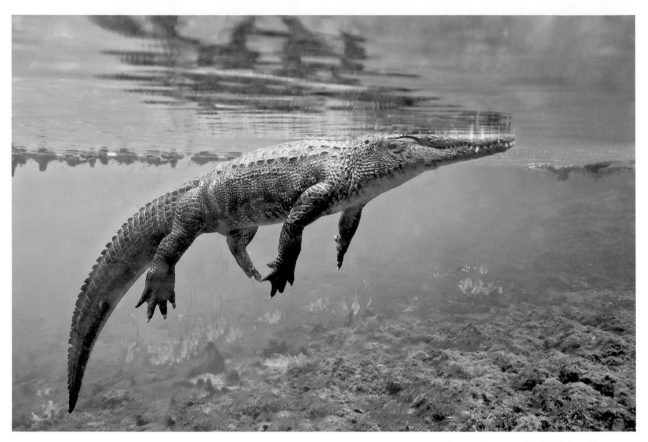

Alligator floats motionlessly in a Florida spring, its short, muscular legs and partially webbed feet hanging in the clear water. The long, powerful tail droops at rest.

The alligator's legs are almost comical: short but very muscular. The hind limbs are longer than the forelimbs, a remnant of an archosaur ancestor that walked on two legs instead of four. The longer hind legs result in the base of the tail riding higher than the shoulders when an alligator walks. The front feet have five digits, whereas the hind feet have only four. However, as an embryo an alligator has the beginnings of a fifth toe on the hind feet, but it fails to fully develop. Fossil evidence suggests the crocodilian lineage lost that toe more than 250 million years ago.

The hind feet are long and wide with webbing that extends about three-fourths of the length of the outer toes. Much like a duck, an alligator can use its webbed hind feet to swim, steer, or push along a muddy bottom. In contrast, the forefeet are relatively small with elongate digits and very reduced webbing.

All Mouth

An alligator's head is all business. The rest of the body is just a means of transporting the head and maintaining essential functions of life so the head can do its job. Sight, hearing, smell, taste, touch, and balance are all centered in the

alligator's head. Prey need only fear the head, not the claws, as is the case with some predators. But the head is an evolutionary compromise, the result of conflicting physical restrictions. It must be sizeable and strong enough for the stresses and strains of capturing prey, but it must be light enough to lift, turn, and swing rapidly, even in water. And the head must be compact and streamlined so the alligator can move through the water inconspicuously prior to an attack. The result is a remarkable trade-off—an impressive feat of bioengineering. The alligator, with its enormous and frightening head, is capable of sneaking to the water's edge before exploding into view and quickly crushing the skull of a deer. On that same day, that same head may also gently lift one of its hatchlings, moving the chirping six-ounce offspring unharmed from nest to water.

Unlike the skulls of non-crocodilian reptiles, alligator skulls lack the joints that allow certain elements to flex relative to others. The upper jaw is firmly fused to the rest of the skull, while the lower jaw is capable of opening and closing, but not moving sideways like your lower jaw. Thus, it is not possible for an alligator to chew its food, so the food must be consumed whole or thrashed apart using wild jerks and spins.

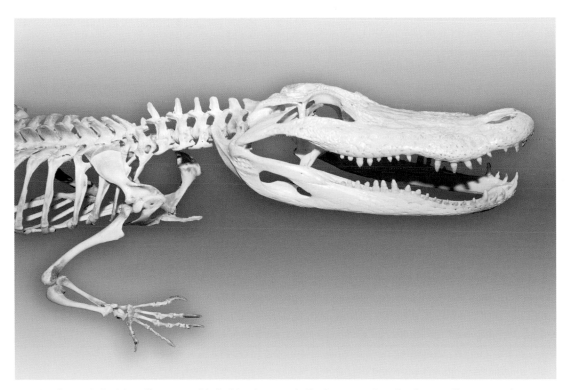

Massive, bony skull of the alligator, studded with robust teeth. The bony openings for the nostrils, eyes, and ears are visible along the top of the head. In life, the large openings in the back of the skull are filled with a complex of large jaw muscles to deliver a crushing bite.

A complex of massive jaw muscles originate on the bones of the skull, behind the eye. These muscles insert on the interior surfaces of the back of the lower jaw. Straps of these muscles extend forward within the interior of the snout and inner spaces of the lower jaw, stabilizing these structures when they are exposed to the tremendous force emitted by an alligator biting with its seventy to eighty teeth.

The shape and proportions of an alligator's skull change dramatically as it grows. The length of the head, relative to body length, remains more or less constant. But the snout elongates over time, so the ratio of snout length to cranium length increases. In old individuals, especially males, snouts may widen somewhat. The surface of the skull is fairly smooth in juveniles but becomes increasingly more ornamented and pitted with age.

The crowns of alligator teeth are cone-shaped and solid. Each tooth has a long, hollow, and fairly cylindrical root. Roots of each tooth extend deep into the jaw, each within its own individual pit. The result is teeth that are very securely set in place. Biologists call this type of tooth attachment "thecodont." The crown is composed of enamel on the surface overlying a deeper layer of dentin. The enamel becomes increasingly thin toward the root until it disappears entirely just above the level where the crown meets the root. A thin layer of cementum covers the enamel in this area. The root itself is composed of dentin with an overlying layer of cementum (in a similar manner to what occurs on the roots of human teeth).

Unlike humans, who have one set of "baby" teeth (or milk teeth) and then one permanent set of teeth, alligators replace their teeth continually throughout their lives. On average, an alligator replaces each tooth about once per year, but it is a staggered process. There are almost always functioning teeth in all regions along both the upper and lower jaws. The teeth are shed in a sequence, with every third tooth in the mouth being shed at roughly the same time. A few months later, the teeth immediately next to those that were just shed are lost. The sequence continues as long as the alligator lives. An old alligator, living to fifty years of age in the wild, might produce as many as four thousand teeth in its lifetime.

As alligators grow, the replacement teeth become larger, stronger, and increasingly blunt. These changes reflect the change in diet as the animal ages. The small, sharp teeth of young alligators help them penetrate the scales of small fish or the hard exoskeleton of large insects such as grasshoppers. The larger, stronger teeth of adults can withstand the great forces exerted during the capture of larger, struggling prey, or while attempting to crush a turtle shell.

An alligator's tongue is wide and flat, and it thickens toward the back of the mouth. It is attached to the floor of the mouth almost entirely, except that the very tip of the tongue can move freely. As a result, an alligator cannot stick out

its tongue. The surface of the tongue has a tough, keratinized covering with several types of microscopic cone structures called papillae. These structures seem to have both tactile and chemosensory functions.

An alligator's tongue is a surprisingly "meaty" structure. It is very muscular but lacks an intricate array of muscles. In combination with the actions of their jaws, and thrusts of the head, alligators are able to use their tongue to move prey in the mouth: from front to back, side to side, or turn it around. An adult female alligator can also use its tongue when assisting its young during hatching and nest opening. When picking up hatchlings in its jaws, the female will drop its tongue, forming a "mouth pouch," in order to carry the hatchling from the nest to the water. A female will crack open eggs that have not fully hatched by using its tongue to force the shell against the roof of its mouth. The hatchling then crawls out.

The back of the mouth has a large palatal valve that prevents water from passing into the throat and lungs. Even if the alligator's mouth is open under water, water will not enter the lungs because of a coordinated system of structures and muscles. Yet, an alligator with open jaws can lower its tongue and open a very wide gullet through which prey can be swallowed.

The importance of the palatal valve in allowing a crocodilian to hold prey in its mouth without the risk of taking water into its lungs was recognized as early as 1812 by the great explorer Alexander von Humboldt. I have seen alligators grab hold of large aquatic turtles and hold them in their partially open mouths, the palatal valve preventing the intake of water. They keep the turtle underwater to prevent the chelonian from breathing. The alligator, however, pokes its

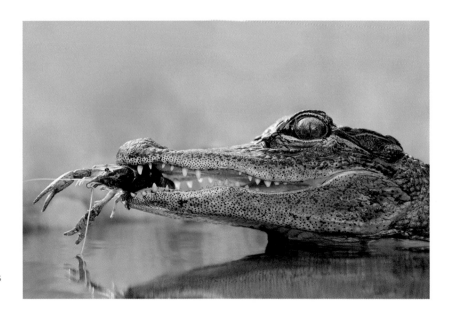

Teeth of juvenile alligators are not as stout as those of adults, but have sharp points to penetrate and hold hard-bodied prey, such as this crayfish.

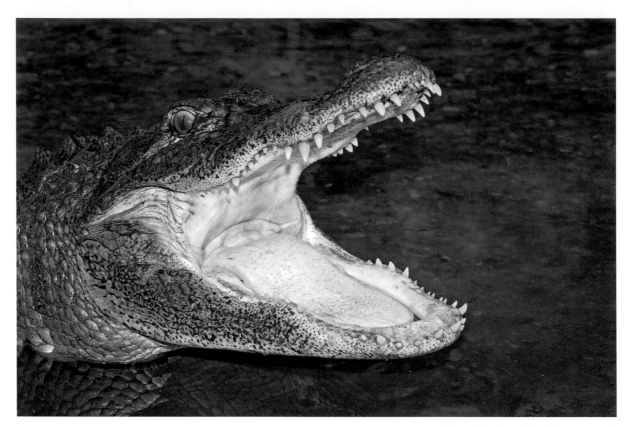

nostrils just above the water so it can breathe. With its palatal valve closed, the alligator can hold the doomed turtle underwater until it is lifeless, at which time the alligator can crush and swallow the turtle without the possibility of the turtle escaping.

A Bit of Brain, a Lot of Sensing

Alligator brains are noteworthy for being extremely small. An adult male, with its massive head, has a brain that is about as big as your thumb. In its early life, a hatchling alligator's brain grows fairly rapidly, but then it slows markedly, even as the body becomes huge. As far as we can determine, an alligator's brain grows continuously through life, albeit extremely slowly. As a consequence of the disproportionate growth of body and brain as alligators age, very large alligators have remarkably small brains. The brain of one 450-pound (205 kg) alligator was only 0.5 ounces (14 grams). Its body was 14,560 times heavier than its brain. For comparison, your body is about fifty to seventy times heavier than your brain.

In contrast to the brain, an alligator's spinal cord grows proportionally with the body, with bundles of sensory and motor neurons running up and down the

spine within the vertebral column, stretching from the brain to the tip of the tail. Because the nerves receive and send signals to all parts of the body, the spinal cord must keep up with the growth of the body.

As ambush predators, alligators often position themselves so that only the top of the head is visible above water. This position allows them to survey the environment, with their eyes, ears, and nostrils exposed. Their skin contains about four thousand tiny pressure-sensing organs, which are scattered all over the head. The organs are particularly dense along the side of the head and jaws, especially around the teeth. So sensitive are these organs that small alligators can even sense drips of water.

Alligators have eyes that are positioned high on the side of the head, giving them a wide field of vision. The elevated position of the eyes on top of the head allows alligators to function somewhat like the periscopes of submarines—they surface just enough for their eyes to protrude while the rest of the body remains hidden. Alligators have binocular vision about 25 degrees in front and a monocular field of view of about 152–160 degrees. Their bit of binocular vision allows them to have some distance perception. However, an alligator can't use binocular vision during actual prey capture. When an alligator opens its mouth to capture the prey, the snout blocks its view of the prey item. Because of this limitation, alligators often approach prey from slightly off to the side, and then bite with a quick bend of the neck and rotation of the head.

Alligators have multiple eyelids. The portion of the upper eyelid that covers the top of the eye is quite thick and contains a small bone called a palpebrum. The lower eyelid is relatively thin and soft. Alligator eyes can be drawn down, completely below the outer margins of the skull. This movement, plus the bony palpebrum, helps protect the eyes from potentially devastating injuries during aggressive encounters with other alligators, the violent struggle of prey, or

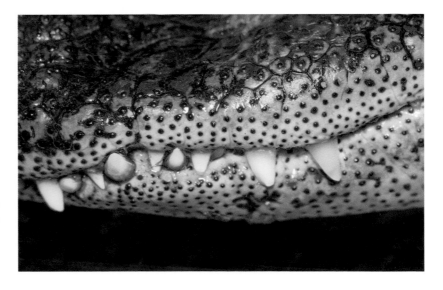

Integumentary sense organs, or ISOs, are visible here as small black bumps. They are scattered all over the alligator's head but are especially concentrated along the sides of the jaws.

even from brushing against logs, branches, and rocks when swimming through murky waters.

In addition to the upper and lower "regular" eyelids, alligators have a "third eyelid," called a nictitating membrane. This membrane covers the eye whenever the eyes are shut or when the alligator is submerged in water with its eyes open. When not in use, the nictitating membrane lies unseen in the front corner of the eye. When needed, it passes across the surface of the eye. In young animals it is transparent, but as animals age it becomes opaque. In older alligators it is often scarred, filled with heavy blood vessels, and probably obscures their vision. The nictitating membrane offers some protection against abrasion when an alligator's eye accidentally brushes against an object. But the membrane is not like wearing swimming goggles. An alligator's eyes do not accommodate for underwater vision, so they see the same sorts of blurry images we do when we look underwater in a swimming pool.

Alligators do not possess tear glands, but they do have Harderian glands that secrete fluids between the nictitating membrane and the eye. These fluids presumably lubricate the eye when exposed to air and may flush the eye while submerged. When excess fluids drain from the corner of the eye during feeding and swallowing, some people mistakenly believe the alligator is crying. When alligators hiss loudly as a threat, they sometimes squeeze out Harderian fluids, and large bubbles may form in the corner of their eyes.

The alligator eye is structured more or less like the human eye—basically a fluid-filled sphere. Most of the wall of this sphere is composed of a tough fibrous sclera upon which the muscles that control the movement of the eye are attached. The sclera is white in color (the "whites of the eyes"). Light first enters the eye through the transparent cornea and then through the pupil, which is centered in the iris. The iris is dark brown in color for most alligators, often with light gold flecks or streaks running through it. Occasionally, alligators will have greenish colored eyes, or even blue eyes.

Alligators are well adapted for seeing in very low light. Their pupils are a vertical slit during the day but become almost circular at night to let in more light. The lens of the eye is large, collecting and focusing the available light onto the photosensitive retina. To further improve vision at night, a tapetum lucidum lines the back of the eye behind the retina. The tapetum lucidum is a layer of highly reflective guanine crystals that function like tiny mirrors. Light passing through the retina is immediately reflected back through the photosensitive receptors of the retina, doubling the amount of light perceived by the eye. The tapetum lucidum is the reason an alligator's eyes act like reflectors when a light is aimed at them. Some mammals also have a tapetum lucidum, which you may have observed when one is illuminated by your car's headlights.

When light hits photoreceptors in the eye, nerve impulses are stimulated. Signals then pass through the optic nerve and are perceived as visual images

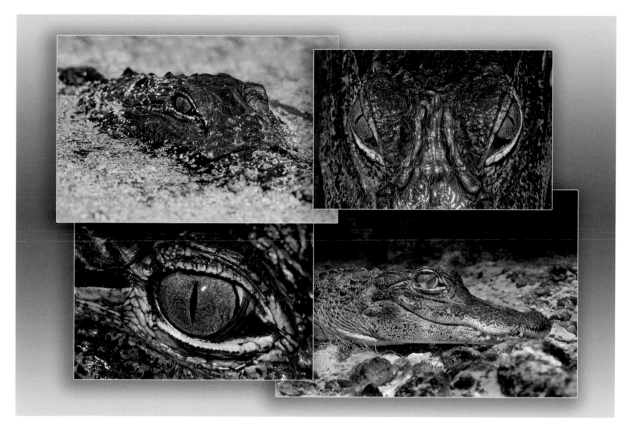

Alligators have large eyes mounted high on top of the head. In daylight, the pupil constricts into a vertical slit, but at night, the pupil opens wide until it is almost round. The nictitating membrane, the so-called third eyelid, is visible covering the eyes of a submerged alligator (*below right*).

within the visual cortex of the brain. The resolution of the images formed in the alligator eye is similar to that of our own vision. But an alligator floating on the surface of the water has greater visual acuity along the horizontal plane, which means that when its eyes are just above the waterline, it sees most clearly across the surface of the water.

When an alligator floats near the surface, its nostrils also sit above the water, in a fleshy elevated mound at the tip of the snout. The two openings are muscular valves and can be closed when the alligator submerges. Soft, nerve-infused skin surrounding the nostrils allows the alligator to sense where the water level is relative to its nostrils. When water touches this area, the nostrils quickly close.

Air passes through an alligator's nasal sinuses in much the same way it does ours. The alligator's nasal sinuses extend through the length of the snout, ultimately exiting in the back of the throat. The nasal sinuses are a complex series of channels and chambers and are rich with chemosensory receptors, providing alligators with a great sense of smell. A portion of the brain extends forward in close association with the nasal cavity, where it expands into two large olfactory bulbs.

Do You See What I See?

Like other animals, an alligator's photoreceptors contain visual pigments that absorb specific wavelengths of light. The alligator retina is dominated by rods. This helps alligators see in low-light situations. The retina contains enough cones to allow alligators to distinguish colors. Cones come in three distinct types: two types of single cones and one twin cone. Each cone type has distinct visual pigments that are sensitive to specific colors. The single cone types are each sensitive to violet and red. The principal member of the double cone is maximally sensitive to green and the accessory element of the double cone to blue-green.

The pigments can also absorb light of other wavelengths with reduced efficiency. The overlap in light sensitivities of these four pigments spans a spectrum of wavelengths from 400 to 700 nanometers, meaning alligators can see colors similar to what we see.

This system of cone and rod photoreceptors possessed by alligators allows them to see best at dawn and dusk, which is when they do the majority of their hunting and traveling. During the day, alligators spend more time basking, courting, and engaging in various display behaviors.

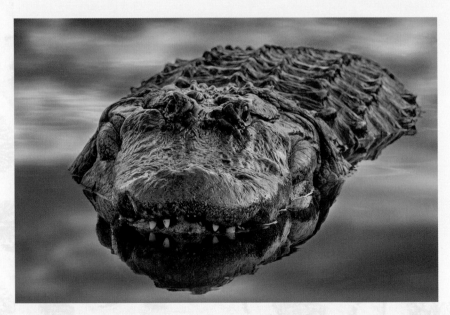

Alligators are really creatures of the night. It is in these dark hours that they most actively hunt. Their eyes are adapted for night vision. Their pupils expand to allow more light to enter the eye. A layer of highly reflective crystals in the back of the eye, called a tapetum lucidum, magnifies the amount of light perceived by the retina.

Alligators have two different chemosensory systems. One is used to smell; the other is more difficult to characterize. This second system has been found in some fish, amphibians, and even mammals, including humans. The specific chemicals this system detects seem to vary by organism. In mice, for example, this second system detects chemical irritants. In humans, the system is known to be associated with bitter taste detection as well as inflammatory response of the sinuses to bacteria. Its function in alligators is not yet known.

When alligators bask on land, their throats often move up and down. Simultaneously, their nostrils open and close. People often think the alligators are breathing, but the alligators are actually smelling the air. The movement of the throat is called gular pumping, a behavior that draws small amounts of air in and out of the nasal sinuses so it can be sampled for chemical cues.

Unlike the quite visible nostrils, an alligator's earflaps are hard to see. They lie immediately behind the eyes. The flaps are protective muscular structures that cover the tympanic membranes (eardrums). You can often see alligators flip their earflaps a couple of times when resurfacing from the water, shaking off the water trapped along the lower edge of the flap. If you were to lift the earflap and peer into the external auditory chamber, you would immediately see the tympanic membrane. It looks much like the large, round eardrum on the side of a bullfrog's head, except that it is more of an oval shape.

The opening to the ear appears as a dark, narrow slit just behind the alligator's eye. The earflaps are protective muscular structures that close when the alligator dives underwater.

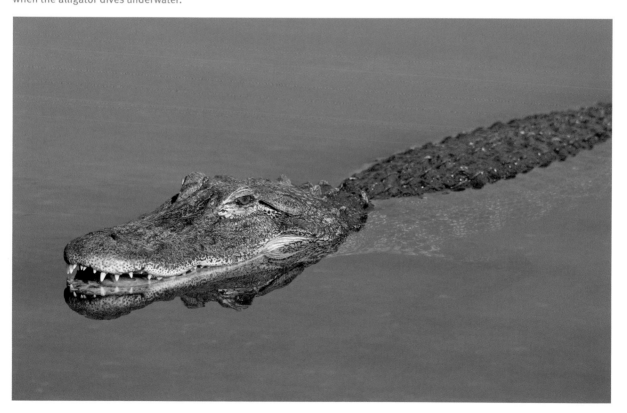

In the center of the tympanic membrane is a small opaque spot: the tip of the columella. This thin bone extends from the membrane across the middle ear cavity to the inner ear. Sound waves cause the membrane to vibrate, which then causes the columella to transmit vibrations into the inner ear, where they are conveyed into the cochlea. The alligator cochlea is more or less a straight canal, rather than the coiled structure found in humans. Within the cochlea, the auditory nerve transmits signals to the auditory portion of the brain, where they are interpreted as sounds.

Alligators, like humans, are able to locate the origin of a sound in part because they have two ears. Slight differences in the strength of a sound are perceived between the two ears, which allows the alligator to identify the direction from which the sound originated. Alligators have another system that helps them locate the origins of sounds. Recent studies have revealed that alligator middle-ear cavities are directly linked with one another. Directional sources of sounds generate differential pressures in this airspace. Neural mechanisms in the alligator brainstem appear to enhance this difference, helping alligators locate sound origins.

Alligator hearing is effective in air and in water. An alligator's sensitivity to sounds in air is comparable to that of birds. In water, alligators hear slightly better than goldfish, which are considered a hearing specialist among fish. Perceiving sound underwater doesn't seem to involve the eardrum. Sound vibrations probably pass directly through the bones of the skull to the inner ear.

Between the Head and the Tail

Between the head and the tail lies the torso, the trunk of the gator. It contains almost all of the of the animal's organs. The torso is subdivided into a series of cavities. The thoracic cavity holds the heart and lungs. The abdominal and pelvic cavities contain the larger organs associated with the digestive, excretory, and reproductive systems.

The heart lies in the center of the torso, very close to the belly. If you laid an alligator on its back on a warm day, you would easily see movement of the ventral skin as it expanded and contracted with each beat of the heart. The position of the heart changes somewhat as an alligator grows, moving a bit toward the tail as the animal transforms from hatchling to juvenile to adult. On each side of the heart lie the lungs, which take up most of the space in the thoracic cavity.

The crocodilian heart has been the object of description, study, and confusion for close to 185 years, and in some respects, it remains a subject of debate among scientists. The heart has four chambers, just like ours: two atria (a right and a left) and two ventricles (also right and left). This four-chambered heart is similar to that of birds and mammals, but very different from the three-chambered heart of reptiles or amphibians, which have only a single ven-

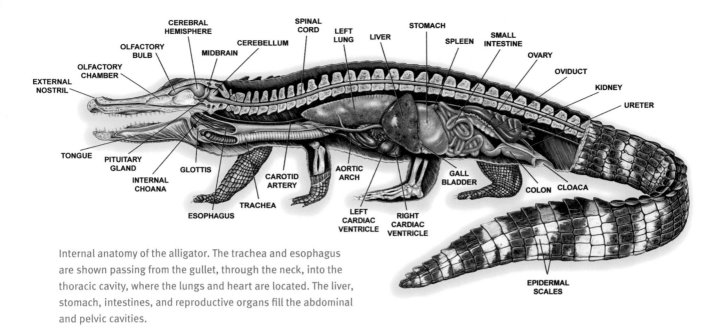

Internal anatomy of the alligator. The trachea and esophagus are shown passing from the gullet, through the neck, into the thoracic cavity, where the lungs and heart are located. The liver, stomach, intestines, and reproductive organs fill the abdominal and pelvic cavities.

tricle. Confusingly, in alligators the aorta arising from the right ventricle curves to the left and is called the left aorta. The aorta connected to the left ventricle is called the right aorta.

Blood from the right side of the heart is carried to the lungs through pulmonary arteries; the blood then travels through the lungs where excess carbon dioxide is removed and oxygen is added. The oxygen-rich blood next flows to the left atrium. This complete separation of the left and right sides of the heart creates differences in blood pressure, just like our standard difference of 120 over 80. Blood pressures in the systemic circuit of resting (that is, not active) alligators are between about 65 and 85 mm Hg (millimeters of mercury) for systolic pressures (compare to our 120) and range from about 40 to 60 mm Hg for diastolic pressures (compare to our 80). However, pressures in the lungs of alligators are substantially lower, about 15–20 mm Hg systolic. The reason is that the respiratory tissues are very delicate and can burst under higher pressure.

In a complicated twist on normal circulation, an alligator's blood can be redirected in the heart away from the lungs and back to the body. This ability is due to pulmonary bypass shunts. There are many hypotheses as to the value that is gained by this unusual circulation ability, such as conserving oxygen in the blood during prolonged submergence or to aid in food digestion.

The heart's ability to put oxygen in blood and remove carbon dioxide is only one role it plays in circulation. Blood also transports nutrients from the digestive tract to the liver for conversion and storage, and from the liver to tissues and cells. It collects and transports excretory waste (nitrogenous waste from the cellular digestion of amino acids in proteins) and transports these prod-

Not all vertebrate hearts are the same. The hearts of these striped mullet (*above left*) swimming with a Florida manatee have only two chambers (an atrium and a ventricle). The green tree frog (*above center*) and the coral snake (*below left*) have three-chambered hearts (still a single ventricle, but with two atria). Birds and mammals, such as this roseate spoonbill (*right*) and raccoon (*below center*), have four-chambered hearts (with two ventricles), as do alligators.

ucts to the kidneys. Hormones are also transported between the brain, glands, gonads, and other organs. Blood contains and transports antibodies that are critical for fighting infections. This is only a partial list, as most bodily functions rely on the circulatory system in one way or another.

The total blood volume of an alligator is about 1.1 fluid ounces per pound of gator (72 milliliters per kilogram). About 23 percent of the blood is made up of red blood cells and other cellular components, although this value can vary, as it is influenced by many physiological factors. Oxygen molecules are bound to hemoglobin proteins within red blood cells and alligators also have myoglobin in their muscles. Myoglobin is another oxygen-binding protein similar to hemoglobin. It increases the volume of stored oxygen within the body, allowing alligators to stay underwater longer. When both the hemoglobin and myoglobin oxygen stores are spent, alligators may still remain submerged. Their bodies shift to an anaerobic form of metabolism through glycolysis. In the absence of oxygen, glucose is converted ultimately into lactic acid. But lactic acid has det-

rimental impacts as it builds up—this is what makes your muscles fatigue when you exercise too intensely.

Accumulation of lactic acid in the alligator's body is reversed once the animal surfaces and begins to breathe again. Alligators and other crocodilians are capable of withstanding greater lactic acid buildup than any other vertebrates, but there are limits to their endurance. At some point, an alligator without access to oxygen would experience a fatal overdose of lactic acid.

When humans breathe, air is drawn into the lungs by the slight vacuum created when our diaphragm contracts. For us, it is a continual process, in and out, in and out. But alligators typically draw in one or two breaths, followed by a long pause. This pause may last between ten and thirty-five seconds, depending on the gator's body temperature. During a more complete "wash in and wash out" of the lungs, an alligator will take three or four breaths before pausing.

The lungs of alligators and crocodiles are more complex than those of other reptiles. Lungs of lizards and snakes are little more than empty, inflatable sacks with respiratory tissues lining the membranes, but alligators have substantial lungs (though they are not solid structures like those of mammals). Alligator lungs have vascularized tissues that allow for gas exchange, and also contain a vast array of tubules that channel air to specific portions of the lung.

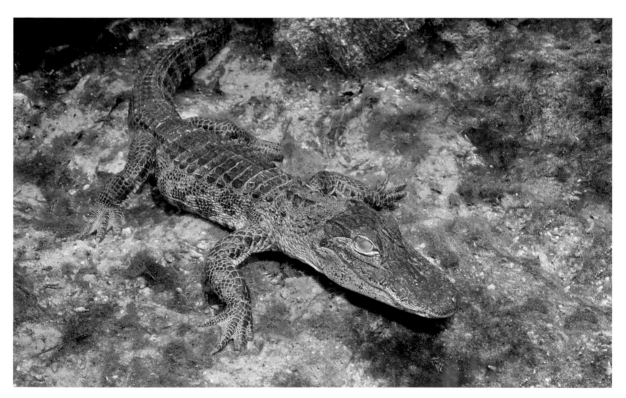

Diving alligators can remain submerged for long periods of time, relying on oxygen stores in their muscles as well as their lungs. When oxygen is depleted, they can prolong the dive through a physiological process called anaerobic metabolism.

Alligators and other crocodilians have a unique structure called a diaphragmaticus. At one point this structure was thought to play the central role in respiration, somewhat like a diaphragm for us. But we now believe the muscles of the ribcage can be used without the diaphragmaticus to allow alligators to breathe. The diaphragmaticus is used during times of great activity or when levels of carbon dioxide are high, such as when the alligator is in a confined space like a den. In these situations, the actions of the diaphragmaticus increase the rate of inspiration beyond what the ribcage muscles can produce.

The lungs themselves are quite large, filling about one third of the thoracic cavity. They lie along the back, toward the head, and are on each side of the vertebral column, with their outer edges against the thoracic ribs. Each lung, when inflated, is more or less oval shaped, but tapers toward the animal's head. Near the midline, the lungs each have small, relatively flat lobes called cardiac lobes. These lobes lie between the vertebral column and the heart. The cardiac lobes also are essentially devoid of vessels associated with gas exchange.

It was long thought that respiration in crocodilians was a tidal flow, much as we fill and empty our own lungs. In a tidal flow, air is drawn into the lungs during inspiration, respiratory gases are exchanged, and then the gases are exhaled.

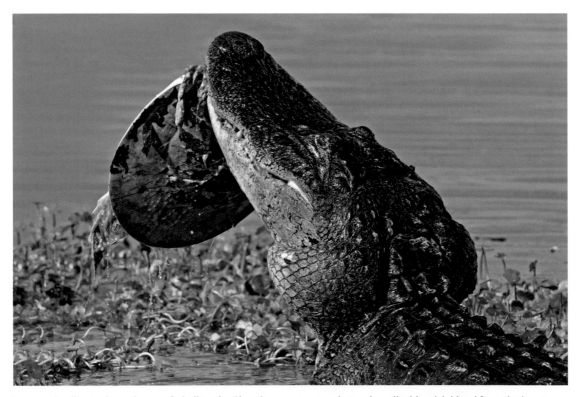

Large male alligator ingesting a softshell turtle. Shunting oxygen-poor but carbon dioxide–rich blood from the heart to the stomach may help make an alligator's stomach more acidic, accelerating the breakdown of bone and proteins as the alligator digests a turtle.

Recent research has indicated that air flow patterns through alligator lungs are more complex; the lungs are not simply terminal sacks that fill and empty like a balloon as ours do. Instead they function more like bird lungs, with air flow patterns that are unidirectional. In other words, the air flows the way traffic does on a loop road, not back and forth as if the lungs were a cul-de-sac.

The discovery that alligator respiration is unidirectional is further evidence of the shared ancestry of crocodilians and birds. But how gas is actually exchanged in crocodilian lungs remains to be verified. In birds, unidirectional ventilation enhances oxygen uptake under conditions of reduced oxygen, such as during migration when they are flying at extreme heights. This same mechanism may aid alligators and other crocodilians following prolonged submergence. The cardiac lobes of the alligator lung may function as bellows, similar to the way air sacs of birds move air into their lungs.

Most of the organs of the digestive, excretory, and reproductive systems are contained within the abdominal cavity. Just beyond the thoracic cavity, the two-lobed liver occupies much of the anterior portion of the abdominal cavity. To the right side of the abdomen is a distinct lateral fat body that is unique to crocodilians. This structure, variable in size, consists of body fat bound by a membrane. The composition of the fat is identical to other stored fat in the body. Fat is rather inert metabolically, so it usually has relatively little blood supply. That is not the case with this fat body, which receives blood from the coeliac artery. The fat body can thus provide energy for rapid utilization. Fat bodies of male alligators have been shown to grow when food is available and shrink during lean times (such as during extended droughts). Those of adult females increase or decrease in relation to reproductive activities, becoming smaller as follicles are being produced prior to egg laying.

The alligator stomach is lined with tissues that produce digestive enzymes and acids for the chemical breakdown of foods. In particular, the tissues produce hydrochloric acid, which creates the most acidic stomach environment of any vertebrate. The acidic stomach rapidly digests all parts of the ingested prey, including bones. A portion of the stomach contains stones or other ingested foreign objects, such as knots of wood, fishing lures, and soda cans. Much like a bird's gizzard, the muscles of the stomach wall use these objects to grind larger food items into smaller, more easily digested, fragments.

Walking the Walk

On land, alligators move using either a sprawling crawl or a high walk. The high walk is the primary means of locomotion when moving more than a few steps. It is considered a "semi-erect" gait because the angle of the femur (thigh bone) is more erect than in the sprawling gaits, but still less erect than you would see in the hind limb of a dog, for example. Still, the body is held off the ground with

the legs partially extended and rotated along the side of the body. At least two feet are on the ground at any time, and the tail drags along behind the gator.

Sometimes alligators rise on all fours and immediately begin a high walk. At other times they will push themselves along on their belly for one or two steps, then lift up on all fours. Conversely, they often drop into a belly crawl for a few steps after a high walk, almost like an airplane landing after a flight.

The sprawling crawl, sometimes called a belly crawl, is often used in wet or muddy environments. The belly remains on the ground and the legs are somewhat sprawled to the sides. The gator then pushes itself along with its limbs. This motion is often seen when an alligator is moving through shallow areas along a lake or river bank, or if it is in a shallow marsh where swimming is not an option.

The speed of running alligators can surprise an unsuspecting observer, but they cannot "run faster than a racehorse over the first hundred feet," as one myth asserts. Based on the fastest alligator movements I have observed, and my more limited observations of racehorses, I find it hard to imagine that the short little legs of an alligator could outrun a horse over any distance.

I've also heard from people who were told it's best to run in a zigzag pattern if chased by an alligator. Bad advice. First of all, running down prey is not a typ-

Alligators use different modes of locomotion. This is a "high walk," in which the legs are held semi-erect and the body is lifted completely off the ground. Alligators often use this gait when moving over dry ground.

ical alligator behavior. Chances are it is trying to scare you away, so the further you move away, the less of a threat you are. Secondly, you are almost certainly a faster runner than any alligator, so use that to your advantage and increase the distance between the two of you. In the very rare case that an alligator is actually chasing you, don't zigzag, just run. But I doubt you'll ever be in that circumstance; in my experience the alligators typically run away from me, trying to escape to the safety of water.

Now that we're all feeling safe, it is worth discussing how fast alligators are when they move at their most explosive speeds. Despite the fact that an average human can outrun an alligator, it is also true that an average alligator can move very quickly over very short distances. But how fast an alligator moves has proved hard to determine. Most of the speeds that have been reported are from laboratory trials, typically from alligators trained to walk and run on treadmills. These studies usually involve small captive specimens—often very small ones because working with them is easier. It's also easier to build the required experimental equipment when the animal is small. These small alligators probably do not reveal the top speeds of the species.

With these caveats in mind, I'll take my best stab at how fast I think an alligator can move on land. The best evidence suggests an adult alligator can run up to 8.5 miles per hour (14 kilometers per hour) over a short distance. By contrast, it is pretty easy for an adult human to surpass 10 miles per hour, and the human record speed, set by Usain Bolt, is 27.8 miles per hour (44.7 kph). During typical high walking, alligators travel around 1.25–2.5 miles per hour (2–4 kph). Small alligators, around 2 feet long (60 cm), reach maximum speeds of about 0.67 miles per hour (1.08 kph).

Tales about Tails

As an alligator swims, its tail becomes both a propeller and rudder. On land, the same tail is more of a hindrance than a help. The tail is long and heavy, accounting for as much as 28 percent of total body weight. When high walking, the weight is only part of the problem. Friction from the tail's contact with the ground adds resistance, slowing the forward motion of the alligator and increasing the energy used during overland movements.

The tail does have its advantages on land. An alligator's first defense on land is to rapidly retreat to water. But what happens when there's no water nearby? The front of the gator is protected by its mouth, but alligators can also strike with their tails, slapping with a surprising amount of force.

Some accounts of the danger posed by alligators claim the most dangerous body part is the tail, though that seems a bit of a stretch. Alligators don't, as some publications claim, stun their prey with a slap of the tail. Some old tales of men having had a leg broken by a tail slap might be true, but such events

While their long, muscular tail allows alligators to move rapidly through the water, dragging this weighty appendage behind them can hinder their progress on land.

would have occurred under extraordinary circumstances. I have personally felt the strong slap of an alligator's tail hundreds of times. In some cases, the alligators were very large male alligators. It definitely hurts. I've experienced bruises, swelling, and even broken toes. I can't say that any of the blows was enough to break a leg bone, but the blows were strong enough that I did worry I might be shoved toward the gator's head. Finding myself off-balance and face-to-face with an alligator on the defense is something I'm glad I was able to avoid.

The weighty tail can serve another advantage on land—a counterbalance. When an alligator swings its massive head toward a potential foe, the tail must swing in that direction as well. The tail can also serve as a counterbalance when the alligator climbs. The tail allows an alligator to lift the front half of its body off the ground. To accomplish this maneuver, the gator puts its weight on the hind legs and tail, allowing it to push its body up an embankment or tree limb.

The tail's real importance, however, is in the water. Almost all aquatic propulsion results from the sinuous undulations of the trunk and tail, but the body's

movements are secondary compared to the thrust provided by the tail. During swimming, the legs are simply folded against the side of the body.

The lateral flattening of the tail provides increased surface area on each side, which makes the sides of the tail more like canoe paddles. To swim more quickly, an alligator increases the tail beat frequency, but never changes how far it swings its tail from side to side. As an alligator grows, it beats its tail somewhat faster than it did at a smaller size.

When the alligator is swimming on the surface, a small swirl, or vortex, can be seen behind the tail. This swirl is formed when the tail tip reverses direction at the end of each tail stroke. A series of these small swirls is spread across the water when a slow-swimming alligator glides past. The serene set of swirls can be lost if even a small portion of the tip of the tail is missing. Tail tips can

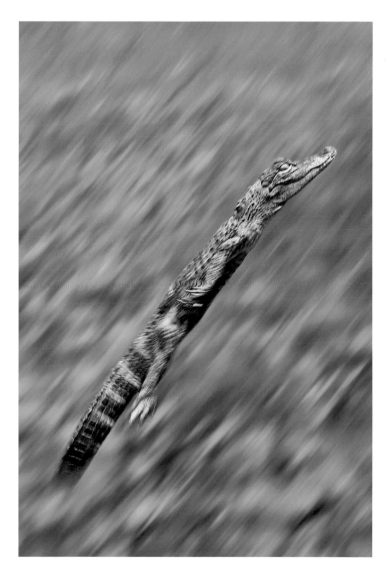

The streamlined hydrodynamic shape of an alligator's body allows it to move rapidly through the water while diving. In open water, limbs are held close to the body to reduce drag and lateral undulations of the tail provide forward thrust.

be nipped off during aggressive encounters with other alligators. In those cases, instead of swirls, the tail tip produces sloshing somewhat like a washing machine agitator.

The maximum speed at which an alligator can swim, just like their speed on land, is often overstated. Unlike on land, there's no doubt that alligators have the capacity to outswim the average person. But an alligator might have trouble catching up with Michael Phelps, who has been clocked at 6 miles per hour (9.6 kph).

A charging male can swim with enough velocity to lift its entire head and neck above the water. Sometimes even the shoulders will rise above the surface, making the alligator look like it is body surfing. During these times an alligator probably exceeds 6 miles per hour (9.6 kph). Under normal conditions, adult alligators move at moderate speeds, around 1.25–2.5 miles per hour (2–4 kph). Swimming speeds increase with body temperature until an alligator warms up to around 68 degrees Fahrenheit (20 degrees Celsius). After that point maximum swimming speed does not change.

During a Dive

Alligators dive to escape predation, avoid confrontations with other alligators, ambush prey, and drown animals they have captured. They also dive in order to rest on the bottom or escape heat during long summer days.

I'm often asked how long an alligator can stay submerged, but there is no easy way to answer the question because the answer depends on many factors. How large is the alligator? Small alligators can't store as much oxygen as larger gators. What is the body temperature? Cold alligators have greatly reduced metabolisms, so they use up oxygen at a slower rate. Has the alligator been active? An active alligator will have to surface sooner than one that was relaxed before the dive. Is the animal diving voluntarily or because it has to? Voluntary submergence seems to have a shorter duration.

Alligators exhibit two types of free dives—short active dives and longer resting dives. Active dives are of short duration, usually not more than one or two minutes in length. Resting dives generally last ten to fifteen minutes. But if forced to dive, a large alligator can stay submerged four to five hours. One large alligator, observed under ice, stayed submerged for eight hours. During prolonged dives, an alligator's heart rate may drop to only two or three beats per minute, a condition known as diving bradycardia. It can take several days following a forced dive for an alligator to fully recover because of lactic acid build up during the dive.

Very little is known about how deep an alligator will dive. In part, this is due to the fact that most habitats in which alligators live are not deep. Alligators commonly rest on the bottom or on ledges in lakes and rivers. At least into the

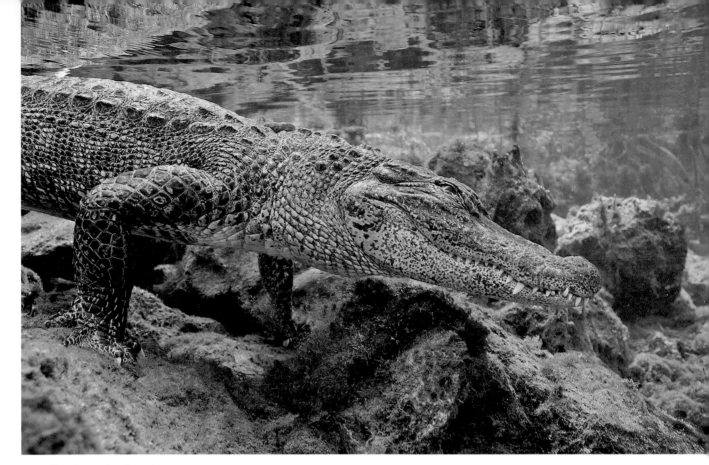

Most dives last only a few minutes, but alligators can spend much more time underwater if forced to.

1950s, before Florida had so many residents and tourists, alligators could be found at depths of 50 feet (15 m) inside the outflow boil of natural springs in North and Central Florida. One alligator was videotaped resting on the bottom of the ocean, 7 miles (11 km) east of Key West, Florida. It was 59 feet (18 m) below the surface, making this a record for an alligator dive.

When we dive, we take a big gulp of air to sustain us while we are underwater. Alligators actually release air from the lungs prior to submerging. Air in the lungs makes gators buoyant, so they must expel their air before diving. You can sometimes see streams of bubbles escaping from an alligator's nostrils as it sinks below the surface.

Where They Live

Nothing stops the heart in midbeat quite like the sight of a large alligator in a cypress swamp. The prehistoric atmosphere is reminiscent of times long past. You feel yourself transported into another world. Yet in the home of the alligator, such scenes are commonplace.

Alligators live in a wide variety of wetland habitats—lakes, ponds, low-velocity rivers and nearby flooded marshes, bogs, and swamps. They are also quite at home in human-made reservoirs and canals, cattle ponds, irrigation ditches, and golf-course water traps. In fact, many golfers visiting the southeastern United States often arrive home with their "gator tale." The term water hazard takes on a new meaning in alligator country.

In the warmer months of the year, alligators move about considerably. In some areas, the drying of wetlands can force movements. But social pressures can also force them to move. A big male will often bully a smaller gator, leading to one of the ways humans may run into a backyard visitor.

Everyone living in the Southeast knows that alligators may appear in almost any place that holds water. Roadside ditches and culverts, storm-water retention basins, and swimming pools may suddenly serve as a new home to a wandering alligator. Occasionally a news crew arrives, or a video goes viral, thrilling viewers both locally and across the world.

Smaller alligators, even adult males, may find themselves repeatedly driven from areas by dominant animals. As a result of such territorial behavior, it's common for a large number of alligators to find themselves living in very suboptimal habitats, such as tiny forest streams or ponds, cold spring runs, clear water, and low-productivity upland lakes.

Most aquatic habitats where alligators live change over time. The main reason for the change is that water levels rise and fall in relation to precipitation. Temperature has some impact on water levels, but rain is king when it comes

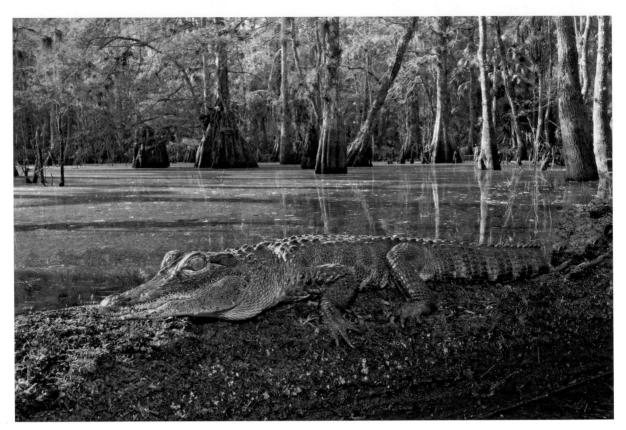

to wetland hydrology. In periods of high water, ponds and rivers overflow their banks and flood adjacent marshes and forests, opening new spaces where alligators can hunt prey. As water levels drop, ephemeral, or short-lived, wetlands dry, lake areas shrink, and streams may become little more than scattered, stagnant pools.

Alligators live in almost any habitat with sufficient water for them to survive. This juvenile alligator called this cypress swamp in the Atchafalaya Basin of Louisiana home.

Down by the River

It is almost certain that the early European explorers, and the colonists who followed them, first came to know alligators in rivers. Sailing or rowing up the coastal rivers of the Southeast, they must have seen many large alligators laying on the banks or crossing languidly in front of the boat.

During periods of rainfall and high water levels, marshes and swamps bordering rivers are flooded. Alligators venture extensively into these shallow-water habitats in search of prey. As water levels drop in the dry season, alligators move back into the open channels of the river. If water levels continue to drop, alligators may become restricted to deeper holes in the bends of the river. The forces of flowing water in a river system naturally create deeper pockets of water along the outside shore on a bend in the channel. If water levels drop very low,

The Everglades

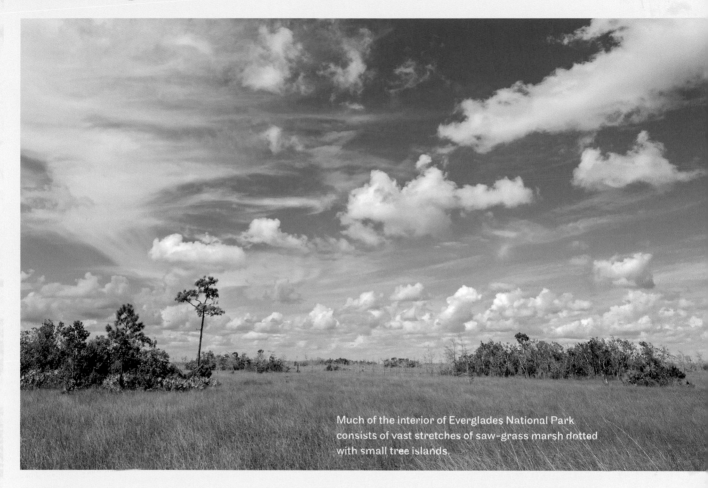

Much of the interior of Everglades National Park consists of vast stretches of saw-grass marsh dotted with small tree islands.

The Everglades is a massive wetland in southern Florida, draining much of the lower half of the state. Its water source is the Kissimmee River, which drains south into Lake Okeechobee, ultimately forming a vast, slow-moving, shallow river flowing south and southwest to Florida Bay and the Gulf of Mexico. The Kissimmee River, in its original form, was 60 miles (97 km) wide and more than 100 miles (160 km) long.

From the 1880s through the first half of the twentieth century, hundreds of miles of dikes and canals were constructed to impound and channel the Everglades water flow for flood control, development of agricultural lands, and use by the rapidly growing population centers along the Atlantic and Gulf of Mexico coasts. Prior to these water management efforts, the Everglades was well populated with alligators.

For many years, the timing of water release from the water conservation areas north of Everglades National Park was at odds with the alligator's natural nesting cycle, and alligator reproduction suffered. Many adjustments have been made as a result of alligator research conducted in the Everglades since the mid-1960s. Today, Everglades alligator populations are being used as one of the criteria for gauging the success of restoration efforts.

Paynes Prairie

Paynes Prairie Preserve is a state park in North Central Florida near my home. The prairie is a marsh about 2 miles (1.2 km) across and 6 miles (3.7 km) long. It was originally produced by the collapse of sinkholes from the Pliocene and Pleistocene epochs, which resulted in a wetland surrounded by a rim of oak hammocks. The Spanish ran cattle and horses on these grasslands when they owned "East Florida." In 1871, the La Chua sinkhole draining the prairie became blocked and turned the prairie into a large lake, called Alachua Lake. Steamboats transported supplies and merchandise across the lake between Gainesville and Micanopy. The sink opened suddenly in 1891 and the lake drained over a period of a few days, leaving fish flopping in the mud and a steamboat stuck in the middle. In the 1900s, many canals were dug across the prairie in an attempt to drain it for cattle ranching.

I have found that Paynes Prairie is the best place to observe large numbers of wild alligators, and it is a wonderful place to understand the influence of water levels on alligator habitat use and alligator movement patterns. Dikes along the canals allow you to walk out into the prairie. Adult male alligators claim territories in the deep-water canals and females build nests on the dikes. The females stay with, and protect, their young after the nests hatch. When juveniles disperse, they simply have to cross the dike from the canal side to the shallow marshlands on the other side.

During periods of low water, alligators may cluster together in very high concentrations in whatever water remains. As their numbers increase, adult alligators give up typical territorial conflicts and live together relatively peacefully.

When water levels are high, the entire prairie is flooded and alligators are dispersed throughout. During periods of drought, most of the prairie dries up. All of the alligators scattered across this vast marshland migrate to the La Chua sink and its associated canals, the last places to hold water. Alligators congregate by the hundreds in the water that remains. Fish, turtles, and other aquatic prey collect there as well. Alligators feed furiously on them. Smaller alligators, driven from their shallow-water refuges by dwindling water levels, mix with larger alligators. Cannibalism is commonly observed during these times.

Once the prey have been reduced to the point of being extremely rare, the alligators begin a waiting game. Alligators line the banks, shoulder to shoulder, and more alligators float in the open water. Still others lay on the bottom. All waiting for the chance to be the first to catch any prey that might appear.

When the rains return, the prairie fills quickly, receiving runoff from all of the lands around the basin. Alligators follow the advancing water line and abandon the sink area. They then begin exploring the newly inundated habitat and the wet-dry cycle continues.

water in a river channel may cease flowing, leaving only these deeper pockets of water. Alligators will sometimes congregate in these deep pools and, if water levels drop even further, dig out the pocket to hold onto the water.

A radio-tracking study of adult male alligators along the Pearl River in central Mississippi indicated that alligators rarely used the open channel of the river itself. Alligators were located most often in the floating emergent vegetation along the margins of the channel, or in the flooded forests and swamps associated with the river. They also used backwaters and oxbow lakes, which were further from the channel itself.

A Dash of Salt

Alligators are primarily a freshwater species, but they are also opportunists. Gators living in coastal areas often make use of habitats with brackish water (a mixture of fresh and salt water). They may even venture out into marine zones for periods of time. Because alligators don't possess salt glands like crocodiles and gharials, they are unable to actively rid their bodies of excess salt loads taken in by swimming in saline environments or absorbed when they eat marine prey. So if they venture into saltier habitats, they must toggle back and forth from freshwater habitats to brackish and marine habitats. Once back in freshwater habitats, they drink enough water to flush excess salt from their bodies.

Access to fresh water is often scarce in coastal or estuarine regions. When that is the case, alligators are rare or nonexistent in the salty reaches. But alligators are crafty. Coastal dune habitats and barrier islands can have small, perched freshwater ponds or marshes. Such pockets of water provide enough refuge for alligators looking to quench their thirst. And even when fresh water is not available on the surface, some alligators have dens that are deep enough to reach into freshwater supplies. These gators have a personal retreat where they submerge themselves in the den's fresh water before returning to hunt in the salt marsh.

Some clever alligators position themselves in tidal creeks near areas where fresh water flows downstream even as the saltwater tide pushes upriver. They can sometimes find enough fresh water from these flows to stay in an otherwise salty environment. During or immediately after storms, fresh water sits on the surface and forms what is called a lens. This freshwater lens can last long enough for an alligator to drink from the thin surface to rehydrate instead of making the long trek back to a refuge.

Larger alligators are better able to cope with salt loads acquired in saline habitats. Thus, alligators in tidal salt marshes tend to be longer than 5 feet (1.5 m) from head to tail.

During the wet season, salinities, or salt levels, are reduced because of an influx of fresh rainwater, and alligators move further out into estuarine habitats.

Coastal alligators often spend time in brackish water habitats. This old alligator is currently residing in a patch of red mangroves in the Everglades of Florida. Alligators like this one must gain access to fresh water from time to time to rinse their bodies of excess salt.

As the rainy season subsides, salinities again rise, and alligators must retreat into the freshwater wetlands. In South Florida, where alligators may share habitats with American crocodiles, the crocodiles move in a reverse pattern: in rainy periods, as salinities drop, crocodiles move into more brackish or saline parts of the estuary. Alligators then move out to fill the habitats that crocodiles just vacated. In the dry season, alligators move back up into more freshwater areas, whereas crocodiles return to their positions in the brackish backwaters.

Alligators are occasionally seen out in the ocean, or swimming in the surf along a beach. Larger alligators in these habitats may simply be swimming from one coastal river to the next. Smaller alligators found in the ocean are probably not there by choice. Sometimes they wash up on beaches after heavy rains. These animals, often exhausted, were probably washed out of the mouths of rivers due to storm water runoff.

Some accounts from the mid-1800s mention alligators found in the ocean up to 10 miles (16 km) from the mouths of rivers. Even as late as the 1950s, alligators from freshwater ponds in the dunes of the Florida Gulf Coast would swim a

few miles out into the Gulf of Mexico following fishing trawlers. They would feed on the bycatch being thrown back into the water.

House Hunting

Newly hatched alligators often find themselves in a neighborhood that will not welcome them for very long. Once the young alligators are no longer under the protection of a parent, they must leave the area where they hatched. The dangers small alligators face are extreme and include the threat of cannibalism. Survival for small alligators depends on finding a new home away from habitats occupied by large alligators. Typically the small gators move to wetlands or lake edges that are too shallow to accommodate larger alligators. These shallow habitats are densely vegetated and rich with smaller prey species.

Shallow bodies of water are also the first to dry up during periods of low rainfall. When drying becomes a problem, small alligators must move, which sometimes means they have no choice except to take their chances in more permanent bodies of water occupied by adult alligators. It's a tough choice to make and the risk of cannibalism increases greatly during periods of drought. Alligators that have survived for many years in more peripheral habitats, and

Juvenile and subadult alligators, such as this one, are constantly on the move to find a suitable habitat that offers them food, shelter, and safety from larger alligators and other predators. This little fellow will have to keep moving as this swamp may well be home to bigger alligators.

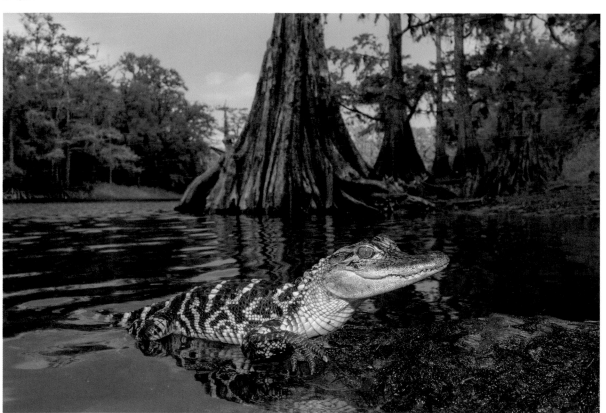

Climbing

Many species of crocodilians are surprisingly good at climbing. That is not to say they are regularly shinnying up tree trunks (although they do sometimes climb trees). They will climb up angled trunks or onto low-hanging branches. At times, this may be their only avenue to a sunny spot, but more often they are positioning themselves over water, as a green iguana or a water snake typically does. If a potential problem arises, they can just leap into the water and disappear.

Many adult female crocodilians have fairly good climbing abilities, and often climb up steep slopes to find a proper nesting spot. Many homeowners in Florida and Louisiana have been surprised to see an alligator climbing over a chain-link fence into or out of their backyards. Adult males seem somewhat less prone to these climbing feats due to their generally larger size.

maybe have reached subadult size, may be forced by a drought to move into a body of water with a high density of hungry adults.

Adult alligators tend to prefer habitats that allow access to deep, permanent aquatic environments with ample resources that ensure their growth, survival, and reproductive success. An ideal adult habitat includes constant access to fresh water, seasonal temperatures that are not too cold, plentiful and high-quality food, sites for dens, areas for successful nesting and raising of young, and enough alligators nearby that finding a mate is likely. But a crowded habitat isn't ideal. Too many alligators in one place leads to competition and aggression that reduces the chances of survival and reproduction.

Alligators instinctively assess habitat quality as they move about the environment. The "ideal" habitat probably never exists, and in fact most alligators are not living where they would prefer because they have been driven into less optimal habitats because of dominant, territorial adults.

Remodeling

Alligators have a powerful impact on the places where they live. In fact, they are often plentiful enough to significantly transform the environments where they feed, rest, and breed. They are often referred to as "ecosystem engineers" or "landscape architects" because of the extent to which they physically alter their habitats. Many of the changes have beneficial effects on wetland plants and animals.

One impact is the result of simply moving about. Alligators create trails by crushing down vegetation as they move across a marsh. Those trails soon become pathways used by other animals. In habitats with severe dry seasons,

bay. Her movements appeared closely linked to water temperatures. If the bay was warmer than the den, even by only one or two tenths of a degree, she would move out of the den.

As air and water temperatures continued to climb, she began shuttling between the bay and the lake, again closely associated with minor differences in water temperature. She spent the summer months in the lake, never venturing back into her bay or den. We never located her more than 160 feet (roughly 50 m) from the site of her initial capture in front of the little bay. In the fall, she reversed her pattern from the spring, spending increasing amounts of time in the bay and eventually settling in the den for the winter. We were left with the impression that she was amazingly sensitive to the temperatures of the waters in her immediate surroundings.

That particular female used her den solely as a winter retreat. While this approach is common, many alligators use dens throughout the year. Alligators living in clear-water habitats, such as those in cooler spring runs in Florida, use dens year-round, venturing out to bask, feed, or socialize before returning to

Juvenile alligator escaping into its underwater burrow. Burrow entrances are typically at or near the water surface, but some are well below water. The burrow chamber would rise to an air pocket above the water level.

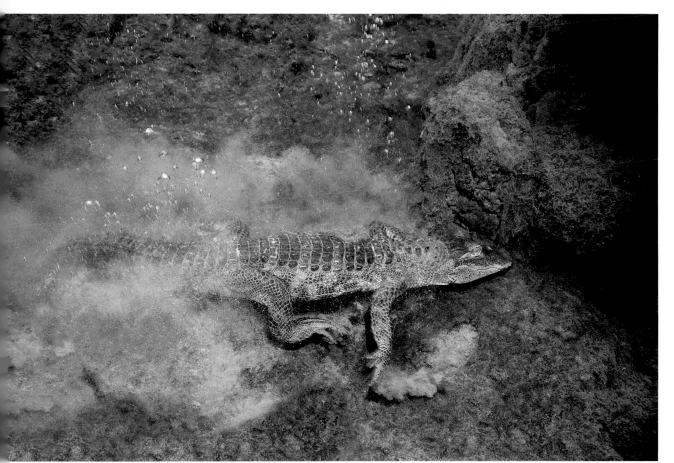

their shelter in the bank. During droughts, some alligators crowd in the remaining pools of water, and some alligators hole up in their dens. In the heat of summer, alligators will retreat into their dens by day and emerge only at dusk or after dark. Radio-tracked adult females in Louisiana spent 87 percent of daytime in or near the den, while only 46 percent of their time at night was at the den site. But day/night patterns in den use changed in late fall and early winter months, with females only leaving their dens during the day.

Adult females may be found with their newly hatched offspring in their dens through the first winter after hatching. These hatchlings sometimes have their own tiny entrances into the den site, often underwater.

During dry periods, larger dens around pools with large concentrations of alligators may hold multiple adults. One den adjacent to a small freshwater pond on an island off the coast of South Carolina contained five alligators, including both adult and subadult size classes.

Being smaller, juvenile and subadult alligators can usually find many places in the environment to seek shelter, even in the absence of a den. They fit into natural holes and burrows of other animals, retreat into dense vegetation or underneath overhanging plants, or bury themselves in debris and detritus. But small alligators, even juveniles of 3 feet (1 m), often have their own small dens. As they grow, they may not be able to enlarge their den because of the den's environment, for example, roots interfering or a lack of stability. So they must move to construct new, larger dens for themselves. The inherent instability of most den structures results in eventual collapse, requiring the occupant either to rebuild or construct a new den elsewhere. As a result, the average alligator most likely will occupy many dens during its lifetime.

When Winter Comes

Adult alligators in some areas make an annual migration between winter sites and areas used in the active seasons of spring, summer, and fall. Migrating alligators typically move to areas with deeper water for the winter. Studies of alligators on Wassaw Island, a coastal barrier island in Georgia, revealed that many winter den sites were communal, occupied by adult females, plus yearlings, juveniles, and smaller subadult alligators up to about 4.25 feet (1.3 m) long. It is possible that these smaller alligators are the offspring of the adult females in the dens.

When alligators on Wassaw Island first emerge from their overwintering sites in the spring, some form basking groups on the banks of the freshwater ponds. These groups contain as many as thirty subadult alligators measuring 4–6.5 feet (1.25–2 m) long. It is possible that basking groups are made up of subadults that shared communal dens through the winter months. Adult males, and females without young, seen basking at this time of year are typically sol-

itary. In more southerly parts of the range, alligators may emerge to bask on warmer, sunny, windless days, even in the middle of winter.

Instead of denning in the winter, some alligators may simply lay on, or bury themselves in, the bottom of the body of water, rising occasionally to breathe. Puzzlingly, some northern alligators have been known to leave their dens during particularly cold periods in the winter. In Lake Alice, a small lake on the University of Florida campus, I have several times witnessed alligators rising out of the muck in early spring, with thick piles of peaty mud on top of their heads and backs. Were they just emerging from a winter's nap, or simply surfacing after a short exploratory dive? Dens have air spaces so the occupants can breathe through the winter, but an alligator buried in the mud in the bottom of a lake can't. In the southern portions of their range, cold periods are of relatively short duration, often only a few days. Could a cold alligator, with a very slow metabolism, remain buried for a few days without taking a breath? Just how long can an alligator stay underwater, anyway? These are questions for which we have very incomplete and unsatisfying answers.

Alligator holes provide access to permanent water for many species which might otherwise not survive extended periods of drought. Aquatic turtles, such as the peninsula cooter (*left*), red-bellied cooter (*above right*), and snapping turtle (*below right*), are prime examples of such species.

Parting the Waters

One of the influential roles that alligators play in their aquatic environments is the creation and maintenance of open bodies of water. During the late 1800s, cattlemen in the southern part of Florida began complaining that alligator populations were being depleted. For those cattle ranchers, there was both good and evil in alligators. Alligators certainly did take some of their stock, especially younger and smaller cattle. But alligators also maintained alligator holes, places of open water from which cattle could drink. As alligators were heavily harvested, alligator holes began to close and vegetation grew over them, preventing access to the water for cattle.

During prolonged droughts, alligators seek out the lowest, wettest spots in the environment. As water levels drop, alligators naturally dig down in the bottom sediments to keep themselves immersed in water. Alligators are large and muscular enough to move both sediments and harder substrate materials. The substrate over many parts of the Everglades is a hard limestone crust, the fossil remains of coral beds from times when sea levels were higher than today. Much of it is too hard even for alligators. But the rock in the wettest areas is degraded enough by tannins in the water that digging alligators can penetrate this substrate. The larger alligator holes in the rocky areas of the Everglades probably represent the actions of many generations of alligators, each working to maintain, deepen, and enlarge the size of the pond.

Everglades alligator holes average 26 feet (8 m) across, but only about 2.2 feet (67 cm) deep, with another 3 feet (1 m) or so of sediment on the bottom. After the summer rains have ceased, water levels across the Everglades recede below the limestone crust. The holes hold most of the water and provide refuges for fish, amphibians, reptiles, and aquatic invertebrates. The exposed surface waters also allow access to drinking water for birds, mammals, and all other terrestrial organisms. Despite the dangers alligators pose, without the holes they construct, many species would simply not survive the droughts. Because of their role in the environment, alligators are a classic example of a "keystone species," one that, by its presence or actions, allows many other species to survive than could otherwise in its absence.

Even with today's extensive series of water-trapping canals and dikes in the Everglades, alligator holes still play an important role in maintaining the biological diversity. One reason is that alligator holes are prevalent in areas of the marsh far from the canals.

Alligator digging activities disrupt vegetation growing in the pond and push sediments up onto the banks around the pond. The enriched soils surrounding alligator holes support some plant species that are found nowhere else in the Everglades. The roots of woody shrubs and trees growing on the margins of the

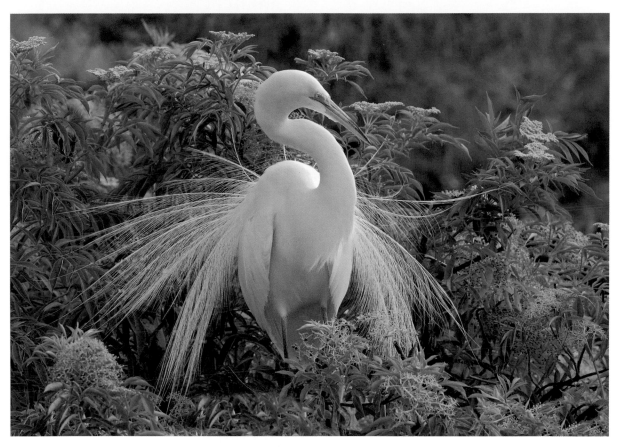

Great egret displays its nuptial plumage and green coloration associated with the mating season. Several species of egrets and herons seek out trees over alligator holes in which to roost and nest. The presence of alligators below may provide protection from other predators seeking to feed on eggs or hatchlings.

alligator hole are able to grow down the side of the hole to the water table. By reaching the water table, they can tap into a steady supply of water and grow much taller than similar trees and shrubs in the rest of the marsh. The taller trees and open water of the alligator hole entice wading birds, principally egrets and herons, to nest in these areas.

There is evidence to suggest that these birds favor ponds inhabited by alligators over those without. Large rookeries of dozens or even hundreds of nesting pairs may form over pools with alligators. The presence of alligators below these nesting birds might provide added security against potential mammal predators of the eggs and chicks. The guano, as well as regurgitated food brought back to the nest but dropped, from these large nesting colonies may provide increased nutrients to these ponds, which could increase productivity in plant growth and the diversity of the aquatic animal community. During the

Benefits for Birds

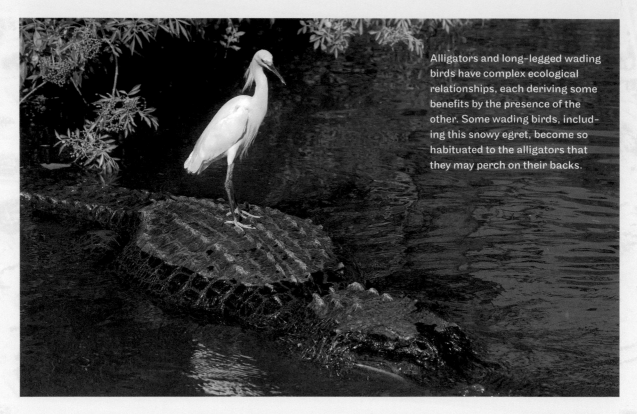

Alligators and long-legged wading birds have complex ecological relationships, each deriving some benefits by the presence of the other. Some wading birds, including this snowy egret, become so habituated to the alligators that they may perch on their backs.

Bird rookeries (colonies of breeding birds) are commonly associated with alligators, especially with groups of alligators. The bird species making up these rookeries are generally long-legged wading birds such as egrets, herons, storks, and ibis. Do the birds seek out the alligators and choose to nest over them? Or are alligators simply positioning themselves to make an easy meal out of some hapless young egret? Observations suggest the former—that nesting colonies of birds choose sites with concentrations of alligators.

At the St. Augustine Alligator Farm Zoological Park in northeast Florida, wading birds formed rookeries over the main breeding pen when alligators were first moved there in the 1920s. In 1971, a natural portion of a buttonbush swamp was enclosed at the back of the alligator farm, but alligators were not moved into this enclosure until 1972. The nesting birds followed immediately.

Why would birds choose to nest so close to their natural predator? The likely reason is that alligators offer protection from other predators, animals like raccoons or opossums. Just a few of these mammalian predators can ravage a breeding bird colony and cause birds to abandon their nests. Birds nesting over alligator-filled waters, or in trees and shrubs on islands surrounded by water, can benefit greatly from reduced nest predation, even if alligators occasionally pick off a naïve fledgling. Alligators benefit from this relationship in more ways than just preying upon the occasional weak or clueless young bird. The presence of the breeding colony does attract bird predators such as raccoons, opossums, and snakes. Hungry, risk-taking predators occasionally succeed in their quest, but more often end up as alligators' prey.

height of the plume trade in the 1880s, hunters complained there were so many alligators under the rookeries that birds shot for their plumes were often eaten by the alligators before the hunters could get to them.

Walkabouts and Worn-Out Welcomes

At some point early in their lives, young alligators are given the boot by their mother. At that point they begin their "walkabout" years, which last until the females become large and sexually mature and the males become both mature and large enough to compete with other large males. Hatchling alligators live in groups called pods. They typically move only 15–50 feet (5–15 m) apart from each other to feed or bask, but they always remain close enough to one another for the pod to reform quickly. Even very young hatchling alligators are surprisingly strong swimmers and can swim rapidly for at least 150 feet (45 m). When pods break up, small alligators must move over much greater distances as they seek out safe habitats in which they can avoid predators, and larger alligators, and find sufficient food to survive and grow.

Young alligators often begin to disperse within the first two to three months of life. In most cases these early dispersals result in staying within a few hundred yards of their natal area for the first year of life. Fidelity for the natal area is so strong that one- to two-year-old alligators transported to an unfamiliar area will try to return "home." Beyond their second "hatchday," the dangers of remaining in their natal area increase. Immature alligators, 20–40 inches (50–100 cm), must disperse away from the area in which they hatched. In one study, small alligators dispersing from their natal regions moved an average of 0.8 miles (1.3 km) in eight weeks.

Navigation

Subadult and adult alligators are very capable navigators. During their juvenile and subadult years, alligators begin developing a local map. The map is enhanced as they learn landmarks, detect changes in topography, notice site-specific differences in odors, and remember the locations and permanence of various bodies of water. There are many possible sensory cues that alligators might use to orient themselves, including (1) patterns of polarized light, (2) variations in the Earth's geomagnetic field, and (3) daily and seasonal variation in celestial landmarks, like the position of the sun or the patterns of stars. With all the various layers of their map in place, alligators become amazing navigators. For example, some alligators displaced from areas with which they are familiar are able to use celestial and magnetic cues to return home.

Juvenile alligators must find habitats free of larger alligators, or microhabitats where they can conceal themselves. Such habitats are commonly shallow wetlands with dense, heavily vegetated areas.

Immature and subadult alligators move several miles in their early years. One 3-foot (91 cm) alligator was tagged and caught in a private catfish pond 8.4 miles (13.5 km) from the location where it was originally found two years earlier. A 4-foot (1.25 m) alligator in northeast Georgia was recaptured three months after being tagged; it had traveled 7.5 miles (12 km) from the original capture spot. In 1980, a 5-foot (1.5 m) female was captured and tagged on a beach in coastal Georgia. She was caught two weeks later crossing a dirt road on Hilton Head Island by a South Carolina Wildlife Services employee. The subadult female had traveled a straight-line distance of more than 31 miles (50 km) in fifteen days.

Moving between habitats is dangerous for alligators. Young animals are unfamiliar with the habitat and must evade larger animals. Alligators traversing terrestrial habitats sometimes die from dehydration or overheating. When moving through areas inhabited by humans, they may be attacked by dogs. The internet is full of photos of alligators in someone's swimming pool, caught on the front porch, or crashing through a screen door into a kitchen.

Most juvenile and subadult alligators perish in these early years. Those alligators that successfully survive their several years of exile have probably learned the details of their surrounding habitats and how to stay alive. As older individuals, when water levels begin to drop, they are wise enough to know exactly where to go to find water.

Of Males and Females

There are distinct differences in habitat preferences and movements between adult male and female alligators. Adult females establish a core-use area, with a den, in the dense marsh. They remain in their area most of the time and can remain in the same small home range for many years. During the breeding season, females move out of the marsh into the open-water channels where the males are located. After breeding, females return to the more closed marsh habitats where they construct their nests and deposit their eggs. Their nest sites are generally near their dens.

The maximum home-range radius of adult females in Louisiana marshes during the nesting season was less than 1,150 feet (350 m) and less than 1,050 feet (320 m) for adult females in a lake in North Central Florida. Almost half of a group of nesting females in a long-studied population in coastal South Carolina were recaptured at nests within 325 feet (100 m) of their initial capture locations, even though their initial capture was sixteen to thirty years prior. Another

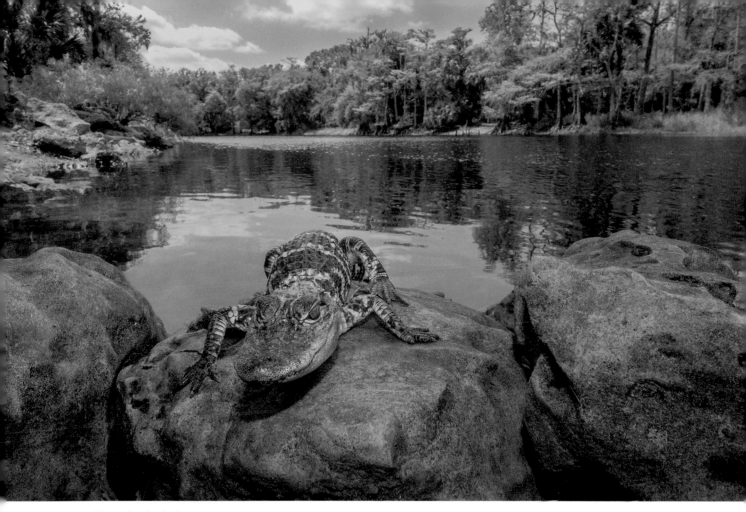

Small alligator begins its journey out of Fisheating Creek, in South Central Florida, to find a safe refuge in which to grow away from larger alligators.

quarter of the nesting females were within 0.6 miles (1 km) of the site of initial capture and the remaining quarter was recaptured 0.75–2 miles (1.2–3.3 km) from their first capture location.

Adult males move much more than females. Home-range size estimates for individual adult males in the Rockefeller Refuge ranged from 452 to 12,560 acres (183 to 5,083 ha). The average *daily* movement in spring, summer, and fall was almost half a mile, 2,372 feet (723 m)—far greater than the average *seasonal* movement of females.

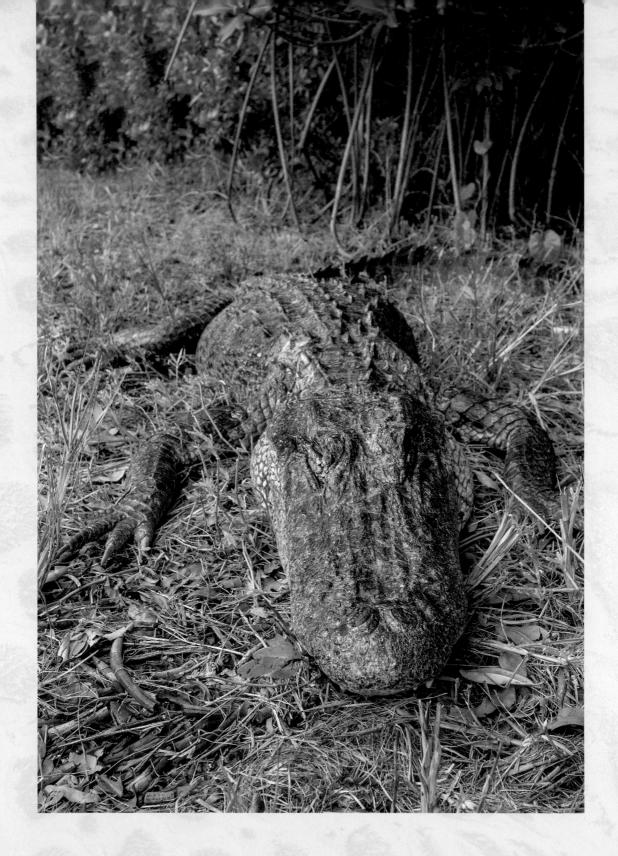

Sun Bathers

I was standing motionless on the edge of a grassy levee along a canal in Paynes Prairie Preserve State Park, near Gainesville, Florida. It was a cool morning in early April and although the sun was up, its rays had not reached the spot where I stood. It was cool and rainy over the two previous days, and the nights had been downright cold by Florida standards. But clear skies and a changing wind promised a better day. Alligators were visible in the water, hanging motionlessly with only eyes, nostrils, and the tops of their heads showing. The sun's warmth finally reached me; first my head and then down my body and legs as the sun rose higher. Finally, it lit up the land on which I stood. Within moments, the backs of the alligators rose to the surface and ten adults began moving in my direction.

It was as if their movements had been choreographed. The first two alligators, the smallest of the group, reached the shore and slowly crawled up the bank seemingly heading straight toward me. I remained motionless, like a tree that had been there all night. In unison, the two dropped down on their bellies and rotated their bodies and tails parallel to the shoreline. The full length of their black bodies gleamed in the morning sun. Within ten minutes, the remaining gators performed the same morning ritual, lying still on the grassy bank, tails and limbs outstretched, eyes closed, bathing their cold bodies in the sun's warming rays.

Alligators are cold-blooded. "Cold-blooded" is a term that many biologists despise, but on that morning, it seemed quite appropriate. Unlike mammals and birds, alligators rely on external sources of heat to warm their bodies to temperatures higher than the surrounding air and water. We achieve a similar effect by using large amounts of metabolic energy to heat our bodies, as do all "warm-blooded" creatures. The reason biologists frown on the terms warm-blooded and cold-blooded is that they are misleading. The blood of an

alligator that has been sunning itself on the bank can be very warm, even warmer than ours. So, technically, alligators are ectotherms, meaning "outside heat," and we are endotherms, meaning "inside heat."

Perhaps biased by our own method of achieving warmth, we often think our approach is more "highly evolved." But there are striking advantages and disadvantages to both conditions. Beyond very high energy expenditure, we also have a very narrow temperature range. This does allow us a constant internal environment for physiological functions, and gives us the ability to run, fight, eat, and carry out our routines over a broad range of environmental temperatures. Maintaining this constant state of readiness also requires us to eat a lot more food than ectothermic animals our size.

Alligators, on the other hand, have body temperatures that vary from near freezing to quite hot. To accommodate this range, their biochemical reactions can function over a wider spectrum of temperatures. They are also more efficient when measured over longer periods of time. A male alligator requires only 5–10 percent of the annual caloric intake of a human male of the same size.

An alligator's metabolism and its other physiological processes are an accumulation of biochemical reactions. Making these chemical reactions happen

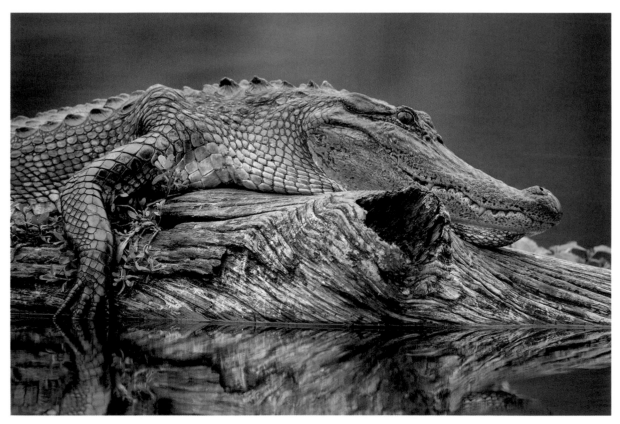

Alligator using a log as a perch to soak up the sun's warmth.

requires energy. The warmer the alligator is, the less food-derived energy it needs to complete the chemical processes. In other words, higher temperatures accelerate chemical reactions.

The amphibious nature of alligators creates an interesting duality in the lives of these creatures. With the exception of basking and nesting, most of the important activities in their lives occur in the water. So, alligators shuttle between terrestrial and aquatic environments to take advantage of the temperature gains basking provides. Typically, an alligator is most active when its core body temperature is 82–92 degrees Fahrenheit (28–33°C). Once an alligator enters the water, stored body heat is slowly lost to the cooler water and the alligator's core body temperature decreases over time. This is especially true for smaller alligators, which lose heat more quickly.

Alligators are sun lovers. They spend many hours a day, especially in the spring and fall months, outstretched on land, soaking up the sun's warmth. They will also lay on hot surfaces, such as a sandy beach, rock outcropping, or road surface. Much as we set a thermostat at home, alligators have a "switch" that tells them to raise or lower their body temperatures. As spring temperatures warm, alligators devote less time to basking, instead soaking up rays in the early morning and moving into the water by late morning. They may then pull out in the afternoon and bask for a few hours before entering the water at sunset for the night.

As their bodies approach optimal temperatures, they alter their basking behaviors, often in fairly subtle ways. Initially they will make seemingly minor shifts of the body. They may swing the tail away from the direction of the sun to limit its exposure. Or they reposition their bodies relative to the sun, so that the angle of the sun's rays is reduced. They may also begin to gape, opening their mouths and dropping their tongues. Evaporation from the moist exposed linings of the mouth and throat cools the surrounding tissues. They may move into shade, if available, and continue gaping. Gaping cools head temperatures but has virtually no effect on core body temperature. Ultimately, the alligator will move down to the water's edge. Then it may enter the water completely, but it is also common to immerse only the head and shoulders into the water, with the rest of the body still on land. This behavior seems to allow the alligator to continue raising its core temperature while preventing its head from overheating.

Smaller alligators will often use dense, floating mats of vegetation as basking platforms. These mats allow alligators to escape into the water should a potential danger arise. Alligators can bask in the water, as well, arching their backs slightly and adjusting their body profile in the water. This position allows their dorsal scales to project above the water so radiation can pass into the body.

While basking, alligators can increase the rate at which their bodies warm by dilating blood vessels in the skin and increasing their heart rate. They can then reverse these mechanisms to conserve heat when they enter the water. A heart

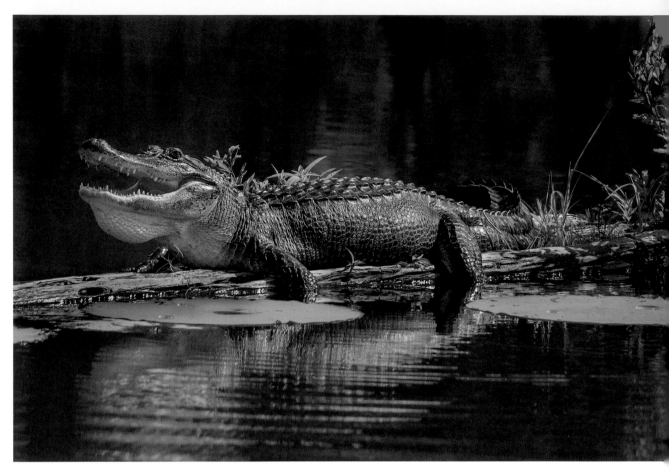

Body temperature rises as basking continues. Alligators will begin to gape, allowing moisture to evaporate from the lining of the mouth and cooling the blood circulating around the eyes and brain, protecting these tissues from overheating.

rate of thirty beats per minute at 68 degrees Fahrenheit (20°C) will rise to over seventy beats per minute at 80.6 degrees Fahrenheit (27°C) while heating. After reentering the water, the heart rate is lowered to about fifty-six beats per minute. The net result is that an alligator gains heat at least three times as quickly as it loses heat.

Alligators slowly reduce the amount of basking time they spend each day as air and water temperatures rise in summer. When nighttime air temperatures rise above the temperature of the water, adults will often spend the night on land. By midsummer, daytime temperatures are generally too high for alligators and they move out of the shallow water areas in marshes to the deeper, cooler open-water habitats. During the hottest part of the summer, they spend much of the day either underwater lying on the bottom, or in the cooler recesses of their dens. At this time of year, they begin emerging at dusk and are active at least through the first half of the night. My own observations suggest activity diminishes around one or two o'clock in the morning. They may become a bit active again at first light and during the dawn hours.

Large alligators can actually become too warm, sometimes to the point where they have difficulty ridding their bodies of excess heat. This can be dangerous, especially to nerves associated with the senses. So alligators have expansive systems of blood vessels in their heads that are believed to help regulate temperatures around these sensitive structures. The nasal sinuses and the lining of the mouth are two primary areas of evaporative cooling. Blood flow can be used to move heat away from sensitive areas and also to carry cooled blood to threatened nerves. Areas around the eyes and portions of the skull near to the brain are also highly vascularized, perhaps for the same reason.

An alligator's size greatly influences how rapidly it heats while basking, and also how quickly it loses heat once in a cooling environment. They follow a basic rule of physics that holds that a smaller body requires less thermal energy to warm than a larger one. This is because, relative to larger alligators, smaller alligators have more surface area (the outside of the body, measured as an area, say square inches or centimeters) relative to their mass (or volume, say cubic inches or centimeters). But small gators also cool off much more rapidly. This physics rule plays itself out when you watch alligator basking behavior closely. Smaller alligators are the first ones out of the water when the sun hits the ground in the morning.

Juvenile alligators commonly bask in groups, benefitting from increased vigilance in case a predator comes near. These little alligators have chosen a basking spot deep in emergent vegetation, in which they can quickly disappear if trouble should arise.

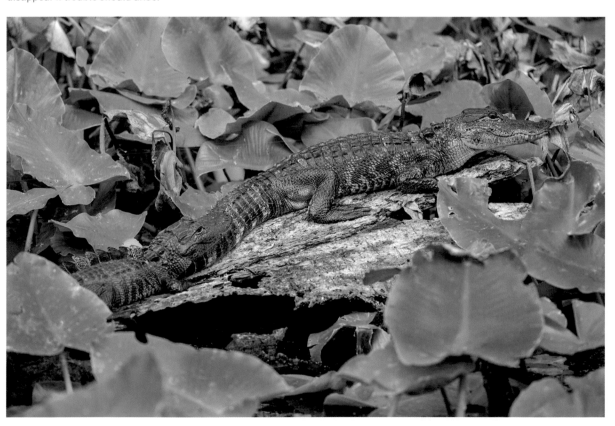

Alligators are masters of conserving energy. They lie perfectly still for such long periods of time that visitors to zoos commonly ask if the animals have been stuffed. After feeding, alligators must raise their body temperatures to promote efficient digestion. Smaller gators, especially hatchlings and juveniles, devote their lives to feeding and converting the energy from food into growth. Their lives literally depend upon it. The smaller you are, the higher the probability you will die before the year is out.

Hatchling alligators fed in laboratory conditions work quickly to digest their food by achieving body temperatures of 91.4–95 degrees Fahrenheit (33–35°C). Once the food is digested, they seek cooler temperatures while the digested food is used by the body. The lower temperature slows an alligator's metabolism, another way to conserve energy. When they feed again, they elevate their body temperatures, continuing the cycle.

American alligators are exposed to a greater annual range of temperature than any of the tropical crocodilian species. In many parts of the alligator's range, winter low temperatures are so extreme that alligators must enter a prolonged period of inactivity (called torpor) to endure the frigid conditions. Alligators essentially become dormant at temperatures below 55 degrees Fahrenheit (13°C). In southwestern Louisiana, they rarely see such cold extremes for extended periods of time. One study found that alligator body temperatures averaged 85.86 degrees Fahrenheit (29.92°C) in summer and 60.19 degrees Fahrenheit (15.66°C) in winter. That study found that larger alligators in winter have somewhat higher average body temperatures than smaller animals do. But because the largest alligator in the study was only 120 pounds (54.5 kg), these results do not apply to very large alligators. My guess is that large gators experience even warmer winter body temperatures.

Throughout most of their range, alligators stop feeding from late autumn through the end of winter. In North Florida, alligators typically do not eat from mid-November until the end of March. But the dates change from year to year. Cold spells come and go in northern Florida, and they are often followed by long bouts of pleasantly warm weather. During warm spells, alligators will emerge from their winter refuges and feed as late as December or early January. As you move further north, however, alligators spend the winter in a more pronounced state of dormancy.

Years ago I studied physiological responses to heating and cooling in very large alligators. A lot of work had been done on smaller animals, but I wanted to see if assumptions about large gators were correct. I managed to borrow a number of large alligators, greater than 750 pounds (350 kg), from alligator farms. I drove them back to my home base at the University of Florida. With help from graduate students, I hauled them into the Zoology Department's elevator up to the sixth floor, and then maneuvered them into an environmental chamber where I could control the temperature. I cooled each alligator to 41 degrees

At the Extremes

The highest and lowest temperatures that an alligator can endure have been estimated. Over a ten-year period at the Savannah River Ecology Laboratory, alligators experienced average winter temperatures of 40.3–40.8 degrees Fahrenheit (4.6–4.9°C) in December and January, and were exposed to air temperature lows between 3.4 and 16 degrees Fahrenheit (−15.9°C and −8.9°C). Note that those temperatures are air temperatures, not the alligator's body temperature.

The death of one large male when its body temperature dropped to 39 degrees Fahrenheit (4°C) suggested that the critical minimum temperature for alligators was near this value. However, during a study in Lake Ellis Simon, Craven County, North Carolina, within about 100 miles (160 km) of the northern extent of the alligator's range, an alligator was recorded to survive water temperatures of 35.6 degrees Fahrenheit (2°C). Unfortunately, the core body temperature of this alligator is not known. But I suspect that North Carolina alligators can survive temperatures somewhat below 39 degrees Fahrenheit (4°C). In fact, many alligators in the North Carolina study area were known to survive an extreme cold spell where the lake covered over with ice. Included among the survivors were some first-year juveniles.

Fog rises from a river on a cold winter morning.

Fahrenheit (5°C), which was my low temperature starting point for the trials. The alligators were almost completely immobilized from the cold. The only response they had was to open their jaws and gape when touched.

But my test alligators were from the South. A study in North Carolina found that northern alligators at similar temperatures are much more active. One wild alligator at about this same body temperature advanced and hissed at the researchers as they approached.

It is generally assumed that frigid temperatures set the northern limits of the alligator's natural distribution. Reported cases of escaped or released alligators surviving for long periods in areas far beyond their range suggest that alligators can survive extreme climatic conditions. An alligator released into southeastern Virginia survived for three winters before being recaptured. That area had an average of forty days per year with minimum temperatures at or below freezing.

There's another published case of a released alligator living for six years in a marsh just south of Pittsburgh, Pennsylvania. This location is over 300 miles (480 km) from the closest breeding population of alligators in North Carolina. The coldest average monthly temperatures in Pittsburgh varied between 21.7 and 35.2 degrees Fahrenheit (−5.7°C and 1.8°C). Cold did not kill the alligator; it was done in by a police officer's bullet. More remarkable still, the alligator was purported to be only about 1.5 feet long (50 cm) on release, and it grew to almost 5 feet (1.5 m) in length by the time it was shot. This alligator has many biologists scratching our heads about what we thought young alligators could endure.

How hot is too hot for an alligator is even less known than the lowest temperature they can handle. My best guess is that extended exposure to temperatures of 100.4 degrees Fahrenheit (38°C) or above are likely to result in an alligator's death.

'Tis the Season

Because alligator populations extend from as far south as the Florida Keys to as far north as northern North Carolina, they experience a wide variety of seasonality. Their metabolisms are severely curtailed at temperatures of 61 degrees Fahrenheit (16°C) and they can neither eat nor grow below this limit. For an alligator, a season is that time of year when it is active, feeding, growing, and reproducing, or not. In other words, I think most alligators live a two-season existence. In South Florida, the active season is twelve months long, so they really have a single season. In North Florida, it runs eight to nine months. In Louisiana and coastal South Carolina, the active season is usually about seven months. At the northern extremes of the range, it is only five to six months long. In that brief period, alligators in North Carolina must pack in time for feeding, growing, breeding, nesting, and incubating and hatching eggs. Alligator nests

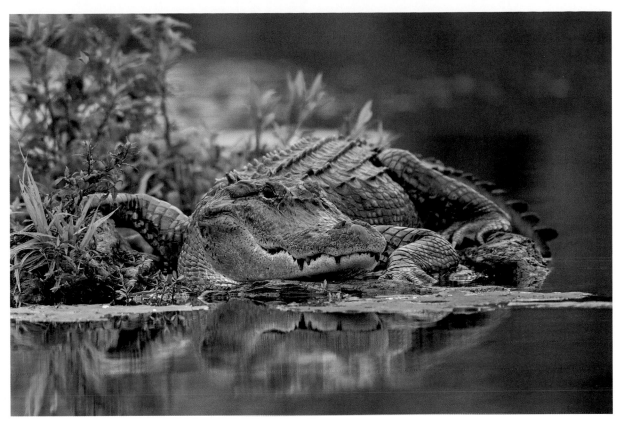

As they bask, large alligators take much longer to raise their internal body temperatures than small alligators do, but once they are warm, bigger animals cool off much more slowly.

True Southerners

We do not know what factor, or combination of factors, determines the limits of the alligator's distribution. We do know that some alligators in any population tend to disperse, due to social pressures, resource limitations, or other influences. So, alligators can extend their range through movements of individuals. But population densities become increasingly low as you approach the northern edge of the alligator's range. You begin to see discontinuous and smaller populations, which finally reach an abrupt end.

It is possible that rare periods of exceptional cold, whether once a decade or even once every few hundred years, kill all the alligators living at the extreme limits. Such events would reset the species' boundary. The duration of cold temperatures may be more important than the absolute lows. Alligators can withstand relatively brief spells of extreme cold, but not longer periods of debilitating cold. Perhaps a more likely reason that alligators peter out at northern latitudes is the brevity of the active season in the north. There may simply not be enough time to complete all the life functions, including reproduction.

tend to hatch in mid- to late August in Florida, but hatching occurs in early to mid-September in North Carolina.

Alligator growth rates in North Carolina are about half of those achieved in Florida and Louisiana. As a result, northern alligators require many more years to reach sexual maturity. More significantly, slower growth keeps the younger alligators vulnerable to predators for much longer periods of time than their southern counterparts.

We know far too little about alligator overwintering behavior. In the southern part of the range, where cold periods are of relatively short duration and separated by periods of more favorable temperatures, alligators will bask when they can. They can warm up enough that the heat can be sequestered in the core of the torso, allowing an alligator to maintain an elevated body temperature for several days.

Large portions of the alligator's range experience long periods of freezing temperatures, cold enough for ice to form on the water surface. Many alligators spend these periods in their dens. Some alligators spend the winter months resting on the bottom of bodies of water, rising occasionally to breathe. Others position themselves against the bank of a body of water, keeping the tip of the snout above water.

As air temperatures approach or drop below freezing, alligators position themselves near the shore with their heads held level at the surface. They face the shore with their bodies in contact with the bottom. The tail trails off away from shore into deeper water. Alligators will maintain this profile until water temperatures drop to just above 40 degrees Fahrenheit (about 5°C). Below this temperature, the back of the head sinks. As the surface of the water freezes, ice forms around the snout. In some cases the snout appears trapped in the ice, but more typically one sees a small gap between the snout and the ice and small shards of ice pushed onto the surface ice around the opening. This is caused by movements of the alligator as it pushes up to breathe before sinking again below the surface. This behavior is referred to as the "icing" response. If an alligator detects a human approaching, it retreats below the water, but the tip of the snout soon reappears in the air hole.

The icing response was first described in adult alligators in Lake Ellis Simon in Craven County, North Carolina. Alligators had been equipped with radio transmitters and their movements and locations were being tracked as part of a study. The alligators had dens and did use them during the winter months. However, when surface ice formed around the den site, the researchers found that most alligators positioned themselves with their snouts projecting up through the ice. The alligators had left their dens during the most extreme winter conditions and were positioned along the shore of the lake, perhaps to take advantage of temperatures found in deeper water outside of their dens.

Instances of very small alligators, less than 20 inches (50 cm), dying when trapped under surface ice are known. They may have been too small to maintain an air hole. Some authors have suggested that young alligators must be near a larger adult, perhaps a parent, in order to have the ice broken for them. But there are also published observations of near-hatchling-size alligators in South Carolina adopting the icing posture and maintaining their own access to air without the apparent assistance of an adult. In more northern latitudes, where the temperatures may be lower, the duration of the ice longer, and the surface ice thicker, it probably wouldn't be possible for smaller individuals to maintain their own holes.

Some alligators do migrate modest distances when water temperatures drop in the fall. These migrations take them from one body of water or a wetland, in which they spent the warmer months, to a deeper body of water for the winter. Deeper and larger volumes of water cool more slowly than shallower or smaller

Adult alligator rises to the surface of a spring to draw a breath of air.

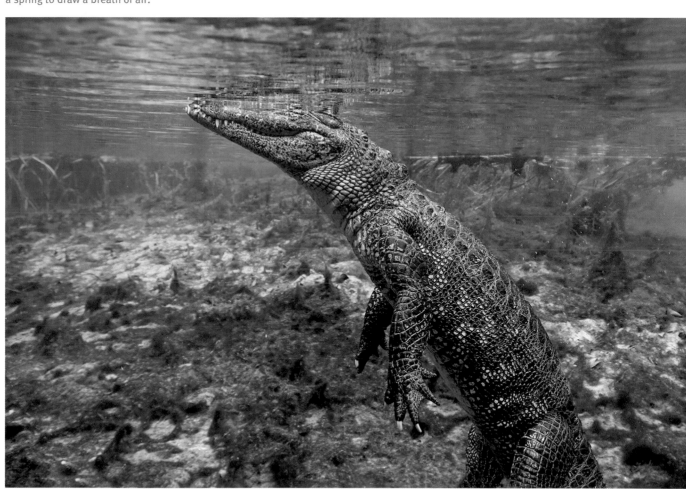

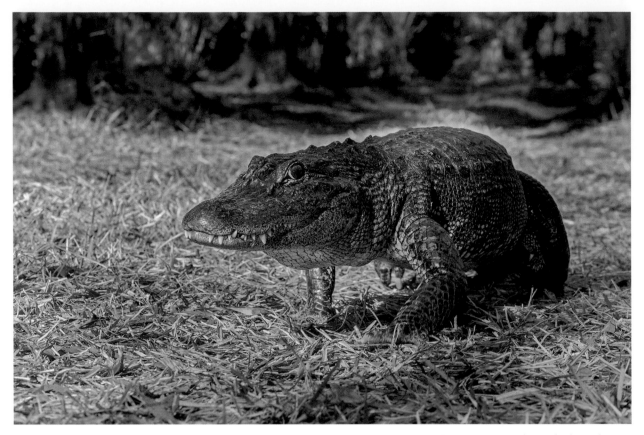

As temperatures change in the spring and fall, or when water levels decrease due to a lack of rain, alligators must often migrate cross-country to get to deeper water.

areas, so they provide a small thermal advantage to the alligator during the cold months. During prolonged periods of cold, an alligator's metabolism slows to a crawl; its heart rate may be as little as one or two beats per minute and respiration may be reduced to one breath every two to three minutes.

Climate Change

Conservative scientific estimates suggest that global climate change may produce temperature increases of 2–3 degrees Fahrenheit (1.1–1.7°C) during the next century. The majority of climate models, however, predict that average global surface temperatures will warm between 2.7 and 6.3 degrees Fahrenheit (1.5 and 3.5°C) by the end of this century. Environmental, atmospheric, and oceanographic variables interact in complicated ways, making predictions very difficult. Changes in air temperature may mean uncomfortably warmer summers but could also mean more mild winters in some locations. Elevated air temperatures influence water temperatures. These same increases affect snow melt, as well as the melting of glaciers and polar ice fields. Thawing permafrost

in the Arctic results in the release of trapped methane (which is a greenhouse gas), further intensifying the problem.

While climatologists, geologists, and meteorologists have been studying and modeling these changes for many years, wildlife biologists have been considering the ramifications of these changes on wild species and their habitats. Alligators have long been considered potentially vulnerable to global changes in climate. Rising temperatures could affect reproduction and development. Warmer nest temperatures could hypothetically result in altered sex ratios, shifting to a point where only one sex is produced. Increased temperatures within the nest, even by only a few degrees, could also result in increased developmental abnormalities and reduced hatching rates. On the positive side, it seems likely that alligator populations would, through natural selection, ultimately shift the timing of the nesting season to overcome some of these problems.

Some aspects of predicted warming conditions could hypothetically prove beneficial to alligators. Warmer weather could result in a longer growing season (assuming the increased warmth was evenly distributed through the year). This, then, could lead to faster growth of the smaller-size classes and quicker transition times through these smaller, most vulnerable, size classes, potentially resulting in higher survival rates in the first few years of life.

But other predictions of changing environments suggest more harm than good for alligators. Precipitation in the southern United States is expected to decrease, forecasting an increase in prolonged droughts. Changing rainfall patterns may lead to a reduction of the freshwater habitats (lakes, rivers, marshes, and swamps) in which these creatures dwell. Decreasing rainfall could severely limit nesting habitat and reduce prey availability. Studies of the impact of dry

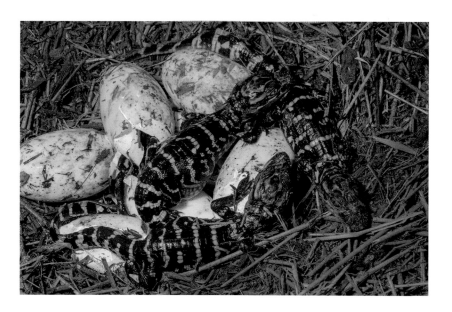

The sex of these hatching alligators was determined weeks earlier by the temperature in the nest as they developed.

spells on Everglades alligator populations indicate, not at all surprisingly, that alligator populations decline during periods of drought.

It might be possible for alligators to begin moving into areas in which they've never ventured before. The impact of changing climate will likely be greatest for populations living at the margins of the species' distribution, if their current distribution is limited by environmental variables. If the northern-most limits to the alligator's range is restricted by cold, increasing average temperatures may shift these barriers to northern expansion. So alligators might begin to spread to the north in many parts of their range, possibly extending up into southeastern Virginia and perhaps spreading north up the Mississippi valley into southern Missouri and southwestern Tennessee. They may extend further west as well, possibly a bit more to the west in Texas. It is also possible that high elevation habitats in the Carolinas and Georgia, those above the fall line, may no longer be too cool for alligators.

These predictions are not really as bold as they may sound. In fact, this expansion appears to have already begun. The small numbers of alligators found in extreme southeastern Virginia may be due to climate change. Other alligators are showing up in small, rocky-bottom, clear-water streams in the piedmont of South Carolina. On the other extreme of the alligator's range, the southern-most populations in Florida and Texas, conditions could possibly become too hot for their continued survival. It's all about temperature when you consider the lives of American alligators. And climate change is all about temperature too.

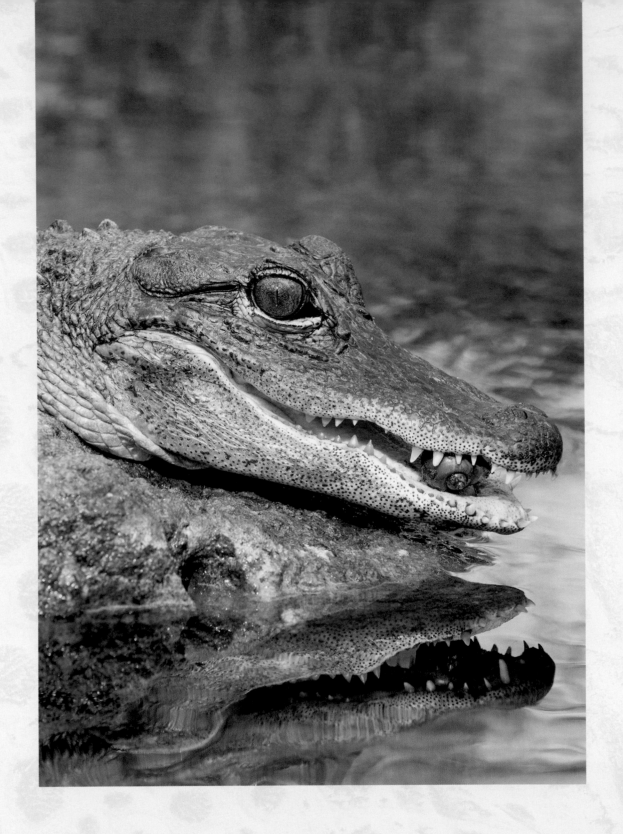

An Alligator's Appetite

It had not rained for weeks. What little water there was could be found in shrinking pools that were pounded by the scorching Florida sun. At the bottom of most pools lay an alligator hole, dug out by generations of inhabitants.

In one pool, I watched a large congregation of hungry adult alligators. With them swam a variety of creatures caught in a catch-22: leave the pool and die or stay in the pool and probably die. There were plenty of fish in the pool, mostly gar, and they were as hungry as the gators. I could also see bowfin and an invasive species of armored catfish. But it was a softshell turtle that really caught my attention.

Softshells are odd turtles. They are aptly named because their outer layer is leathery, not bony like a typical turtle. This particular softshell was large, about 20 inches (50 cm) long. I noticed it because a 10-foot (3 m) male alligator caught it with the tip of its snout. Neither alligator nor turtle was probably thrilled with the situation. The turtle was in a tight spot, but the alligator held it across the belly of the shell, as if it had a large dinner plate at the tip of its teeth. The gator was gripping the little raised ridge that ran underneath the turtle. The alligator needed to get a better grip.

As the gator loosened his hold and attempted to reorient the turtle, he dropped it into the water. He instantly lowered his head, straightened his entire body parallel to the shoreline, and held still. About ten seconds later, the alligator abruptly twisted his body, bringing his head back toward the base of his tail. As the gator's head rose, I could see he'd recaptured the softshell. He had used his entire body as a touch receptor, and it helped him know where to strike.

Unfortunately for the alligator, but luckily for the turtle, the gator lost his grip again and the softshell slipped away into the muddy water. As far as I know, the turtle is still out there somewhere, as none of the other gators came up with him while I was there.

Alligators are at the top of the food chain in their wetland world. They play a critical ecological role, controlling many of the dynamics within the entire ecosystem. Studies have shown that their presence creates a more complex ecological community and their absence can cause problems, sometimes even for people. When alligator populations were overharvested, their importance became apparent. As early as 1890, the depletion of alligators in parts of Louisiana was so extensive that muskrat populations exploded. The overpopulation of muskrats caused destruction of crops, dikes, and levees.

Alligator predation can have indirect benefits on ecosystems, benefits that arise due to the complex interplay of predator-prey interactions within a food web. When an alligator eats a crayfish, that's bad for the individual crayfish, but it's good for the alligator *and* it's good for the turtles in the community. Crayfish and aquatic turtles feed on many of the same food items (filamentous algae, snails, small fish, and a host of other species). The reduction of crayfish leaves more food for turtles and other animals. One research study used a model of predator-prey interactions among sixty-eight components of the ecosystem in Big Cypress National Preserve in Southwest Florida and found that eleven prey species indirectly benefited from the presence of alligators. Alligators, it

turns out, benefited more species than any other species in the ecosystem. The majority of these benefits arose from alligators feeding on smaller predators as well as their predation on some midsized snakes and turtles. In salt-marsh ecosystems, similar effects were found; when alligators feed on blue crabs, it leads to increased survival of periwinkle snails and Atlantic ribbed mussels.

Whenever an alligator eats, the food it consumes can be used in four different ways: for growth, for daily metabolism, to make eggs if the alligator is female, and to store for later use. Alligators are able to store as much as 60 percent of the energy they derive from prey as fat. Most of that fat is stored between the muscle bundles in the base of the tail, in the abdomen, around the neck, and under the forelimbs.

During droughts, alligators concentrate in whatever water remains and eat what they can, but at some point the pickings get slim. It is not uncommon for alligators to go months without eating. Faced with a lack of prey, they reduce their metabolism tremendously and draw on their stored fat for fuel. This system is so efficient that a large adult alligator of average body condition could survive two years or more without food.

There is truth to the claim that alligators will eat almost anything and try to eat everything else. I first got a hint of this concept while wading through an alligator farm. My shoes kept sinking in the mud and pulling off, so I eventually took them off and hung them on an old log sticking out of the lake. A few min-

Dinner Clues

Most diet studies of alligators are not the result of watching them eat, though we've certainly learned a few things from direct observations. Instead, researchers have looked at stomach contents of dead animals or have flushed out the stomachs of live individuals. The prey collected using these methods are in various stages of digestion, so it often takes quite a bit of biological sleuthing to figure out what animal was eaten.

Another, though less specific, approach to understanding the types and sources of prey consumed uses a technique called stable isotope analysis. Stable isotopes provide long-term information on the relative sources (e.g., freshwater, terrestrial, or marine) of food consumed over the past many months. A researcher can take blood from an alligator, analyze it using a mass spectrometer, and determine how much of the diet consumed in the past eight months or so came from a freshwater source versus a brackish or marine source.

Less commonly, aspects of prey types eaten are determined through careful examination of fecal materials. Bones and teeth are generally completely digested, but indigestible body parts, including hair, feathers, fish scales, and bits of insect exoskeletons, can be identified. Fossilized feces (called coprolites) have also been studied to identify elements of extinct crocodilian diets.

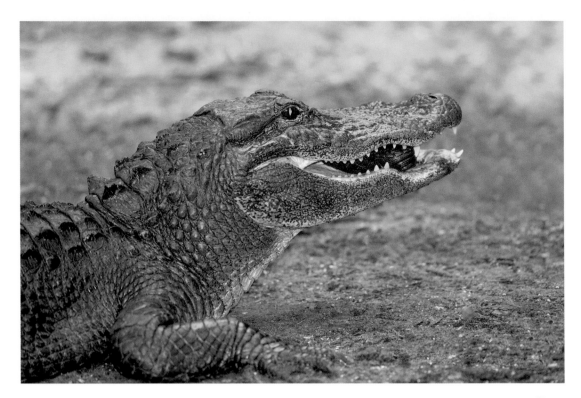

utes later, I turned around just in time to see an alligator reaching up to take one of my shoes. They will investigate anything that is novel, and their first instinct is to treat anything new as food. Eat first, spit out later, is the rule.

What's for Dinner?

An average population of alligators eats twenty-three different types of prey, though some studies found as many as thirty-eight different prey types. Invertebrate prey include mollusks (snails and clams), crustaceans (crayfish, shrimp, and crabs), and aquatic and terrestrial insects. Vertebrate prey include sharks and rays, rough fish (like catfish, gars, and bowfins), ray-finned fish (such as mosquitofish, sunfish, shad, and bass), amphibians (frogs, salamanders, and sirens), reptiles (especially aquatic snakes and turtles), birds, and mammals. The average alligator will have evidence of over sixteen individual prey species in its stomach at any given time, but about 6 percent of alligators have empty stomachs when they are sampled.

At optimal body temperatures, food items digest quite rapidly in an alligator's highly acidic stomach. But some prey types are digested more rapidly than others. One study of juvenile alligators found that a turtle is 90 percent digested in seventy-two hours, a mouse in forty-eight hours, and a bird is about halfway between these two rates. Fish and amphibian prey digest very rapidly, with 90

percent of a fish digested in eighteen hours and a frog taking as little as twelve hours.

Not surprisingly, the types and sizes of prey eaten by small alligators are different than those killed by larger individuals. Hatchlings and yearlings simply cannot subdue larger prey, so they feast on the small stuff. What is surprising is that very large alligators will feed on very small prey. One summer afternoon I saw an 11-foot (3.35 m) male alligator catching—mostly *attempting* to catch—some aptly named mosquitofish. These tiny fish are about 1.5 inches (4 cm) in length. The alligator was in shallow water, where large schools of mosquitofish had congregated. He positioned himself in the middle of the fish schools and remained motionless on the surface. Occasionally, he would rapidly bring his head and shoulders up just out of the water, twist his head to one side and simultaneously open his jaws and draw his tongue down to form a large pouch somewhat like that of a pelican. Then he would snap up a mouthful of water. With his head angled up and out of the water, he would slowly raise his gular pouch and force water out through his closed jaws.

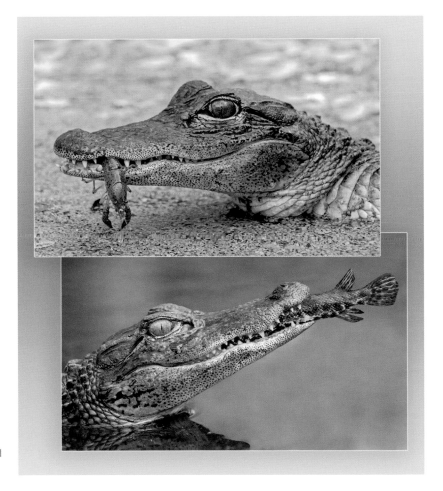

Smaller alligators eat smaller prey species, such as the crayfish (*top*) and young gar fish (*bottom*) shown here.

The alligator's technique did not look efficient. On most attempts he would just lower his head back into the water without swallowing. On rare occasions, about one in twenty tries, he would bring his head up and swallow, suggesting he caught something. My guess was that, if anything, he had one or maybe two of the little fish in his mouth. His four hours of hunting could not have added up to much in terms of nutrition, but adult alligators have a lot of time on their hands.

Tastes Change

During their first year of life, alligators primarily feed on larval and adult insects such as grasshoppers, giant water bugs, soldier fly larvae, dragonflies, and mayflies. Their diets may also include spiders, small worms, and other invertebrates. Once they reach 2–4 feet (61–122 cm), they add crustaceans such as crayfish, crabs, grass shrimp, and shrimp to their diet, along with small fish. The teeth of smaller alligators are relatively small but quite sharply pointed. These teeth allow them to penetrate and hold prey with harder exteriors, like fish scales and the exoskeleton of crayfish or grasshoppers.

As alligators become subadults, about 4–6 feet (1.2–1.8 m) long, they broaden their diets, adding larger invertebrates, such as apple snails and blue crabs. Their prey menu also adds snakes, small mammals, birds, larger frogs, and a variety of fish species. The ability to capture new prey is tied to modifications of the head and teeth. As the alligators grow, the snout becomes proportionately longer, jaw muscles become stronger, and bite force increases dramatically. The size and shape of their teeth changes too. Teeth become thicker, heavier structures, somewhat blunt on their tips, but eventually strong enough to exert the forces necessary to crush the shell of a turtle or to keep hold of a large, struggling raccoon.

Larger subadults take on an "adult diet," eating more fish, turtles, snakes, birds, and large mammals. Alligators do not seem to care what kind of fish they eat, as studies have shown their diet matches what's available around them—so they are not selecting any species preferentially. They also seem willing to eat any mammal, as they have been recorded eating cotton mice, wood rats, marsh rabbits, muskrats, opossums, raccoons, nutria, and just about any mammal they can catch and kill. Humans are very rarely on their list, mainly because of our size.

Alligators are unquestionably cannibals. A lot of studies put tags on hatchling alligators, which allows researchers to later look for tags in the stomach contents of adults. Depending on the study, between 2 and 6 percent of the adult stomachs sampled contained hatchling tags. Stomachs with tags were from large alligators; the majority were from males, but tags were found in the stomachs of females as well.

From Fur to Food

Nutria were introduced to Louisiana from South America in the 1930s to create an additional fur source. The introduction was successful in terms of nutria thriving. They spread rapidly through the marshes and swamps and by the early 1960s nutria surpassed muskrats in terms of the number of hides taken to market. In fact, "beaver" fur felt hats were eventually made from nutria fur.

By the early 1960s, nutria were the dominant prey in Louisiana alligator diets.

Nutria, an introduced species of South American rodent, now abundant in many parts of the alligator's range.

By the early 1970s, adult alligators were feeding on five nutria for every muskrat. The presence of nutria in Louisiana probably accounts for the high densities of alligators seen in many Louisiana wetlands.

A full-grown nutria weighs 15–22 pounds (6.8–10 kg). Alligators longer than 5 feet (1.5 m) in the marshes of Louisiana begin to feed mostly on nutria as well as native muskrats. Both of these prey are very abundant in the marshes, swamps, and lakes of southern Louisiana. The amount of nutria and muskrats in the alligator diet changes with size: subadults and young adults take more muskrats but larger adults prey much more heavily on nutria.

Alligator eggs have also been found occasionally in alligator stomachs. Most of these are in females and may represent nesting females consuming unhatched "dead" eggs as they open their nests. Some eggs, however, have been found in males and may indicate another form of cannibalism.

Dozens of studies of alligator diets, added together, provide scientific data on about 5,500 individuals. About two-thirds of these alligators are from Louisiana, almost one-third are from Florida, 180 are from Georgia barrier islands, and close to 50 are from Texas. Two drawbacks are that most of the samples are from adults taken in the fall and the studies varied in certain ways that make comparisons difficult.

Even though the dataset is imperfect, we can make some comparisons between regions, sexes, and different sizes. For example, we know that juvenile alligators in Louisiana eat more insects and spiders than gators in Florida. Instead, native apple snails form a large part of the diet of Florida alligators. The range of Florida's snails does not extend into Louisiana, but a South American invasive species of apple snail is becoming well established in the southeastern United States. They are now in Louisiana and are starting to be found in alligator diet studies there.

Subadult and adult alligators quite commonly cannibalize smaller alligators, posing a significant threat to a young alligator's chances of reaching adulthood.

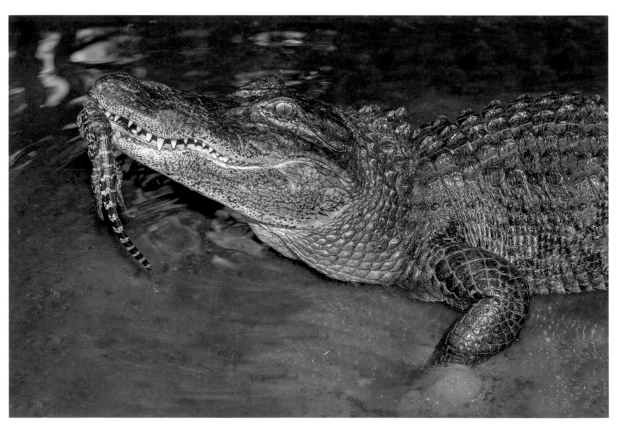

Even within a state, dietary differences can be seen. Adult alligators in south-western Louisiana eat a variety of reptiles along with fish and mammals, while those in the southeastern part of the state principally eat crustaceans, fish, and mammals. Alligators in a cypress lake community in northern Louisiana, however, supplement mammals and fish with turtles.

Adults feeding in freshwater and upland habitats on Georgia barrier islands preyed on crayfish, terrestrial and aquatic insects, small fish, mud turtles and pond sliders, and rice and cotton rats. Grass shrimp were also a very common invertebrate prey item for these alligators. One individual's stomach contained 2,078 of them (yes, they counted them). Adults that left these habitats to forage in salt marshes fed on blue crabs, grass shrimp, horseshoe crabs, mud minnows, topminnows, birds, and mammals.

Florida alligators feed more on fish and turtles and less on mammals. And it was found that the diets of adult alligators on three lakes in Central Florida differed from one another, even though the lakes were only a few miles apart from one another.

Large adult male alligators will kill very large mammals on occasion. In rare circumstances, they prey on large dogs, adult deer, feral pigs, and—in exceptionally rare circumstances—humans. In one odd case, a two-month-old bison that weighed 50–60 pounds (22.5–27 kg) was killed by an adult alligator in Florida when it slipped and tumbled down a slope into a canal. The young bison was much smaller than adult white-tailed deer in the South, which commonly weigh 100–150 pounds (45–70 kg) and are killed by alligators. Feral pigs can weigh even more, and they have been killed by adult alligators. Early colonists in Florida commonly persecuted alligators because they would kill their domestic pigs. Even cows and calves have been taken by alligators, but such events are very rare.

Edible Oddities

One of the more interesting feeding behaviors of adult alligators has been observed on the barrier islands of Georgia. The adults feed regularly on adult white-tailed deer, which are often too large to be consumed at a single sitting. In fact, a large deer can take an adult alligator a week to finish. So the alligator eats what it can and then stores the rest underwater, usually near a den. I once saw a 9.5-foot (2.9 m) male alligator on the bottom of small, deep sinkhole that was saving the remains of a large dog, probably about 75 pounds (34 kg) in life. Half of the carcass was missing, and the other half was wedged under a log. In other cases, the remaining part of the prey is left lying on the bottom, or it is tucked into emergent vegetation. In most cases the alligator is nearby, guarding its loot.

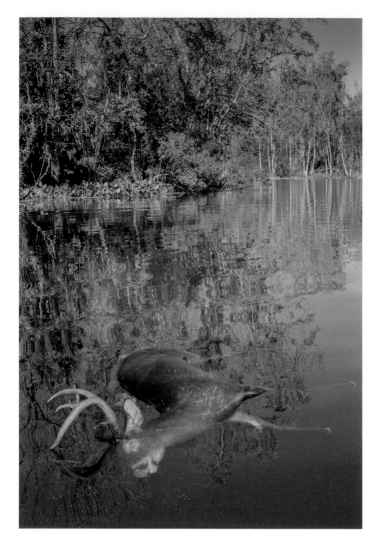

White-tailed deer buck in Florida's Silver River that may have been wounded by a hunter, escaped, and later died. The next day, the carcass could not be found, possibly scavenged by a large alligator of which there were many in the area.

There seem to be two reasons for "caching behavior." The first is simply a mismatch between the size of the alligator's stomach and the size of the prey. The second is a matter of seasoning. After several days of decomposition, the flesh is easier to tear apart.

Another unusual diet-related observation is the presence of plant material in alligator stomachs. Plants are found in 85–95 percent of all sampled adult alligators. For many years, it was assumed that plants were incidentally ingested by alligators. As they grabbed a frog, for example, it was thought that they unintentionally grabbed some nearby plant matter. It was also proposed that plant matter may be "secondarily ingested." This suggestion holds that the prey ate plants and then the alligator ate the prey as well as the plant matter inside it.

But it appears that some plant matter is purposefully eaten by alligators. There have been a number of direct observations of alligators feeding on fruits

and vegetables. Zookeepers at the St. Augustine Alligator Farm Zoological Park have often observed subadult alligators actively feeding on vegetables (yellow squash, sweet potato, lettuce, and other dark leafy greens) that were put out for tortoises in the same enclosure. These same alligators were subsequently observed on numerous occasions rising up onto their hind legs to pull oranges, lemons, and kumquats from fruit trees within their exhibit. Adult alligators in a seminatural lake at the same institution have been observed eating elderberries and wild grapes from plants growing on the banks of the lake.

An 1878 account in the *Lake City Reporter* (Florida) describes the killing of a very large alligator, reported to be 11 feet, 5 inches (3.5 m), that had a "peck of blueberries" in its stomach. A recent video recorded a small adult alligator actively feeding on saw palmetto berries along a grass road in Florida's pine flatwoods. Taken together, the many observations suggest that the predatory alligator will eat what we consider healthy foods on occasion.

Evidence that alligators can find nutrition by eating plant matter comes from laboratory studies. This type of research has shown that alligators are able to digest the proteins, carbohydrates, and fats found in vegetables. Alligators seem to have the enzymes necessary to break down carbohydrates, turning them into simple sugars that can be absorbed and used. There has been some speculation that fruit-eating alligators might pass seeds unscathed, but this possibility has not been demonstrated. If that turns out to be the case, alligators could be one of the agents involved in seed dispersal.

Even though we don't know for sure whether seeds can pass through an alligator unscathed (and subsequently germinate), we do know that undigested parts of prey items are commonly found in alligator stomachs. Bones and teeth might be expected to escape digestion, but in fact they are digested by the

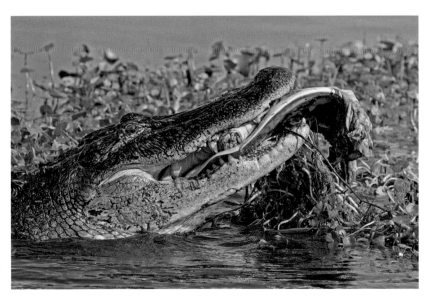

Alligators might incidentally ingest vegetation while attempting to swallow prey like this Florida softshell turtle.

acids in the alligator stomach. Conversely, invertebrate body parts made of chitin cannot be digested. Chitin forms the exoskeletons of insects, spiders, and crustaceans such as crayfish, shrimp, and crabs. The shells of snails can be dissolved, but the plate (operculum) that some snails use to seal in the body is not dissolved because it is made of chitin.

Some parts of fish may also remain undissolved. The heavy, bony scales of some fish, most notably gar, may remain. Keratins, structural proteins like those that form your hair and fingernails, may not digest at all, remaining in the gut for a long time. The keratin scutes that cover the bony shells of turtles are also found undissolved in alligator stomachs. Bird feathers are mostly degraded but the thicker keratin central shaft often remains. Mammal hairs are not digested at all. In fact, alligators that eat lots of mammals will develop dense hairballs that are up to 5 inches (12.5 cm) in diameter.

Alligator stomachs commonly contain stones, pebbles, and other hard foreign objects. These items are intentionally ingested and held in a muscular portion of the stomach. Captive alligators held in tanks with no substrate will quickly ingest stones if you put some in the tank. As they grow, they will ingest larger stones and regurgitate the smaller stones they had swallowed when they were younger. Peter Brazaitis, a crocodilian expert retired from a career at the Bronx and Central Park Zoos, gave an apt name to this taking in of large denominations and spitting back smaller stuff: making change. These stones and such seem to assist alligators by physically pulverizing food items in the stomach, which helps speed up digestion. It is possible that fruit seeds are ingested by some young alligators to fulfill this function.

Some alligators are veritable garbage cans, with stomachs packed with items they've picked up from their surroundings. A short list of odd stomach contents includes hard knots of wood, pieces of glass, fishing lures and hooks, rubber fishing worms, spark plugs, nuts and bolts, old whiskey bottles, arrow heads, beer cans, shotgun shells, cigarette lighters, rope, plastic of all types, coins, bottle caps, plastic dolls, golf balls, tennis shoes, dog collars and tags, and bird bands and other tags that researchers have affixed to study animals (including other alligators). Really big gators may have bricks in their stomachs, which has always made me wonder where in the world they find them.

The Kill

In 1995, a hunter searched for his lost dog in the Blackwater River State Forest in Florida. The $5,000 hunting dog was fitted with a radio transmitter collar, a common accessory for expensive dogs that can get lost in the excitement of a hunt. As the hunter searched for the dog's signal on the west end of the Florida panhandle, he finally picked up a faint beep. The transmitter led him to a large alligator. The state forest managers brought in alligator hunters. The poor alli-

Heavy growth of duckweed further enhances this alligator's stealthy approach.

gator was soon killed, and its stomach was opened. He had three dog-tracking radios in his stomach.

This gator apparently found a spot near a narrow creek bed where the hunting dogs would run when they were tracking deer and fox. The alligator waited in the creek, staying low, the dark color of his back and head concealed in the equally dark water. He was invisible to the dogs.

From what can be pieced together of the story, it seems the alligator lived in a deep hole in a swamp some distance away from the ambush site. He had to leave his hole, cross the swamp, swim up a slough (a backwater off of the swamp), then up a creek about 200 yards (183 m) to a spot right next to a trail. He had made this journey at least three times that year, each resulting in the capture of a dog that the owners thought had been lost or stolen. The last dog he took was a Walker foxhound. Perhaps he learned to move to this location when he heard distant barking. We'll never know, but the dog killings do illustrate an important aspect about alligator hunting behavior: their ability to learn behavioral patterns of prey.

Being rewarded with success in a previous hunt, it seems likely that the dog-killing alligator remembered his meal the next time he heard baying dogs. In addition to three radio collars, he also had dog tags in his stomach. One tag was from a dog that disappeared fourteen years earlier. So he'd been at this type of hunt for well over a decade, and probably had learned some clues that said, "dog is on the menu tonight." He was a big alligator, almost 11 feet (3.3 m) long and weighing in at 500 pounds (227 kg). He might have continued his "caninicide" for much longer if the radio transmitter in his stomach hadn't given away his position.

What makes alligators particularly good killing machines is a combination of traits:

» They are cryptic, blending into their often murky surroundings.
» They can kill any time of the day or night, prey are never really safe.
» They are patient, seeming to wait as long as necessary until the prey is inattentive for a moment.
» They strike like lightning, out of the blue, giving them the element of surprise.
» They are powerful, incapacitating most prey before the actual kill is completed.

Some of these traits make it difficult for biologists to study alligator predation. In the end, we often have to resort to stitching together many anecdotal observations to give us a picture of the behaviors. That is, until Greg Marshall came along and invented the "Crittercam."

I was lucky enough to have met Greg in the 1980s during the early days of his career. Now it seems like I can't turn on a TV without seeing Greg or one of his devices. He spearheaded a revolution in animal studies by developing video recorders that could be mounted on the animals themselves. I partnered with Greg to try his new method on alligators. First we had to catch an alligator, which is always fun, especially when you have someone less experienced along for the ride. Then we had to mount the newly designed harness and Greg's very primitive prototype Crittercam onto the alligator. In the days before digital, we used a videotape recorder.

It took us quite a while to fit the harness onto our captured male. We had to make endless adjustments and then had to get the waterproof video camera properly mounted. Finally, we released him and crossed our fingers. He swam across the lake, stuck his nose under some plants, and didn't move for the next two hours until our videotape ran out. Not very enlightening, but we considered it a small success because we got the video camera back undamaged, and the tape gave us an alligator's view of the plants.

Fast-forward thirty-five years and Crittercam technologies have come a long way. Behaviors captured on these cameras let researchers see amazing animal foraging activities from the critter perspective. Studies that used Crittercams have revealed many aspects of alligator feeding behaviors and activity patterns. But it is usually not possible to see the exact moment when prey are taken, and often you cannot tell which prey were grabbed. The attack stirs so much sediment that all you can make out is a cloud. Another difficulty is that the cameras are mounted on the alligators' shoulders, so the head and snout often block the view of the actual prey. What can be recorded more often are activity periods, capture attempts, success rates, and other aspects of feeding behavior.

One thing we have learned from Crittercams is that the average alligator makes more attempts to capture prey on a typical day than we thought. They average about twelve predation attempts in a twenty-four-hour period. These attacks are successful a little more than half the time (52 percent of attacks), so alligators are eating more often than I would have guessed at the start of my career. We also learned that alligators try to capture prey more often at night, but their attempts were more likely to be successful in the morning hours. Prey attacks were twice as successful when alligators were underwater than when at the surface. All this is known thanks to the inventive persistence of Greg Marshall and the host of researchers who now follow in his footsteps.

Because our observations of alligator attacks in the wild often capture their "sit and wait" strategy of predation, we began to see alligators in this way. But

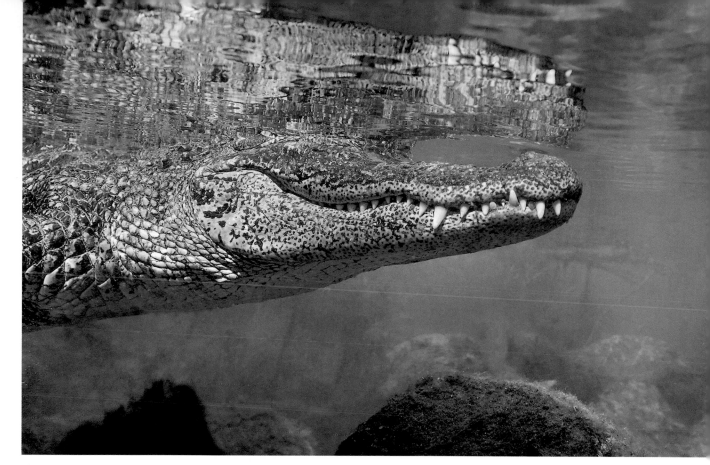

The art of the ambush. With eyes, ears, and nostrils positioned on top of the head, the alligator can discover and approach unsuspecting prey while keeping the bulk of its massive body hidden below the water's surface.

Crittercams and other methods have shown us that alligators often actively forage for food. While submerged, with its head resting on the bottom, an alligator seems to perceive movements of tiny prey animals nearby. Slowly, but very deliberately, an alligator will lift its head, open the jaws, and sweep the open mouth back and forth. Each pass of the head creates a vortex, a small swirl in the water, lifting small items up off the substrate. On the next pass, these items enter the mouth, which snaps shut when an item is detected. Prey taken in this manner include worms, larval and adult aquatic insects, snails, and small fish and crayfish.

Alligators also use their olfactory senses to find carcasses on land and in the water. Hatchling and juvenile alligators often leave the water to hunt terrestrial insects and other invertebrates. Alligators have been seen stealing eggs from Canada goose nests; they even return to the same nest again and again as new eggs are laid to replace what was lost.

One of the more brutish examples of active alligator foraging happens in late spring. Long-legged wading birds that nest above alligator concentrations enjoy their protection from mammalian and reptilian predators. When the fledglings first step out of their nests to test their balance on tree branches, they are very

unsteady. The uncertain youngsters attract the attention of alligators. Some alligators have been seen increasing the chance that a little guy will become a meal. The gators lunge their bodies repeatedly at the trunks of trees that are small enough to shake. Fledglings strain to hold their balance, but inevitably, the first flight for some of them is a quick and lethal fall that ends in an alligator's mouth.

Quite a bit of hunting seems to begin with the eyes, especially for smaller alligators. When a small gator sees a katydid crawling up a reed, it deftly moves in for the kill. Snakes slithering through vegetation, or swimming on the water's surface, equally catch the eye. Alligators in open water consider the heron foraging in shallow water and don't miss the raccoon searching for food on the shore. With body submerged and only the eyes, nostrils, and a bit of the head visible, the alligator points itself toward the prey and moves steadily in its direction. It won't rush, avoiding attention. The pace is even, steady, and slow. When it draws close, it reveals itself a bit early if necessary, such as when the prey reacts or if the slope of the bank mandates abandonment of the cloaking shield. Otherwise, the predator continues its steady advance, only opening its jaws at the last possible moment in an effort to inflict quick, decisive defeat.

One fascinating set of photographs taken by Florida homeowner Bryan Peabody reveals an adult alligator leaving the water and stealthily approaching a bobcat that is sitting on a shore with its back to the water. The bobcat is perhaps 15–20 feet (4.5–6 m) from the water's edge. The alligator gets within inches of its prey before the bobcat notices and springs away. As I viewed the photos, I got a sense that the alligator very likely would not have attempted this kill if it weren't for the fact that the bobcat stayed in one place for a long time. Its immobility increased the alligator's instinctive calculation that it had a chance of success.

There is growing evidence that alligators use somewhat sophisticated prey-capture behaviors. Blocking animals with their body and thumping against trees are a couple of examples that go beyond lunge-and-kill techniques. Another example is the use of flowing water that brings prey to the alligator. By positioning itself facing upstream, with its mouth held open, the alligator waits for a fish to swim in. Even a fish that is trying to swim past may be sensed by the integumentary sense organs on the side of the alligator's head and snapped up. This hunting technique was first recognized as early as 1846 by a medical doctor with a keen interest in alligators. He recorded that during dry spells water would pour out of surrounding swamps and into the Mississippi River. Alligators positioned themselves in the outpourings, with mouths open, and snapped up fish as they tried to make it to the river.

Alligators in coastal habitats will feed on schooling striped mullet in tidal marshes on Wassaw Island, Georgia. During very low outgoing tides at night and in the early morning, the alligators move into shallow shoals and face into

Alligator using its legs to change direction underwater.

the current. Their jaws are opened no wider than your toe is long. As schools of mullet approach, the alligators rapidly swing their heads sideways, back and forth, in a continuous series of jerky motions. The technique seems to have a low success rate, but it causes mullet to leap out of the water and sometimes turn around.

Some of these same alligators use a different hunting strategy when tide waters are a bit higher. Large schools of mullet move into the high mud flats to feed on decaying plant matter from the marsh grasses when the tide allows it. As the tide recedes, these mullet plow their way back through the grass beds toward the deeper water in tidal channels. Alligators position themselves on the outer margins of the grass beds, with their heads placed so that their snouts just penetrate the grasses and their bodies are suspended out in the current of the channel. As the mullet push past, the alligators snap up any that come too close. The gators quickly lift their heads to swallow, and then return to their previous hunting position. Their jaws are not agape during this maneuver and there is none of the rapid head-jerking motions observed when they were attempting to feed in the shallow current. The mud feeding is much more successful than

Many species of water birds, such as this purple gallinule (*top*) and common moorhen (*bottom*), are particularly vulnerable to predation by alligators, especially when walking or swimming through floating vegetation.

the shoal feeding. Once the tide has ebbed enough to fully expose the mud flats, the alligators move out into the shallow tide channels and resume their fishing attempts with open mouths.

Alligators use a hunting technique that has been dubbed "weir fishing" because it resembles traditional weir net methods that have been used by humans for millennia. The alligator lays its body across a narrow, flowing channel with its tail against one bank and its head positioned a bit downstream but close to the opposite bank. The alligator's body becomes a small dam, backing up the water a little. The water flows only through the narrow gap between the alligator's head and the opposite bank. As a fish moves up- or downstream, it has to pass close to the jaws. The game is on and, unfortunately for the fish, the odds are in the alligator's favor.

A small twist in the weir fishing behavior involves the calm eddy that is created downstream from the alligator. Just as fish will gather behind a log as refuge from the constant current, fish will also gather downstream from the alliga-

tor's body, in fact, just behind the alligator. So the alligator sometimes bends its body in a way that brings the head and tail together, much like closing the ends of a net. Any trapped fish face an uncertain future, as the alligator hopes to find its next meal in the eddy it has created.

A hunting method called "float fishing" or "leap fishing" occurs when an alligator is at the surface of deep water. The gator floats dead still with its four legs outstretched perpendicular to the body. The digits of its forelimbs are spread and flexed so that their tips often stick up out of the water. Somehow the alligator seems able to sense that a fish is nearby, although we don't know for sure how it can tell. Whatever the cause, the alligator leaps up out of the water and dives nose first into a spot just in front of its original position. I've seen subadult and adult alligators float fish for hours, putting on a great show. During the leap, the head, shoulders, and torso are driven up and the alligator arches forward by propulsion of the tail and hind limbs. As the head reenters the water, presumably where the intended prey is located, the remainder of the body and tail follow where the head entered. Alligators that are less than 6.5 feet (2 m) long can leap so vigorously that they actually flip over, their tails passing over the position of the head, so they end up splashing back into the water almost on their backs. On rare occasions, you can see that the alligator captured something, which it then swallows. Float fishing is a high effort, very low-yield hunting strategy. The success rate seems to be somewhere in the one-in-a-hundred range.

At the other end of the success extreme is a feeding frenzy I once witnessed. I was catching young alligators from an airboat one fall night on a lake in Central Florida. By chance, mayflies were emerging that night. Mayfly emergence is one of most astounding feats of nature. Larval mayflies, called naiads, are aquatic and live on the bottom of freshwater lakes and streams. They will stay in their larval form for years as they grow and develop. The naiads crawl onto stalks as they transform into winged adults. Their synchronized mass emergence can result in millions, or even billions, of mayflies filling the air. One particular species of mayfly has been estimated to produce 118 trillion individuals in a single year.

On that night in Florida, the air was thick with tens or hundreds of thousands of the mayflies. The water surface and every plant along the shoreline was covered with them. The boat and my face were also covered with the harmless insects. Many that did not find a reed were sitting on the surface of the water waiting for their wings to dry. The mayflies were sitting ducks for fish and little alligators alike.

My goal that night was to collect small alligators and tag them for a research study. The yearlings were so fixated on catching more flies that they were easily scooped up. Several of these little alligators had eaten so many flies that their bellies looked like they were about to pop. Their throats were distended because they were so packed with mayflies. Some had so many in their mouths that they could not close their jaws. It was a feast, and mayfly was the main course.

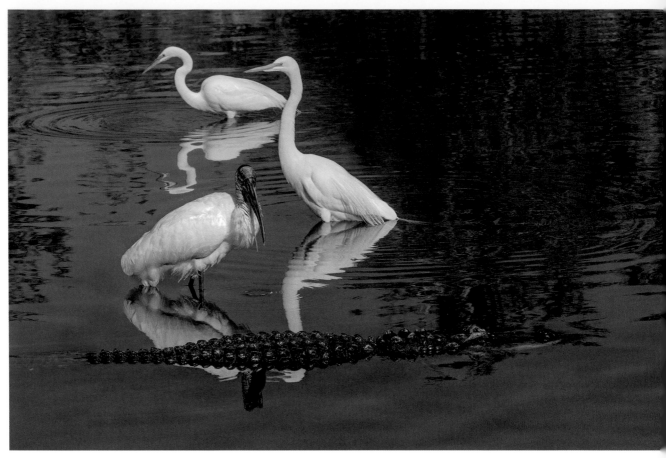

Wading birds, except for new fledglings, are quite aware of alligators and keep an eye on them, as these great egrets and wood stork are doing.

Another feeding frenzy was captured on a 2010 video. Perhaps hundreds of alligators were congregated in a narrow waterway in the Okefenokee Swamp of Georgia. It appears that there was a very high concentration of fish in a small stretch of the waterway. That feeding frenzy is similar to an Okefenokee account from the late 1800s. A concentration of approximately three hundred alligators was recorded as fish were moving through Buzzard Roost Lake. The waterways of the Okefenokee form a spider's web of channels spreading across the swamp, sometimes merging, often splitting, as the water courses around a myriad of small islands on its way to either the St. Mary's or Suwannee Rivers. After heavy rains, water levels rise, and large numbers of fish of several species will move through these channels. In places where the channels narrow, fish can become backed up and reach high densities. For alligators in the area, this is the closest thing to "shooting fish in a barrel."

Dead or Alive

One of America's greatest naturalists and authors was Dr. Archie Carr. One of his books, *The Windward Road,* is widely considered a classic. As a graduate student, I was lucky enough to have had Archie as a member of my supervisory committee. As well-known as he was at the time, Archie was a regular guy. We had many wonderful conversations about alligators. He once told me about problems he was having with his "buzzard feeder," as he called it. His family dog, a huge German shepherd named Ben, became obsessed with chasing and killing armadillos. There was no love lost on Florida armadillos in the Carr household. Armadillos were an invasive species that dug holes under the foundation of the house and ate the eggs of many native turtles, lizards, and snakes. Ben had trouble running armadillos down in the woods but had some luck out in the open yard and fields. Each morning, any freshly deceased armadillos were carried out to the calf pasture. Black vultures ("buzzards") soon found the dead armadillos. Turkey vultures soon began arriving for the 'dillo smorgasbord as well.

Things really heated up one day when a young bald eagle showed up at the buzzard feeder. The operation took on greater import and family and friends were enlisted to find enough road-killed armadillos to keep the feeder stocked. More armadillos brought more eagles. Soon, two adults had joined the daily feast. That's when the "trouble" started. The Carr's house was situated just up the hill from Wewa Pond, which was home to a 9-foot (2.7 m) female alligator. The alligator had apparently figured out that lunch was being served up the hill

Nine-banded armadillo

and she wasn't invited. So, she walked up the hill to the feeder, had her fill of the day's armadillos, and headed back down to the pond.

Every time new armadillos were put out, the alligator somehow knew it, even though the field was 90 yards (82 m) away, through heavy woods, and at least 20 feet (6 m) higher than the pond. How did she know? That was the crux of our talks. I suggested that the alligator could smell the armadillos. I had recently had an experience with an alligator finding a piece of wood I had thrown deep in the woods, and this was still fresh on my mind. Archie did not think this was possible, given the distance and his knowledge of the way smoke from his trash pile moved. He thought the alligator must have been watching the vultures and eagles circling and landing as her clue. We'll never know which explanation, if either, was correct. Archie shut down the buzzard feeder soon after our conversation because he was opposed to humans feeding wild alligators.

Alligators turn out to be frequent scavengers, eating both freshly dead and decomposing carcasses on land and in the water. They use their keen sense of smell for both airborne and waterborne chemical cues. And, as Archie Carr thought, we've since determined that they may react to vultures and other avian scavengers.

Bodies decay due to the actions of bacteria and fungi. Many of these microbes produce toxins that deter vertebrate scavengers from eating the carrion in which they grow. These toxins, botulism is one example, may prevent a fox

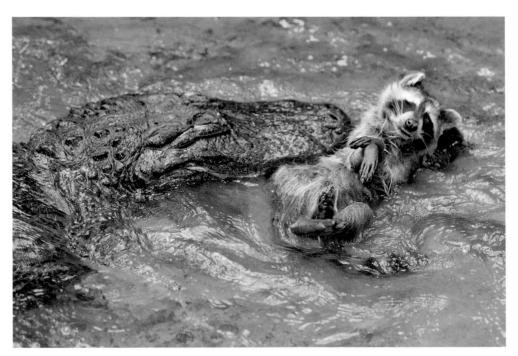

Large male alligator scavenging a dead raccoon.

or raccoon from feeding on a carcass. But these toxins don't seem to bother vultures or alligators. The remarkably high acidity within the alligator's stomach may destroy the pathogenic microorganisms, or it may be that antimicrobial proteins in alligator blood protect them.

Table Manners

However an alligator obtains its meal, it faces the problem of swallowing the food. It cannot easily tear the meal apart the way a lion can. Most prey are simply swallowed whole. Alligator jaws are capable of gaping widely and an alligator can open its throat almost as wide at the back of the skull. The esophagus can also expand, accommodating any prey that can pass through the throat into it.

Alligators reposition food in the mouth and they swallow differently than we do. When we swallow a bite of food, we use our tongue to move that morsel into the back of our mouth, repeatedly sliding the tongue forward under the food and drawing it back. An alligator's large flat tongue is relatively fixed in position, so it cannot be used to assist with swallowing. Instead, alligators move prey into the oral cavity and swallow by relying on the weight and inertia of the prey item itself.

In order to swallow, alligators lift their head out of the water and forcefully flip the head up while simultaneously releasing their hold on the prey. The tongue does have a role, projecting the item up so it is suspended momentarily. By repeatedly "tossing" their head, they can reorient the prey and ultimately pitch the prey item into the back of the oral cavity. As the prey item begins to pass down, the tongue is depressed and the jaws are held agape. To maximize the help gravity provides, alligators lift their heads high. The tail comes up out of the water as a counterbalance to the weight of the head. By contracting its throat and squeezing, the alligator moves the item further down the throat and into the esophagus. At this point, muscles of the neck push the food item toward the stomach.

Alligators can kill prey species far too large to be swallowed whole. A problem alligators face is that their conical teeth cannot cut through animal tissues. But large prey animals must be dismembered before they can be consumed, and alligators use a variety of techniques to tear their prey apart. Juvenile and adult crocodilians can remove tissue from large carcasses simply by biting and shaking their heads vigorously from side to side. The teeth of many young crocodilians are more pointed than those of adults, which may allow them to tear through tissue as they shake, creating chunks small enough to swallow.

Larger alligators can dismember a carcass by slinging or hurling it while holding a leg in the jaws. The alligator grabs a body part and then powerfully lunges up out of the water with the carcass, pulling it one way, then violently slinging it

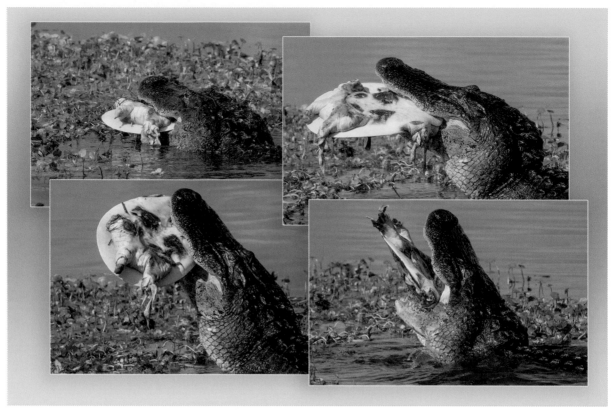

Very large male alligator swallowing a decaying Florida softshell turtle carcass.

in the opposite direction. The whole time, the alligator never lets go of the prey. Eventually a chunk of the carcass tears away from the body and stays in the mouth. The act is powerful enough that the part not held in the mouth may fly as far as 50 feet (15 m). Once the torn portion is swallowed, the remaining carcass is located. The process is repeated until the entire prey is consumed. Alligators usually eat the legs and head before consuming the trunk of their prey.

The vividly named "death roll," is a feeding technique that is a type of rotational feeding. While firmly biting the prey, the alligator's head and tail are angled to one side, forming a C shape. Then the alligator's body spins rapidly and violently. The death roll is used more often in water, but occasionally on land as well. Alligators will also use the death roll motion to try to break free from aggressive encounters with other alligators or when being captured.

Sometimes alligators will retain their dead prey for long periods of time, even a day or more, before attempting to swallow it. They are more likely to hold onto larger mammal prey. It's not always obvious why they wait to eat, though there has been some speculation that muscles and nerves of the prey may lose all tone and responsiveness over time. Or it may be that the alligator is fatigued after killing large prey and needs time to recover.

Snacking on Snakes and Turtles

When you live in a swamp, like many alligators do, mealtime often involves slender, slithering treats. Chief among these prey are snakes, but eels and salamanders, like sirens and amphiuma, are also on the menu.

Alligators grab snakes anywhere on the body and then whip them violently from side to side. Once the brutal thrashing is finished, the snake is flipped into the mouth and positioned across the lower jaw. A long series of masterful manipulations and a succession of bites accompany slight sideways flicks of the head. The snake's body is systematically moved across the alligator's jaws, receiving crushing bites along the way. When the bites approach the end of the snake's body, either the head or tail, the process is reversed. The crushing continues until the other end is reached. An alligator moves the snake back and forth several times, like the fingers of a student at the piano, until the snake is reasonably pulverized.

Snakes do not die quickly. The snake's muscular activity can continue for hours after brain death, so the alligator's excessive pulverizing seems to be an adaptation that guarantees that the prey is crushed to the point that it cannot move.

Water moccasin, a venomous snake commonly eaten by alligators. In the upper left, a juvenile water moccasin swallows a fish. At right, a threat display in which the snake exposes the bright white lining of its mouth, which is the origin of its other common name, cottonmouth.

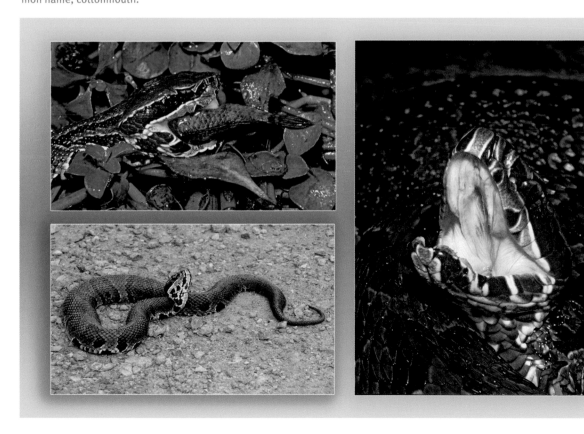

Snake venom seems to provide only a measure of protection from an attacking alligator. Alligators live side by side with water moccasins, and the latter are a favorite food of the former. Only one study has directly examined whether alligators can be killed by water moccasin venom. The study injected one small alligator, 2 feet (60 cm) long and weighing 1.5 pounds (680 g), with 0.0005 ounces (150 milligrams) of moccasin venom. The gator died about fourteen hours later. Moccasin venom is a bit different than rattlesnake venom. Rattlesnake venom is adapted for mammals and birds, warm-blooded animals; moccasin venom acts on cold-blooded prey, like fish, amphibians, and reptiles. So, it is likely that water moccasin venom is more effective than rattlesnake venom at killing an alligator, but I don't believe this comparison has been tested.

Edward Avery McIlhenny, whose family name appears on bottles of Tabasco sauce (his father's creation), was a renowned naturalist during the late 1800s and into the 1900s. He is often credited with writing one of the first major books on American alligators. McIlhenny wrote that alligators violently shake water moccasins and other pit vipers, but do not give non-venomous snakes the same treatment. Whatever prompted him to make this claim, we'll never know, but it is not correct. From the smallest to the largest of alligators, the violent shak-

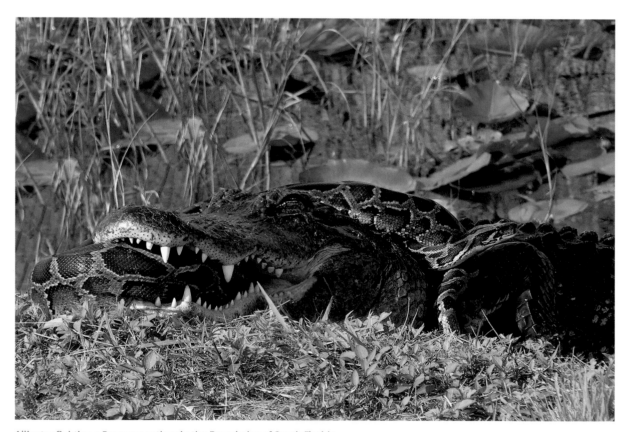

Alligator fighting a Burmese python in the Everglades of South Florida.

ing of snakes does not discriminate based on toxicity. They all get the rough treatment.

No other alligator-snake interaction receives as much modern attention as the gator-python battles. Pythons were introduced to South Florida by pet owners who either tired of their snakes or could no longer care for them as they grew larger. Unfortunately, the snakes were often released into the Everglades and other remote areas. Today the snakes pose a major threat to the entire Everglades ecosystem. A 2012 study showed that marsh rabbits, cottontails, and foxes may be gone, and raccoons, opossums, and bobcats are a shadow of what they were fifteen years earlier. Their disappearance is due to python predation.

We don't yet know what the long-term impact will be on alligators, but researcher Frank Mazzotti from the University of Florida has found that alligators in the Everglades have become less numerous and often appear thin. That finding is almost certainly tied to the tens of thousands of pythons now living free in South Florida and the current absence of many alligator prey species. It is true that alligators will eat pythons, but it seems likely the impact of pythons on mammals isn't being countered by alligator predation on pythons.

Along with snakes, turtles are a favorite food of alligators. In some areas, alligators are thought of as turtle specialists because they eat so many chelonians. An alligator's broad snout can help them overcome the turtle's hard-shelled defense. Alligators will eat any turtle they can catch and kill—mud and musk turtles, pond sliders and cooters, snapping turtles, and softshells. As long as the alligator is large enough to handle the turtle, it will try to eat it.

The force needed to crack or crush a hard-shelled turtle increases with the turtle's size and varies among species. No matter the size or species, however, an alligator will not swallow a turtle until the shell has been crushed. The reason to kill first, eat second, lies with the turtle's strong legs and long, sharp claws, which could do serious harm in an alligator's stomach. The alligator seizes the turtle in its mouth and positions it across the teeth in one corner of the mouth, and then the alligator bites. The domed shape of the turtle's carapace (the top of the shell) makes it difficult for the teeth to grip in a way that exerts the full force of the bite. So, sometimes the turtle just slips out from between the jaws. Several attempts at repositioning the turtle and biting may be necessary before an alligator can successfully "pop" a shell. When the shell finally fails, it makes a loud, distinctive, and somewhat gut-wrenching, popping sound. Once you've heard this, you'll recognize the sound whenever you hear it in the swamp. I, for one, feel a bit of sympathy for the turtle every time I hear it.

Alligators seem to have a good sense of whether they have the ability to crush a particular shell. Once the shell is positioned well in the jaws, they will make a few crushing bite attempts. If they don't feel they have the upper hand, they often release the turtle. In some areas, you can see large turtles with many scars, survivors of attempted crushing.

Famous photo of a dead 13-foot (4 m) Burmese python that had swallowed a 6-foot (1.8 m) alligator in the Everglades. Examination of the snake's remains failed to determine if the body was torn open by the alligator or if the snake died of other causes and this damage occurred post-mortem.

Alligators sometimes try to drown turtles, holding the turtle underwater in the mouth while the gator keeps its own nostrils above the water. But aquatic turtles are adapted to withstand long periods of time underwater. An alligator can win this battle, but it must invest hours in the effort.

Turtles have adapted to life with alligators. Pond sliders and cooters in regions with high alligator densities are known to have heavier shells. Both the bones of the shell and the keratinized outer scutes are thicker than the shells of those same species in areas with few or no alligators. These gator-neighbor turtles also have a higher, more rounded shell architecture. The plastron, a turtle's bottom half of the shell, is also often somewhat domed where alligators are common. Overall, the turtles take on a bit of a football appearance. The curvature of the shell causes the tip of the alligator's teeth to slip across the shell when force is applied. That slipping reduces the full force of the bite just enough to sometimes save the turtle's life. The Florida red-bellied cooter, which commonly lays its own eggs in alligators' nests, is the most striking example of this thick, high-domed shell structure.

Rating the Bite

I've been bitten by alligators a few times over the years. It's no picnic, and I hope I never have to experience it again. I usually tell people the closest example I can give is the sensation you feel when you get your hand slammed in a car door. But it's worse. The force is more like what you would experience if the car dropped on your hand while you were changing a tire. I think the purpose of all that pressure is to inflict such overwhelming force on the prey that it is driven almost immediately into physiological shock. If the bite hits a vital area, the struggling prey becomes immediately subdued and escape is not an issue.

I spent several years studying bite force in crocodilians with my colleagues, Greg Erickson, of Florida State University, and John Brueggen, Director of the St. Augustine Alligator Farm Zoological Park. We measured the bites of all twenty-three crocodilian species recognized at that time. As you might guess, the more they weigh, the stronger the bite. We calculated the bite force at the back angle of the jaw, where force is maximal, and found that the shape of the snout doesn't impact bite force. Broad snouts and narrow snouts were equally powerful.

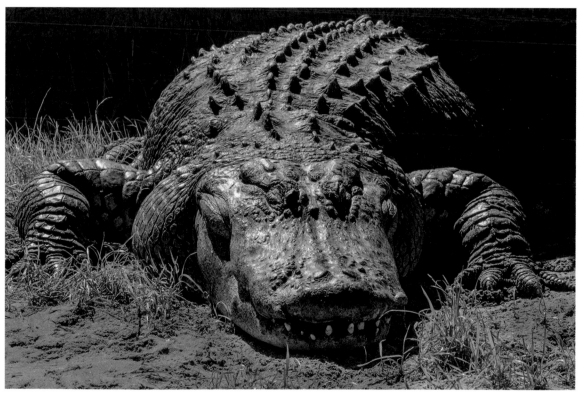

The bulging jowls behind the head of this alligator contain much of the large adductor muscles responsible for the alligator's overwhelmingly powerful bite.

The most powerful alligator bite we measured, and a world-record for a time, was from an old, very big, rough-looking male. He was 12.1 feet (3.7 m) long and would have reached 13 feet (4 m) except he was missing more than a foot of tail. He weighed 535 pounds (242.7 kg) and actually looked pretty lean. His maximum bite force was 2,960 pounds (1,342.5 kg)—almost a ton and a half of sheer force. By comparison, adult humans bite with a force of 150–275 pounds (68–125 kg). Thus the strongest human bite is less than one-tenth as powerful at the most powerful alligator bite.

Our big male soon lost his world record to the Farm's big saltie, and sometime later a large saltwater crocodile in Australia claimed the world record, with a biting force of 3,690 pounds (1,674 kg), which still holds today.

The old gator also lost his alligator-bite title when "the Sneads Gator" was caught. Licensed alligator trapper Tony Hunter caught the new champion at Sneads Landing on Lake Seminole, Florida. Another big male, the Sneads Gator measured 13.2 feet (4.01 m) and 580 pounds (263.1 kg). Tony was an alligator trapper who removed nuisance gators, but he understood that big gators were special; they had lived long and survived much. He always tried to catch these big specimens alive and unharmed, and he would sell them to a zoo instead of killing them. The Sneads Gator became "Crunch," the star attraction at Alligator Alley in Summerdale, Alabama. Crunch is still there and continues to grow even larger. Greg Erickson measured Crunch's bite force at 2,980 pounds (1,351.7 kg), edging out our old record by 20 pounds (9 kg).

Alligators, like most vertebrates, have very little jaw-opening strength. Jaws are designed for biting (and sometimes chewing), so the adductor muscles used to force the jaws closed are bigger, more numerous, and stronger than the abductor muscles that open the jaws. Alligators have eight different pairs of adductor muscles, and they differ significantly from our rather modest muscles, which are located in our cheeks and temples, on the side of our head. Instead, most of the alligator's adductor muscles are behind the head, rather than on it. This arrangement allows them to keep a low profile in the water and provides enough space for the muscles to become bigger. You can see this when you look at the head and neck of an adult alligator; you'll notice they have quite large "jowls." Those jowls are actually the largest of the adductor muscles. These adductor muscles grow at a rate much faster than most of the alligator's body, so as the alligator grows, its jaws are becoming increasingly more powerful to overcome the larger prey it must capture. The end result is the most powerful predator in the American South.

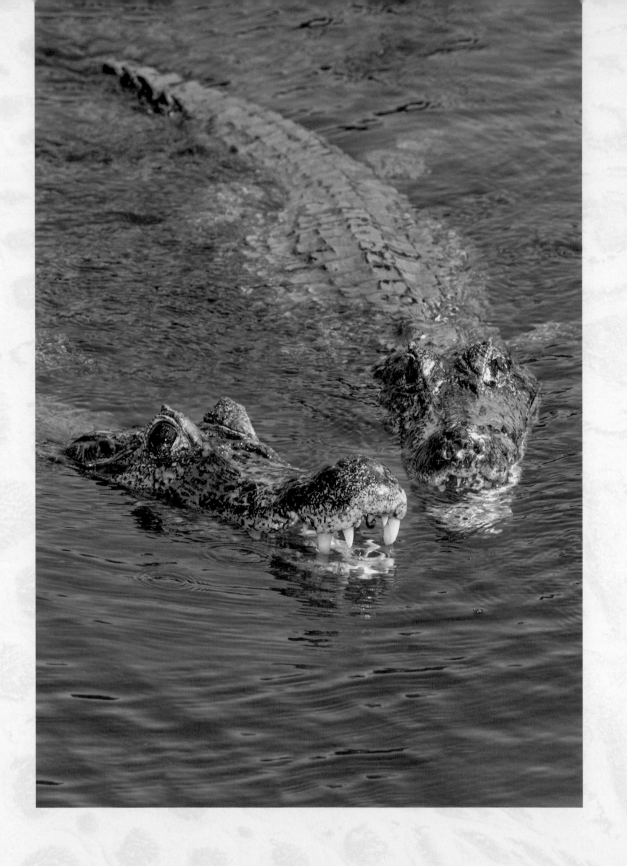

Meet the Relatives

There was a time when I could say that I worked, not only on alligators, but on all of the living crocodilians. Today, I have to admit that I'm a few species short. In a few cases, what was once thought to be a single species is now regarded as two or more species, and I've never touched a few of these newly named crocodillans. I suspect there are other species still to be named, so I'm content to say I've worked on at least twenty-four of the unknown number of crocodilian forms. Yet I feel fortunate to have had such a broad exposure to so many close relatives of the American alligator.

Just as I began my career, I now work mostly with captive animals. But for many years, between my clumsy start in St. Augustine and now, I conducted research on free-living crocodilians. These experiences have given me the chance to see firsthand the variety, diversity, similarities, and often subtle differences among the species.

The American alligator and its living relatives are a moderately diverse group of reptiles. All told, they number at least two dozen species. The exact number of species will always be debated, and the arguments on this front date back to those first studies that began more than two hundred years ago. Crocodilians have proven difficult to recognize, distinguish, and classify. The bodies of many crocodilians are superficially very similar to one another, and differences in head shape are not always the best indicators for distinguishing one species from another.

The ebb and flow of species identification has been a two-way street. Some crocodilians were once thought to be multiple species but are now recognized as only a single species. Sometimes these situations arose because animals were described and named by several early scientists, each of whom, in good faith, recorded separate specimens from different parts of that species' range. My guess is that the Nile crocodile wins the contest for the number of times a

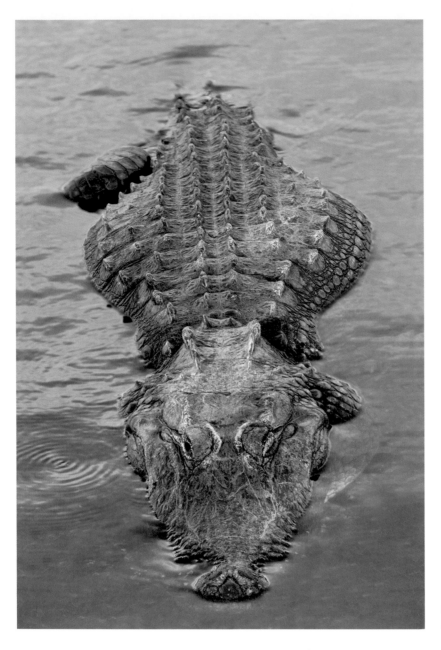

American alligator, *Alligator mississippiensis*.

species has been named (misnamed, really). Since the original description of the Nile croc in 1768, there are close to a dozen records that assign it to a different species. In fairness, it is a very wide-ranging species and looks somewhat different in different parts of its range.

Just like the Nile crocodile, biological specimens of other species were collected from all over the world, and the race to find new species (it really was a competitive race) often inspired scientists to declare "finds" a bit early. This was the "Age of Discovery." Collecting expeditions to Africa, Asia, and North

and South America often took three to five years to complete and yielded so many specimens that museums had trouble keeping up. As specimens were collected, they were prepared or preserved, carefully packed and crated, and then transported to the nearest port to be shipped back to Europe. Ships traveling from South America or Asia often stopped along the way, in ports in Africa or India, and crates were commonly transferred to new ships destined for Europe. So, by the time these specimens finally arrived in Europe, the origin of specimens was sometimes unclear. Mistakes were made.

On the other side of the naming race were the missed species. The African dwarf crocodile and the Philippine crocodile, for example, are species from remote areas and they have fairly limited ranges. They were not recognized and described by science until the twentieth century, long after many other species had been thoroughly chronicled. Very recently, with the advent of advanced genetic techniques—often called "molecular revolution in biology"—we have realized that some crocodilians once thought to be a single species are better classified as two or three closely related, but distinct, species. The term "cryptic species" is often used to describe such situations because the species look physically similar to one another, but hidden in their genes are enough differences to indicate they have been on their own evolutionary trajectory for millions of years.

Sorting Out the Family

Biologists judge relationships by shared ancestry. It is sometimes impossible to know with certainty what ancestral form gave rise to today's species, but we can reasonably determine when a lineage split. For example, we have a pretty good idea of when the family Alligatoridae divided into the two lineages that resulted in the American and Chinese alligators, on the one hand, and Central and South America's caimans on the other.

Quite a bit of our knowledge concerning crocodilian lineages comes from fossils, which provide a record of hard structures, that go back millions of years. We can also use molecular techniques, such as comparisons of specific gene sequences. Both of these methods have strengths and weaknesses. When relying on fossil evidence, we often look for fossils early in the origin of a new species, and then we try to accurately assign an age to the fossil. If we are determining divergence times from genetic data, we use estimates of mutation rates, which vary between taxonomic groups and may change over time. In ideal situations, we see multiple lines of evidence converge to support a conclusion. Most of the time, however, we must reach rational conclusions based on the strongest evidence we have, always recognizing that science is healthiest when everyone understands that truth is elusive and new evidence may change previous conclusions.

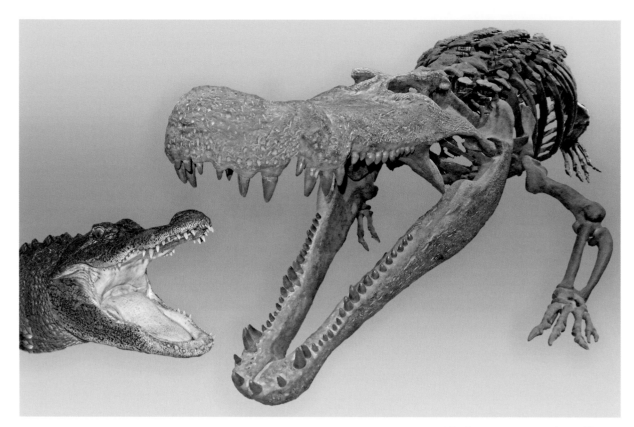

The largest recent American alligator, 14 feet, 9 inches (4.5 m), shown next to the remains of *Deinosuchus riograndensis*, an extinct species that lived in the interior of North America in the Cretaceous, about seventy-three to eighty million years ago. The largest specimens of *Deinosuchus* are estimated to have been 39 feet, 5 inches (12 m) long and weighed perhaps 8.5 tons (7,700 kg).

Based on the various lines of evidence we currently have on hand, alligators and caimans seem to have split from the other crocodilian lineages in the late Cretaceous, about eighty-five to ninety million years ago. The ancestral alligator-caiman lineage first arose in North America, but then spread across Europe, Asia, and central and northern South America. Alligators and caimans seem to have split apart from each other somewhere between fifty-four and seventy-one million years ago. The once widespread distribution of the genus *Alligator* is now represented by only two species, the American and Chinese alligators, which can be thought of as relatives who live on different continents.

Meet Today's Crocodilians

Many scientists agree that, at the time I write this, there are twenty-six species in the scientific order Crocodylia. But a few more recently "discovered" species are likely to be added to the list. Today's two dozen plus known species belong to three families: Alligatoridae, the alligators and caimans; Crocodylidae, the true crocodiles; and Gavialidae, the gharials. Each of these three families of crocodilians represents distinct lineages reaching back to known fossil forms in the late Cretaceous, more than eighty-five million years ago. Whatever species

Order Crocodylia

Family Alligatoridae (Eight Species)

American alligator	*Alligator mississippiensis*	Southeastern United States
Chinese alligator	*Alligator sinensis*	Eastern China
Cuvier's dwarf caiman	*Paleosuchus palpebrosus*	North and central South America
Smooth-fronted caiman	*Paleosuchus trigonatus*	Amazon River and Orinoco River basins, South America
Yacare caiman	*Caiman yacare*	Central South America
Common caiman	*Caiman crocodilus*	Central America and northern South America
Broad-snouted caiman	*Caiman latirostris*	Eastern and central South America
Black caiman	*Melanosuchus niger*	Amazon River basin, South America

Family Crocodylidae (Sixteen Species)

American crocodile	*Crocodylus acutus*	Southern Florida, Caribbean, southern Mexico to northern South America
Orinoco crocodile	*Crocodylus intermedius*	Colombia, Venezuela
Freshwater crocodile	*Crocodylus johnstoni*	Northern Australia
Philippine crocodile	*Crocodylus mindorensis*	Philippines
Morelet's crocodile	*Crocodylus moreletii*	Mexico, Belize, Guatemala
Nile crocodile	*Crocodylus niloticus*	Sub-Saharan Africa (widespread)
New Guinea crocodile	*Crocodylus novaeguineae*	New Guinea
Mugger crocodile	*Crocodylus palustris*	Indian subcontinent
Saltwater crocodile	*Crocodylus porosus*	Indian east coast, Southeast Asia, Northern Australia
Cuban crocodile	*Crocodylus rhombifer*	Cuba
Siamese crocodile	*Crocodylus siamensis*	Southeast Asia, Borneo
West African crocodile	*Crocodylus suchus*	West and Central Africa
West African slender-snouted crocodile	*Mecistops cataphractus*	West Africa
Central African slender-snouted crocodile	*Mecistops leptorhynchus*	Central Africa
Africa dwarf crocodile	*Osteolaemus tetraspis*	West and Central Africa
Congo dwarf crocodile	*Osteolaemus osborni*	Central Africa

Family Gavialidae (Two Species)

Indian gharial	*Gavialis gangeticus*	Indian subcontinent
Sunda gharial	*Tomistoma schlegelii*	Peninsular Malaysia, Borneo, Sumatra, Java

Currently recognized living species of the order Crocodylia.

■ Critically Endangered
■ Vulnerable

might one day be added, I think we'll probably see science stick with the three named crocodilian families.

As a group, crocodilians have successfully colonized most of the world's wet tropics in both the Northern and Southern Hemispheres, and in both the Old and New Worlds. The ranges of distribution of some, the American and Chinese alligators being the best-known examples, even reach into temperate zones, where the climate is much more seasonal. Some species have broadly overlapping ranges, for example, six South American crocodilian species live in the same region.

Alligators and Caimans

Within the family Alligatoridae, the caimans can be thought of as Central and South American alligators. A big difference between caimans and alligators is that today's alligators live only north of the Equator and can handle some cold weather. Caimans are found throughout the tropical and subtropical regions of Central and South America, extending north into southern Mexico. Today there are eight known species in Alligatoridae, the two species of alligators and six species of present-day caimans that are divided into three genera.

Despite its geographic location, the Chinese alligator (*Alligator sinensis*) is undoubtedly the closest living relative of the American alligator. However, genetic studies comparing the two species indicate they are more distantly related than was once thought. Essentially, the two living alligators evolved within the same genus, but they represent the ends of two lineages that split from a common ancestor very soon after the genus came into being. It's a bad analogy, but you might think of them as third or fourth cousins.

The obvious question is, "How did the Chinese alligator get to China?" The short answer is, "We really don't know." There are three possibilities: first, they dispersed across the Pacific; second, they crossed an ancient, long-since disappeared land bridge from North America to Asia; or, third, they moved from North America across the land masses of Greenland, Europe, and Asia before continental drift blocked this route—and left them in what is today China.

The Pacific crossing is highly unlikely due to the Chinese alligator's small size and lack of salt glands. The Greenland option is probably incorrect because the land masses likely separated too early in geologic history and no alligator fossils have been found along that possible route. So the land bridge from North America to Asia seems the most likely route. There is evidence that a land bridge has formed between the continents at least a few times in geological history. There was the more recent one that brought humans to North America and two previous ones, twenty and fifty-five million years ago.

Unfortunately, the Chinese alligator is an endangered species, with less than 150 individuals remaining in the wild. In modern times, their range was never

as broad as the American alligator, but they once lived in the extensive wetland marshes and tributaries of the lower Yangtze River in southeastern China. The Chinese alligator is now restricted to a small part of Anhui Province. Virtually all of the marshes in its range were converted into fields for agriculture, mostly for the production of rice and rapeseed (the plant from which canola oil was developed). In other cases, the land was converted to ponds for raising tilapia, carp, catfish, ducks, and geese. All this habitat conversion quickly led to a decline in the number of Chinese alligators.

In the year 2000, a survey of all known localities of this species in China concluded that the entire known range of the species was reduced to tiny fragments totaling less than 28 acres (11 ha), which is one-tenth the size of the National Mall in Washington, D.C.

Chinese alligators can live in regions where temperatures fall below freezing. They dig deep burrows that help them survive the cold winter months. Their aptitude for digging often disrupts the carefully constructed earthen structures necessary for controlling water levels for rice growing. Thus, rice farmers grew to dislike the alligator's presence. Villagers would catch them, but, rather than killing the alligators, they often took them to China's breeding centers. Decades of captive breeding within these centers have resulted in more than ten thousand captive Chinese alligators. And so, the future of this species rests in this paradox, an abundance of Chinese alligators in farms, but almost no habitat into which they might be released. On the positive side, national and state governmental authorities have recently shown increased concern for the dire circumstances of this little alligator.

Chinese alligator, *Alligator sinensis*, the closest living relative of the American alligator.

The alligator has substantial cultural significance in China. Many believe this species contributed to the origin of China's dragon mythology. The Chinese central government seems to be adopting their alligator as a national symbol, as they have the giant panda and the Chinese crane. Programs have now been initiated in order to restore habitat and reintroduce alligators from the breeding centers. The restored areas are few and very limited in size, but so far so good. Alligators are reproducing in the restored habitats, providing some hope that the Chinese alligator will one day regain its place in nature.

The six species of caiman from Central and South America fall into three genera: *Paleosuchus, Melanosuchus,* and *Caiman*. Caiman can be amazingly numerous in certain habitats. Caiman may number in the hundreds of thousands or even millions in the seasonally flooded grasslands and savannas of the Venezuelan and Colombian *llanos* (plains) or the Pantanal of southern Brazil, Bolivia, and Paraguay. During the dry season, when wetlands recede, the density of caimans in the remaining pools of water represents some of the highest concentrations of vertebrate animals in the world.

The three species in the genus *Caiman* are identified by a curved, bony ridge that runs across the "bridge of their nose" (that is, between the eyes at the very base of the snout). This bone gives them an appearance of wearing eyeglasses, or at least resembles the bridge between the lenses of a pair of reading glasses. They can also be recognized by the large, pointed scale over each eye, called a palpebrum.

The common caiman, *Caiman crocodilus,* has an expansive range throughout most of the tropical and subtropical regions of South America and Central America, and it even extends into North America as far as extreme southern Mexico. They are small- to medium-sized crocodilians, but males may grow to over 9 feet (3 m) in rare instances. Females are small and usually don't exceed 5 feet (1.5 m) from head to tail.

Common caimans inhabit a wide variety of habitat types, consuming prey from many animal groups. They prefer open areas with still waters, such as flooded grasslands, but are found in most wetland habitats within their range. They are harvested in many parts of their range, primarily for their hides, but sometimes for local consumption as meat.

Several subspecies of common caimans are recognized. The most widespread, simply referred to as the common caiman, is *Caiman crocodilus crocodilus*. It is found throughout northern South America, east of the Andes Mountains. Its range includes the basins of the northern Amazon and the Orinoco Rivers. A second subspecies of particular interest is the brown caiman, *Caiman crocodilus fuscus*, so named because it has more of a brownish hue than its more melanistic relatives. This is the subspecies of caiman found in pet stores, with most of the market originating from Colombia. Brown caimans entered the pet trade more broadly in the 1950s when trade in American alligators as pets

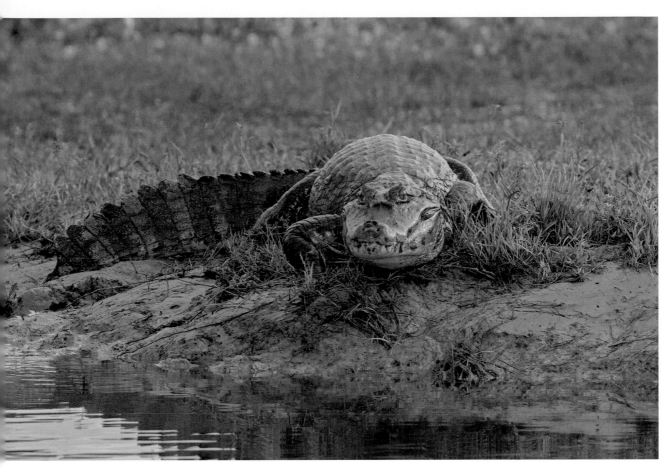

Yacare caiman, *Caiman yacare*, on a bank in the Pantanal of southern Brazil. Flank hides of this species represent about two-thirds of all international sales in crocodilian hides each year.

became illegal. Released pets have resulted in invasive populations of brown caimans becoming well established in several countries, including a small breeding population in southern Florida. They have become widespread in many locations in Puerto Rico.

Another named subspecies, *Caiman crocodilus chiapasius*, really doesn't have a common name but could be called the Chiapas caiman in reference to the Mexican state from which it was first described. This caiman is found along the Pacific lowlands of Oaxaca and Chiapas, Mexico, to El Salvador. One last subspecies, the Apaporis River caiman, *Caiman crocodilus apaporiensis*, was described from the upper Apaporis River in Colombia. This caiman is quite distinct as its snout is much narrower than that of any other living caiman. The Apaporis River caiman had not been seen in the wild for almost fifty years until an expedition found some in early 2019.

The two other species of the genus *Caiman* that are currently recognized are the yacare caiman, *Caiman yacare*, and the broad-snouted caiman, *Caiman latirostris*.

Size Matters

The living crocodilian species can be thought of as coming in small, medium, large, and extra-large sizes. At the small end is the dwarf caiman, which reaches 4–5 feet (1.2–1.5 m) as an adult. Chinese alligator males rarely reach lengths of greater than 6 feet (1.8 m), but they are stocky and might be thought of as sitting on the border of small to medium. The American alligator fits into the large category, with the largest adult male specimens alive today reaching above 14 feet (4.25 m) from snout to tail tip. Saltwater crocodiles fall into the extra-large category. They grow rapidly to about 14 feet, then begin to slow down. The largest males alive today reach lengths of 19–21 feet (5.8–6.4 m). Some fossil crocodilians far exceeded the sizes of any living members of the Crocodylia order we have today. These XXL crocodilians reached 41 feet (12.5 m), the length of an average house.

FACING PAGE Living crocodilians come in a diversity of sizes. The Chinese alligator (*top*) typically does not exceed 6 feet (1.8 m) in length, whereas male American alligators (*middle*) can still be found topping 14 feet (4.25 m) in total length. The saltwater crocodile (*bottom*) grows to truly impressive dimensions. Living specimens of greater than 20 feet (6 m) are still occasionally captured.

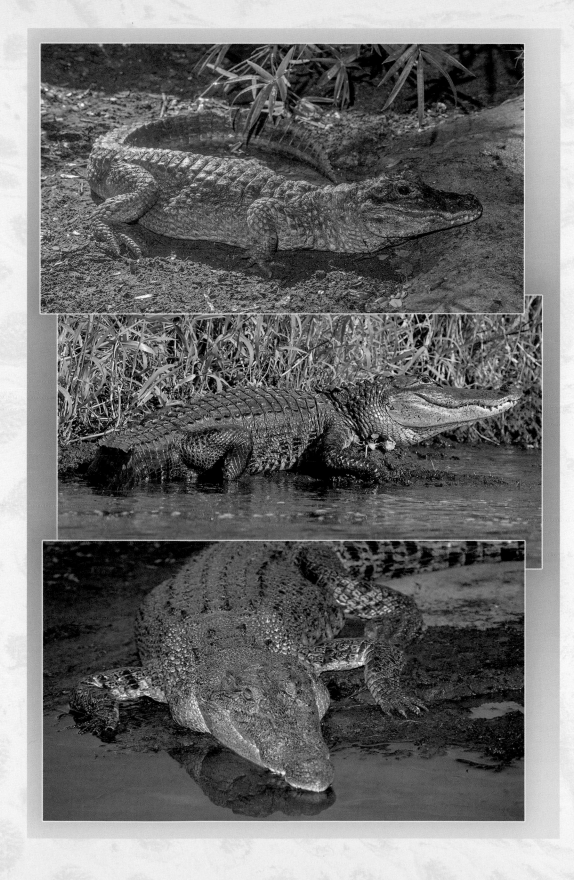

The yacare caiman was originally described as a subspecies. It is distinguished by the presence of dark blotches on the sides of the jaws, which are present throughout its life. The yacare ranges through the southern Amazon River and the Paraguay-Paraná River drainages of northern Argentina, Bolivia, Paraguay, and southern Brazil. Astonishingly, about one million yacare are harvested each year for their hides, which represents almost two-thirds of the entire international trade in crocodilian hides. The belly scales of caimans have bony "buttons" in them, making them poor for fine leather, so hide is taken from the throat, across the side of the neck, over the shoulder, the entire sides of the body (the flanks), over the hind legs, the side of the base of the tail, and underneath the tail around the vent. When the butchery is completed, the result is two "flanks" that are connected as one piece. These flanks can be used to make belts if the caiman was large enough, but the majority of flanks are turned into smaller items such as watch straps, wallets, and accents for fashion items.

The broad-snouted caiman, *Caiman latirostris*, as its name implies, has the shortest, bluntest head shape of any living crocodilian. The snout shape is thought to be an adaptation for crushing hard prey. The species is something of a dietary specialist, feeding heavily on hard prey, like apple snails. Larger individuals are known to crush and consume turtles, for which the broad snout is well adapted. Snails are commonly the intermediate host for parasitic flukes, which then infest mammals as the ultimate host species. It has been suggested that fluke parasite loads in cattle have increased in areas where broad-snouted caiman populations have been reduced because of increased densities of aquatic snails.

The genus *Melanosuchus* has only one recognized species of caiman: *Melanosuchus niger*, the black caiman. The black caiman is quite a large species, larger even than the American alligator. Males can reach lengths in excess of 19.6 feet (6 m) and weigh up to 1,650 pounds (750 kg). They are unusual among crocodilians in that they retain much of their bold juvenile coloration throughout life. The dorsal surfaces are a true black color, but the dorsal skin on the neck just behind the head is tan or copper colored. The ventral surfaces are pure white, forming a sharp contrast with the black coloration on the flanks. The head is large and deep, with heavy bony ridges extending from just in front of the eye, down the snout to the base of the largest teeth in the upper jaw. Black caimans have large eyes; in fact, they are the largest eyes relative to head or body size of any living crocodilian.

Black caimans inhabit the Amazon basin, preferring slow-moving rivers and flooded forests, as well as wet savannahs, oxbows, and other lakes. They are usually found in softer environments where rocks are lacking. The species typically basks on floating mats of vegetation, rather than on the shoreline like many other crocodilians. Larger black caimans consume fairly big mammals, such as capybaras, tapirs, and, occasionally, livestock.

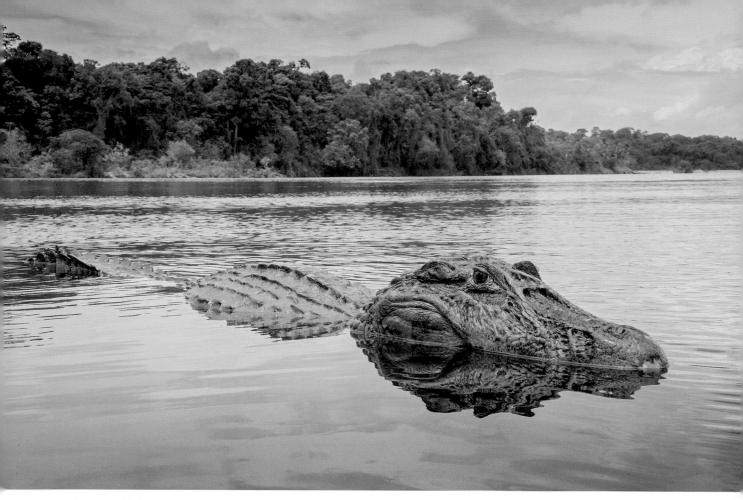

Black caiman, *Melanosuchus niger*, in the Essequibo River, Guyana. The black caiman is the largest of the living alligatorid species.

There are two species of caimans in the genus *Paleosuchus*: the dwarf caiman, *Paleosuchus palpebrosus*, and the smooth-fronted caiman, *Paleosuchus trigonatus*. The ranges of these two species overlap extensively. It is possible to find both species in reasonably close proximity to one another. Dwarf caiman inhabit the entire Amazon basin, plus the Orinoco River basin, the Guianas, and Paraguay. The range of the smooth-fronted caiman extends to the more southern portions of Brazil and Paraguay. They are generally small creatures, and the dwarf caiman is considered the smallest of all living crocodilians.

Dwarf and smooth-fronted caimans live in habitats with heavy canopy cover and little access to sunlight. They frequently dig burrows in the banks of streams, but also burrow on land as much as 328 feet (100 m) from water. Tolerance to cool temperatures may be a key adaptation of the *Paleosuchus* species, allowing them to occupy habitats unsuitable for any other crocodilians. Neither species shows much, if any, tendency to bask, and both species forage for invertebrates and small vertebrate prey on land at night.

Both *Paleosuchus* species are rugged little crocodilians with very heavy and

bony osteoderms in the enlarged scales on both their backs and bellies. The belly scales overlap to form a complete bony shield.

Recent genetic studies of both *Paleosuchus palpebrosus* and *Paleosuchus trigonatus* from throughout their ranges suggest that each consists of two or three distinct lineages, perhaps subspecies or yet other cryptic species.

Crocodiles

The family Crocodylidae is often referred to as the true crocodiles. It includes well-known species like the Nile and saltwater crocodiles, plus lesser-known species such as the slender-snouted crocodiles of the genus *Mecistops*. Crocodiles are a diverse family that includes some recently added cryptic species, which are similar in appearance to other species. It took genetic testing to demonstrate that they should be split into more than one species. This work is ongoing, so more species may be identified in the near future. As of the time of writing, there are at least sixteen species in the crocodile family, with three species having been added in recent years.

The American crocodile (*Crocodylus acutus*) extends into South Florida, making it the only crocodilian that naturally overlaps with the American alligator. The American crocodile's very widespread distribution is associated with coastlines and coastal rivers. The range extends to the Caribbean, Mexico, and south through Central America into South America. A brackish water species, it is often found in coastal mangrove forests and shallow bays and estuaries. It can venture hundreds of miles up coastal rivers and live in lakes and impoundments.

The American crocodile is a large species, with males typically reaching 13–16.5 feet (4–5 m) in total length. It typically has a light gray-green color to its skin with light colored eyes. The snout is fairly narrow. In adults, there is a noticeable raised swelling or bump on the snout just in front of the eyes.

Is the American crocodile a single species? There is much debate on this question. To make matters more confusing, the American crocodile regularly hybridizes in nature with at least two other New World crocodile species: Cuban and Morelet's crocodiles. There is growing evidence from genetic studies that what we call the American crocodile may include a few, as yet unnamed, cryptic species. It may be a decade or more before we have more definitive information that could help us address this question.

One of the most closely related species to the American crocodile is the Orinoco crocodile, *Crocodylus intermedius*. Named after the Orinoco River of Venezuela and Colombia, it is often considered the largest crocodilian in the New World. Males grow to 16.5 feet (3.5–5 m) in length, but there are historical accounts of much larger specimens. Alexander von Humboldt's journal of his travels in South American (circa 1800) mentions what is likely an Orinoco crocodile that was 22 feet, 3 inches (6.78 m).

The Orinoco crocodile is, if one can use this descriptor, a beautiful crocodile. It's light creamy yellow above with gray or black bands across the back and tail. Its hide, particularly the underside, made it very desirable for the exotic leather trade. The result was catastrophic, as there are now only about 2,500 individuals remaining in the wild. Conservation programs that involve captive breeding and reintroduction are trying to divert extinction, but the species is still imperiled. Andrés Eloy Seijas, who has worked on the species for over twenty-five years in Venezuela, believes there is hope that Orinoco crocs can recover. Just as when heavy harvesting of American alligators was halted, we could also see a recovery of this critically endangered species.

The Cuban crocodile, *Crocodylus rhombifer*, once ranged from the Cayman Islands, through Cuba, and across virtually the entire Bahama chain. It is now restricted to a single very small area in Cuba, the Zapata Swamp on the Bay of Pigs in south-central Cuba. A reintroduced population in the Lanier Swamp on Isla de la Juventud on Cuba's southwest coast was just recently again exterminated by poachers. The Zapata Swamp is ecologically similar to the Florida Everglades, sharing the features of eroded lime rock substrate, scrubby vegetation, and saw grass.

American crocodile, *Crocodylus acutus*, from Panama.

Most Cuban crocodiles are medium-sized, with males being 6.5–8.2 feet (2–2.5 m) long, but occasionally reaching 10.5 feet (3.2 m). A powerful, robust crocodile, with somewhat short, strong legs and short toes, it is the most terrestrial crocodilian and certainly the most agile on land. It has a relatively short snout and long, stout teeth. Adults have bumps on the top of the skull somewhat behind the eyes that look like short horns.

Because there are no large mammal predators in Cuba, it seems like the Cuban crocodile has taken on this role. It leaves the water at night in order to hunt on land. Once on the hunt, it is capable of running, and it is notorious for its jumping abilities. They sometimes leap up and into bushes, striking wading birds. One of their favorite prey items is a large rodent, Desmarest's hutia, which can weigh over 18 pounds (8.5 kg).

Cuban crocodiles may become extinct in the wild within the next few decades. In an odd twist, their demise is tied to the expansion of American crocodiles, which have invaded their swamp habitats over the past fifty to sixty years and are hybridizing, or interbreeding, with the Cuban crocs. As a result, the Cuban crocodiles are essentially being genetically swamped. Today, less than four thousand more-or-less "pure" Cuban crocs remain.

The final New World species of true crocodile is the Morelet's crocodile, *Crocodylus moreletii*. It is another medium-sized crocodile, one that inhabits the freshwater wetlands of Central America, sometimes moving into brackish water. Its range includes both the Atlantic and Pacific coasts of southern Mexico, Belize, and Honduras. When young, they eat aquatic invertebrates, fish, and

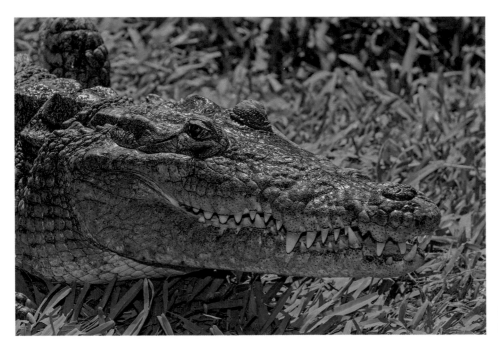

Morelet's crocodile,
Crocodylus moreletii.

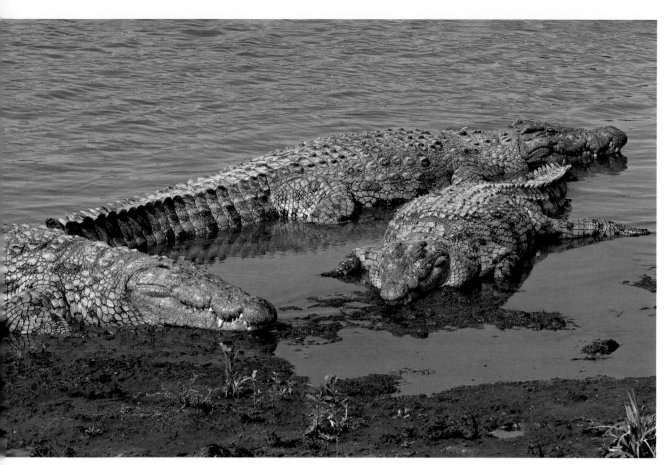

Trio of big Nile crocodiles, *Croco-dylus niloticus*, lying at the edge of the Mara River in Kenya. Their large size is sustained by the twice-yearly migration of wildebeest and plains zebras crossing the river.

other small vertebrates. As they grow, their diet shifts to include turtles and larger mammals. Morelet's have a dirty brown coloration and small, very dark eyes. Their heads are wide and flat with a slight swelling on their snout in front of their eyes.

Across the oceans lies the land of the African crocodiles, which were long thought to include only three species: the Nile, dwarf, and slender-snouted crocodiles. But our concepts of crocodile diversity have been upended by results of genetic studies of crocodile populations across the African continent, revealing previously unrecognized differences. Today, most crocodile scientists would agree that there are at least seven African crocodile species.

The Nile crocodile, *Crocodylus niloticus*, is iconic. From movies of ancient Egypt to wildlife documentaries, most of us have seen this species sliding off banks as canoes cross rivers. Or we have watched them on the hunt, snapping at zebras and wildebeests during migrations that cross the waters where they live. Averaging 13–16.5 feet (4–5 m), some of the largest known individuals reach 19.5 feet (6 m). The Nile crocodile ranks as one of the most dangerous to humans. They probably kill 150–250 people a year, though the number is hard

to pin down. It is not unreasonable to suggest that they may kill as many as 500 people in any given year. In terms of human fatalities, it is a contender for the most dangerous vertebrate in Africa.

Nile crocodiles utilize a wide variety of habitats, including lakes, rivers, swamps, and brackish wetlands along the coast. They dig extensive dens into riverbanks to use during periods of drought. For their nest, they dig a simple hole into the ground and drop the eggs into it.

Portions of Central and West Africa that were once thought to be populated by Nile crocodiles are now understood to be the realm of the West African crocodile, *Crocodylus suchus*. From the outside it looks very much like a Nile crocodile, but it differs in terms of both DNA and number of chromosomes. Researchers Evon Hekkala and Matt Shirley found that Nile crocodiles have thirty-two chromosomes, whereas West African crocodiles have thirty-four.

The debate is a fairly old one. *Crocodylus suchus* was first described in 1807 from crocodile mummies found in Egyptian temples. French naturalist Étienne Geoffroy Saint-Hilaire named the species after noting differences in skull shape and other characteristics suggesting it was not the same as the Nile crocodile. But his findings were dismissed, and our "newly restored species" spent two centuries being called a Nile crocodile.

Nile crocodile, the quintessential crocodile, with its massive head, heavy teeth, and large, keeled scutes arranged in regular rows down its back.

Best Nest

There are two basic ways that crocodilians construct nests. One method is to create mounds. To create a mound, a female scrapes together a large pile of plants, debris, and soil. She uses her hind limbs and feet to excavate an egg chamber in the center of the mound. Once the eggs are laid, she covers the chamber. Even an experienced biologist finds it virtually impossible to tell where in the mound her covered eggs lie.

A few species of crocodilians construct nests in an entirely different

Scenic view of the Mara River in Kenya, Africa. The sandy patch of bank to the left is a known nesting area for Nile crocodiles.

manner. These are the hole nesters, and their nests are typically dug in loose sand. Hole nesters also use their hind limbs to scoop out an egg chamber. Females of some species wallow out a body pit before digging the chamber, which causes the eggs to be buried deeper. Once the eggs are laid, they cover the chamber and body pit and smooth over the entire area.

All alligators and caimans are mound nesters, as are most other crocodiles. For the most part, hole nesting species inhabit riverine areas with profound wet and dry seasons. For example, the Australian freshwater crocodile experiences an annual cycle that alternates between almost daily rainfall and a dry season of virtually no rainfall for several months. During the height of the wet season, rivers are wide, deep, and freely flowing. Once the dry season commences, water levels decrease, eventually resulting in dry riverbeds with scattered stagnant pools of water. The eggs are laid during the dry season but hatching coincides with the start of the next rainy season. Hatchlings take advantage of newly flooded areas in search of insects and small fish that flourish in the new wet season.

Mound nesters time their nesting activities differently than hole nesters. Typically, mound nesters build their nests and lay their eggs at the end of a dry season, or very early in a wet season. Eggs incubate as water levels rise with increasing rainfall. Hatchlings emerge at a time when wetlands are filled and shallow, providing an abundance of small invertebrate prey.

On the face of things, there are differences one can spot. The West African croc is a rougher-looking, drabber crocodile than the Nile. I would describe it as olive or brown in color, with dark crossed bands on its back and a distinctive dark band running over the shoulder and down onto the flank. The head is generally broader and flatter than its Nile neighbor, more rugose, or bumpy, and the snout is less pointed than that of the Nile. West African crocs are also generally smaller than Niles. That said, they are not small. West African crocodiles can reach lengths of 10–13 feet (3–4 m). They range across sub-Saharan Africa, from southern Mauritania and southwestern Mali, to Cameroon and southern Chad, down through northern Democratic Republic of Congo, and east into Ethiopia. Their range overlaps with that of the Nile crocodile from southern Sudan east into Ethiopia.

Crocodylus suchus tends to prefer ponds and wetlands in open savannah habitats, whereas Nile crocodiles favor larger seasonal rivers. Interestingly, relict (remnant) populations of West African crocodiles can be found in the Sahara in Mauritania. These are small populations that were left isolated around eight thousand years ago as the Sahara expanded and most wetlands disappeared. These desert crocodiles tend to be quite small, reaching no more than 7 feet (2.1 m). They have adapted to desert conditions, shutting down their metabolism and living in caves and burrows through the dry season. Showing similar abilities to adapt, there are also relict desert populations of small Nile crocodiles in Chad and Algeria.

West African crocodiles have a milder disposition than Nile crocs, and although a few attacks and deaths have been attributed to them, they are generally non-aggressive. In countries such as Burkina Faso and Ghana, West African crocodiles are considered sacred. They can be found in village ponds where they are fed by the people who live nearby.

The ancient Egyptians encountered both the Nile and West African crocodiles, as both species historically occupied the Nile River in Lower Egypt. Herodotus wrote that Egyptian priests knew the difference between the two crocodiles and selected *Crocodylus suchus* as a sacred icon. This choice was probably based on its more benign temperament. Samples of DNA taken from crocodile mummies have all been shown to be *Crocodylus suchus,* rather than Nile crocodiles. It looks like Geoffroy Saint-Hilaire was right all along.

Slender-snouted crocodiles, now classified in the genus *Mecistops*, were included in the genus *Crocodylus* for almost two centuries. The genus *Mecistops* was thought to consist of only a single species, but genetic analyses within the past decade indicate that this crocodile is actually two similar species.

One species is now named the West African slender-snouted crocodile: *Mecistops cataphractus.* It is a highly aquatic crocodile that lives mostly in heavily forested rivers and streams. Until quite recently, we probably knew less about this crocodile than any other living crocodilian species. It is a slender

species with a smooth, elongate, narrow snout. This crocodile's diet is made up chiefly of aquatic invertebrates, crabs, fish, frogs, and snakes. Like the Cuban crocodile, it has two raised horns behind the eyes. The scales that cover the legs are very thick and keeled.

The second species, the Central African slender-snouted crocodile, *Mecistops leptorhynchus*, was only formally described and given its scientific, or Latin, name in 2018 by Matt Shirley and me, along with some of our colleagues. The Central African slender-snouted crocodile is very similar in appearance to *Mecistops cataphractus*, but it lacks dark blotches on the side of the face, is absent of small horns, and has thinner, unkeeled scales on its legs.

The genus *Osteolaemus* contains very small dwarf crocodiles that live in the equatorial lowland rainforests of Central and West Africa. The average adult length is only 3.3–5 feet (1–1.5 m). These crocodiles are ecologically and physically quite similar to the dwarf caiman of South America. Like dwarf caiman, they are very dark crocodiles that live mostly under heavily vegetated canopies in dense swamps, forest streams, and flooded forests. Some populations live in caves. Previously, the genus *Osteolaemus* was thought to contain a sole species with two subspecies. However, recent genetic analyses of wild dwarf crocodiles revealed there are actually three separate species. The first is the African dwarf crocodile, *Osteolaemus tetraspis*, from the Ogooué River basin of West Africa. The second is the Congo dwarf crocodile, *Osteolaemus osborni,* which rivals the dwarf caiman as possibly the smallest crocodilian. Adults attain lengths that may not exceed 4.6 feet (1.4 m). Dwarf crocodiles extend through sub-Saharan West Africa to Gambia and Senegal. Morphologically very similar to the African dwarf crocodile, the West African dwarf crocodile represents a separate closely related species, as yet unnamed.

At least six species of crocodiles live in the region that contains Australia, Southeast Asia, and South Asia. The most famous, sometimes infamous, of these is the saltwater crocodile, *Crocodylus porosus*. It probably kills more people in any given year than any other species of crocodile. In turn, they are hunted by humans. Saltwater crocodiles have the most valuable hides of all crocodilians. Their size is one reason, but more importantly, they have little to no bony inclusions in the flanks and belly. The flank scales that are present are small and aligned in regular patterns, making the hides ideal for high-quality leather goods.

Commonly called "salties" in Australia, this species has both the widest distribution of any species of crocodilian and almost certainly contains the largest living crocodilians. It is generally accepted among crocodile biologists that the record length is 23 feet (7 m).

Saltwater crocodiles typically inhabit brackish water habitats—tidal rivers, mangrove swamps, bays, and lagoons—although they may be found hundreds of miles up freshwater rivers. They will sometimes venture into fully marine

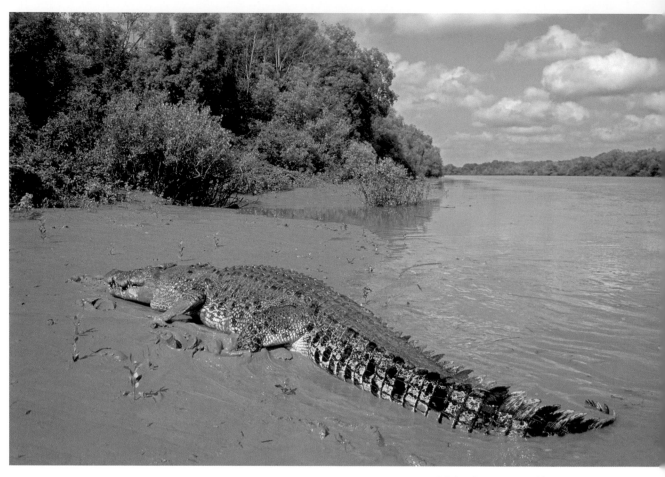

Adult saltwater crocodile, *Crocodylus porosus*, basking on a mud bank in Kakadu National Park, Northern Australia.

environments and are frequently observed far from shore by ships at sea. Their ocean-going abilities are confirmed by their presence on isolated, distant islands in the Pacific. Individuals have even made it to the Fiji Islands, which are at least 683 miles (1,100 km) from the nearest known breeding population in the Solomon Islands. In 1971, a 12.5-foot (3.8 m) male was caught on Ponape in the Eastern Caroline Islands. This capture astonished biologists, as the nearest known breeding population is in the Bismarck Archipelago, which lies 845 miles (1,360 km) south of Ponape. Our best evidence suggests that crocodiles use tides and ocean currents to assist them during these long-distance trips.

Their ability to cross the open ocean spread saltwater crocodiles all the way along the South China Sea west to Sri Lanka and the east coast of India. Of course, one, or even a few, immigrants are not enough to establish a new population. But over time there must have been sufficient flow of males and females to establish ranges across much of coastal Australasia.

In contrast to the broad distribution of salties, wild populations of Siamese crocodiles, *Crocodylus siamensis*, are restricted to several Southeast Asian

countries. In the wild, the species is critically endangered. A medium-sized freshwater croc, the Siamese crocodile lives in swamps, marshes, and slow-moving rivers and streams. It was once widespread throughout its range, but now exists only as small, fragmentary populations in remote areas. The largest single population of this crocodile may be that of a recently discovered stronghold in the Mesangat wetlands of East Kalimantan, on Borneo. But there is some speculation this population may actually represent a unique species that strongly resembles Siamese crocodiles.

All told, perhaps five thousand Siamese crocodiles remain in the wild, mostly in Cambodia. Despite its endangered status, tens of thousands of these crocodiles are farmed in Southeast Asia for their hides and to satisfy an ever-growing demand for crocodile meat in China.

Another South Asia crocodile, but one with an unusual name, is the mugger, *Crocodylus palustris*. The name "mugger" seems to be taken from the Hindi word *magar*, which means "river monster." This predator is known for snatching prey quickly, sometimes by the face. Research led by Vladimir Dinets has shown that this species shares a fascinating behavior with American alligators: it will collect sticks on its head in order to lure nest-building birds to their doom.

Muggers are medium to large, stout-bodied crocs that are generally slow-moving. They live in seasonally dry wetlands and dig very deep burrows. During droughts, they bury themselves deep in the mud, take shelter in a burrow, or walk cross-country to find water. With the broadest head of any living crocodile, adult muggers are of average length, stretching to 6.5–10.5 feet (2–3.25 m). They live in still or slow-moving waters where they eat a wide range of prey items, including insects, crustaceans, and small fish when young, and fish, reptiles, birds, and mammals when larger. Large individuals occasionally prey on monkeys, deer, and buffalo. Muggers do attack people and are considered the third most dangerous crocodile.

The Indo-Pacific area is home to another medium-sized species, the Australian freshwater crocodile, *Crocodylus johnstoni*. Unlike muggers, this species has a very narrow snout. Its range runs across the tropical northern portions of Australia. These so-called freshies are 6–8.85 feet (1.8–2.7 m) long as adults. They live in rivers and streams, lakes, and billabongs (pools of water that remain when rivers run seasonally dry). Their range overlaps, in part, with that of the saltwater crocodile, but whenever salties move upriver, freshies face the choice of clearing out or being killed.

Australian freshwater crocs feed largely on aquatic invertebrates and fish, but larger individuals will eat mammals and birds. Their willingness to eat an invasive species is leading to the demise of many freshies. Cane toads are massive toads that can reach well over 2 pounds (1 kg). They were introduced around the world as sugar plantations spread in the mid-twentieth century. The toads eat a beetle that is harmful to sugar cane.

These toads make for a tempting treat, but they are toxic when swallowed. As they spread, they kill freshies. In Northern Australia they have killed more than 75 percent of the crocs in some areas. In a complicated twist, water monitor lizards, a significant nest predator for freshwater crocodiles, have been even more adversely affected by the toads. As a result, egg predation in the nests of freshies has been reduced and the number of young freshwater crocodiles has increased by as much as 400 percent. What the end result will be is still up in the air.

The next true crocodile was never broadly distributed. Restricted to the island after which it was named, the medium-sized New Guinea crocodile, *Crocodylus novaeguineae*, is a freshwater species that inhabits lowland rivers and their associated marshes and swamps. In these same rivers, one can find salties, so New Guinea crocs tend to favor the protection of very dense, plant-choked marshes bordering the rivers. They build mound nests there on floating mats of vegetation. Unfortunately, the weight of a nest is substantial enough that some sink, drowning the developing eggs.

A central mountain range separates New Guinea crocs into northern and southern populations, and the differences run deeper than location. Northern New Guinea crocodiles nest during the dry season and lay about thirty-five eggs. Southern populations nest in the wet season and lay clutches of about

Saltwater crocodile gapes while it basks in Kakadu National Park, Northern Australia.

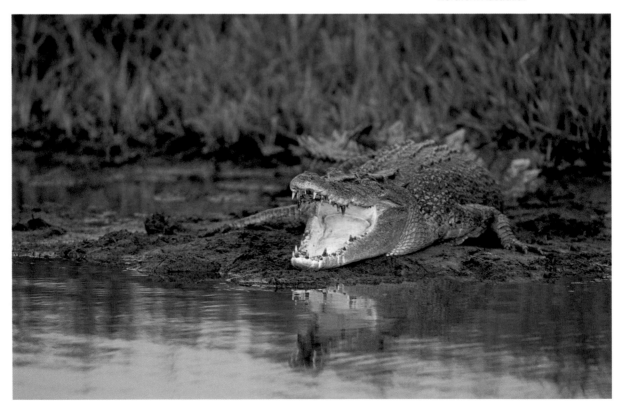

twenty-two eggs. There are also genetic divergences between the two populations, but so far, they have not been formally recognized as two separate subspecies or species.

The Philippine crocodile, *Crocodylus mindorensis*, was once distributed throughout the islands. Today it is found in a few scattered, fragmentary populations. This small- to medium-sized croc is critically endangered, living on only four Philippine islands: Luzon, Mindanao, Negros, and Mindoro. At one time, the species probably lived in wetlands, marshes, shallow ponds, and small creeks. Now they can be found in freshwater swamps, though a population in northern Luzon lives in fast-flowing mountain rivers at elevations up to 2,800 feet (850 m).

Philippine crocodiles have short, stocky legs and tails. They are adept at climbing, jumping, and high walking (walking with the body off the ground). These types of movements are indicative of a species with strong terrestrial tendencies, somewhat like the Cuban crocodile. Philippine crocs are highly aggressive toward each other, even when small. At two years of age, they will establish their own territories through aggressive encounters. Males change color upon reaching maturity, assuming a drab gray-blue coloration. Numbers in the wild are not known but may be less than two hundred.

Other species of crocodilians not formally recognized at present are suspected to exist. Some of these may be described in just the next few years, so this list will quickly become out of date. I'll mention one last possible species of true crocodile, whose very existence has been debated and doubted for much of the time since it was originally described as a subspecies of the saltwater crocodile in 1844. It has no agreed-upon common name, but I'll refer to it as the Bornean freshwater crocodile, *Crocodylus raninus*. This crocodile is a conundrum. Whether it is a distinct species is debatable, and I must admit the general consensus among croc biologists is against it. Although I can't really endorse one position over another, I think there is enough evidence to warrant its mention here as possibly another crocodile species. It shares some similarity in form with the saltwater crocodile. However, there are differences, such as the presence of enlarged post-occipital scales across the top of the neck. Salties lack these scales, and in fact are the only crocodile that doesn't possess them. Saltwater crocodiles also have raised bony ridges running in parallel down the snout from the corner of the eye to at least the level of the enlarged ninth tooth of the upper jaw. The Bornean freshwater crocodile does have these ridges as well, but they are not parallel, instead angling in about thirty degrees toward the midline of the snout. There are other differences in skull structure, as well, and there is the issue of its being a freshwater marsh-dwelling crocodile from the interior of Borneo. Unfortunately, it may be too late to make further comparisons of living specimens. Attempts over the past two decades to locate the Bornean croc have been in vain. It may well be extinct.

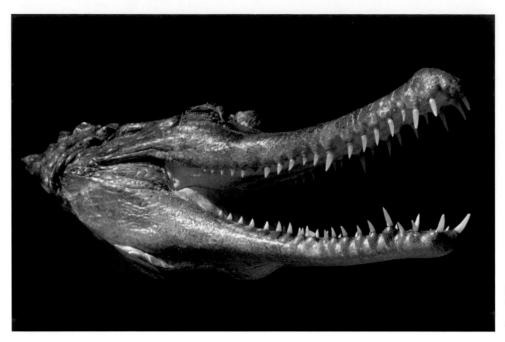

Sunda gharial, or Tomistoma, *Tomistoma schlegelii*.

Gharials

The family Gavialidae has just two living species, each of which is in its own genus. In fact, for many years biologists believed that there was only one living species, the Indian gharial, *Gavialis gangeticus*. We now know that the Sunda gharial, *Tomistoma schlegelii*, once thought to be a member of the true croco-diles, is in fact a member of the Gavialidae.

The bulk of the morphological evidence—comparative anatomy, embryology, and paleontological findings—all supported the notion that *Tomistoma* was just a very slender-snouted crocodile, not at all closely related to the Indian gharial. However, every genetic analysis conducted to date indicates a close evolution-ary relationship between *Tomistoma* and *Gavialis*—in direct opposition to vir-tually all of the anatomical evidence. The lines of evidence are so diametrically opposed that this has literally become a textbook case of the collision between morphological and genetic lines of inquiry. This debate is certainly not over, though I do believe it is winding down. For me, the dozens of genetic studies are so compelling that I am confident listing *Tomistoma* and *Gavialis* as the two genera of the family Gavialidae.

The Indian gharial is a crocodilian unlike any other. It is an amazingly elon-gate animal—long tail, long body, long neck, and a remarkably long, slender snout. The snout is really a bill filled with slender, sharp teeth. The bill is so narrow that the bones of the lower jaw are fused for essentially the entire length of the jaw. Its tongue is a small, triangular structure placed well to the back of

Head Games

At first glance, most crocodilians look pretty similar to one another. They differ in size, color, habitat, and temperament, but they are easily recognizable as "some kind of croc." The best way to tell them apart is probably the heads or, more specifically, the snout.

Heads are the business end of crocodilians, the tool they use to catch their prey. Their snouts run the gamut from tubular to stout and from short to long. Broader, heavier snouts are better-suited for generalist diets and for hard prey such as turtles, snails, and crabs. More slender, elongate snouts provide some advantages for catching fish and other quick, light aquatic prey.

The head's size and shape, and the lower jaw structure, are often part of what specialists use to identify crocodilian species. But biologists often look "under the hood" at the bones of the mandibles. These bones fuse together at the front of the lower jaw, creating what is called the mandibular symphysis. In the majority of crocodilians, the symphysis extends back to the level of the fourth or fifth tooth. In more narrow-snouted species, the length of the symphysis increases. For the moderately narrow snouted Orinoco crocodile, the symphysis reaches the sixth or seventh tooth. In the narrow snouted Sunda gharial, it extends to the fourteenth or fifteenth tooth. In the most extreme example, the tubular snouted Indian gharial, the mandibular symphysis encompasses virtually the entire lower jaw, back to the twenty-third or twenty-fourth tooth.

Skull of an Indian gharial with jaws agape. The mandibular symphysis, the portion of the lower jaw in which the bony elements of the jaws are fused along the midline, is longer in this species than in any other living crocodilian.

the mouth. The eyes are round periscopes mounted high on the square head. The legs are short, with stubby toes, and the hind legs are flattened somewhat, almost like incipient flippers. Without doubt, the Indian gharial is the most aquatic of living crocodilians, feeding almost exclusively on fish.

Male Indian gharials can become incredibly long, reaching more than 20 feet (6.2 m). There are unconfirmed historical reports of even larger gharials. When they reach sexual maturity, males develop a large bulbous growth on the tip of the snout surrounding the nostrils. This is called a "ghara," a reference to an Indian water jug of the same name. The ghara is a visual signal that lets females know the male is available. The ghara may also have a role in vocal and acoustic signals produced by males.

Indian gharials are critically endangered. Historically, they inhabited the major steep-banked rivers of the Indian subcontinent. Today they are found only in small stretches of rivers in India and Nepal. Their greatest foothold is in the Chambal River of north-central India where there are perhaps 1,500 individuals. Gharial habitat in India and Nepal has been depleted by hydroelectric dam projects, and other projects that block the flow of rivers, and by sand mining along the riverbank. Gharials in habitats that remain still face the threats posed by fishing, as the nets trap and drown the crocodilians.

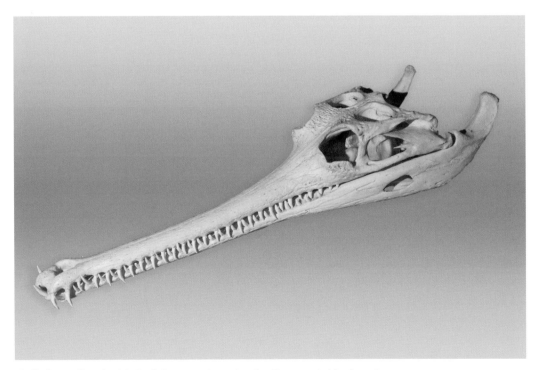

Skull of an Indian gharial, *Gavialis gangeticus*, showing the remarkably elongate, narrow snout of this species.

The threat posed by fishing nets also impacts the Sunda gharial. This secretive, solitary species once ranged throughout many lowlands of Southeast Asia, but today there are fewer than 2,500 individuals restricted to eastern Sumatra, Borneo, and certain areas of the Malay Peninsula. Like the Indian gharial, the Sunda gharial is a large, slender-snouted species. Males are known to grow to at least 19.5 feet (6 m), just shy of the record for their Indian relative. Females grow to an impressive 15 feet (4.5 m) or more, making them proportionally (compared to males of the same species) one of the largest female crocodilians.

Long needle-sharp teeth help Sunda gharials grasp the wide variety of prey that make up their diet, which is more diverse than the diet of Indian gharials. Older Sunda gharial males have a snout that becomes more robust with age. This change may help them consume larger prey such as monkeys, large birds, and livestock. There are two well-documented cases of predation on humans.

Sunda gharials are one of the few crocodilians that retain much of their juvenile coloration into adulthood. They can be absolutely beautiful animals with mottled patches of orange, tan, burnt umber, and black. Their secretive lives are confined to peat swamps and freshwater swamp forests, which can be dense, impenetrable wetlands. As a result, we know relatively little about their behavior. The biggest threats they now face are illegal logging, conversion of peat swamps to palm oil plantations, and other agricultural enterprises. Valiant conservation efforts are underway to protect and restore habitat, but the world's growing demand for food products is likely to threaten Sunda gharials for decades to come, if they survive that long.

Captive Crocs

Ironically, some of the most endangered crocodilians are abundant in captivity, a situation that is similar to wild versus captive tigers. Like tigers, captive crocodilians often take on a general appearance that is different from their wild counterparts. Captive crocs are typically much more rotund than wild members of each species. They are also shorter, a result of living in more confined spaces. Captives are, to put it bluntly, short and fat.

If kept at high densities, the keels of nuchal and dorsal scales are worn down because cage mates constantly crawl over each other. These same keels are high and sharp in wild crocodilians. The head shape of captive crocs takes on an altered appearance as well, something that is most obvious in broad-snouted forms. The snouts become significantly wider and flatter among captive individuals. We know that captive animals have maxillae (tooth-bearing bones forming the margins of the upper jaws) that rotate laterally, as well as nasal bones that are somewhat sunken relative to their wild position. The causes of these changes are not known with certainty, but the changes may be gravitational deformations of the bones of the skull due to the large amount of time captive specimens spend out of the water. Other explanations include nutritional deficiencies, or other dietary differences, or the high mineral content of the water in which captive specimens are housed (which might leach certain minerals from their bones).

Changes in head shape occur within a few years of bringing wild alligators into captive conditions. Teeth in captive specimens also change. They are often displaced or misaligned, perhaps in association with the deformation of the skull. These changes give many captive alligators a protruding fourth mandibular tooth, which makes them look somewhat similar to true crocodiles.

FACING PAGE Alligators in captivity often take on an appearance different from that of wild alligators. In addition to frequently becoming overweight (a negative effect of their highly efficient metabolisms and ample food provided in zoos), their heads often change in shape. The head becomes flatter and the snout often notably broader. The keels on scales along the back and tail are often somewhat flattened, most likely the result of enclosure mates crawling over one another.

Love Is in the Water

Many of us might imagine that alligator mating is a somewhat brutish act of male domination. Males do have a bit of a playboy reputation, that is to say, individual males might mate with multiple females in a single breeding season. But it turns out that males cannot get very far without female consent. She holds all the cards, as it's a pretty tricky process for him to successfully inseminate the apple of his eye. As is true of many aspects of the biology of these animals, much of what we know comes from a few studies, observations of captive animals, and a couple of lucky observations in the wild. But I'll try to paint the best picture I can of the rarely observed courtship behavior of alligators.

Courtship and mating always occur in the water and both are a pretty gentle type of affair. Alligator courtship can occur from about the second week of April until the end of May, depending on the location. I've seen pairs of alligators courting for as long as four-and-a-half hours in the afternoon, although most of the exchanges are much briefer. Courtship is a tactile affair. On the surface of the water, the courting pair touches and rubs, pushes and presses, on each other's head and neck.

They form an orientation that I can best describe as a face off. With their heads parallel to one another, one animal will turn and begin to touch, push, or rub along the side of the other's face. Usually this is "chinning" along the side of the face and moving on top of the head. After a bit of time, it becomes a little more vigorous. They start rising up and trying to push each other down. They seem to be sizing one another up, perhaps assessing strength and fitness by determining how hard the pressing is and how much resistance is being offered. Sometimes females will try to dunk males underwater and hold them down. Alligators are curious by nature, so when a pair begins courting, other alligators come over to see what's going on. They often become involved in

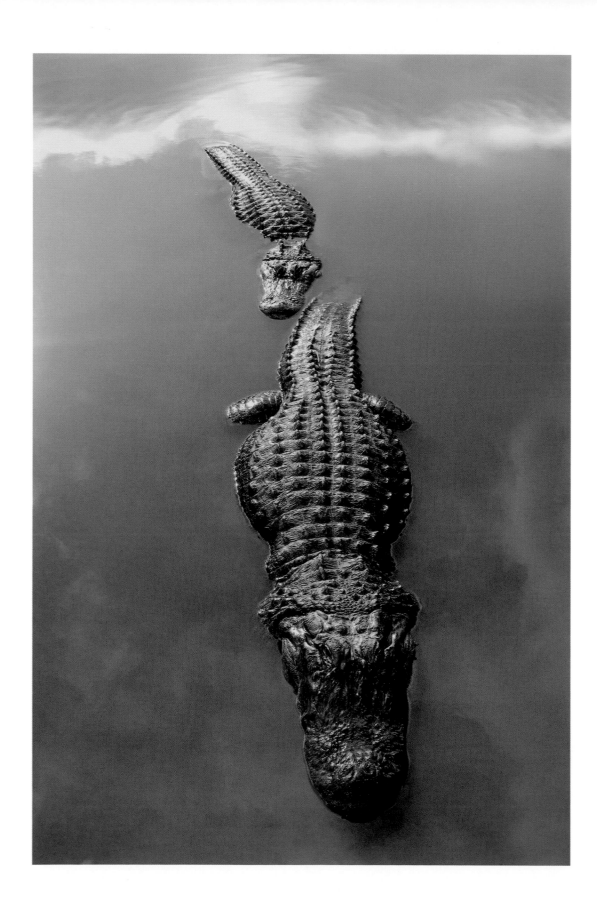

these exchanges, resulting in courting groups. Up to a dozen alligators, including multiple males and multiple females, may form these writhing balls of courtship.

Once the female decides a particular male is worthy, she allows him access to her cloaca, the vent under the base of the tail through which intromission occurs. Having won her approval, he tries to determine the best way to position his body so that he can insert his phallus into her cloaca. It isn't easy and, depending on the place and circumstances of their encounter (like water flow and size differences between male and female), he may have to improvise.

The male typically positions himself atop the female and clasps her with his forelimbs. His torso and tail trail off to one side of the female and he rotates his body so that his belly is somewhat turned toward her side. His head is either above hers, where he can continue the pressing behaviors of courtship, or it is pointed over her other shoulder. If he is draped off the left side of her body, his right hind leg and foot will usually remain on top of her pelvis, bracing or steadying his body position. He then begins sweeping motions with his tail, ultimately bringing his tail underneath hers. The female will often lift the base of her tail to help the male. He then brings his tail forward, bending his body until he is able to enter her cloaca with his phallus. His body is usually twisted

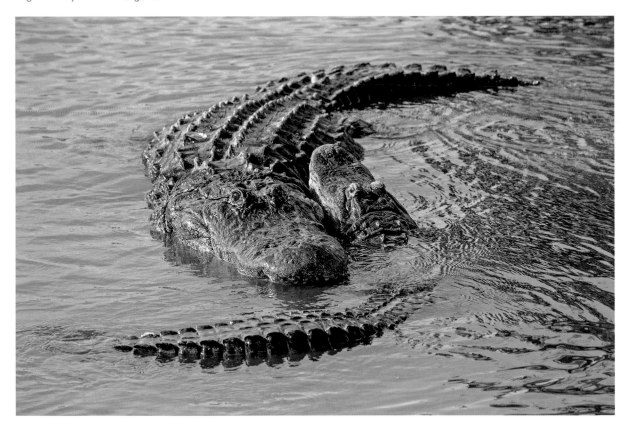

obliquely around that of the female in an extended C shape, with his head over her shoulder, his torso wrapped diagonally down the length of her body, and his tail underneath hers pointing off to the other side.

The male's phallus is a rigid structure of dense fibrous connective tissues. It is largely composed of collagen that surrounds an interior vascular space and is permanently erect. It is curved in shape and does not swell appreciably during copulation. It measures only about 4.3 inches (11 cm) in length for a large alligator (not taking the curved shape into account). When the shaft is everted (pushed out of his cloaca), it projects forward more or less parallel with the belly and is inserted into the female's cloaca. The male ejaculates with a rapid release of a substantial volume of fluid into the female's cloaca. Copulation lasts only two to four minutes, though it will be repeated multiple times.

If the male is much larger than the female, which is often the case, mating postures are adjusted so that the two cloacae line up sufficiently. In these cases, the male does not wrap his tail underneath that of the female. Rather, while still embracing her with his forelimbs, he rolls his body off to one side so that he is positioned on his side with the base of his tail alongside hers. The expanded head of the phallus, and the strong curve of the shaft, help secure the phallus in the female's cloaca. Occasionally you can see the phallus "hooked" into the side of the female's vent, pulling it slightly to one side.

After the Lovin'

Before and after she has finished mating, the female is preparing her eggs. In many ways, a female's reproductive anatomy is similar to that of a human female. She has a pair of ovaries and their associated reproductive tracts, the oviducts. Each ovary contains hundreds of ova, produced during early embryonic development of the gonad. Ova are contained within follicles in the ovaries, some of which grow and mature each year that the female is reproductively active. During ovulation, the follicles rupture and the ova and their associated yolk are released into the oviducts.

As sperm leave the male, they make their way through the uterine horns, through their openings in the lateral wall of the terminal chamber of the cloaca, and into the oviducts. It is likely that the sperm are swimming toward hormones released by the oviduct. Sperm must fertilize the ova before all of the other components of the egg are added, so they must ultimately work their way up most of the length of the reproductive tract. The exact site within the oviduct where fertilization takes place is not known, but it must be in the upper stretches of the oviduct.

The oviduct is divided into regions that are responsible for the addition of albumen, extrusion of membrane fibers, and formation of the shell. The first portion of the oviduct, which is close to the ovary, is lined with tiny beating

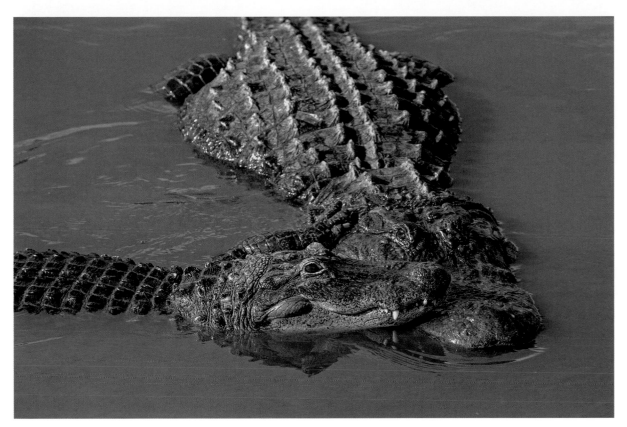

Tactile interactions become increasingly vigorous as courtship continues. Here, the female has pushed forward onto the male's snout and is chinning back and forth.

hair-like structures that create a weak current, drawing the released ova into the oviduct. The ova move down the oviduct, as components of the egg are added by each region, until the eggs are finished. Egg formation is like a factory assembly line with ova moving down each oviduct with new parts being added along the way. The length of time for this entire process of egg formation is not known.

The alligator oviduct is quite similar to that of birds in this regard, which further suggests their evolutionary relationship. One obvious difference between egg formation in alligators and birds is that birds produce a single egg at a time, whereas the alligator oviduct fabricates two to four dozen or more finished eggs all at once or over a short period of time.

'Tis the Season

Spring is a busy time in the yearly cycle of an alligator's life. After a long period of cold-induced quiescence, or inactivity, alligators become increasingly active. When day length increases, and air and water temperatures rise, winter's slumber begins to shake off. If the weather is cooperative, much of the day is spent basking, raising body temperatures to optimal levels. Alligators begin moving

about, feeding on their favorite prey and looking for mates. Blood tests would show that levels of reproductive hormones are rising in the spring months.

The size of male testes increases in late winter and very early spring. In southern populations, testicular development is evident in February. By March, the testes are clearly enlarging. Size reaches its maximum in late April and May. The right testis is larger than the left. The combined weight of the two testes of a mature, 9.8-foot (3 m), male can be as much as 10.6 ounces (300 g) during the peak time. By late June the party is over, and the testes shrink to their smallest size by August, remaining that way until the next year.

The size increase is due to the production of sperm cells. The testes are largely made up of dense bundles of tiny tubes called seminiferous tubules in which sperm cells are produced. In the spring, when they are active, the tubules swell to about twice their over-winter diameter. Nearby tissues surrounding the tubules receive increased blood flow and also enlarge.

Testosterone levels are also very low throughout the late fall and winter but increase in February. The levels rise to a peak in April and May, followed by a dramatic decrease in June after mating ceases. Interestingly, there is a secondary rise in testosterone in September. The cause or function of this secondary peak is not known. In other reptiles in which this secondary peak occurs, primordial sperm cells are produced at this time. But there is no evidence of sperm formation in the alligator testes during the fall.

Sex and Size

On August 22, 1921, E. A. McIlhenny marked an Avery Island, Louisiana, alligator hatchling that was still in the nest. He observed her building her first nest as a mature female on June 18, 1931. On June 23, she laid a clutch of thirty-four eggs. She was nine years and ten months old and 7 feet, 3 inches (2.2 m) in total length. She weighed 116.5 pounds (52.84 kg). Her eggs hatched sixty-seven days later, somewhat longer than the sixty-two to sixty-four days typical of Avery Island alligators.

McIlhenny's careful observations were among the first clues about age of sexual maturity for alligators. We now know that maturity is a matter of size, rather than age. The size of sexual maturity, essentially the initiation of puberty, is approximately 6 feet (1.8 m) for both males and females. About half of all alligators at this length show signs of sexual maturity—such as motile sperm in the testes of males or ovulation and nesting attempts in females. All alligators seem to achieve sexual maturity by the time they are 7 feet (2.1 m) in length. The smallest nesting alligator I have ever seen was a captive female that was 5 feet, 7.5 inches (1.7 m) long. She produced a small clutch of infertile eggs.

Courtship escalates into pressing behaviors, often resulting in the lower animal being dunked underwater. The strength with which an alligator presses, and how vigorously the partner resists these presses, may be important cues in determining if courtship will proceed to mating.

The onset of reproductive activity in alligators seems to be initiated by increasing temperatures in late winter and very early spring. Increasing day length at this time of year is thought to play a secondary role in the initiation and regulation of these physiological processes.

Even with the season at hand, not all female alligators will reproduce. Most studies find that about one out of every three or four females produces eggs in a given year, though these numbers vary among populations and years. It may take an average female three or four years to save up enough energy to produce a clutch of eggs. A large study on Marsh Island, Louisiana, found that 26 percent of 298 females laid eggs.

While some females may nest two or three years in a row, it would be very unusual for a wild female to nest every year over an extended period. No female nests more than once in a single year. The large amount of energy required to produce a clutch of eggs, and to supply each egg with an adequate amount of yolk to ensure the survival of the hatchling produced, is immense.

One Nest, Many Fathers

As a graduate student, I spent three springs watching courtship and mating at the St. Augustine Alligator Farm. I've seen thousands of courtship interactions and hundreds of mating attempts. Individual females were very often courted by several males in a breeding season. At the time, there was no way to know if more than one male had successfully fertilized the eggs of one of these females.

More recently, paternity tests have been performed on captive and wild alligators. In some nests, it is apparent that sperm from more than one male have contributed to fertilizing eggs within the clutch. Females that mate with more than one male during a season may have sperm from a previous mating within their oviducts. The first reported instance of multiple paternity in a crocodilian was a study of twenty-two clutches of American alligator eggs from the Rockefeller Refuge. Seven of the nests (32 percent) had multiple paternity, including one clutch for which three males had fathered eggs. Results from a later study of 114 clutches, also from Rockefeller Refuge alligators, indicated 51 percent of the clutches had more than one sire.

Many reptiles and birds are capable of storing sperm within the female reproductive tract. Sperm cells are stored in specialized sperm storage tubules, though the actual location of these tubules differs in different reptile groups. In turtles, for example, sperm are stored in the albumen-secreting glands closest to the ovaries, or within the uterus. Only a few years ago it was finally discovered that stored sperm cells were kept in two separate regions of the oviduct of American alligators. The sites are less discrete than those of other reptiles; the glands are shallower and more scattered, and the regions of the oviduct in

Older Parents

Old male alligators seem to remain reproductively viable without any obvious signs of decline. Females can lay eggs to an advanced age, but do show signs of reproductive senescence, or decline. Some large females appear to be barren and cease to nest. In South Carolina, the age of senescence of one female was estimated at sixty-six and a half years. Another female, estimated to be sixty-two years old, still produced viable eggs with a normal clutch size.

which sperm are stored are quite short. Uterine glands near the junction with the cloaca also contained stored sperm, as did other locations, though seemingly not through to the next year.

Oscar and Suzie

A locally famous male alligator named Oscar lived for many decades in the east side of the Okefenokee Swamp, near Waycross, Georgia. Alligators were few and scattered in 1945 when Oscar, a large alligator with distinguishing characteristics, first got his name. In those days, Oscar was the only adult male alligator in the area.

Although quite mild-mannered in general, Oscar did not tolerate other adult males in the area and drove them away. Oscar consorted with the several resident adult female alligators in his range each spring and his descendants fill the waters of that portion of the Okefenokee today.

From at least the early 1980s until the last few years, the largest, and most dominant, female in that area was Suzie, a one-eyed alligator that measured well over 9 feet (2.7 m). Her missing eye had been shot out by someone years before.

I was observing Suzie one fall day, recording her interactions with her newest pod of hatchlings, which were less than a month old. Oscar swam around the corner and approached Suzie. As he neared her, his swimming slowed and his body sank lower in the water. She turned away from her young on the bank and slowly swam toward him. As they came together, Oscar turned toward Suzie, ever so slowly, and touched her with the tip of his snout, below the ear, then below the eye, and then he slid his snout along the side of her snout and stopped. After seventeen seconds, she backed up just enough to swing her head to his other side. She then touched him on the side of his jaw and stopped with a touch below his eye. They remained in contact for twenty-five seconds longer. Oscar then turned away very slowly and languidly continued his swim up

Pressing behaviors ultimately result in mounting and mating. The male grasps the female with his forelimbs, while his torso is draped off to one side, as he attempts to bring the base of his tail next to hers to mate.

the waterway. Forty-five seconds later, Suzie turned back to her babies sunning on the bank.

This brief exchange was exactly like pre-mounting tactile courtship behaviors, but the encounter was in very late September, well outside of the courtship season. If this had been observed between a mated pair of birds, one might conclude these behaviors served to maintain the pair bond outside of the reproductive season. But this was between two alligators, and I know of no direct evidence of male and female crocodilians forming "pair bonds."

There have been other intriguing observations of behaviors among pairs of alligators that might hint at a deeper relationship. Alligator biologists often use baited snare traps to catch adult alligators. The animal catches itself in the snare at night and the biologist comes along the next morning to collect data before releasing the animal. If this occurs during the breeding season, and if the alligator in the trap is an adult female, an adult male is often nearby.

A dramatic series of photographs taken in the 1980s by a ranger at the Okefenokee National Wildlife Refuge headquarters shows two alligators that nested along a canal behind the visitor's center building. They appear to be an adult male and female, the apparent male much larger than the other. The pair remained together throughout the summer months as eggs incubated in the nest. The sequence of photos shows these two animals chasing an 8-foot (2.4 m) alligator early in the day as it swam up the narrow canal past the nest. Later that day, they attacked and killed the alligator as it returned down the canal. While this observation does not necessarily imply traditional pair bonding, it does at least suggest cooperation between the pair throughout one reproductive season.

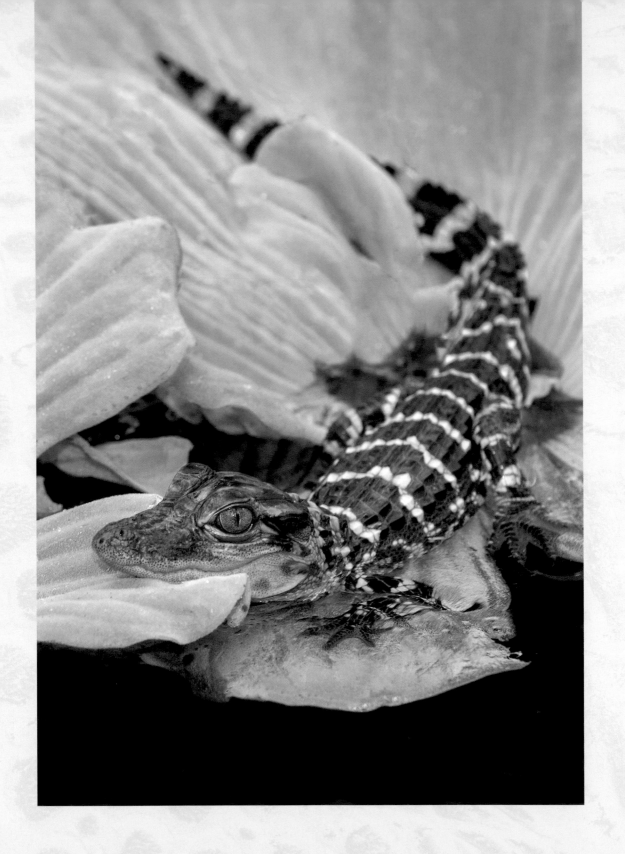

Small Beginnings

Life begins, for an alligator, inside a hard-shelled white egg that is somewhat larger than the typical chicken variety. The egg is more uniformly elliptical, rather than having a "fat" and "narrow" end seen with birds. The eggshell protects the developing alligator from water loss, but still allows some water to enter and respiratory gases to pass through the shell. Similar to the shells of bird eggs, the alligator eggshell offers protection from bacteria and other microbial invaders. The calcium carbonate crystals of the shell ultimately provide the calcium that allows for bone formation.

The eggshell itself is somewhat more brittle than that of a chicken egg. The calcium carbonate crystals are mixed with protein, and the crystals are stacked together sort of like bricks making up a wall. But the bricks are of different sizes and are pieced together this way and that; some are laid upright, whereas others are horizontal. In some parts of the wall, the bricks are laid tightly together, but elsewhere there are spaces between the bricks.

The outer layer of the shell is dense, and below it is a honeycomb layer where the crystals are not as tightly packed. Air spaces run throughout this layer, which then transitions to a very thin third layer that is mostly an organic matrix with very few crystals. A final "mammillary layer" is very narrow and more apparent in the central portion of the egg than toward the ends. The mammillary layer attaches the shell to the egg membranes. To allow the exchange of gases, the eggshell has a lot of pores. The pores are more common in the central portion of the shell, but a few are found toward the ends of the egg.

Just below the shell are an outer and inner membrane, closely pressed to one another but distinct and capable of being pulled apart. The membranes are much thicker and more leathery than those of a chicken egg. Beyond the membrane lies the "white" of the alligator egg. This is the albumen, and it is much denser than in a bird egg, feeling kind of like jelly. The albumen is a protein that

Clutch of alligator eggs revealed in the nest after the nesting material covering them has been removed.

holds large amounts of water. In fact, an alligator egg's albumen is about 96 percent water.

From its earliest beginnings, the little developing alligator floats in a complicated matrix of membranes and other structures, but it is protected from bumps and other traumas that might dislodge it from its moorings. Surrounded by amniotic fluid, similar to a human, the embryo is fundamentally living in an aquatic world that is, in some ways, not that far removed from a larval fish. Over time, our little alligator forms blood vessels and organs as it slowly takes on the look of a future predator.

On the other hand, some eggs won't produce the king or queen of the swamp. Certain eggs are infertile, in that they contain no embryos. It is possible to tell if an alligator egg contains a healthy, growing embryo just by looking at it. As the eggs are laid in the egg cavity of the nest, they are uniformly translucent white, whether they are fertile or not. Twenty-four hours after being laid, fertile eggs have a chalky white spot on the top-most part of the eggshell. Over the next few days, this spot will grow. By the fifth day, a thin band of this chalk spreads around the central "equator" of the egg. At the end of the first week, the band forms a complete opaque ring that fully encircles the middle of the egg. Over the next four weeks, this band will spread, slowly extending toward both ends of the egg, changing the egg surface from translucent to opaque as it progresses. Overall, about 90–95 percent of the eggs in an average nest are fertile.

The "eggshell banding" marks a change from a cluster of cells, lying on the surface of a relatively enormous sphere of yolk, to an embryo that has begun secreting a small pool of liquid between itself and the yolk surface. These secretions cause a minute shift in the center of gravity of the yolk mass, making the opposite pole of the yolk slightly heavier than the pole with the embryo. Gravity

The Mound-Shaped Nest

Two to three weeks after the end of courtship activities, female alligators turn their attention to the business of building their nests. Alligator females construct large nests—mounds of vegetation, soil, and other debris that they scrape together. The mounds are variable in size, depending on the size of the female and the types of plant materials used. Usually they are about 2–2.5 feet (60–75 cm) tall and 5–6 feet (1.5–1.8 m) across at the base. Some ambitious females will pile up mounds over 3 feet (91 cm) high and some nests may spread over 8 feet (2.4 m). The nest is essentially mound-shaped and is built anew each reproductive season. Nests may be built in open areas of a wetland or concealed under heavy vegetation, often pushed up against the trunk of a tree or large shrub. These shaded nests are very likely to yield cooler incubation temperatures than nests located in the full sun.

The nest of the alligator is a mound of vegetation, soil, and other debris that the female scrapes together and compacts. The eggs are buried deep within. A mound nest is essentially a compost pile and the heat released from the decaying vegetation helps to heat the eggs and speed the development of the embryos inside.

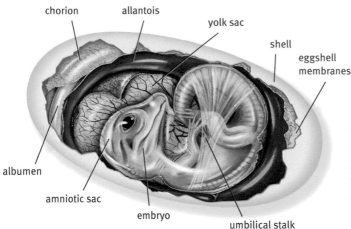

chorion allantois

yolk sac

shell

eggshell
membranes

albumen

amniotic sac

embryo

umbilical stalk

The egg is a self-contained world with everything the alligator needs in its journey through development. Albumen supplies water. Yolk is the food with which the embryo grows. Membranes surround the developing alligator and provide protection, gas exchange, and waste removal.

then causes the yolk mass to rotate, resulting in the embryo being at the top. When the egg is laid by the female, it tumbles into the nest and the initial orientation of the embryo in the egg is random. Then rotation of the yolk mass brings the embryo to the top, something that happens within the first hours after laying.

One membrane, the chorioallantoic membrane, will bind with the porous inner eggshell membrane. The displacement of the albumen causes the overlying eggshell to dry, resulting in the opaque appearance of the spot on the top of the shell. As the chorioallantoic membrane grows, first around the central band of the egg and then toward the ends, the process of albumen displacement and eggshell drying continues. Eggs that have failed never go through this process and continue to look translucent.

At some point after the spot has formed, an alligator embryo will likely die if the egg is rotated. In alligator farms, this problem is avoided by collecting eggs from nests within the first twenty-four hours of laying, before the embryo has irreversibly attached. It is still safe to rotate eggs at this stage. When taking eggs from older nests, the top is marked with a pencil. Each egg is then handled carefully and placed in an incubator with the mark up, just as it was in the nest. Much older eggs, around five or six weeks along, can be handled with less care, as the large embryos are well attached and will no longer rotate within the egg.

Other changes in the appearance of the eggshell have to do with the metabolic activities of the embryo. Blood vessels collect minerals from the eggshell membranes, which cause the membranes themselves to become chalky white. The minerals are used by the developing embryo for formation of bones and other tissues.

Alligator eggs have a lot of yolk. The little alligator starts as a single nucleus laying atop the huge round sphere of yolk. As the nucleus divides (to make two, four, eight, sixteen, thirty-two, and so forth, cells), it forms itself as a small

cluster—an island—floating on a sea of yolk. Initially, this cluster is a fairly flat circular disc of cells. These earliest cell divisions occur while the egg is still within the female's reproductive tract. Development then proceeds at a rapid pace following laying. Within the first few days, the early embryo has the beginnings of what will become the head. The developing body begins to lift off the flat surface of the yolk, and the beginnings of both the head and neck are present.

At two weeks a heart is visible, and a small amount of blood can be seen. The initial formation of the central nervous system is soon apparent as are the building blocks of the spine, skeleton, and muscles. But most of the final details are still a ways off, occurring in the last five weeks prior to hatching. About a month after the egg was laid, it is time to enter a period of rapid embryo growth.

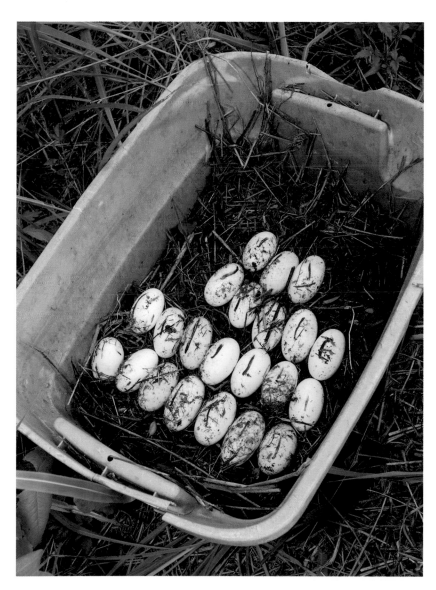

Alligator eggs being removed from a nest in Louisiana by a licensed alligator farmer. Each egg is marked on the top before removal from the nest and is placed in the transport bin so that it is not turned. Beyond the first twenty-four hours after laying, turning an egg can be detrimental to the embryo.

The last burst of growth is accompanied by a substantial decrease in the volume of yolk, as these nutrients are now needed. Both yolk and albumen are consumed quickly in this "second and last month" of the egg phase. Around one to two weeks before hatching, the alligator embryo stops growing. The baby alligator, finished with its development, enters a waiting period. It is waiting for its nest mates to begin to hatch or for its mother to return to help it escape from the nest.

The exact length of time from laying to hatching depends a lot on temperature, though humidity within the nest also has an impact. Cooler, drier nests tend to have the longest incubation times. Recorded lengths of incubation times in wild nests run from a little over sixty days to as long as eight-four days for cooler nests. Among all crocodilians, alligators have one of the shortest incubation periods, perhaps an adaptation to life in more temperate habitats where the warmest season is a short one.

By the end of incubation, the pores in the eggshell become quite large and form cone-shaped craters. These large, deep pores allow for substantial exchange of gas with the outside world. The actual process of pore-size expansion is the loss of the calcite crystals. These "bricks" are slowly pulled out of the wall, letting more air flow through.

A second effect of the brick removal is the weakening of the shell. This weakening is enhanced by bacteria, fungi, and other microorganisms that live on the shell surface. Some of these microscopic organisms produce organic acids which mix with metabolic wastes being excreted from the shell by alligator embryos. Even carbon dioxide being "exhaled" by the embryo can mix with the high humidity in the nest to form a weak carbonic acid. Added together, the shell has become an easier wall for the little alligator to break through when the big moment comes.

Have a Cigar, It's a . . .

One of the strangest realities of nature is the somewhat random process by which males and females are created. In our case, this fundamental aspect of our existence is the result of which of the millions of sperm is the first to penetrate the egg membrane, and whether that particular sperm carries an X or a Y chromosome. For alligators, the sex of the newly hatched animal is not determined at fertilization; it occurs later and has nothing to do with chromosomes. The sex of every hatchling is the result of the temperature at which the egg incubated. At cooler temperatures, females are produced. Warm eggs yield males. Very warm eggs again produce females. Hot temperature, 95 degrees Fahrenheit (35°C) or more, produce females or harm or kill the embryo. The exact mechanism that causes temperature to determine sex is only beginning to be understood, but some recent work suggests that a particular protein is

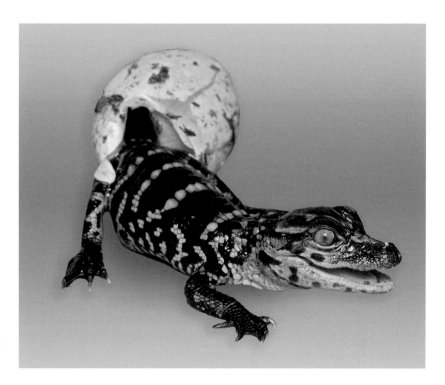

Hatchling alligator emerging from the eggshell.

activated in the male-producing temperature range. Females may be created in the absence of this protein.

Where the nest is located has a big impact on temperature, and thus on the sex of the hatchlings inside. Nests built on elevated levees are generally warm, so most of the hatchlings are male. Nests located in marshes tend to be cooler, producing more females. Some nests will produce 100 percent of one sex, but most produce both sexes. In many cases, higher temperatures near the top of the nest cavity create a "boy zone," while the cooler region all the way at the bottom tends to be a "girl zone." As you might imagine, the probability of becoming one sex or the other changes away from these edges, though the center tends to be warm and is more of a male-producing zone.

Exactly when temperature impacts an embryo's sex has been studied in many species that have temperature-dependent sex determination. For alligators, the critical window is a ten-day period during the middle third of development.

A "Bird" on the Nest

In many ways, a mother alligator behaves toward her nest and eggs in a manner that resembles bird behavior. This makes some sense, as alligators are archosaurs, a group also including birds. Some of the parental-care behaviors displayed by mother alligators are nest guarding, nest maintenance and care, nest opening, assisting the young out of the egg, transporting hatchlings to

water, forming a nursery pool, and guarding and protecting of the young for some amount of time after hatching. A lot of this sounds more like bird behavior than typical reptile behavior.

Mother alligators can often be found at or near their nests for much or all of the incubation period. They guard the nest against intruders and potential predators. Nesting females will frequently position the nest near an existing burrow or dig a burrow near their nest. They also dig guard pools near the nest. This allows them to have a nearby water refuge and still maintain a protective watch on their offspring. Some females are daring enough to challenge intruders the size of black bears, but most females are not so bold.

Nest-guarding behaviors are highly variable. Some females do not remain with their nest, while others who do remain with their nest won't actively defend it against an invading raccoon. It seems like there are individual differences in

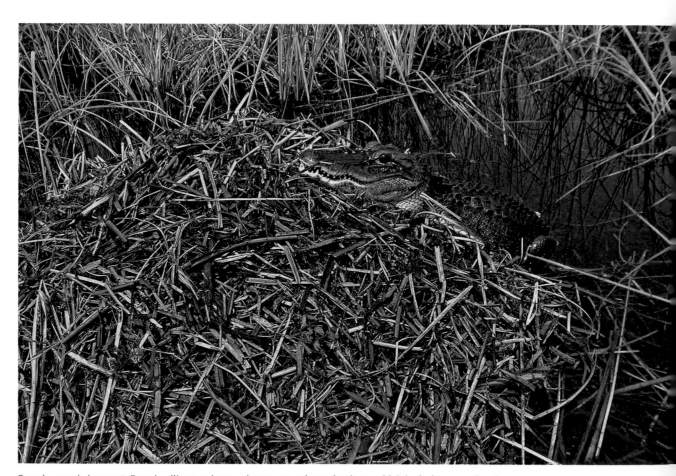

Female guards her nest. Female alligators have robust parental-care instincts which include protecting the eggs while still in the nest. Females do not spend all their time at the nest. Many are nearby and will come back if they sense danger, as this female has done. Others leave the vicinity of the nest but return periodically to check on it.

temperament and that a female's past experiences may alter her next response. The degree of protection also seems to differ among populations. I've noticed that alligators in the Okefenokee Swamp strongly guard their nests, with males even joining the protective efforts. Populations outside Okefenokee, but nearby, seem much less aggressive in terms of nest protection. In Louisiana, a study that used motion sensors found that females visit their nests from eight to twenty-five times over the course of incubation. Many females were observed remaining near the nest, within 60 feet (20 m) or so.

On the other hand, one study of nest attendance in North Central Florida found that less than 15 percent of nests at Paynes Prairie Preserve State Park had mothers present at the nest. And not even a single nest at nearby Orange Lake had a female guarding her eggs. Some females simply abandon their nests completely once the nest is built and eggs are laid. Others visit a few times early in incubation and then disappear. Overall, about half of females guard their eggs and half don't.

It is somewhat surprising that more females do not guard their nests, given the protection their eggs would receive. In the Okefenokee Swamp, 88 percent of unguarded nests suffered predation from predators such as raccoons and black bears. Nests guarded by the female were raided only 17 percent of the time. It is possible that centuries of human hunting of alligators have impacted guarding behavior. One suggestion is that protective mothers were easy targets for hunters, and also gave away the location of the nests to egg poachers. Over time, females who tended to not guard nests would have fared better, perhaps passing down that tendency to their offspring and leading to what we observe today.

The popular image of female alligators attacking when a human approaches a nest is somewhat exaggerated. Perhaps this image is the result of dramatic scenes depicted on nature shows on television. In truth, a relatively small proportion of the nesting female population, probably only a few percent in most areas, will approach a person at their nest. Adult humans are just too big for most alligators, so the mother opts not to fight the battle.

Even when a female objects to human presence at a nest, she often does so in a way that is very different from that seen on television. Almost invariably, protective females quietly, slowly, and deliberately crawl out of the water and up the hill to their nest. They have their jaws slightly agape and their heads cocked down a bit. They look as if they are looking over a pair of reading glasses at you, but they are definitely looking right at you. Then they crawl up the side of the nest, slowly settle to their belly with their throat resting on the peak of the nest. At this point, they just stare at you. If you fail to take the hint, the protective female draws in a deep breath, inflating her body and emitting a long, low hiss. The hiss may increase in volume if you have not yet been convinced to leave. If you approach more closely, within 8 feet (2.4 m), the alligator may

Mound nest of an alligator in a Louisiana marsh. The female scraped together plant and soil materials from around the nest site to construct the nest before she laid her eggs in the mound.

make short lunges toward you. Usually these lunges are only a couple of feet in length, with the alligator leaping over the top of the nest with an open mouth and a loud hiss. Very rarely she will come off the nest and make any run at you.

I had one of these rare, hair-raising, encounters at a nest in the Okefenokee Swamp several years ago. The nest belonged to the 9.5-foot (2.9 m), one-eyed female named Suzie. I had become so accustomed to females underreacting to my presence that I became a bit complacent. So, when she charged at me, I was a little slow off the mark. Soon I was slipping and sliding, breaking branches and running through spider webs. She was right on my heels as I tried my best to stay at least a step in front of her. The chase went on for a good while. She finally stopped, and when I looked back, I could see that she had pursued me for about 80 feet (25 m). She didn't quit until I was back into the swamp, safely away from her nest. What would have happened if she caught me, I'll never know, and I'm glad of that.

The Odds Are Long

The chances that a nest will produce hatchlings run in the range of 46–74 percent, depending on the study location and the environmental factors when the study was done. Some nests suffer due to flooding, but most failed nests are destroyed by predators. But in some years flooding will impact a lot of nests. In a single year, one study recorded that 95 percent of nests were destroyed by floods.

In the 1980s and early 1990s, flooding of alligator nests in the Everglades was a regular occurrence due to water management practices. Flooding was the major source of egg mortality during that time, eclipsing predation. A system of levees and canals in the northern Everglades disrupted the natural cycle of water flow through the area. Water was being held in the north to ensure adequate supplies of water for people living along the Atlantic coast of South Florida. Water was impounded until water managers were confident they had enough, and then it was suddenly released. These releases flooded the alligator nests, drowning the developing eggs.

Droughts are also bad for nests. Alligator nests are offered some protection when surrounded by water. In drought years, it is much easier for nest preda-

Suzie

There is a one-eyed alligator named Suzie whom I've known and watched for more than thirty years. Suzie is a wild alligator, living near Waycross, Georgia, in the waterways of the Okefenokee Swamp Park, a non-profit nature park within the Okefenokee National Wildlife Refuge. She is a pretty large female, well over 9 feet (3 m) in length. Suzie is the most protective female alligator I've ever met, and she has made me feel sure that threats made by nest-guarding females are not all bluff.

Suzie exhibits extremely strong parental behaviors. In her younger days, I never saw her without her young nearby. Her hatchlings would often climb on her and use her as a basking platform, but that was not all. Her offspring stayed with her for up to three years. If anyone messed with Suzie's kids, they would face her wrath. Suzie's older juveniles often hung out with their much younger siblings.

But when Suzie's offspring were around three years old, and much larger than the newest hatchlings, she would drive them off, aggressively pushing them and chasing them. Once juveniles reach a certain size, the idea of having hatchlings for dinner becomes very appealing. If Suzie's three-year-olds didn't get the hint from her chasing and pushing, she would pick them up in her jaws and shake them. I never noticed that she harmed any of the juveniles; she just shook them and released them. That was enough to let them know it was time to go.

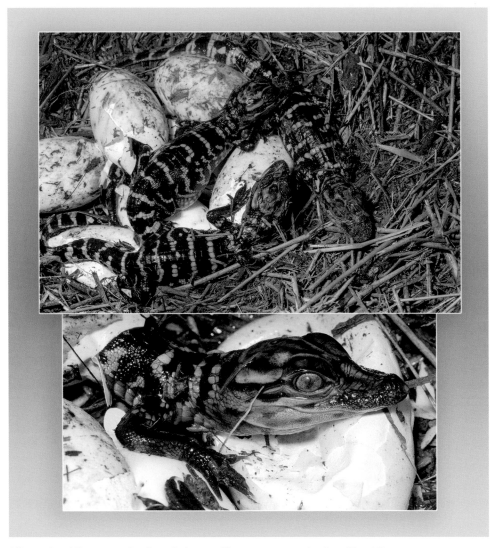

Alligator hatchlings emerging from their eggs. The movement and noise of hatchlings breaking free from the eggshell and crawling within the egg chamber stimulates other nest mates to emerge.

tors, such as raccoons, to reach a nest. They don't have to swim to the nest, a move that turns them into "gator bait," as they cross the water. Even wading decreases the chance they can escape a hungry or protective alligator. It can also be more difficult for the female to remain near the nest when it is dry, as she may seek deeper water away from the site. Lastly, raccoons might feed more heavily on alligator eggs during dry times because other food, such as crayfish, becomes harder to find.

Female alligators produce large clutches of eggs and reproduce every few years during their lifetime, so each female has a pretty good chance of having

at least a couple of offspring survive to adulthood. In fact, a stable population requires just that—two adults produced by each female. When the average runs less than two, the population size declines. When the average is more than two, it means the population is growing.

Bears and raccoons are only two of many nest predators. Opossums, snakes, and a variety of other animals also desire the rich source of protein found in alligator eggs. Feral hogs, river otters, and rice rats are also common nest predators.

Nest predation is highest early in the incubation period, perhaps because the scent of the female and odors associated with egg laying are still apparent, making the nest easier to locate. Many nest predators rely heavily on their sense of smell to locate food. It is possible that olfactory signals also increase late in the incubation process, which may explain why some studies have found an uptick in predation in the weeks prior to hatching.

Even turtles can pose a problem for developing embryos. Turtles commonly lay their own eggs in alligator nests, and their actions may leave chemical trails that predators detect. Turtles sometimes can damage alligator eggs when they nest and the addition of turtle eggs to the alligator nest increases the reward associated with the raid, perhaps serving as a further enticement for predators to seek out alligator nests as a potential food source. Evidence of the negative effect turtles have on alligator nest success can be found in the fact that predation rates are higher for alligator nests that contain turtle eggs.

Even without turtle eggs present, the reward for predators can be substantial. The largest clutch size ever recorded in American alligators was a single clutch of seventy-five eggs collected in 1925 in South Florida. However, in 2012, researchers working on Eagle Lake, Colorado County, Texas, discovered a nest containing ninety-one eggs. The uniform size and hatching date of the eggs suggests that they were all laid by a single female. Of these ninety-one eggs, eighty-two were fertile and sixty produced hatchlings.

When a nest is invaded, but not completely emptied, the female sometimes tries to restore the nest. The mother alligator will rebuild the nest using methods similar to the ones she used when she originally constructed it. Crawling over the nest, she uses her legs to pull materials back up into the mound. She will cover the exposed eggs, fill any cavities, and smooth the surface. The nest looks pretty much like it has never been raided. Her efforts are usually in vain, as predators typically return and eat the remaining eggs.

One of the most vicious threats to alligator eggs is found in the tiny red fire ant, an imported species that has spread throughout the American South. When a female alligator builds her nest, she creates a zone of disturbed soil and vegetation around the nest. Fire ants love disturbed soil. But how they find their way to an alligator nest is usually a bit more complicated.

Water levels typically rise in a marsh with summer rains. The rising waters can flood areas with fire ants, causing the ants to bunch up into rafts made up

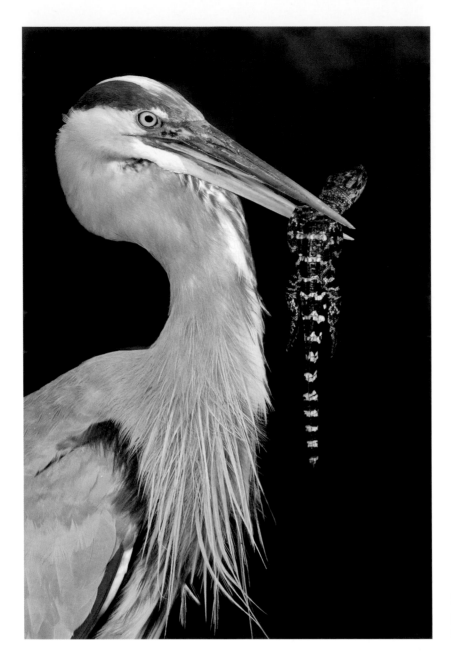

Newly hatched alligators have many potential predators. Few are as great a threat as the great blue heron.

of individuals that are connected body to body. The queen and eggs are kept on the top of the raft. These rafts are often thousands of ants strong and float on the water's surface. Once the collection of ants bumps into a dry spot, the raft is unassembled and ants begin exploring the land in search of a place to make their nest. It turns out that alligator nests are often the only high and dry areas in an otherwise flooded landscape. So alligator nests are commonly invaded by the ants.

After the ants have set up shop in or near an alligator nest, the fire ants look for food. Sometimes they chew their way into the eggs, but most of their terror awaits the emerging hatchlings. As the hatchling breaks the eggshell, the fire ants will swarm their way inside. The young alligators may be eaten alive before they emerge from the egg. Some hatchlings successfully exit the egg only to be mobbed by fire ants as they try to push their way to the surface of the nest. Sometimes the fire ants kill every hatchling, other times some of the hatchlings survive the ferocious onslaught.

The presence of fire ants at an alligator nest even bothers the mother, whose attendance at the nest is reduced when the ants are there. Adult females are so bothered by fire ants that it even impacts the amount of assistance they offer emerging hatchlings. So even the hatchling that escapes the army of ants may find that its mother isn't coming to the rescue, so it must push on in search of water by itself. The end result is a reduction of survivorship for hatchlings.

When Things Go Right

If the predators have missed the nest, and the rains have brought neither floods nor fire ants, the vast majority of the eggs in a nest will produce a hatchling. Using a hardened, pointy piece of skin on the snout, called an "egg tooth," the hatchling will try to scrape its way out of the shell. After breaking through the eggshell, the hatchlings usually remain in the nest cavity with their siblings, or at least those that have also broken free. The movements of the first few emerging hatchlings stimulate the remaining siblings who soon begin scraping away.

The activity inside the nest gets everyone excited, and soon vocalizations become frequent. If the alligator mother is nearby, she can hear the calls of her offspring. But she may not immediately open the nest mound, often preferring to wait until after dark.

When the mother decides it is time to greet her hatchlings, she moves up onto the nest. Her presence is sensed by the hatchlings who begin an energetic bout of calling from inside the mound. The female reacts to their calls by often rotating her head to one side, as if she is placing an ear to the nest to listen. Behavioral researchers have placed a speaker inside a nest mound and played recorded hatchling calls to see if the calls alone will stimulate a female. They do, causing the female to start opening the nest. When the recording is stopped, the mother stops. Restart the recording, and she restarts the excavation.

The female begins the process of nest opening near the base of the mound. On several occasions I've seen females initiate the process by first shoving the tip of their snout into the nest. Sometimes they push their entire snout into the nest. They may hold this position for minutes, perhaps because they are sniffing the interior atmosphere of the nest for any olfactory clues that hatching has occurred.

The Hatch Act

The word "hatching" is often used both for the actual act of breaking out of the egg and for exiting the nest. Alligators hatch in late August or early September. Days or weeks before they hatch, longitudinal cracks form along the long axis of the egg, followed by cracks around the egg. Even before breaking through the shell, the baby alligator inside the egg begins to call, repeatedly making punctuated chirping vocalizations. These vocal signals, in combination with activities of alligators still in their eggs or recently emerged, stimulate other nest mates to initiate hatching behaviors.

To exit the egg, the hatchling must first rupture or cut the leathery eggshell membranes. For this, they have a caruncle—a tiny pointed "egg tooth" on the tip of their snout. It is made of keratin, similar to your fingernails. The sole purpose of this egg tooth is to tear through the membrane and help puncture the hard exterior of the shell. It drops off within twenty-four hours of the hatchling emerging from the egg.

The first visible evidence of hatching is usually a small rupture of the shell, perhaps with the very tip of the snout and nostrils exposed. This is called "pipping" the egg. The hatching alligator then forces its head through the shell. The amount of time spent in either of these states is highly variable. Some hatchlings remain in the egg for up to three days before finally fully emerging. Once they decide to emerge, the process is quick. The hatchling begins vigorous writhing motions within the egg, swinging its head back and forth and wiggling its shoulders, forelimbs, and torso through the expanding tear in the membranes, until the whole body and tail are finally out.

The yolk sac, with a remaining reserve of yolk, is largely within the body cavity when the hatchling emerges. It is basically like a packed lunch and will feed the hatchling for days.

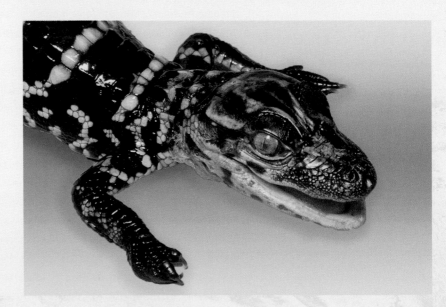

The tiny white "egg tooth," or caruncle, is visible on the tip of the snout of this freshly hatched baby alligator. This structure helps the hatching alligator cut through the tough eggshell membranes during pipping. The egg tooth drops off within the first day of life outside the egg.

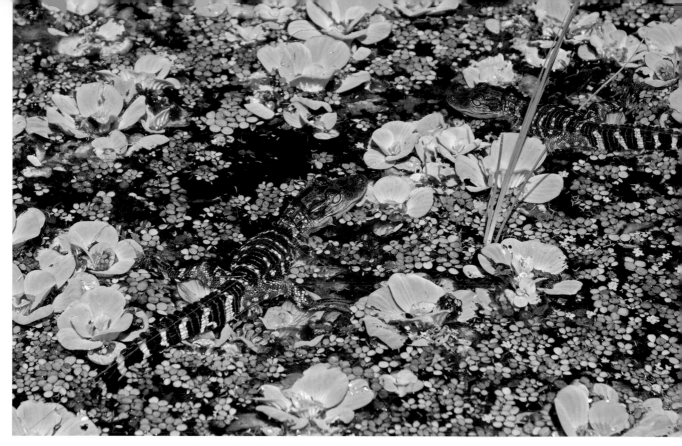

Many nesting female alligators will wallow out a nursery pool in heavy vegetation near the shore. They will deposit their hatchlings into the pool as they emerge from the nest. This provides a safe, sheltered place in which the hatchlings can spend their first few days of life.

Once she is confident that her offspring have emerged from their eggs, the mother thrusts her snout deep into the mound, angles it down slightly, and then raises her head and slings the nest material to one side. She is essentially using her head as a garden spade. Once the mound is penetrated with her spade-head, she begins to use her forelimbs to tear away the nest material, shoving it off to the side. She moves forward as the excavation deepens, using her snout and limbs to dig deeper into the mound. I have seen females grab nesting material in their mouths to excavate, but this isn't the typical approach. Eventually the egg chamber is exposed, reached either from below or to the side. Hatchlings and unhatched eggs tumble out when this moment arrives.

It is at this point that the true wonder of this process really begins. The first hatchling to emerge walks straight up to its mother's head. She turns her head, grabs the baby in her jaws, and slings it into her mouth. She uses the same movements that are used when she positions prey for swallowing. Instead of swallowing, she drops her tongue and the skin below her jaws forms a pouch. The hatchling settles in for a short journey to the water.

The female may take the hatchlings to a nursery pool she prepared prior to opening the nest. Females will often wallow out a secluded pool of water within the emergent vegetation along the shore. Upon arrival at the nursery pool, or some other watery spot, the mother lowers her head and gently floats the hatchling out of her mouth. The baby awkwardly wobbles, attempts to float, and then takes its first swim. The mother returns to the nest to retrieve another hatchling, and one-by-one the family is assembled in the water. Occasionally she will pick up two hatchlings, accelerating the process. If the female encounters an egg that has yet to hatch, she picks it up in her mouth, rolls it onto the center of her tongue, presses the egg between her tongue and palate, and cracks the shell. The freed hatchling then gets a ride to the water. If the mother encounters infertile or rotten eggs, she either eats them or leaves them behind.

The time from nest excavation to the transportation of the last hatchling runs several hours. When I've checked nests after the female has finished, I have found a few unopened eggs that appeared to have once held healthy, fully developed babies. It seems like these were eggs the female failed to find, or that she abandoned them for some reason. These hatchlings look like they might have survived if she had cracked the shell, but instead they were left to die inside the shell. It is possible she detected something unseen by me that caused her to not bother with those particular eggs.

Not all nests are opened by the mother alligator. Sometimes the female lays her eggs and never returns. Other times she returns earlier during incubation but does not assist with nest opening or transport the hatchlings. When that happens, the hatchlings are able to extricate themselves from a nest mound. The hatchlings work their way up the mound, much like turtle hatchlings do, and emerge from a single hole at the top of the nest. Of course, hatchlings that cannot break through their eggshell are doomed in such cases.

Where's Daddy?

Whether male alligators ever provide care for their offspring is something of an uncertainty. In some areas, it is known that some adult males, as well as apparently unrelated females, sometimes aggressively respond to hatchling or juvenile distress calls. I've personally been charged by males while holding vocalizing hatchlings. Male alligators have also been observed at nests during incubation and at the time of hatching. I do not know of any observations of male alligators participating in nest opening or transport of hatchlings to the water, although this behavior has been observed for some crocodile species. In general, it seems that male alligators are mostly AWOL when it comes to parental care but may help defend the little guys from time to time.

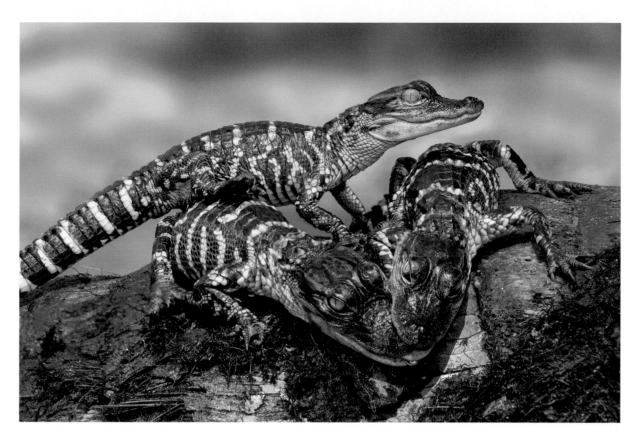

Newly emerged hatchlings squabble. Hatchlings remain together in social groups called pods. Social interactions between the pod-mates begin quickly.

The hatchling alligators stay together in a social group called a pod. The pod-mates often communicate with each other, using vocalizations and possibly visual signals as well. The mother alligator remains close to the pod, offering her hatchlings some measure of protection. If, for example, a heron approaches, the hatchlings emit a distress call that attracts the mother, or even another nearby adult. If a person approaches a pod of hatchlings and the mother is nearby, the little alligators usually scurry to their mother and climb over to her other side, putting the female between them and the person. Pods often remain near their nest sites, and their mother may stay with them through their first winter, having them stay in her den. They may remain with her into the following summer, until it's time for her to begin the nesting process anew.

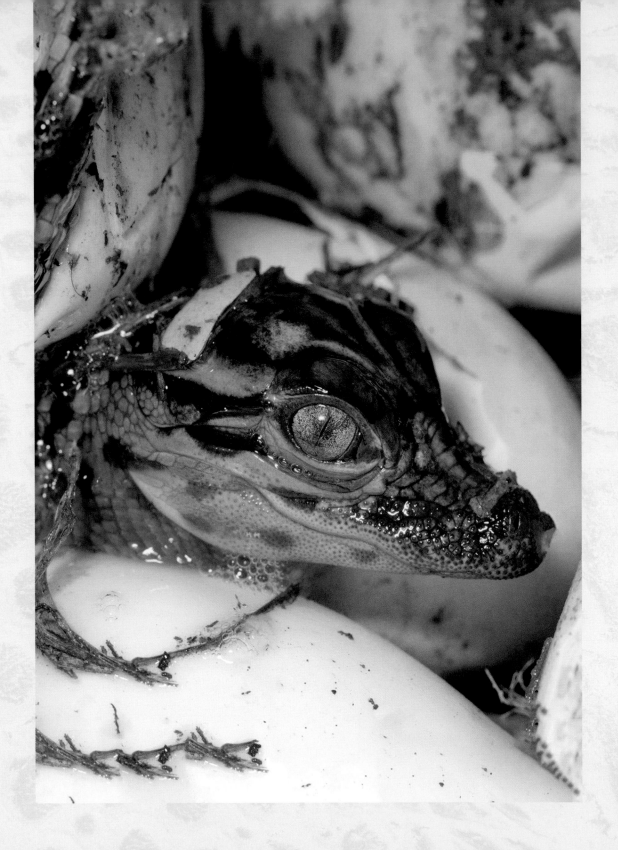

Long Odds for a Long Life

One summer night almost twenty-five years ago, I was helping biologists
from the state of Florida capture alligators on Lake Griffin, which is just south of
Ocala. The biologists were conducting a drawdown—a process of partially emp-
tying the water from the lake basin to cause loose, muddy sediments to compact
on the lake bottom. Drawdowns, when conducted properly, can reduce aquatic
plant growth and keep lakes from being choked with emergent vegetation.

I rode in an airboat with the other biologists as we searched for alligator
eyeshine using high-powered spotlights. We knew that some alligators might
become trapped in the mud and our job was to free them. There was an enor-
mous swath of exposed mud along one of the shores, and we spotted a single
alligator's eyeshine in the very middle of it. This is the exact sort of situation for
which an airboat was designed, so we pointed in the alligator's direction and
skimmed over the mudflat. When we arrived at the right spot, we saw nothing
but mud—no eyes, no alligator.

After about a minute of sharing confused looks and searching further from
the spot, we saw a glistening, wet eye opened on the surface of the mud very
close to the original pinpointed location. No other part of the alligator was vis-
ible, just that single eye. Using our arms and paddles, we groped in the mud
to define the edges of the alligator's body. We found and freed his left hind leg
from the embedding mud. In the webbing between the third and fourth toes
of the foot was a tiny metal tag. It was the size and type of tag that biologists
attach to hatchlings.

With a bit of cleaning, we could see that the stamped number was still leg-
ible on the flat metal. Records of tagged animals are supposed to be properly
maintained, though this isn't always the case. Luckily, the record of this tag was
available, and we learned it had been placed on the alligator as a hatchling in
the 1970s by a graduate student who studied behavioral ecology of young alli-

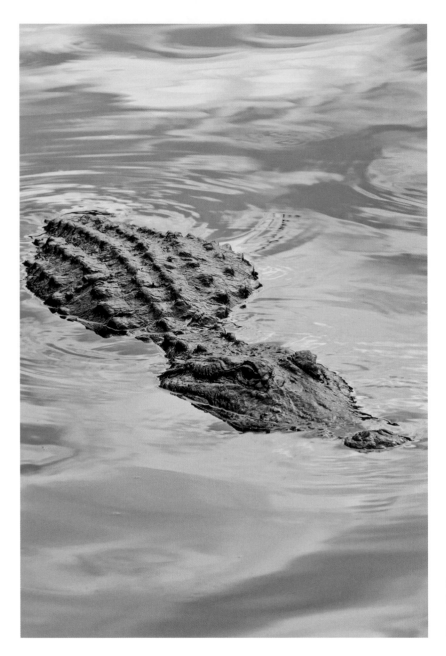

Adult alligator floats on the surface of a Florida lake. For an alligator to reach this size, it must survive at least twenty years.

gators. The alligator was a male, just barely ten feet long, and was living on the northwest side of the lake, very close to the spot where he hatched almost two decades earlier.

What life was like in the interceding twenty years for that alligator, we'll never know. We were able to recover growth and location data, adding valuable information to the growing body of scientific information about the species. But in trying to tell the life story of an alligator, we are forced to piece together the bits and parts we have from the lives of thousands of animals. Every data point

gives clues of an alligator's struggle for existence, its effort to stay alive and reproduce. The alligator we found that summer night in 1994 is the inspiration for this chapter.

Be Gone and Grow Big

When you're a little alligator, there must be tremendous comfort in knowing that your mother is nearby to protect you. So it must also be stressful when she lets you know, in no uncertain terms, that it is time for you to leave. That was likely the fate for the tagged male from Lake Griffin around the time his first or second birthday rolled around. Even the hyperprotective alligator named Suzie, who would allow her offspring to stay until they were three, finally drove them away with some degree of violence.

At hatching, alligators are 8.5–10 inches (22–25 cm) long. They grow fairly rapidly as youngsters, in the range of about 1 foot (30 cm) every year for the first two or three years of life. After this early growth, they slow down, females more so than males. Ten-year-old males may be about 8 feet (2.4 m) long, while females are 1–2 feet (30–60 cm) less. By the age of twenty, most males are near 10–11 feet (3–3.4 m), but females are perhaps 8 feet (2.4 m) long.

A young alligator that is booted by its mother may well go on to be king or queen of the swamp, but very few youngsters will ever survive to adulthood. If they do, they might end up becoming truly astounding animals. In a study of alligators killed in the annual harvests in Florida from 1977 to 1993, the longest male was measured at 14 feet (4.3 m) and the heaviest male weighed 1,043 pounds (473 kg). The largest female was 10 feet, 2 inches (3.1 m) and the heaviest female was only 285 pounds (129 kg). A similar study of harvested alligators

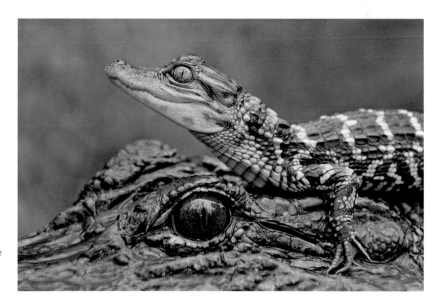

Yearling alligator using its mother's head as a basking platform. The care and protection offered by the parent do not last indefinitely. Eventually, the young alligator will be forced to leave and venture out on its own.

Male or Female?

There are somewhat subtle differences between mature male and female alligators. A simple rule of thumb is that any alligator longer than 9 feet, 6 inches (2.9 m) is almost sure to be a male, although a few females may grow to close to 10 feet (3 m). (I only know of three or four females that have reached this size.) The head of adult males tend to be lower built, that is, the slope of the head from the eyes down to the snout is shallow. The eyes of males are also a bit less rounded, sort of flattened, but only slightly. Male eyes look as if you took a grape and squeezed it between your thumb and index finger. In contrast, female heads have a somewhat taller architecture, with the cranial table and eyes elevated so that the slope of the bridge in front of the eyes to the snout is a bit steep. In addition to being more rounded, female eyes project up more above the cranial table, making them sort of "frog-eyed."

Of course, these descriptions are not foolproof. I've worked with alligators for more than thirty-five years and when I've tested my guesses against more foolproof scientific methods, I have found that I'm right only four out of five times.

The only way to be absolutely sure of the gender of an alligator is to physically examine the genitalia within the cloaca. Researchers and wildlife managers do this either by looking inside the opening or feeling inside with a finger. Of course, the alligator must first be captured and restrained. If the vent opening is large enough, you can put the tip of your finger inside and feel the solid shaft of the phallus (penis) along the ventral wall if it is a male. If it is a female, you won't feel the phallus and you might detect a very small appendage, which is the clitoris. If the vent is too small to insert a finger, you have to spread the opening with either forceps or an infant nasal speculum. You might then be able to see the genitalia enough to determine whether the alligator has a penis or a clitoris.

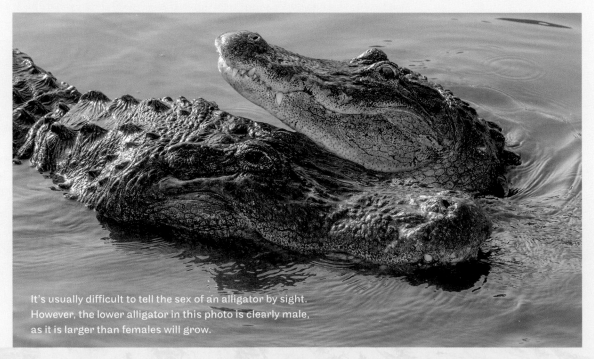

It's usually difficult to tell the sex of an alligator by sight. However, the lower alligator in this photo is clearly male, as it is larger than females will grow.

in Louisiana from 1972 to 1992 found that the longest male taken was 14 feet, 1 inch (4.3 m).

The largest alligator killed in Florida in recent history was a male killed on November 1, 2010, in Lake Washington, Brevard County. It measured 14 feet, 1.5 inches (4.4 m) long and weighed 654 pounds (297 kg). Its head length was almost 2 feet (60 cm) long. Alabama currently holds the official record for the largest alligator, which was measured at 14 feet, 9.25 inches (4.5 m). It weighed 1,011.5 pounds (458.8 kg).

Records are made to be broken, and I suspect we'll continue to see reports of extremely large alligators. Historic records, which are hard to verify, suggest alligators may have once exceeded 18 feet (5.5 m) in length.

Today's alligator hunters have become as avid as mammal hunters—scouting out sites before the season, finding big males, learning their habits and home range, and doing everything possible to land a record-size alligator. In states like Alabama, Arkansas, and Mississippi, where regular harvests have only recently been allowed after several decades of stringent alligator protections, new state records are set every year or two. In August 2015, a new Mississippi state record for male weight was set: 826 pounds (375 kg).

Lifespan

Alligators have evolved to live a long time if they can survive the gauntlet of early life. The chance of reaching adulthood may be less than one in a thousand, but those that make it may live to age fifty, or considerably longer. A long-term study of South Carolina alligators suggested that a number of individuals were in their eighties. In captivity, alligators can probably live even longer lives.

The best current method for determining alligator age is also the hardest method: tagging them as hatchlings and capturing them later with intact tags. A tag might be metal and placed in the webbing of a hind foot or clipped to the crest scales from the tail, or it might be a small microchip injected under the skin and later detected using a specialized scanner. Tens of thousands of hatchlings are often tagged in the hopes of recapturing a small percentage down the road. These known-age alligators are the gold standard, and data from them is coveted.

For older alligators, at least those that were killed, we can estimate age from their bones. Bone is laid down in the skeleton during periods of growth and can leave traces of the slow and fast growth much like rings tell the age of a tree. If a thin slice is cut from the middle of an alligator femur and examined under a microscope, the growth rings in the bone can be counted. But it can be difficult to get a precise count, especially for large alligators. As the bone grows, the marrow cavity in the center of the bone enlarges, and that removes the innermost rings. Also, growth slows so much in larger animals that the outmost rings

The Largest Alligator Ever Measured?

Tabasco Sauce heir and natural historian Edward Avery McIlhenny killed an extremely large alligator in 1890. It may have been the largest alligator ever measured, but this claim is very controversial. The story McIlhenny told is that he was hunting for game when he came upon the biggest alligator he had ever seen. Using his shotgun, he killed it. As it was getting dark, he came back the next day with companions to retrieve the animal. When he returned the next morning, McIlhenny found the carcass was difficult to maneuver in the bayou, so he decided to measure the alligator and abandon it. He did not have a tape measure with him, so he removed the barrel of his shotgun and laid it from head to tail along the back of the animal, making a mark with his knife each time he reached one "barrel length." He recorded that he remeasured three times. Upon returning to his home, McIlhenny measured the barrel of the gun. He used this to come up with a length of 19 feet, 2 inches (5.84 m). It is reasonable to deduct several inches because measuring along the back, as opposed to modern straight-line measurement, adds to the length.

Title page of E. A. McIlhenny's classic book, *The Alligator's Life History*, published in 1935.

McIlhenny's records have been widely questioned, and some experts don't believe alligators reach the lengths that are reported in historical accounts. Some have been especially dubious of the records reported by McIlhenny. A justification of this skepticism is that there are no archived materials in museums of animals that reach these extreme lengths. But I'm not so sure McIlhenny's data should be dismissed, and I know that, even today, museums don't house the largest alligators that have been scientifically verified (such as those taken in legal hunts).

E. A. "Ned" McIlhenny was a gentleman naturalist and conservationist in Louisiana in the late nineteenth and early twentieth centuries. The McIlhenny estate on Avery Island, Louisiana, was surrounded by coastal marshes and swamps. McIlhenny was fascinated by the alligators in the environs of Avery Island and made extensive observations of their lives and natural history. His book *The Alligator's Life History* provided a wealth of information on alligator biology, including habitat use, diet, growth, behavior, reproduction, and parental care. The book provided the first relatively comprehensive account of the biology of this species. It is true that McIlhenny was a businessman, and not a professional biologist, so many in the professional zoological community of his time largely discredited the book and its accounts of alligator biology and behavior. Even into the 1970s, McIlhenny's treatise of the life of the alligator was condemned, even vilified, by some in certain scientific publications.

Many of the observations of alligators McIlhenny illuminated in his book were unknown, so skepticism by the scientific community at that time is understandable. However, as our knowledge of alligator biology expanded, it became increasingly apparent that McIlhenny's descriptions of behavior and biology, including detailed data regarding age at first reproduction, dates of nesting, incubation length, egg and clutch size, nest temperatures, hatchling sizes, and growth rates, were in near perfect agreement with those collected by professional biologists decades later. In fact, virtually every element of biological data he collected in the early decades of the 1900s that can be replicated today, with one or two exceptions, seem absolutely accurate. So, maybe he did find an alligator in excess of 18 feet (5.5 m).

Official alligator size records for each state

State	Sex	Total length	Weight	Date	Location	Record
Alabama	Male	14'9.25" (4.50 m)	1,011.5 lb. (458.8 kg)	16 Aug 2014	Alabama River, near Millers Ferry	State length and weight
Arkansas	Male	13'10" (4.22 m)	—	24 Sept 2015	Moore's Bayou, near Arkansas Post	State length
Arkansas	Male	13'3" (4.04 m)	1,380 lb. (626.0 kg)	14 Sept 2012	Lake Millwood, Hempstead County	State weight
Florida	Male	14'3.5" (4.36 m)	654 lb. (296.5 kg)	1 Nov 2010	Lake Washington, Brevard County	State length (male)
Florida	Male	13'10.5" (4.23 m)	1,043 lb. (473.1 kg)	17 Apr 1989	Orange Lake, Marion County	State weight (male)
Florida	Female	10'6" (3.20 m)	325 lb. (147.4 kg)	8 Oct 2015	Lake George, Volusia/Putnam County	State length and weight (female)
Georgia	Male	13'10.75" (4.24 m)	620 lb. (281.2 kg)	—	Lake Seminole	Records not kept
Georgia	Male	13'6" (4.11 m)	660 lb. (299.4 kg)	2 Oct 2014	Lake Blackshear	Records not kept
Louisiana	Male	13'4" (4.06 m)	760 lb. (344.7 kg)	—	Near Solitude Point, West Baton Rouge Parish	Records not kept
Mississippi	Male	14'0.75" (4.29 m)	766.5 lb. (347.7 kg)	28 Aug 2017	Mississippi River, near Natchez	State length (male)
Mississippi	Male	14'0.25" (4.27 m)	826 lb. (374.7 kg)	29 Aug 2015	Mississippi River, Davis Island	State weight (male)
Mississippi	Female	10'0.5" (3.06 m)	283 lb. (128.4 kg)	19 Sept 2015	Issaquena County	State length (female)
Mississippi	Female	9'11" (3.02 m)	319 lb. (144.7 kg)	30 Aug 2015	Eagle Lake, Warren County	State weight (female)
North Carolina	Male	13'6" (4.11 m)	400 lb. (181.4 kg)	16 May 2017	Jacksonville	Records not kept
Oklahoma	Male	11'6" (3.48 m)	500 lb. (226.8 kg)	2005	Eagletown	Records not kept
South Carolina	Male	13'5" (4.09 m)	1,025 lb. (464.9 kg)	2010	Lake Marion	Records not kept
Texas	Male	14'8" (4.47 m)	880 lb. (399.2 kg)	2008	Chalk Creek, near Lufkin	State length

are laid down on top of one another, making them hard to differentiate. You can get close for immature alligators. Numbers of growth rings from femurs of known-age animals (those with hatchling tags that had their femurs studied later in life) correlate well with the age of the alligator from which the bone was taken. This same technique was also used to study the age of dinosaur bone fossils, including estimates for *Tyrannosaurus rex.*

Even with all our various methods of determining age, how long an alligator can live remains a topic of debate. On March 6, 1893, the *New York Times* reported on an alligator that had become something of a family pet on a plantation near Thibodeaux, Louisiana. The family story was that the "pet" was the sole survivor of the great-grandfather's 1773 wholesale slaughter of every alligator he came across as he cleared the land for agriculture. His slaughter included a mother alligator and her young, except for one that escaped with its life but lost 5 or 6 inches (12–15 cm) of its tail in the encounter. Over time, the family warmed to it and the family children fed it table scraps every evening and nicknamed it "Shorty." The article reported that, 120 years later, the alligator was shot and killed by a visitor to the plantation who didn't know the alligator had protected status.

Another age-related story is Oscar of Okefenokee Swamp, an alligator that was "full grown" when a nature education center was built in 1945. When Oscar died on July 19, 2007, he was 13 feet, 7 inches (4.1 m) long. We know he lived near Okefenokee Swamp Park for sixty-two years, and his "full grown" estimated size in 1945 was perhaps somewhere near 11.5–12 feet (3.5–3.7 m). So it is possible that in 1945 Oscar was at least twenty-five to thirty-five years old, a typical age for a wild male alligator in Georgia that is "full grown." If so, that would put Oscar at something like eighty-seven years old when he died, and it is certainly possible he was much older than that.

Of Telomeres and Time

Biologists continue to search for new ways to determine the age of alligators. One recent effort involves measuring the ends of chromosomes. Telomeres are essentially protective caps on the ends of each chromosome in cells. They prevent the loss or degradation of genes near the ends of chromosomes during cell division. We have known for some time that the length of telomeres for most cells shortens as an animal ages. Every time a cell divides, a small portion of the telomere cap is lost; however, the functioning genes on the chromosome are unaffected.

Because alligator red blood cells have a nucleus (human red blood cells don't), it is possible to take a blood sample from an alligator and examine telomere lengths. This method has yet to be accurately calibrated, but one day it may be possible to estimate the age of an alligator just by taking a blood sample.

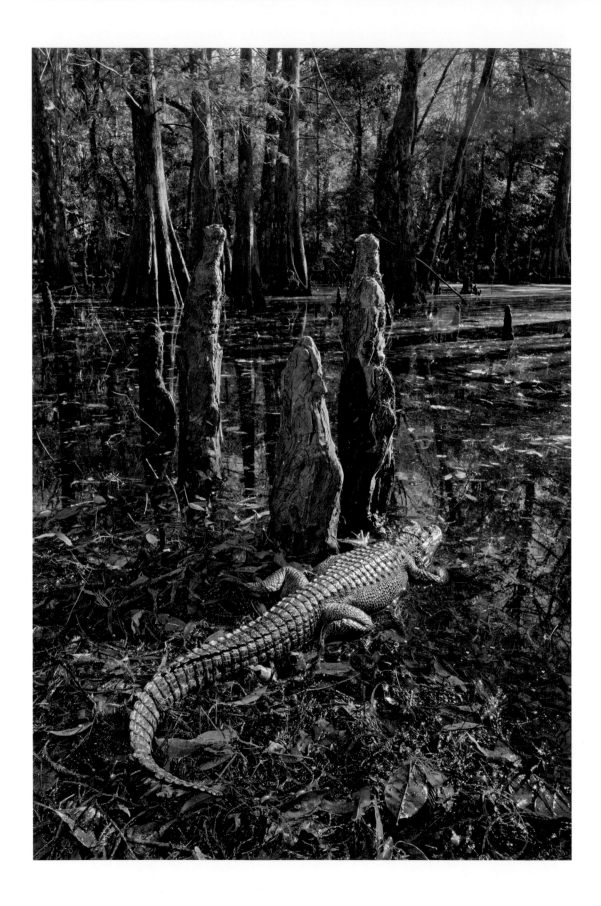

The most detailed study to measure longevity of wild alligators was conducted at the Tom Yawkey Wildlife Center in South Carolina. Researchers followed alligators estimated to be over thirty years old for another thirty to thirty-five years, depending on the individual. One female they studied was estimated to be sixty-eight years old at her last recapture, and another was likely sixty-six.

There are numerous records of zoo alligators that reached ages of over eighty. A Paris, France, zoo record from 1937 documents an alligator that lived in the Jardin des Plantes for eighty-five years. The alligator was apparently the last survivor of a group sent from Louisiana to Paris. It was donated to the Jardin des Plantes on March 25, 1852. The alligator was called Jean-qui-rit ("smiling Jean") because the teeth of its upper jaw protruded. This feature distinguished the animal from the other alligators that came and went from the menagerie over the years. Its unusual feature provides a little more certainty that the alligator was not confused with another animal. Jean-qui-rit died on April 4, 1937.

An alligator named Čabulītis was reported to live in the Riga Zoo in Latvia for seventy-two years. He arrived at the zoo on April 1, 1935, and remained there until his death on August 21, 2007. Records suggest he was one to three years old when he arrived, so he may have lived to the age of seventy-five. Čabulītis in Latvian means "sweet and tender creature." Three other alligators arrived at Riga Zoo at the same time as Čabulītis, another male and two females. They lived together somewhat disharmoniously until the other male was sent to the Kiev Zoo in the Ukraine in 1965. This male is still alive and turned eighty-four years old in 2019. He is considered the oldest living male alligator in captivity.

An alligator named Muja (pronounced "mooya") arrived at the Belgrade Zoo in Serbia in 1937. He survived bombings of the zoo during World War II, first by the Germans in 1941 and then by Allied Forces in 1944. He also survived very cold winters that occurred when the partially destroyed zoo was barely able to function. Muja is still alive, so is at least eighty-one years old, plus however many years old he was when he arrived.

The Cincinnati Zoo had an alligator named Bob that arrived at the zoo in 1917. Bob ultimately retired to Florida, where I knew him for a short time before his death in 1998. He was at least eighty-one when he died. The Honolulu Zoo's male alligator named Goliath was acquired from an alligator farm in Texas in 1953. He was 10 feet (3 m) long and thought to be at least twenty years old at that time. He died in April 2015, so was probably eighty-two or older, if the age estimate in 1953 is to be believed.

Two female alligators living in zoos turned eighty-eight in 2018. One is Marta, who lives in a zoo in Plock, Poland. Marta is a bit of a movie star, having appeared in the Polish cult film *Hydrozagadka*, which is a 1971 spoof of life under communism. The other long-lived female is named Alison and lives in the Australia Zoo in Beerwah. Alison was made famous by television naturalist

Steve Irwin, a.k.a. the Crocodile Hunter. Both Marta and Alison are thought to
have hatched around 1930.

To Live Another Day

Staying alive is easier for alligators as they get older. Out of a typical clutch of
thirty-five eggs, about fifteen produce live hatchlings. Seven of the fifteen will
survive their first six months of life. Less than one in five fertilized eggs will
produce a hatchling that is still alive on its first "hatchday."

The year in which you hatch can make a big difference. In one Texas study, the
estimated survival of hatchlings from all of the nests laid in one population in
one year was just 6 percent, but 43 percent of alligators hatched from the same
area survived the following year.

Once an alligator reaches 2 feet (60 cm) in length, at about two years of age,
they need to worry less about the list of potential predators. In fact, other alli-
gators and humans are the only animals they have good reason to fear. Increas-
ingly, the tables turn and the animals that used to prey on them become prey for
the alligators.

Cannibalism is the most serious threat to smaller alligators; mostly little
gators being eaten by larger juveniles and subadults. Pods of hatchling alliga-
tors in the fall are often stalked by 3-foot (90 cm) or larger alligators that seem
to hang around the periphery of the pod. I've revisited many pods that, over
time, contain fewer members. I have also noticed an increase of injuries, such
as a lost leg or missing tail tips as the months progress.

By the time an alligator reaches maturity, it has very few predators. Adults do sometimes eat each other, and a nesting alligator may kill other adults that come too close to a nest or pod. Diseases and parasites do kill some alligators, and there have been rare cases of mass mortality in alligators due to these causes. Droughts have significant impacts on adult alligators, and I have often found dried or skeletonized remains of alligators in the middle of dried marshes.

For alligators, it is a long road to adulthood, and the chances of making it to the end of that road are long. But the reward may be great, possibly four to six decades of reproduction, possibly resulting in two thousand or more hatchlings.

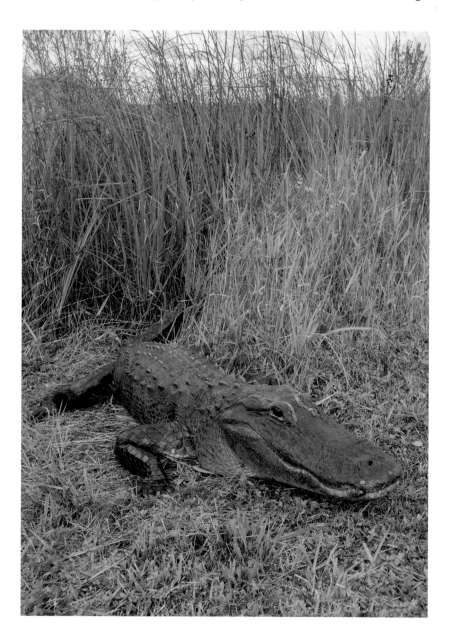

Large alligator basking on a grassy bank, one of the small percentage of alligators that survive to this age.

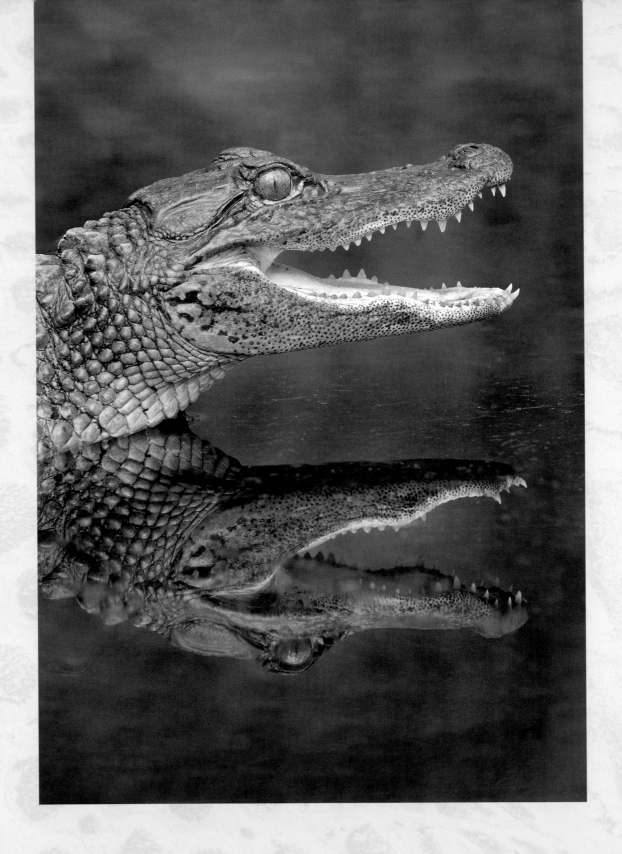

Alligator Societies

Despite their loutish countenance, armored skin, and an inclination to crush or drown doomed prey with long jaws festooned with big teeth, the alligators I have known are quite sophisticated animals with somewhat laid-back attitudes. For most of the day, they appear to be doing absolutely nothing; chilling out might be a good way to put it. Most people who stop to watch an alligator in the wild will eventually leave out of boredom. On a good day, a tourist might see a wild gator swim, but probably that's about it.

It takes a lot of watching, or a lucky break, to see some of what I have witnessed over the past three-plus decades. I hope I can paint a better picture of the secret lives of alligator societies than one might get from having seen an alligator bask or be fed in a zoo or on a farm. In many ways, alligator behavior is more similar to that of behaviorally complex birds than to other reptile groups.

When I first studied alligator social behaviors in the early 1980s, I quickly learned that my starting point was biased because of my mammalian, and more specifically human, sensibilities. This is not a problem unique to me or to those who study alligators; animal behaviorists all know they must always be wary of interpreting the actions of other species from a human perspective. The difficulty lies in seeing the world through the animal's eyes. This is actually impossible, but we get closer to the truth when we try to record observations that are biologically meaningful to the animal.

Our internal clock is set to the fast pace of a primate. We expect a stimulus to be followed quickly by a response. An alligator's internal clock is set at a much slower pace. For example, a male that performs a single head slap, which is a loud snap of the mouth to signal nearby alligators, may have to wait thirty-five or forty minutes before getting a response. Only by understanding the pace of the alligator internal clock can we hope to recognize the connection between the head slap and the long-delayed response.

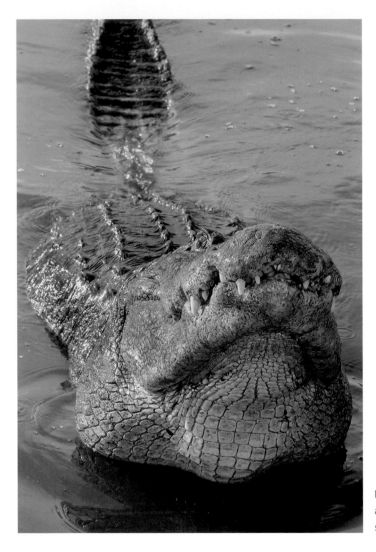

Despite their brutish, armored appearance, alligators exhibit remarkably sophisticated social behaviors.

Many of the early animal behavior studies grew out of learning studies, such as running laboratory mice and rats through mazes. Alligators were put through the same sorts of lab learning trials, which were conducted at room temperature. The alligators fared poorly under these conditions, reacting slowly and taking many trials to learn the pattern of a simple maze. They were tagged as being dim witted. When similar trials were conducted some years later, but in spaces heated to the alligators' more optimal temperatures, they were able to learn mazes as rapidly as lab rats.

Perceptions among the community of biologists of the alligator's behavioral abilities were slow to change. Decades after McIlhenny's book was published, Archie Carr began observing a female alligator that lived in Wewa Pond, near his house. His observations of that female spanned more than four decades. He studied her daily and seasonal activities, her various behaviors, the male

suitors that came each spring to court and mate with her, and the way she nested and cared for her young. She was an attentive and protective female, and Carr would often explain her behaviors to visiting biologists. (While he was alive, Carr was certainly one of America's most respected herpetologists and conservationists.)

If the season was right, herpetologists visiting Dr. Carr's home were invariably introduced to Wewa Pond and its alligator. The succession of visitors was able to observe nest guarding and parental-care behaviors firsthand. I've often thought that concepts about alligator social structures and various behaviors began to change because this one female alligator, living on a small pond in an oak hammock in Florida, helped people to see that the "dim-witted alligator" was probably a myth.

The Social Registry

Long ago, as a graduate student studying alligator social behavior, I spent time swimming among my study specimens. My goal was to understand how alligators communicate using body profiles and visual cues. This pair of alligators is courting despite my close approach.

On land, alligators often congregate in large numbers while basking. They either settle in next to one another or drape across each other. In the water, groups of alligators form when concentrations of fish or other prey species are plentiful, sometimes engaging in cooperative feeding behaviors. During the reproductive

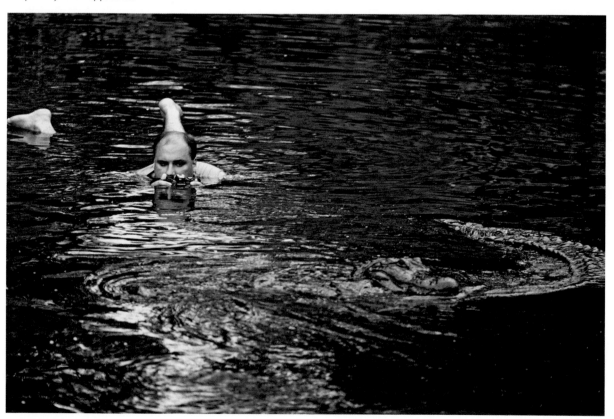

One Is the Loneliest Number

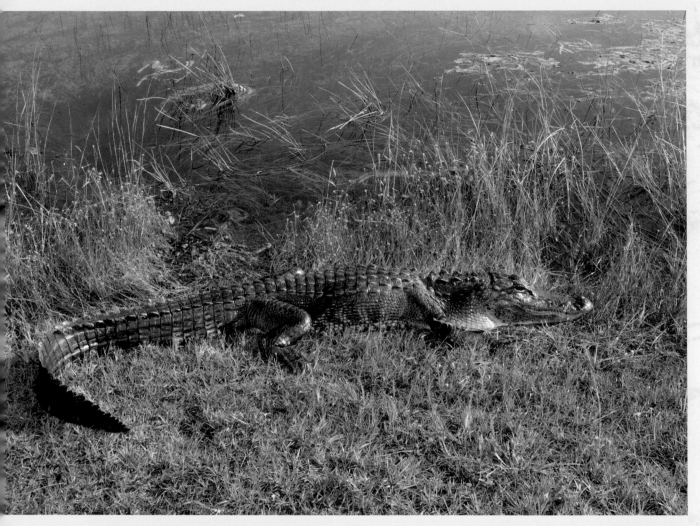

Single adult female alligator living in a sinkhole pond.

From their earliest days, alligators live in association with hatchlings, juveniles, and even sub-adults of similar size. But some adult alligators will live alone, usually in some small pond, sink-hole, or recess. Females living in very small ponds or lakes, or sinkhole ponds in North Florida, may live much of their adult life in isolation. Males will wander through the area in the spring and court and mate with these females. The females nest nearby and keep their young for peri-ods of time in these small bodies of water.

Adult males of lower social status may find a body of water in which they can avoid aggres-sive contact with a more dominant male. Commonly, these subordinate males have to move frequently and will be displaced by other males repeatedly.

season, groups form for the purpose of courting and mating. During periods of drought and receding water levels, even alligators that have lived for years in isolation will move into group housing. In some cases, the few remaining wet areas will contain hundreds of adult alligators.

The alligators in these groups all have different personalities. I believe part of that personality is formed even before they stick their heads through the eggshell, and it's certainly obvious to anyone who has handled more than a few hatchlings. They all come out with the cute attributes—big eyes, short snouts, and oversized heads relative to the body. Many of these little alligators are docile and show no desire to bite when you handle them. Then there is the rebel of the group. I've been bitten on the finger by hatching alligators still inside the egg as I tried to help them out. These "James Dean" babies come out pugnacious, or quarrelsome, with the personality of a teacup Chihuahua. They snap and bite, inflating themselves as they try to look as big and menacing as their 8 inches (20 cm) will allow.

Soon after hatching, alligators begin to establish a social hierarchy within the group. The social interactions involve posturing, lunging, and sometimes biting. Dominant individuals emerge through these acts of social aggression. Body size is important in the dominance hierarchy, but even the largest of the hatchlings won't move far up the ranks if it doesn't have an aggressive attitude that matches its size. This same rule holds true later in life. I've seen adult male alligators that were much larger than the dominant male in the area, but never tried to impose themselves on the alpha males or other large males in the area. When challenged by other males, they would retreat.

Even at young ages, alligators may display quite distinct personalities. This little guy is particularly feisty.

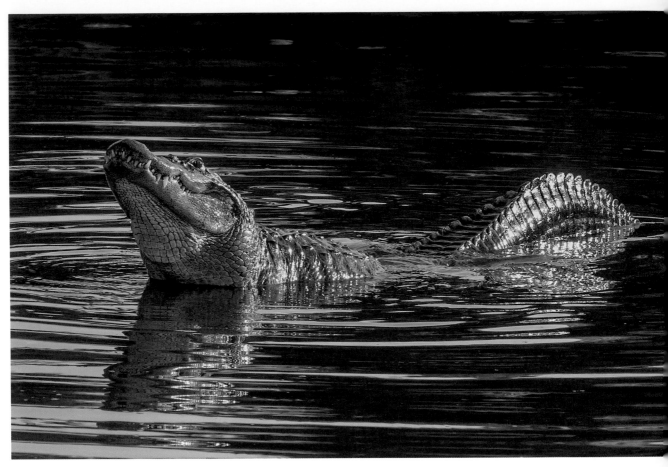

Although typically little of an alligator's body projects above the water's surface, in some social displays, alligators inflate themselves and show quite a lot of their body.

Fights are a way of life among adult males. Fights establish and maintain dominance ranks and will take place at any time during the alligators' active part of the year. The peak of fighting is the breeding season, with most of these fights instituted when a dominant male attacks an alligator that just performed a social display such as bellowing.

In addition to bellowing, head slapping, and other acoustic displays, alligators communicate with one another by visual means. Social interactions occur at the water surface. If a refuge is needed, all an alligator needs to do is move below the surface. Typically, they can avoid contact with other alligators as long as they stay submerged.

An alligator communicates its social position, attitude, and willingness to be aggressive by the amount of its body that is above water, as well as the posture of the exposed portions. In one posture, the body is elevated slightly in the water so the head is high enough for the teeth to be exposed, the top of the

neck and dorsal armor of the back are above the water, and the base of the tail is arched above the water's surface. During fights, males often assume an "inflated" posture in shallow water, with their legs held straight below them, their mouths gaping, their backs arched, bodies compressed from side to side, and tails bowed up above the surface, showing as much of themselves as possible and making their bodies look as large as possible. Even without fighting, they may remain in their inflated postures for as much as three-quarters of an hour, until one animal finally gives in, very slowly lowering himself and moving away from the victor. In contrast, when alligators approach one another for courtship, they are very low in the water and move slowly.

When fights do occur, they can be very aggressive, even ending in the death of one of the individuals. More often, the vanquished animal flees. After the defeat, the subordinate gator will try to appease the dominant individual, offering a lower body profile in the water and moving at the approach of all alligators of higher social status.

Swamp Sounds

Alligators are noisy animals, vocalizing and producing other auditory displays throughout their lives. They start life making the weak chirps of hatchlings as they pip through the eggshell. Calls begin even before they first pip through the eggshell. The calls stimulate others in the nest to begin the process of hatching. As hatchlings emerge, their movements within the egg chamber motivate alligators still in the egg to bust through and wiggle free. Grunting calls then ensue, which may attract their mother so she will open the nest. Once free from the nest, hatchling calls help maintain the cohesiveness of the pod, keeping hatchlings near one another.

Alligator sounds reach their zenith with the booming, tumultuous bellows of an adult male. Most written accounts of early explorers and settlers in the South include a mention of the bellows of alligators. John James Audubon wrote in an 1827 letter that male bellowing sounded like "thousands of irritated bulls about to meet in fight."

The bellowing display begins with the alligator raising his head out of the water. The tail lifts, as well, to counterbalance the weight of the head. He then takes in great gulps of air as his body rises and falls with each drawn breath. His bowed body then sinks in the water. At the moment before the sound begins, the water over and around his torso begins to move, then erupts, projecting fingers of water up into the air—sometimes as much as a foot high. I call the aquatic reaction to a bellowing male the "water dance." As the water falls back to the surface, the male lets out a great roaring bellow. He will repeat this several times, usually four or five cycles of bellows per bout. The water dance is produced by sound waves that are below our hearing threshold.

Females bellow as well, usually a few more times than males and at a somewhat higher frequency. The cadence of a bellowing female is faster than a male's and there is no eruption of water around a female.

The male's water dance display is one of the most spectacular social behaviors of any animal. It seems to be common to most or all species of crocodilians. If you watch the response of alligators lying nearby as the water dance begins, they are instantly startled by the infrasound of the displaying male.

I think the origins of the fire-breathing dragon may have their roots in part of the bellows of alligators. As a really big male alligator bellows, you can see a cloud coming out of his mouth and nostrils toward the end of the call. It looks like smoke, but it is really water vapor, driven from the lungs. We don't know for sure, but I think the water in the exhale is vaporized by the infrasound. This is not the same as seeing your breath on a cold winter morning, where moist, warm air meets cold, dry air. The "smoke" comes out even when temperatures are too warm for you to see your own breath.

Bellowing is contagious. When one alligator begins, another joins in, then another, and so on, until the alligators in the vicinity form a chorus. Bellowing choruses, at least the longer, more sustained choruses, occur in the morning hours, sort of like songbirds singing at dawn. As the sun rises earlier each morning in the spring, bellowing choruses also start earlier.

Although bellowing will occur any time of the day or night, and at any time of the year when alligators are active, alligators most often and most vigorously bellow in the spring months. By early to mid-May, as alligators enter the peak period of courtship and mating, they spend a fair amount of time bellowing. At this time, their bellowing choruses often split, the first round occurs before or at first light and then another span of chorusing occurs later, perhaps at ten o'clock in the morning. The bellowing sound travels far across wetlands. I have heard the strange, low rumble as far as half a mile from the source, perhaps further over open water.

Another sound of the swamp is caused by a conspicuous social display called a head slap display. Both males and females head slap, though males do it much more frequently. From an alert posture, the alligator slowly lifts its head and tail, much the same way it does before bellowing. In this case, it remains quite still, holding that posture for up to seventeen seconds. Then, very rapidly, the alligator slaps its head against the surface of the water. They often growl at the same time they slap, and they may throw in a water dance with the head slap.

In the most intense displays, an alligator will arch its back and stand up on all legs. Then it starts throwing water violently with the tail, a behavior called a tail wag. If you watch slow motion footage of a head slap, you can see that the alligator rapidly opens its mouth, slapping its lower jaw against the water, and almost instantaneously claps its jaws shut.

Why the Water Dances

Just before you hear a male alligator's bellow, the water "dances" because subsonic sound energy is released in immense outbursts. Our ears are not sensitive to these infrasonic sound waves, which are emitted as low as 16 hertz (cycles per second). If the male's torso is just below the water surface, the disruption to the water surface forms the shape of an oval disc over the body. If his back protrudes above the surface, the water dance appears as two parallel walls of water erupting along either side of his body. When an alligator is bellowing on land, you can see intense vibrations of the body wall.

The actual mechanism by which this infrasound is produced is not known, but it is likely caused by muscles of the body wall. If you are standing on land anywhere near a male alligator when it bellows, you can feel the vibrations passing through the ground and up your legs. In the water, it is a different matter.

As a graduate student, I used to swim with my study animals, and I was in the water several times during bellowing choruses. But I could not feel any vibrations in my body, even when I was only a few feet from a large bellowing male. I had thought the vibrations might be felt as intense thumping, like you feel in your chest when you stand near a large woofer. I even tried putting my head underwater, hoping my ears might detect the infrasound passing through the water. But I heard and felt nothing, even as the water danced above me. These sound waves were as undetectable to me as a dog whistle.

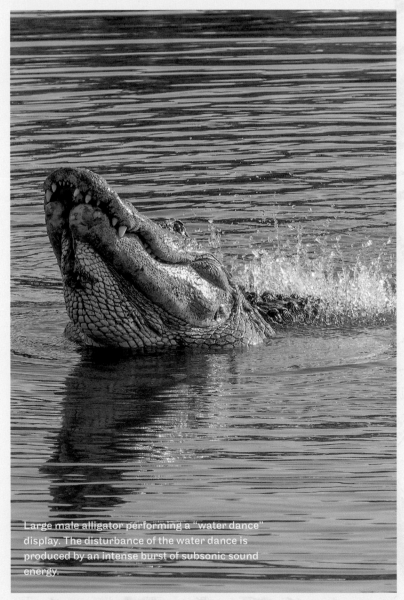

Large male alligator performing a "water dance" display. The disturbance of the water dance is produced by an intense burst of subsonic sound energy.

Look, It's a Bird! It's a Dinosaur! No, It's an Alligator!

A branch of science called systematics tries to figure out the evolutionary relationships of species. The vast majority of systematists believe that dinosaurs and the lineage leading to crocodilians shared a common ancestor, and the strongest evidence suggests that one of the dinosaur lineages gave rise to birds. Together, dinosaurs, birds, and crocodilians constitute a group called archosaurs. Of course, a lot of time has passed since the bird and crocodilian lineages split, heading down the separate paths of their own evolutionary trajectories. But we can still see some similarities shared by the two groups.

Some of the associations that are pointed out among crocodilians, birds, and dinosaurs are somewhat conjectural, as would be expected when one is trying to make analogies between the living species and long extinct dinosaurs. So we should be imaginative in trying to propose possibilities but also cautious about drawing firm conclusions. There has been a shift in our understanding of the behavior of dinosaurs, from lumbering, slow-witted beasts, to active animals that ran and leaped. We have begun to see many dinosaurs as parents that had sophisticated social displays and vocalizations and that cared for their young. Most of these behaviors have been drawn from comparisons with crocodilians and birds, and there is much modern evidence from paleontology that supports these possibilities.

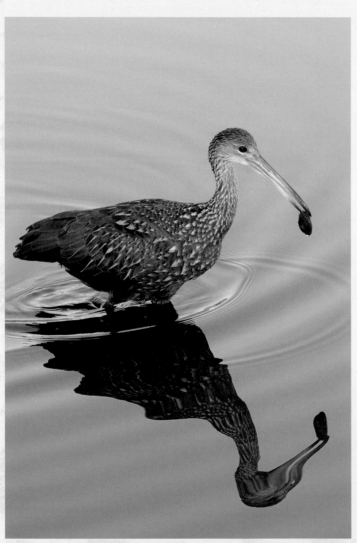

Limpkin feeding on a freshwater clam. The limpkin is a common wetland inhabitant throughout the Florida range of the alligator. Its distinctive, haunting call is often used in movies. When an alligator is nearby, limpkins will often give a loud agitated rattle.

Large male alligator performing a "water dance" immediately before emitting the loud bellow. To bellow, alligators raise their heads up out of the water. The tail must also be raised as a counter balance to the very heavy head.

The head slap display is highly variable in intensity, exhibiting gradation from relatively minor to really explosive displays. The display can include a few or many different elements and many of those elements can vary in intensity. It can be as simple as a clap of the jaws with no other elements or as complex as an explosive display that has a head slap, jaw snap, tail wag, and water dance.

The purpose of the head slap can best be summarized as, "here I am." Often alligators will jaw clap just before they leave an area or just after they get into an area. Alligators frequently select specific display sites, usually up against the bank and frequently under overhanging vegetation, from which to perform the head slap display.

Living with Alligators

Close to one hundred million people reside in states where alligators live. Today, the interactions between these people and their gator neighbors have reached a reasonable coexistence. The history of humans and American alligators has gone through the familiar stages experienced by certain other once-imperiled species: historically abundant, persecuted and overexploited, seriously depleted or rare, and finally, with legislative protection, rebounding enough to have a foothold on the future.

Without doubt, our modern experiences have many tragic flashpoints. Living with large predators anywhere means that humans have to take precautions. Even with precautions, we are bound to see rare instances of news-making headlines. Injuries and fatalities are inevitable when people share space with large animals. It may be of little consequence to point out that deer and mosquitoes kill many more people than alligators, and that we ourselves are the greatest threat posed to our fellow citizens (both intentionally and unintentionally, such as car accidents). When an alligator strikes a human, the media outlets jump on the story. In short, living with alligators requires an understanding that we can manage the interactions only so much.

At some point, perhaps by the late 1970s or early 1980s, alligators became numerous enough that complaints rose about increased conflicts with humans. Though alligator populations have recovered, species rarely attain the abundance they once enjoyed. The progress has led to population levels that are reduced but sustainable.

I think we are now close to the top of the upward trend of recovery, topping out somewhere around (we'll never know for sure) 10–25 percent of the numbers that once existed. Population levels will never again be as high as they were prior to European settlement in the New World. This is, in part, because wetland and other suitable habitats have been significantly reduced or altered

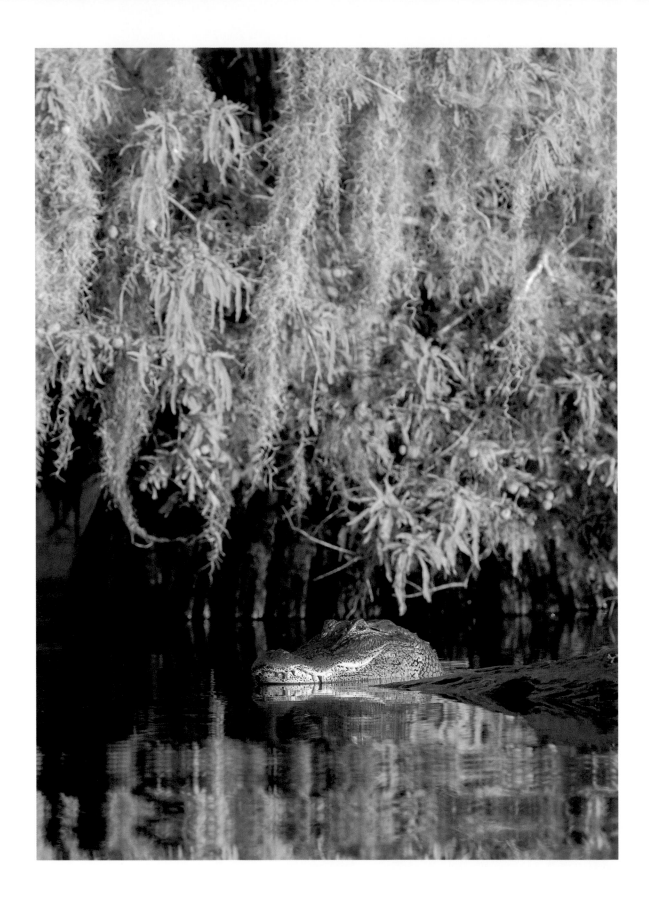

over the past three hundred years. We have created some new habitats that alligators use, such as canals, but the losses overwhelm the gains.

Real or perceived conflicts with humans compel us to impose limits to alligator population sizes. None of us is OK with accepting human loss, and many people draw the line at risks to family pets. The result is a set of very coordinated programs to keep alligator densities and locations in balance with human fears and concerns.

Every state within the alligator range has its own management program, and most allow hunting as a way to keep alligator numbers in check. I think hunting can be used effectively, if properly managed and controlled. It allows citizens of the state to become vested in maintaining healthy alligator populations because they derive economic or recreational benefits. Those benefits extend to the habitat, as well, meaning a wetland may have one more advocacy group when a developer eyes it for building or paving. Hunters can also be allies to researchers and wildlife managers by providing access to animals they take. That access allows collection of data pertinent to studies of population size, population growth rates, reproduction, and recruitment of younger animals into the adult population. Early experimental harvest programs were very closely monitored in order to gather those kinds of data and to record the number, size, and sex of the alligators taken. Wildlife managers have also been able to assess the economic benefits alligators generate, which can then be used to justify program goals and expenditures.

Not everyone believes that hunting alligators is needed or morally acceptable, and I've often listened to their opinions, especially those with strong animal rights beliefs. For most of these people, animals have their own value, place, and purpose in the natural world, and there is no justification for denying the right of the animals to existence based on our economic desires. There is no *right* answer to these sorts of issues. I don't agree with their viewpoint because I take a pragmatic approach, based on the goal of having sustainable populations while trying to reduce risks to people. That's where I think most of us fall. It certainly seems to be in line with the public positions in the alligator range states. Of course, I wish we would do a better job of preserving habitat and establishing additional refuges for wildlife, but realistically, I'm convinced we'll only go so far as a citizenry to sustain alligator populations.

Fates in the States

State wildlife authorities in each alligator range state conduct surveys of varying extents to monitor population size and population growth trends. Results from this monitoring effort allow wildlife managers to set quotas for the number of eggs and hatchlings that can be collected and the number of adult alligators to be taken during hunts in each specific area of the state. If a survey reveals

Alligators as Commodities and Conservation Keystones

Conservation through utilization has been a common theme in alligator management. The thought is that, if alligators have economic value, more people will be committed to their preservation—and to preserving the habitats in which they live. But the commodity viewpoint is countered by the fact that alligator commerce was once the big problem—ending the slaughter required eliminating the trade in alligator goods.

A key difference between then and now is the existence of effective laws and law enforcement. Today a significant portion of alligator populations is harvested for hides, meat, or other products. It is hoped that the hunts and nuisance alligator programs provide incentives for some people to counter calls for more widespread removals.

Our human population is constantly increasing, and we continue to destroy alligator habitats. But I would say there really isn't much reason for concern about the alligator's survival in the long run. This is because we have established management programs in each state that monitor alligator populations, and harvesting is largely based on surveys of population size. One example of the effort succeeding can be found in Louisiana, where private individuals own very large tracts of bayou wetlands. The property owners receive tags each year for the number of alligators to be harvested and then sell the tags to hunters. The number of tags issued is based on the number of alligators on the property. This example is the essence of sustainable utilization as a conservation tool.

Sustainable use of wildlife is not a panacea, or cure-all. It is not a good approach for all species, not even all crocodilian species. But the life history characteristics of many crocodilians (for example, large clutches of eggs and long lifespans) may make them ideal candidates for sustainable use approaches. All that is required is making sure that sufficient amounts of habitat are protected and harvests are carefully managed. As a side benefit, alligator habitats support ecological communities rich with biodiversity.

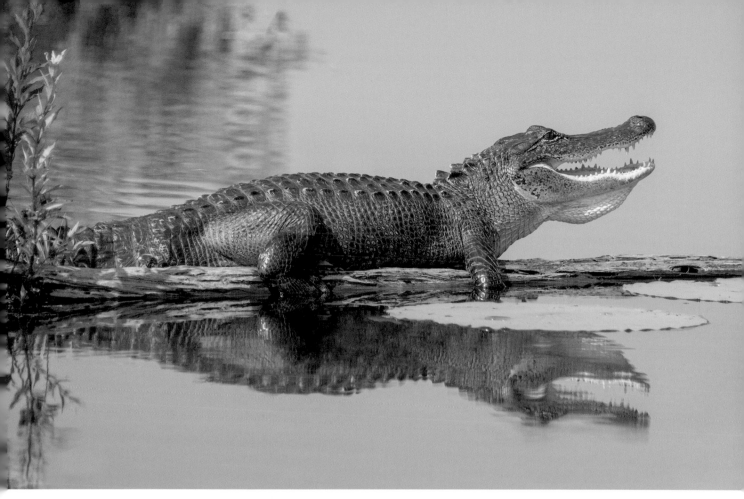

Young adult alligator taking in some sun on a log in Louisiana.

that alligator populations in an area are beginning to decline, quotas can be rapidly altered to reduce the impact of harvests on a population. These methods have been used in fisheries and upland game management for decades, and although they are not perfect, they are fairly effective when applied properly.

The marginal alligator population in North Carolina is an example of the pressure wildlife managers face. It is distributed in the coastal counties along most of the Atlantic seaboard, with the greatest preponderance in the lower-most portion of the state. Populations decrease dramatically as you move north. People living in the most southeastern part of the state feel that alligator populations are getting out of hand. However, recent statewide survey results do not support that conclusion, and researchers and managers have argued that the population in North Carolina is not large enough to sustain any sort of harvest.

A proposal to have a limited harvest of alligators was struck down by the North Carolina Wildlife Resources Commission in 2015. Then, in November 2016, that same body voted to create a fifteen-member task force to evaluate the state's alligator population and develop an alligator management plan for the state. This debate has continued because of local perceptions and politics.

Specific interested parties have pushed for a hunting season despite the contrary indications from the repeated population surveys by wildlife biologists. And so, at the time of this writing, there are plans to have a limited hunt in North Carolina. This example demonstrates that wildlife management is part science and part politics.

Considering the large size of alligators, and the very large number of alligators living in close proximity to humans, there are remarkably few human fatalities attributed to alligators. In comparison, Nile crocodiles in Africa and saltwater crocodiles in Southeast Asia kill hundreds of people each year. People living in these areas do derive economic benefit from these crocodiles, by collecting eggs and hatchlings for sale to ranches, selling skins, or being employed in crocodile management or ranching operations. In some cases, these economic benefits help communities see value in the presence of crocodiles. But the economic benefits should always be weighed against an animal population's sustainability.

Louisiana landowners receive about $150–$200 for each alligator that is harvested from their property. The state's alligator program currently harvests about 35,000 alligators a year out of an estimated population of 1.5 million. Alligator farmers in Florida recently reported annual sales of $6.8 million in skins and an additional $1.7 million in meat sales. Now that the harvesting is properly managed, both states have sustainable alligator populations.

Egg and Hatchling Harvests

Early research at the Rockefeller Refuge on alligator farming protocols helped develop farming techniques, including captive breeding, egg collection, incubation, and hatching. In 1974, the Louisiana Legislature passed regulations allowing private alligator farming operations. To jumpstart production on the newly created farms, the state began collecting eggs and hatchlings from state lands and giving them to the farms. This effort expanded to collecting hatchlings from private lands in 1986.

The high incidence of nest predation, embryonic death by nest drowning, and very high levels of mortality in the first couple of years of life suggest that a large proportion of the eggs and hatchlings produced in a year can be removed from wild populations without negative consequences to population size or growth. State biologists conducted studies in Florida in the early 1980s in which half of each year's offspring were removed from study areas over a five-year period. No detectable drop in the number of larger juvenile and subadult alligators was ever detected, suggesting that, as Dickens might have put it, they removed the excess population.

Alligator managers in the state of Louisiana took a somewhat different approach in their egg collection programs. There, biologists attempt to collect

Biologist removing eggs from an alligator nest in the Rockefeller Refuge, Louisiana, as part of a statewide alligator egg collection program.

eggs from all wild nests. In peak years, over six hundred thousand eggs are collected through the massive program. Eggs are transferred to alligator farms where they are hatched and raised. When these alligators reach 4 feet (1.2 m) in length, the farmers return a proportion of them to the wild. Currently, farmers return about 10 percent of the number of eggs collected, which is what the state estimated for the proportion of wild-hatched young that would have survived to this size in the wild. There is controversy among biologists as to the efficacy of this approach. However, tracking and recapture data suggest that growth and survivorship of these released alligators is on par with those of wild alligators.

In the past decade, the Louisiana coast has been hit by a series of large storms, causing massive property destruction and loss of life to inhabitants of that state. Alligators are displaced and killed by storm surges and pollutants spilled into flood waters during storms. Fortunately, Hurricanes Katrina and Rita, in 2005, and Gustav and Ike, in 2008, all hit the bayous of Louisiana after the egg and hatchling collection activities had been completed for the season. Uncollected eggs would have flooded in these storms and the hatchlings probably killed or displaced. Storm surges flood the bayous with highly saline waters,

Pellets of Poison

News accounts in the 1980s and 1990s, based largely on research and activism by the University of Florida's Lou Guillette, reported that alligators were a sentinel species—a "canary in the coal mine." The studies revealed that pollutants in Lake Apopka, near Orlando, Florida, were having an odd effect on the alligators that lived there. Lake Apopka had once been one of the greatest sportfishing lakes in the world, producing record-sized largemouth bass. By the 1960s, run-off from agricultural fields and citrus groves and contamination from municipal sewage had turned the lake and adjacent wetlands into a cesspool of pesticides, weed killers, and fertilizer. Organochlorine pesticides such as aldrin, chlordane, DDT, dieldrin, endrin, and heptachlor were used as insecticide soil treatments for half a century. Those chemicals became part of the lake and marsh ecosystem.

Problems with Lake Apopka's alligators became apparent during the early years of Florida's egg collection program. Fewer eggs were viable than in nests from other lakes. Of the eggs that hatched, the hatchlings were small and grew extremely slowly. A nationwide story broke when it was learned that pesticides in the environment mimic the actions of the female reproductive hormone estrogen. These "estrogen mimics" permeated the tissues of every living thing in contact with that water. Every time an alligator ate a fish or a frog from the lake, it ate a dose of estrogen mimics. The levels of these steroids built up in their bodies. Females passed these compounds on to their eggs to the point that the estrogen mimics overrode the normal temperature-dependent sex determination mechanisms in the embryo.

More females were produced than males, and the steroid mimics altered gonadal development in the embryos. Some hatchlings produced were "intersex," their gonads containing both male and female tissues. The toxic compounds had an effect of "feminizing" male alligators, producing males with small penises. The impact of estrogen mimics on humans is an ongoing area of research. Many studies suggest there are good reasons to be concerned about the role these chemicals play in human health. Although some research preceded the Lake Apopka alligator studies, there is no doubt that the public and Congress reacted to the clear-cut impact of estrogen mimics on alligators. As a result, some measures have been taken to address the widespread use of chemicals that break down into estrogen mimics, but we still have a long way to go if we are to protect ourselves and our wildlife.

Lake Apopka Water Management Area.

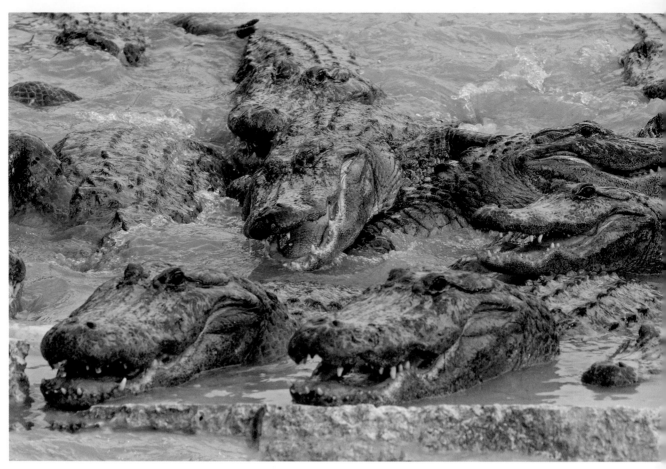

Crowd of hungry alligators waits for feeding time at the Everglades Alligator Farm in South Florida.

which would likely kill many hatchlings. Thus, it seems tens of thousands of eggs and hatchlings were saved by the alligator ranching activities conducted by the Louisiana Department of Wildlife and Fisheries.

This management practice requires monumental effort on the part of wildlife biologists. In 2016, more than 58,000 nests were surveyed and over 600,000 alligator eggs collected. Farmers released 58,105 farm-raised alligators back into Louisiana wetlands that year.

Gator Hunts

Annual alligator hunting seasons are held in most southeastern states. The 2015 fall harvest in Florida yielded more than 6,700 alligators with hunting license fees generating $1.5 million for the Florida Fish and Wildlife Conservation Commission. Hunts are conducted on public waterways as well as on private lands, with population surveys guiding how many alligators can be removed. On private lands, landowners can purchase tags for the number of

alligators to be harvested and then sell these tags to hunters using their property. Public-land hunting permits in Florida are awarded through a lottery system. Florida residents winning the lottery pay $272 and out of state hunters pay $1,000. In addition, hunters may pay a guide and must use state-approved processors to skin the alligator, prepare the hide, and butcher the meat if they intend to sell these products.

As legalized harvests became annual events, hunters started using tactics from other big-game harvests. Professional guides seek out the biggest alligators in the months prior to the fall alligator harvest, learning where they stay and their patterns, so that they can find these huge alligators for their clients. Some hunters are now using electronic predator calls to attract alligators toward them so they can shoot them with a crossbow.

Of the nine states with significant alligator populations, only North Carolina does not currently have an annual harvest (but will have a limited hunt soon), and Arkansas only allows small harvests, perhaps seventy to ninety alligators taken in each harvest. South Carolina initiated their Private Lands Alligator Harvest Program in 1995 to allow private landowners with large tracts of land to manage alligators on their property. Size- and class-specific quotas, based on habitat area and survey data, are set each year for each property. In 2008,

Archival photographs of early alligator hunters.

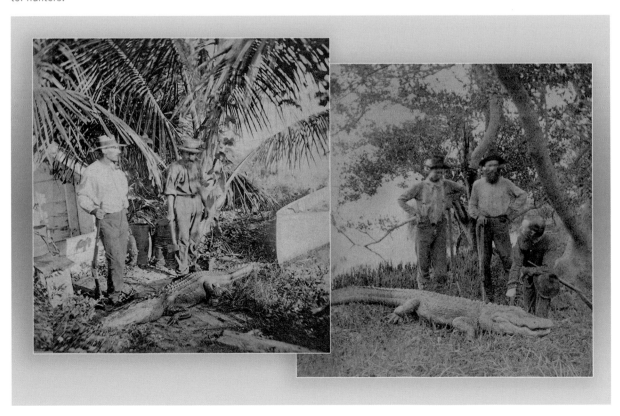

South Carolina opened a general alligator hunting season on public and private lands. Applicants are selected at random to receive a permit and hunting tag to take one alligator from a specific hunting area. Just over one thousand tags are issued each year.

There is not a current, reliable estimate for the number of alligators in South Carolina, though some say there are perhaps one hundred thousand. The absence of systematic surveys of the state does concern harvest managers. In 2015, biologists from Clemson University, assisted by biologists from the South Carolina Department of Natural Resources, initiated a comprehensive survey of alligators in South Carolina—the first in more than three decades. In the 2014 annual hunt, the average size of alligators killed was only 8 feet (2.4 m). This size raised concerns that the annual harvests could potentially deplete the wild stock.

Not in My Backyard

The sight of an alligator can be a thrilling experience, even for people who live in the southern United States. But that thrill can turn to fear or disdain pretty quickly. When an alligator preys on a pet or shows up in a swimming pool or on a back porch, people expect someone to do something about it. As a way of reducing actual or potential conflicts, every state in the alligator's range has some form of nuisance alligator removal program. Alligators do not have to do anything overt to be considered a nuisance. Someone just has to be concerned enough to make a phone call.

Even if the probability of an attack is quite small, state wildlife managers take public concerns and complaints seriously. The goal is to make sure that the public feels reassured that state authorities are dealing with problem alligators. In a sense, nuisance alligator control programs protect alligators from people as much, or more, than they protect people from alligators. Not only do these programs help foster more favorable attitudes toward alligators, they also reduce the chances that people will take the law into their own hands.

As populations of both alligators and humans have increased over the past few decades, so have the number of nuisance alligator complaints. In Florida, the state received about five thousand nuisance alligator complaints in 1978, but now gets well in excess of ten thousand calls. On an average summer day, it would not be unusual for the state to receive fifty calls. The 12,772 nuisance alligator complaints Florida received in 2016 led to the removal of 8,118 alligators.

To handle all this work, states establish contracts with private individuals who serve as nuisance alligator control agents. In Florida, each agent has a district. When the Florida wildlife emergency hotline gets a complaint that is judged to be valid, the agent in that district is issued a tag for the offending alligator. The agents are not paid by the state. Their earnings come from whatever

they can make from the sale of the hide, meat, head, or other products they obtain from the nuisance alligator.

Enough alligators wander about in the normal course of their life that some invariably end up in the wrong place at the wrong time. Although an attack of a dog or calf will be enough to prompt a call to the hotline, the most serious threat they pose is to people. Florida records more alligator bite injuries than any other state, usually in the range of twelve to twenty-four unprovoked bites each year. That's more than all of the other states combined. Florida has also been the location of the vast majority of fatalities: twenty-seven of the thirty-one recorded alligator-caused deaths since 1948.

There is nothing different about alligators in Florida. The state's ignoble position in this regard is all a matter of numbers. Florida has a very large alligator population, at least 1.3 million non-hatchling alligators. And Florida is the third most populous state in the union, having an estimated twenty-one million residents, which is increasing by another quarter of a million each year. On top of this, over one hundred million people visit the "Sunshine State" annually. Most of these residents and guests spend lots of time in, or next to, the water. Almost everyone will find themselves somewhere near an alligator during the course of their travels.

In contrast, Louisiana has 15 percent more alligators than Florida but less than one-quarter Florida's human population and seventy million fewer visitors.

The exact number of alligator-caused fatalities is not known with certainty, because it is not always possible for medical examiners to determine with confidence that the alligator caused the death. There are known cases of accidental drownings, for example, where an alligator damaged the body after death. Thus, if the attack is not witnessed and a body is found in the water with alligator-inflicted damage, it can be difficult to determine if that damage was pre- or postmortem.

When alligator-attack record keeping began in 1948, it was nine years before the first suspected fatality was recorded—a nine-year-old boy. The next death was in 1973, a sixteen-year-old girl swimming in a state park at dusk. One year earlier, during the summer of 1972, four children between six and fifteen years of age were attacked in a two-month period. Since the 1970s, the number of recorded attacks has continued to increase, corresponding with increases in the numbers of alligator and humans in Florida.

The first alligator-related fatality in Texas since 1836 was recorded in 2015. A twenty-eight-year-old man jumped into Adam's Bayou in Orange, Texas, at two thirty in the morning. He was immediately seized and pulled under by an 11-foot (3.3 m) alligator. The next year, a ninety-year-old resident of a nursing center in Charleston, South Carolina, wandered away from the facility. She was found in a pond behind the center, an apparent victim of an 8-foot (2.4 m) alligator. This was the first alligator-related fatality since South Carolina began

Dead alligator on the side of a road, a victim of being hit by a car. This is a dangerous occurrence—people have been killed when they lost control of their vehicle after hitting an alligator.

keeping records. The 2007 death of an elderly woman found at a golf course water hazard on Skidaway Island, Georgia, was deemed an alligator attack. It is possible that she stumbled into the pond prior to the attack.

Louisiana, despite having more alligators in the state than Florida, and despite experiencing a number of bites and injuries, has not experienced any fatalities. This may be due to the multigenerational families who live there. Many are hunters and fishers, accustomed to the presence of alligators in the environment. Residents of Louisiana may benefit from their understanding of how to behave around alligators.

One particular type of attack occurs on or near land. These attacks, including one fatality, were on people doing landscaping. In each case, the people were on the edge of the bank or in shallow water, crouched down or bent over with their backs to the open water. They were pulling out plants or cutting them back—conspicuous actions certain to be noticed by a nearby alligator. Each person remained in more or less the same spot for a long time, a half-hour or more. Under most circumstances, I do not believe an alligator, even a big one, would

be motivated to attack a person in this situation. But a predator's mind is always calculating, and the chances of a successful attack seem more certain with a person crouching, remaining stationary, and facing away from the advancing predator. Aside from people actually swimming in the water, I suspect people doing landscaping or similar activities near the water's edge is the second most common "class" of attacks by alligators on humans.

Some inherent dangers do exist in attacking larger prey, such as humans, though these risks are fairly limited for an adult alligator. There is always the potential for injury, a broken jaw or damage to an eye for example. Prey are fighting for their lives, whereas the predator is only after its next meal. So, their relative motivations in the struggle are quite different. I believe predators assess these sorts of factors in their decisions about initiating an attack, and in evaluating whether to maintain an attack once engaged. An alligator may break off an attack if the balance of the two motivational forces of fight or flight shifts.

I think this fight-or-flight factor is often in play during attacks on humans while swimming. Alligators are only looking across the surface of the water, not below. So very little of a person swimming or floating in the water is visible to the alligator. Movement and access to prey motivate the attack. Once an alligator takes hold of a person in the water, it may be surprised by the degree of struggle. The alligator may realize it has something larger than it bargained for, and it may release the victim—a shift from fight to flight. However, if an alligator is large enough, or if it is sufficiently energized by the success of the initial attack, it may not care that the prey is larger than it initially expected. The attack continues.

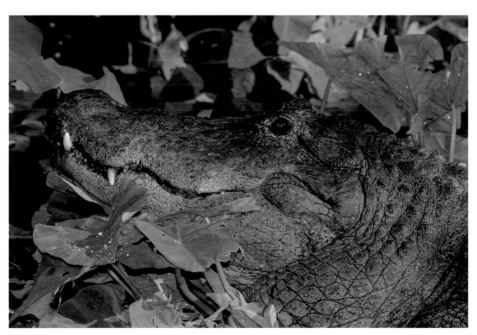

Large alligator hiding in vegetation along a lakeshore.

Antibiotic Alligators?

Alligators injure themselves and each other often. These injuries include amputations of legs or ends of tails. The injured animals seem to just keep right on going. Despite open wounds that are exposed to water full of potentially pathogenic organisms, alligators infrequently develop severe infections. We now know that the blood of alligators has strong antibacterial properties, and we suspect these properties extend to all of their tissues.

If you grow bacteria in a petri dish and you drip a drop of alligator blood plasma on it, everything that touches the plasma dies. The impact extends beyond bacteria: amoebas, fungi, and some viruses, including HIV, are killed.

Researchers have begun examining tiny proteins in the blood plasma that seem to be responsible for at least some of the protective properties. These proteins are called anti-microbial peptides, or AMPs for short. The blood of alligators has thousands of varieties of them. Each AMP appears to be lethal to some form of pathogen and, in combination with all the other types of AMPs circulating through the animal, can probably overwhelm almost all forms of infectious organisms.

Humans are facing a very real crisis of antibiotic-resistant bacteria. It is possible that alligator AMPs offer a new type of antibiotic therapy. It is also possible that these same mechanisms may be responsible for the extreme rarity of cancer among alligators. We aren't there yet, but the research into these areas is promising.

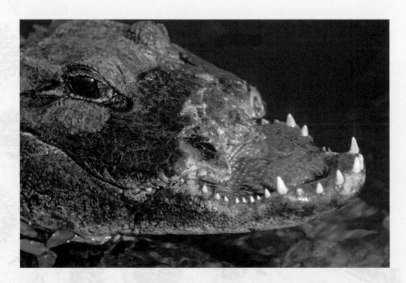

Alligator with horribly disfiguring injury. This poor beast apparently lost a fight with another alligator. But, as terrible as this injury appears, the wound is clearly healing. Alligators have remarkable immune systems that limit infections in many cases.

There are quite a few cases of bites on swimmers where the alligator initiates the attack, the swimmer struggles, and the alligator lets go, only to attack again. One never knows for certain what the motivations of other organisms really are, but it is possible these attacks represent exactly this notion of a shifting balance of motivations—initial fight, then flight, then a shift back to fight again.

We tend to think of alligators as the predators and humans as the victims. One fact that surprises most people living in states with alligators is that, compared to most crocodilians, the American alligator is relatively benign, almost shy. In truth, humans have always been the predators of alligators, even before the slaughter of the past few centuries began. Even in recent times, people have accounted for the deaths of tens of thousands of alligators each year. Alligators, on the other hand, have killed about two dozen humans in the past six decades. To be sure, alligators can be dangerous, even deadly, and we all need to treat them with respect.

It is only natural to be repulsed by the thought of being attacked and killed by a predator. To be caught in a predator's grasp and dragged underwater must certainly be the most primal fear of all. Humans naturally want to remove potential dangers from their lives. Although such fears are difficult to overcome, it may be possible to at least put these fears in perspective. In the sixty-five years from 1948 to 2013, Florida's alligators were responsible for 22 fatalities, 206 major injuries, and 116 minor bites (the data exclude provoked attacks). In contrast to the alligator attacks, more than 150,000 people are injured in car accidents every year in Florida, and more than 2,500 auto-related fatalities occur annually.

Most alligator-attack victims were Florida residents (93.5 percent), and most bites occurred during the day and in residential neighborhoods. Most of the offending alligators were males (77 percent) and larger than 8 feet (2.4 m). About two-thirds of the incidents involved a single bite, rather than multiple bites. Half of the victims were alone, and most (87 percent) were either in the water or at the water's edge. More than a third of the alligators had been fed by humans previously. A dog was present during 10 percent of the bites. No females guarding nests were ever documented delivering a bite.

There are learning opportunities to be taken from the data on alligator attacks. First, the odds of an attack diminish if you swim in designated areas. You should also keep your pets away from natural waterways. And it's a bad idea to feed gators. Feeding them brings them closer and makes them associate humans with food. Just because alligators will let you get close to them doesn't mean that it is wise. I always suggest staying at a safe distance, certainly no closer than twenty feet. The odds will always be on your side. The chance of being attacked is small, no matter how reckless a person behaves. But the chance increases from nearly zero to possible when you ignore sound advice.

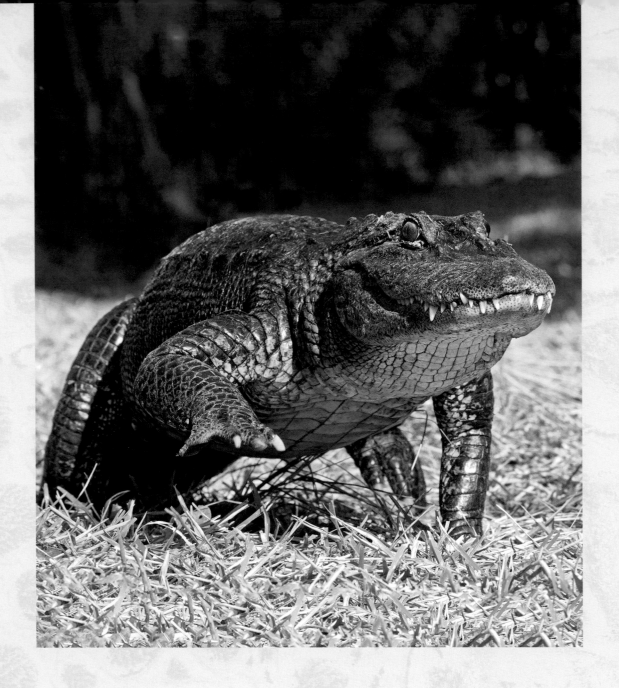

From Slaughter to Salvation

That American alligators were becoming rare was apparent to some people by the 1880s and to many more over the next few decades. Where alligators were once seen lying on top of one another along the banks of rivers—by the dozens or hundreds—they had become scattered sights or were absent. The only alligators that survived the hunters and target shooters were those that seemed wary by nature; animals that disappeared into the water at the first sight or sound of an approaching human. Or they were alligators that preferred the densest vegetation, far from human transportation routes.

The escalating pressure of hunting that followed the Civil War was not limited to the alligator. The complete annihilation of American bison herds is well known. The passenger pigeon was once the most numerous species of bird in North America, with numbers estimated in the billions. They were shot for meat, to be used as fertilizer, and as food for hogs. By the 1890s, only seven remained; the last of the species died in 1914 in the Cincinnati Zoo.

The unregulated slaughter of alligators slowed in the 1960s and finally ended by 1970. But, compared to pre-Columbian numbers, there were only about 2–4 percent of alligators left by the time Neil Armstrong walked on the moon. Still, there was reason for hope, as America had somewhere between 250,000 and 400,000 wild alligators. Rebuilding the populations throughout the range seemed possible.

There's no doubt that wetland preservation was the main reason alligators escaped extinction. They were saved in places like the Everglades and Big Cypress regions of Florida, the Okefenokee Swamp that spans southern Georgia and North Florida, and the expansive coastal marshes of Louisiana and Mississippi (Rainey and Rockefeller refuges and Louisiana's state wildlife refuges). Had these places not been preserved, and had the slaughter continued a few

The existence of large protected wetland refuges saved the alligator during its bleakest period. *Clockwise from upper left:* Everglades National Park (Florida), Rockefeller Wildlife Refuge (Louisiana), Okefenokee National Wildlife Refuge (Georgia/Florida), Big Cypress National Preserve (Florida).

more decades, we well might have seen the American alligator go extinct. But the environmental awakening that took place in the 1960s helped save an American treasure.

Before the Endangered Species Act

Even before the Endangered Species Act was passed and the alligator was given federal protection, some states did protect the species to varying degrees. Alabama was particularly aggressive, protecting alligators as early as 1938.

The Florida legislature passed a law in 1906 restricting hunting of alligators in certain areas of the state. In 1925 and 1927, the Florida Department of Game and Fresh Water Fish adopted a series of laws regulating alligator harvests in various counties. Hunting was allowed from the first of March through

mid-November in five counties making up the southern Everglades. Alligators could be taken only in January and February in Hendry County, and only in January in Brevard and Volusia Counties. Some other counties had similar restrictions.

Florida also started collecting fees for hunters' licenses. The state designated the State Alligator Reservation on Tomoko Creek and River, Volusia County, as a permanent refuge for alligators in the late 1920s. In 1944, Florida passed a state law prohibiting the taking of any alligator under 6 feet (1.8 m) in length, and it protected all alligators during the breeding season. Florida alligators finally received statewide protection on September 2, 1961. Louisiana stopped commercial hunting of alligators in 1962.

Despite the continued tightening of commercial hunting in the states, and the earnest and vigorous efforts of state wildlife law enforcement agencies to arrest and prosecute individuals caught poaching alligators, the hunts continued. Laws on paper are one thing, but until laws change behavior, they have little impact.

On July 1, 1971, Florida prohibited the sale of all alligator products in the state. The law also made it illegal to possess lights and weapons in the vicinity of alligators and allowed for the seizure of vehicles, boats, and gear. These laws made it easier to charge poachers.

As other southern states passed laws similar to Florida's, Texas was slow to act. Alligators were completely protected in only two Texas counties, and had no state protection in the other forty. Hunting had been so ferocious for so long in Texas that, by the mid-1960s, alligators were in grave danger of statewide extinction. But the bigger problem was that hides taken in other states found a market in Texas. Poaching in Louisiana and Florida was supported because hides were

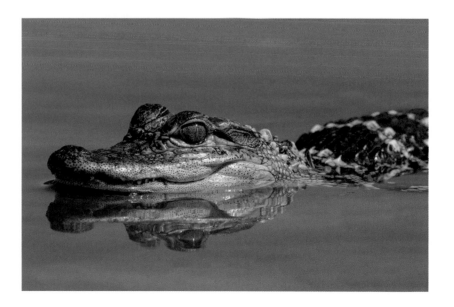

Legislation ultimately saved the alligator. Early laws in Florida prevented the taking of alligators under 6 feet (1.8 m) in length.

smuggled into Texas and sold. The exporting of alligator hides was a principal reason Louisiana wildlife officials strongly pushed for stronger federal laws.

The Long Road to Growing the Population

The Endangered Species Preservation Act of 1966 was the first iteration leading to the US Endangered Species Act of 1973. The Preservation Act mandated that a system be developed that would assess and classify native species that were in need of protection. The initial list of endangered species was published March 11, 1967, and included seventy-eight species. The American alligator was one of them.

In 1969, Congress passed the Endangered Species Conservation Act, which replaced the Preservation Act. The Conservation Act was the second iteration of America's attempt to build a robust list of threatened and endangered species. The American alligator was one of the iconic species on the list. The Conservation Act included two provisions that were particularly important to the alligator. The first was an amendment to the Lacey Act to include reptiles, amphibians, and certain invertebrates among the animals that could be regulated with regard to interstate commerce. The second provision proposed an international convention be organized with the aim of developing a treaty on wildlife trade and conservation. The result of that provision was the creation of the Convention on International Trade in Endangered Species, commonly called CITES. To this day, CITES is the most effective international protection for endangered and threatened species.

The Lacey Act was first passed in 1900. It was the first federal law in the United States to regulate commercial activities related to animals. It restricted the interstate commerce of animals or animal products that were illegally obtained under the laws of the state of origin. The law was created to stop the trade of egret and heron plumes, as well as other birds and mammals. The 1969 amendment to include reptiles and amphibians was instigated by Ted Joanen of the Louisiana Wildlife and Fisheries Commission. His inspiration was a desire to protect alligators being sold in Texas. Joanen began his effort in 1964 when he urged the Southeastern Association of Game and Fish Commissioners to pass a resolution to press Congress to amend the Lacey Act. The association worked with a Louisiana congressman who introduced a bill amending the Lacey Act beyond birds and mammals. Pressure on Congress was maintained, and five years later the Lacey Act was finally amended as a part of the Endangered Species Conservation Act. The changes took effect in January 1970.

The impact of the Lacey Act changes on illicit trade in alligator hides was almost immediate. For the first time, wildlife law enforcement officers had a federal law that could be used to charge alligator poachers. The pressure was quickly ratcheted up on illegal operations. High-profile prosecutions in Florida

Only a Pawn in Their Game

The alligator became a pawn in a struggle among competing interests in the 1960s. On one of many sides there were politicians intent on passing the Endangered Species Act, and the predecessor legislation to the Act. Then there were the pragmatic wildlife managers and regulators, both federal and state, who acted on their own to address the species' decline in their locales. And there were the trappers, tanners, and manufacturers—they were interested in the economic value of the alligator as a resource. There were also the somewhat fledgling animal rights groups, some of which were opposed to wildlife products of any kind. Finally, there were some mainstream environmental groups that used the alligator as a rallying cry and as one of their iconic species during fund raising efforts.

The many players in this chess game shared some common goals but did not always see eye to eye. Sometimes they opposed each other's moves. In the end, the alligator survived, and it continues to serve as a prime example of how effective state and federal legislation can be. But the story is more complex than just passing a law. Alligators benefitted from effective management programs and prior efforts to preserve wetland habitats. The alligator example continues to provide inspiration to new generations of conservationists because it reveals that a heavily persecuted and vulnerable species can recover to a level that some might reasonably describe as thriving.

resulted in a marked reduction in poaching in 1970 and a virtual elimination by 1971. In Louisiana, a repeat-offender was given a sentence of five-and-a-half years in jail. Poachers were shocked by the renewed seriousness with which the wildlife officials and courts were now taking alligator poaching. Within a few years, all the large, organized alligator poaching operations in the South had been completely dismantled. Almost all poachers who were charged were prosecuted under the Lacey Act.

In the wake of the amended Lacey Act, several states passed laws completely banning the sale of any crocodilian products. Among the states that passed such restrictions were California, Connecticut, Illinois, New York, and Pennsylvania. Large cities with affluent, high-end fashion houses that sold alligator products began to withdraw from that business.

The Arrival of the Endangered Species Act

On December 28, 1973, President Richard M. Nixon signed the US Endangered Species Act. The remarkable and rapid recovery of the American alligator under the protections of the Endangered Species Act is often touted as one of the great success stories of that law. These claims are somewhat exaggerated. The

Endangered Species Act played only a minor, supporting role, though its predecessor acts of 1966 and 1969 were helpful. The various state laws enacted in the 1960s certainly helped slow the slaughter. It was the amendment of the Lacey Act in 1969 that was probably the critical legal change that helped end the killing.

Beyond the preserved wetlands and the legal changes, it was biology that next aided the alligators. The species' remarkable resilience and substantial reproductive capacity allowed populations to grow quickly when the slaughter fully ended in the 1970s. One might argue that enough had been done by 1973 that the alligator could have been classified as threatened, rather than endangered, when the Endangered Species Act was finally passed. A questionnaire completed by members of the Southeastern Association of Game and Fish Commissioners in 1973 indicated an estimated total population size of 734,384 alligators. There is some evidence that, in 1973, 168 counties within the alligator's range had increasing alligator populations, 152 had stable populations, and only 25 counties had decreasing populations. (Florida counties were not included in this survey because they did not have population trend data at the time.)

Despite the technical reasons why alligators might have been classified differently, politics led things toward a classification as endangered. The alligator was a "charter" member of the endangered species lists of the 1960s and, as

the assistant secretary of the interior said at the time, its removal from the newly minted Endangered Species Act could have weakened the chances of the Act passing. So, the alligator not only was on the list, it was on the list as endangered—a species that is in danger of extinction throughout all or a significant portion of its range.

Within a few years after passage of the 1973 Endangered Species Act, some areas were experiencing problems because alligators had become numerous enough to be perceived once again as a danger to residents. The term "nuisance alligator" is still with us today and had its roots in the early days of the alligator's comeback. As state, and then federal, legislative protection took hold, alligator populations began to rebound remarkably quickly. Alligators also seemed to become a bit less wary of people. State and federal wildlife biologists became inundated with calls to relocate alligators to remote areas away from people. It was time- and labor-intensive work, and as alligators became more numerous, the strain on resources mounted.

As early as 1975, alligator populations in many prime areas had assumed population sizes that made it overwhelmingly obvious that their status as endangered was not defensible. The Governor of Louisiana petitioned the federal government to delist the alligator from three southwestern parishes: Cal-

The Endangered Species Act protects hundreds of species. This protection has helped many populations rebound, including the alligator. *Clockwise from upper left:* grizzly bear mother and yearling cub, Florida manatee, adult male snail kite, and adult bald eagle.

casieu, Cameron, and Vermilion. Rather than delisting alligators entirely, the status was changed to "threatened by similarity of appearance" to the American crocodile, which was a legitimately endangered species. The new classification still mandated protection and management.

The change of status did allow limited hunting of alligators in the three parishes, but the hunting was highly regulated. Wildlife managers and wildlife law enforcement officers now faced their old problem again: there was no way to recognize alligators or skins taken legally from alligators illegally poached elsewhere. The good news was that the similarity of appearance classification allowed managers to require that each legally collected hide was tagged to differentiate them from poached hides. Louisiana provided its legal hunters specialized tags to be affixed to each skin as soon as the alligator was killed. The tag, locked through a slit in the skin at the end of the tail, was required to be attached to the skin through the entire market process—from skinning, cleaning, storage, sale, tanning, finishing, and sale to a fabricator. The tag was only removed when the skin was being cut into the pieces used to manufacture the final product. Skins without a tag were known to be illegal, greatly reducing their value and marketability. A similar process is used to this day on all legally marketed crocodilian hides all over the world.

Protected alligators in Everglades National Park seem to appreciate the warning signs.

The Comeback

With a fair amount of habitat still intact and plenty of prey around, alligators in many areas began to thrive in the 1970s. By 1977, things were looking up in Florida and the US Fish and Wildlife Service proposed changing the alligator's status in the entire state from endangered to threatened. They proposed the same status change for coastal populations of South Carolina, Georgia, Louisiana, and Texas. The change was controversial and triggered a frenzy of comments, both in support and opposition of the change. In 1979, alligators were reclassified as threatened by similarity of appearance to American crocodiles in nine additional Louisiana parishes, and by 1981, all of Louisiana's alligators were reclassified. The low point was in the past and alligators were on the rebound.

On June 4, 1987, about twenty-five years after the most earnest conservation efforts began, the American alligator was officially declared a recovered species throughout its range. This change marked the first official recovery of an American species. Even today, alligators continue to receive some federal oversight because they are still listed under the Endangered Species Act as threatened due to similarity of appearance. Anyone who hunts or possesses alligators must, due to federal and/or state laws, have appropriate permits.

America doesn't have as many alligators as we once did, but we also have many fewer wetlands than in the past. Less habitat always equals lower numbers of any species that relies on that habitat. All matters considered, we probably have 10–20 percent of the number of alligators that were present in America on the day Ponce de León first set foot in Florida.

The reason that alligators recovered lies in these three facts: First, the carnage stopped before alligators became extremely rare. They fell to 2–4 percent of historic numbers, which was not ideal, but was manageable. Second, there was enough habitat left to support a few million alligators. The credit for that goes to E. A. McIlhenny and a host of other wetland preservationists. Third, wildlife managers, legal professionals, law enforcement professionals, and politicians teamed up to create a system that controlled the out-of-control alligator harvest. These three factors allowed for recovery, while the speed of the recovery can be credited to the alligator's resiliency and the species' high reproductive output. Similar efforts for species that have one offspring per year might have required centuries, whereas the alligator's recovery only took a couple of decades.

There are enough wild alligators today that I can say with confidence the species will be here long after the humans who saved them. And that is the outcome every conservationist hopes to achieve. It's a legacy, a way of leaving the world a little better off than it was.

Alligators at Sunset

From the first time I captured an alligator when I was a fledgling graduate student to my most recent fieldwork, I've maintained a sense of wonder and respect for this great American predator. Deep in the swamps of the South, surrounded by cypress trees as the sun goes down, when catching a glimpse of eyes on the water's still surface, it hits you: there are still dragons among us. At least metaphorically.

A trip to the Everglades or through the Okefenokee Swamp will make almost anyone a fan of alligators. You feel like you've been transported to the Jurassic. Even just a glimpse of an alligator in the water, or basking along the shore, will rival your best vacation experience. Perhaps alligators represent our last links to the wild and remind us that we are part of nature, holding just one of many places in the natural order. Maybe we perceive our own evolutionary roots as a prey species—roots that run far deeper than our recent role as a predator. Some are repelled or even repulsed by this possibility. The mere thought of being seized by a predator in the water is unnerving—especially when it's a predator that casually glances at us before deciding whether we are something worth pursuing. The American South is not a zoo, and everyone who treads there watches alligators through neither bars nor glass.

The same primal fear of predators simultaneously attracts us to alligators and pushes us to avoid them. The allure of the alligator (to borrow a beautiful phrase from Virginia Tech professor Mark Barrow) draws us to them, makes us want to get as close as we safely can, and tests our nerves. We do know that, as alligators became scarce, the desire of people to see them grew, and captive alligators became more numerous. With millions of alligators in the wild today, and many thousands in captivity, anyone who wants to see one will surely find plenty of opportunity.

Alligators were a booming business long before the first "alligator farms" came into being. Leather made from their skin has long been a fashionable commodity, even if it doesn't always make the most durable product. Alligator oil, meat, teeth, and even small skulls and stuffed baby alligators are still sought after by visitors to the South.

Alligator farmers were among the first to figure out that visitors would pay a small entrance fee to see the animals, and they soon began selling merchandise to these guests. Fascinatingly, the most prized purchase by early tourists visiting the farms was a live baby alligator. Demand for baby alligators was so high that alligator farmers developed incubator facilities to hatch large numbers of eggs collected mostly from wild nests. In 1921, "Alligator Joe" Campbell's farm in South Jacksonville, Florida, sold more than ten thousand live baby alligators. That was just one of many farms. You could even order one: baby alligators sent by mail cost $2.00 for one and $3.85 for two, and for an extra $0.50, you were guaranteed live delivery. It wasn't a healthy fascination, but the American alligator and the American people had forged a connection.

A Future with Alligators

Alligators are remarkably well adapted for coexisting with humans, perhaps more than any other large American predator. The question really is, can we live with alligators? Their fate is our choice. Today, their future in most areas looks bright; we have overcome the uncontrolled slaughter and there is now sufficient habitat and protection for them to flourish. With the exception of potential issues in North Carolina, and putting aside debates about the particular man-

agement approaches taken by each state, I think most alligator experts would reasonably conclude that American alligators are a crocodilian we don't need to worry too much about. The American alligator's cousin, the Chinese alligator, is a very different story.

I believe that today's well-regulated management practices, including annual harvests, egg and hatchling collections, and nuisance alligator control, have succeeded in keeping most people comfortable with the idea of alligator-human coexistence. Of course, it would be ideal if the generally peaceable and shy alligator never attacked a human. These events are mercifully rare, markedly less than the odds of being struck by lightning or having a serious reaction to a bee sting. Even cows and horses are more dangerous. In fact, pet dogs pose a much greater risk to people than alligators, not to mention the greatest threats of all—fellow humans and daily trips in our cars.

The good news is that we have found a way to live with alligators. A good example can be found in the communities on Sanibel and Captiva Islands, on Florida's southern Gulf Coast. They have an abundance of nature and wildlife. Their shores are scattered with sea shells and are considered by many to be the finest shell-finding beaches in the United States. The inhabitants of Sanibel and Captiva have a strong sense of environmental protection. Decades ago, plans for large-scale development caused the formation of the Sanibel-Captiva Con-

Sanibel Island beach

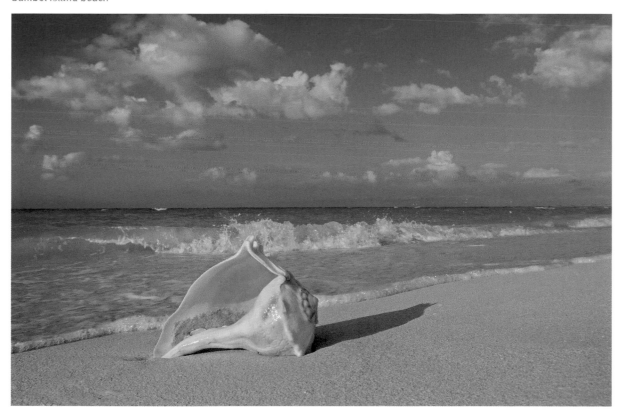

servation Foundation. The foundation acquired its first parcel of land in 1968. Since that time, it has protected more than 1,850 acres. This small group of people prevented large-scale, high-density housing development over much of these islands.

When the State of Florida began the nuisance alligator removal program, the residents of Sanibel and Captiva petitioned to be excluded from this program. They argued that they would rather learn to live with their alligators, not see them killed. Alligators that caused problems were captured by local authorities and moved to other regions of the islands. For a long time, the program succeeded, even though alligators became plentiful and the human population grew as well. This peaceful coexistence was shaken in 2001, with the death of an eighty-two-year-old man on Sanibel Island. He was grabbed by a large alligator while he was walking with his dog on a narrow path that ran between two wetland areas.

The relationship between alligators and people on Sanibel and Captiva was further shaken by a highly publicized attack on a landscaper on Sanibel. She was working with her back to the water when a very large male alligator seized her. A person nearby grabbed hold and a tug-of-war ensued. The alligator eventually released its grip, but only after many minutes. The landscaper's injuries were severe, and she died two days later from infections.

These attacks broke the community's solidarity. Nuisance alligator control agents descended on the islands, and hundreds of alligators were killed over the next few years. The magnitude of alligator removal was so extensive that some citizens argued it had gone too far. The Sanibel-Captiva Conservation Foundation began a community education campaign to encourage a reduction in nuisance alligator removal. The foundation initiated a type of "neighborhood watch" program, which I believe is unique in the United States. The program's intent is to raise the public's awareness of the alligators on the islands, and in their neighborhoods, and to educate the many occasional visitors (such as people with second homes on the islands and tourists). People are taught the proper dos and don'ts of living among alligators.

One person living in each neighborhood serves as an alligator ambassador. Whenever new homeowners or renters arrive in the development, the alligator ambassadors welcome them to the neighborhood and talk with them about the alligators in the area and where they might encounter them. These ambassadors explain the ways we can all live as safely as possible when living near hundreds of alligators. They encourage their new neighbors to contact the ambassador, rather than the police or game commission, if they sense a problem with an alligator in the neighborhood. The ambassador can then evaluate the situation and perhaps help alleviate the neighbor's concerns. The creation of alligator ambassadors has greatly reduced the number of nuisance alligator complaints on Sanibel and Captiva Islands.

There is an exclusive golf and tennis community on Sanibel Island called "The

With proper management, education, and care, the future of this hatchling alligator looks bright.

Sanctuary." It is built within the island's forest and wetland habitats, with every effort made to preserve the natural area—so much so that it is recognized by the Audubon Society as a bird sanctuary. Alligators live within The Sanctuary and make use of the water features along the golf course. Kyle Sweet, the superintendent of the course, wanted to institute modifications to the golf course that would ensure the safety of The Sanctuary's members without negatively impacting alligators. I've worked with Kyle during this process.

Embankments and extensive landscaping were installed to act as natural barriers between alligators and members. Basking beaches were built on portions of water features away from human traffic. Steep, low earthen walls and landscape plants were constructed to limit the alligators' movements up onto fairways; they also keep alligators out of sight of the golfers. I have given talks to the members living in the development and spoken with grounds care staff about alligator behavior and how to assess whether an alligator is a potential problem. A few additional golf courses on Sanibel and nearby communities have started using similar methods to help them coexist with alligators on their courses.

We can, and I think we should, all learn to live with alligators. They preceded even the original tribes, and with a bit of caution, we can further reduce the risks of living with predators. Our goal should always be safety, but it must be balanced with respect for nature. I urge everyone I meet to learn as much as they can about alligators and watch them from a safe distance whenever the opportunity allows. When you do, you will sense a connection with nature. It's a connection I've been lucky enough to explore for decades; a connection to nature through alligators that I hope I've now shared with you.

Acknowledgments

Kent A. Vliet

I've spent the last forty years of my life, my entire professional life, studying alligators and other crocodilians. I had the good fortune of growing up in a university town and had the opportunity to interact with a number of prominent biologists who recognized my passion for reptiles. They made it possible for me to work in the University of Oklahoma's research laboratories after school while I was still in junior high school. For taking the time to care, I thank George Lynn Cross, former president of the University of Oklahoma, George M. Sutton, the great bird artist and author, Victor Hutchison, then chair of the Zoology Department at OU and in whose lab I began, and Charles C. Carpenter, pioneer in the study of reptile behavior, with whom I worked for several years, and who showed me the wondrous lives these animals lead. I owe these gentlemen infinite thanks and gratitude for the career they made possible. Walter Auffenberg and F. Wayne King drew me into my first study of alligators. And I can't fully express how much I appreciated the many times I was able to sit and talk with Archie Carr about alligators and other Florida wildlife.

My initiation into the world of alligators was due to the generosity of David Drysdale, owner of the St. Augustine Alligator Farm Zoological Park, who allowed a young researcher access to his animals and facility. He is a true southern gentleman in all manner of the term—charming, sophisticated, intelligent, social, steeped in the history of St. Augustine, and a consummate storyteller. I thank him for all he has given me and for the pleasure of spending so many wonderful times with him over the years.

I thank all those staff at the Alligator Farm with whom I've worked and learned, especially its director, John Brueggen, but also Tim Williams, Lynn Kirkland, Mark Wise, David Kledzik, Greg Lepera, Kevin Torregrosa, Jim Darlington, Gen Anderson, and all the other staff who have helped me so much over the years.

Wayne Lynch provided so much more than just the beautiful photographs that fill these pages. He was a constant source of encouragement, support, advice, and motivation during the process of writing this book. I've been enriched by getting to know him and his beautiful wife, Aubrey. They are both such interesting people with fascinating lives.

I thank the editors and staff at Johns Hopkins University Press: Vince Burke—who did monumental work honing my writing into the book you now hold and without whom this book would never have been written—Esther Rodriguez, Juliana McCarthy, and Carrie Love, who diligently and meticulously reviewed and improved the manuscript. I thank Dawn Witherington for the illustrations she provided and Lisa Bibko-Vanderhoop for permission to include one of her photos. Jessica Mercado helped transcribe some dictated portions of the manuscript. Thanks also to the efforts of an anonymous reviewer of the manuscript.

I dedicate this book to my great friend and colleague John Thorbjarnarson, crocodilian biologist and conservationist, lost to us too soon, with whom I spent so much time working with alligators, caiman, and crocodiles. I thank other colleagues who have contributed to my understanding of crocodilian biology relayed in this book: Dick Franz, Greg Erickson, Gordon Grigg, Casey Holliday, James Nifong, Evan Whiting, and Allan "Woody" Woodward. A special thanks to Matt Shirley and Chris Brochu, both of whom I pestered unmercifully with questions about crocodilian phylogenetics and other topics to verify if my thoughts about these issues were right-minded or not. Thanks also go to my "journal club," Ruth Elsey, Val Lance, Steve Platt, and Thomas Rainwater, colleagues with whom I exchange publications and information to help us keep up with the newest information in the world of crocodilians. Several colleagues have provided me with info from other states so that the perspective in this book is not too "Florida-centric": Colette Adams, John Groves, Cord Eversole, Ricky Flynt, Scott Pfaff, and Jon Warner. My European colleague Fabian Schmidt and my dear departed friend Ralf Sommerlad both helped me immensely in discussions involving international captive collections of crocodilians. For that I am very grateful.

Many additional people have kindly offered information and answered my questions as I have attempted to make the information in this book as factual as possible: Briane Aucone, Arnold Brunell, Steve Conners, Morgan Cooney, Chris Dieter, Barry Downer, Israel Dupont, Mark and Mary Emery, Kelsey Engle, Dino Ferri, Drew Foster, Curt Harbsmeier, David Heckard, George Heinrich, Douglas Hotle, Tracy Howell, Emily Hutchison, Scott Johnson, Diane Kelly, Jessi Krebs, Janaki Lenin, Andrew Lentini, Bill Magnusson, Kari McKeehan, Bill McMahan, Peter Meylan, Jeff Mitchell, Nathaniel Nelson, Mary Noell, John Paling, Dan Pearson, Craig Pelke, Carlos Piña, Irvy Quitmyer, Robert Redwine, Coleman Sheehy, Charles Sheridan, Bruce Shwedick, Paul Smithson, Andy Snider, Karen

Sprague, Brian Strickland, Joe Wasilewski, Rom Whitaker, and Don Wyckoff. Any errors in the book are, of course, entirely of my own doing.

Lastly, I wish to thank my wife, Kathy, who has put up with me being locked away in my office many weekends for the last few years as I worked on this book, and who has put up with me and my passion for crocodilians, and all that entails (skulls, skins, books, travel, and muddy shoes), for the last thirty years.

Wayne Lynch

Working on an alligator book was never on my bucket list. In my forty-year freelance career as a natural history writer and wildlife photographer, I had published over sixty books on ecosystems, mammals, and birds, but aside from a children's book on leatherback sea turtles, I had not seriously tackled any project about a reptile. The alligator book was a major departure from my usual photo targets, but one that I thoroughly enjoyed, as much for the adrenaline rush of focusing on a potentially dangerous animal as for the fascinating science I learned while researching the subject. The various crocodilian photographs in this book were captured in exciting far flung corners of the world: Australia, Borneo, Brazil, Guyana, Belize, Panama, Kenya, and Tanzania, and on multiple trips to Florida, Georgia, and Louisiana. All of these adventures were captured with my trusty Nikon digital camera gear that has never let me down during the many decades of my career as a visual artist.

Assistance in the field is vital for any photographer trying to tell a story and in Louisiana I wish to thank alligator farmers Mark, JJ, and Reggie Little; land owner Ronnie Oustalet; and nest-finder Rick Hall. One afternoon, lawyer Damon Baldone from Houma, Louisiana, and his family introduced my wife and me to the warm southern hospitality so characteristic of the region. When no other boats were available, they insisted we crash their family reunion and join them on a boat trip into the bayou for an especially memorable outing.

In Florida, I am thankful for the help of wildlife biologist Lori Oberhofer in Everglades National Park and Kevin Torregrosa, the curator of reptiles at St. Augustine Alligator Farm and the best doggone gator wrangler I've ever met.

This is my fifth book with the creative crew at Johns Hopkins University Press. I owe special thanks to science editor Dr. Vincent Burke for skillfully shepherding this project to the end, even after his retirement, and to the friendly and skillful efforts of managing editor Juliana McCarthy. Thank you also to the designer, Omega Clay, for her visual mastery, and to art director Martha Sewall and production editor Kyle Kretzer for their contributions to this collaborative effort.

As an old guy, I never underestimate my need to be strong and spry in the field to maximize photo opportunities, and this would not have been possi-

ble without my friend and personal trainer of nine years, Wayne Loftus. With encouraging words and professional expertise, he enhanced my athleticism so that I could traipse through swamps, crawl over cypress knees, snorkel with gators, and best of all, return to tell the tale with all of my limbs intact.

It was a joy to meet author Kent Vliet and an honor to collaborate with him on this book. I still remember seeing him featured in an awe-inspiring nature documentary decades ago, as he researched the intimate behavior of alligators while swimming nose to nose with these toothy armored beasts armed with nothing more than a length of stick. Who would have imagined that a Canadian Arctic adventurer like me and a swashbuckling Florida herpetologist would eventually cross paths and collaborate on such a satisfying book endeavor? My heartfelt thanks go out to Kent for all his assistance in the field and for helping me survive Alligator 101.

One person above all others, Aubrey Lang, my partner and delightful wife of forty-five years, deserves special mention. Aubrey accompanied me on virtually every field trip I made for this project. Together, we snorkeled in crystal spring waters, paddled the bayous of Louisiana, tramped through the wetlands of the Everglades, and sipped Sazeracs in New Orleans. She was a constant source of love, support, encouragement, and laughter. My life would be so empty without her.

Where to See Wild Alligators

If you live in one of the states that is blessed with a healthy population of alligators, like Florida or Louisiana, you most likely already know places where you can go to see these magnificent creatures in the wild. Some of you may live someplace devoid of alligators and wish to see a wild alligator while on vacation. Some others of you may have spent your life intentionally avoiding these big reptiles and now, having read about them, wish to get to know them up close and personal. Here's an abridged list of places, by state, at which you have a good chance of seeing alligators in the wild. In most cases, I've selected locales where you can safely view alligators from land or boardwalk, though a few may require you to take a small boat, canoe, or kayak to get the gator experience.

ALABAMA

Alligators are easiest to see in the rich coastal wetlands along the Gulf of Mexico.

Bon Secour National Wildlife Refuge, Gulf Shores (www.fws.gov/refuge/Bon
 _Secour)

 If you are not ready to look an alligator eye to eye, take the Pine Beach Trail.
 There's an observation tower from which you may see alligators in Gator
 Lake.

Gulf State Park, Gulf Shores (www.alapark.com/gulf-state-park)

 Check out the lakes in the park for alligators.

Wade Ward Nature Park, Gulf Shores (www.gulfshores.com/things-to-do/wade
 -ward-nature-park)

Meaher State Park, Baldwin County (near Spanish Fort) (www.alapark.com
 /meaher-state-park)

 Look along the causeway leading to the park.

Weeks Bay National Estuarine Research Reserve, Yupon (www.nerra.org/project
/weeks-bay-national-estuarine-research-reserve)

But alligators can be found in the far north end of the state too, though these
may require quite a bit more looking.

Wheeler National Wildlife Refuge, Decatur (www.fws.gov/wheeler)
In 1979, fifty-five alligators were brought from southern Louisiana and
introduced into the refuge to establish another population of the endangered
species and to help control beaver populations in the area. Though outside of
their natural range, a small population of alligators has persisted here.

ARKANSAS

Although recovering and expanding their range in Arkansas, alligators are still
not very abundant here. You may have to work to find yourself an Arkansas
alligator.

Arkansas Post National Memorial, Gillett (www.nps.gov/arpo)
Try Alligator Slough, they've been known to nest in that area.

Millwood State Park, Ashdown (www.arkansasstateparks.com/parks/millood
-state-park)
You may need a boat, but there are definitely gators to be found.

FLORIDA

Where do I begin? You have to work pretty hard to not see alligators in Florida.
They are found anywhere there is water. If you find a pond, lake, swamp, canal,
river, or big ditch and wait long enough, one will meander by. There are so many
good places in the state for alligators, I cannot possibly list them all. Here are
some of the best. I'll start in the middle of the state, then go down the east coast
and up the west coast.

Paynes Prairie Preserve State Park, Gainesville (www.floridastateparks.org
/parks-and-trails/paynes-prairie-preserve-state-park)
I've mentioned this place numerous times in the book. If the water levels are
relatively low, there's no better place anywhere to see large numbers of adult
alligators up close. On a good day, you can see 300–350 alligators. The main
park entrance is in Micanopy, but the place to see gators is the La Chua Trail
on the north side of the prairie. In Gainesville, go south on SE 15th St. There's
a boardwalk and an earthen dike that lets you walk out into the middle of the
Prairie.

Lake Apopka Wildlife Drive, Lake Apopka (www.sjrwmd.com/lands/recreation
/lake-apopka/wildlife-drive)
Very near to Orlando, a wonderful wildlife drive through the restored wetlands
of Lake Apopka.

Merritt Island National Wildlife Refuge, Titusville (www.fws.gov/refuge/Merritt
 _Island)
 Take Black Point Wildlife Drive and also Biolab Road. Both are great for
 viewing alligators from your car.

Everglades National Park (www.nps.gov/ever)
 The Everglades is huge and there are alligators all over. From Homestead,
 enter the main entrance. Visit Anhinga Trail, a paved walkway and boardwalk
 that's absolutely guaranteed to get you close to some wild alligators.
 To the north, take SR 41 (Tamiami Trail) to *Shark Valley Visitor Center*.
 (A canal runs along the north side of Tamiami Trail. Alligators are commonly
 seen basking on the sides of the canal.) There is a paved loop road into the
 Everglades out to an observation tower. You can take a tram ride or walk.
 Bicycles are allowed. Alligators all along the way and a great view from above
 at the tower.

Big Cypress National Preserve, Ochopee (www.nps.gov/bicy)
 Driving west of SR 41 from Shark Valley, you enter Big Cypress Preserve. Just
 past the Tamiami Ranger Station, Tamiami Trail takes a bend to the northwest,
 but a loop road forks off to the left. This is a fantastic scenic drive with gators
 in road side ditches along the way, February to April (dry season).

J.N. Ding Darling National Wildlife Refuge, Sanibel (www.fws.gov/refuge/jn
 _ding_darling)
 Traveling up the Gulf Coast of Florida, Sanibel Island lies just northwest of
 Fort Myers. Ding Darling has a loop drive great for birds and other wildlife.
 Much of the drive is in brackish mangrove and estuary habitats, but gators
 can be found in the freshwater areas.

Myakka River State Park (www.floridastateparks.org/parks-and-trails/myakka
 -river-state-park)
 Myakka River State Park (and the Myakka River itself), southeast of Sarasota,
 is a great place to view large alligators.

St. Marks National Wildlife Refuge, St. Marks (www.fws.gov/refuge/st_marks)
 The drive through the refuge down to the Gulf offers many chances to see
 alligators in the coastal wetlands.

Edward Ball Wakulla Spring State Park, near Crawfordville (www.floridastate
 parks.org/parks-and-trails/edward-ball-wakulla-springs-state-park)
 One of Florida's historic parks, take a river boat tour down the spring run to
 see big alligators.

GEORGIA

Okefenokee Swamp National Wildlife Refuge, Folkston (www.fws.gov/refuge
 /okefenokee)

The Okefenokee is a big swamp and has lots of alligators. You can see some of them without a boat. The main entrance into the wildlife refuge is south of Folkston. Several elevated walkways, one with an observation tower, allow you to get out into the swamp and possibly see some gators. There are usually a few in the small marina and the canals behind the visitor center. You can rent canoes or kayaks or, seasonally, there are guided boat tours down the grand canal.

Okefenokee Swamp Park, Waycross (www.okeswamp.com)
The Okefenokee Swamp Park is a private concession nature and cultural center on a point of land that juts out into the Okefenokee. Wild alligators are common in the roadside ditches on the drive in and in the waters surrounding the park. Guided boat tours into the swamp are available.

Coastal Georgia
Alligators are common in the coastal wetlands and barrier islands of the Georgia coast. Visits to Darien, St. Simon's Island, or Jekyll Island are beautiful and likely to turn up some alligators along the way.

LOUISIANA

Louisiana has an extensive series of coastal wildlife refuges and wildlife management areas, especially in southwest Louisiana.

Sabine National Wildlife Refuge, Cameron Parish (www.fws.gov/refuge/sabine)
Sabine is the largest coastal refuge on the Gulf. The Wetland Walkway nature trail, south of the refuge headquarters, includes a boardwalk and an observation tower.

Cameron Prairie National Wildlife Refuge (www.fws.gov/refuge/cameron_prairie)
Just southeast of Lake Charles. Take the Pintail Wildlife Drive, just south of the visitor center, for your best chance to see alligators.

Lacassine National Wildlife Refuge, Lake Arthur (www.fws.gov/refuge/lacassine)
Wildlife drives with viewing platforms within the refuge. State Road 14, called the Jean Lafitte Scenic Byway, passes by the refuge and allows opportunities for wildlife viewing.

Rockefeller Wildlife Refuge, Grand Chenier, Cameron Parish (www.wlf.louisiana .gov/refuge/rockefeller-wildlife-refuge)

Avery Island, near New Iberia (www.tabasco.com/visit-avery-island)
Home of Tabasco brand pepper sauce and former home of E. A. McIlhenny.

Barataria Preserve, Jean Lafitte National Historical Park and Preserve, Jefferson Parish (www.nps.gov/jela/barataria-preserve.htm)
Numerous trails along canals and boardwalks through wetlands, allow you to get a close look at the wetlands.

Lake Martin, Breaux Bridge, St. Martin Parish

> Classic swamplands with a few trails. Look for alligators along Rookery Road. Lots of gators in this wetland. Private swamp tour concessions are available.

MISSISSIPPI

Sam D. Noxubee National Wildlife Refuge, Noxubee County (www.fws.gov/re fuge/noxubee)

> Alligators can be viewed on Bluff Lake, Loakfoma Lake, and Goose Overlook.

Natchez Trace Parkway, Madison County (www.nps.gov/natr)

> Look for alligators in the Cypress Swamp Site and the River Bend Site (both north of mile marker 120), in Ross Barnett Reservoir, and in the Pearl River Wildlife Management Area, Madison Co. (www.mdwfp.com/wildlife-hunting /wma/region/southwest/pearl-river) off of Hwy 43.

Yazoo National Wildlife Refuge, Washington Co. (www.fws.gov/refuge/yazoo)

Hillside National Wildlife Refuge, Holmes Co. (www.fws.gov/refuge/hillside)

Sky Lake Wildlife Management Area, Humphreys Co. (www.mdwfp.com/wild life-hunting/wma/region/delta/sky-lake)

> Look for them along the Giant Bald Cypress Boardwalk.

Pascagoula River Audubon Center, Jackson Co. (pascagoula.audubon.org)

Pascagoula Wildlife Management Area, Jackson Co. (www.mdwfp.com/wild life-hunting/wma/region/southeast/pascagoula-river)

> Look for them in Parker Lake.

Ward Bayou Wildlife Management Area, Jackson Co. (www.mdwfp.com/wildlife -hunting/wma/region/southeast/ward-bayou)

NORTH CAROLINA

North Carolina is the northern edge of the alligator's natural range. Most of the population is located in the southeast corner of the state in the coastal lowlands around Wilmington.

Cape Fear River, near USS North Carolina (www.battleshipnc.com)

> The mouth of the river has lots of pretty big alligators.

Greenfield Lake, Wilmington (www.wilmington-nc.com/greenfield-lake-park .html)

> This is also a good spot to see alligators.

North Carolina Aquarium at Fort Fisher (www.ncaquariums.com/fort-fisher)

> There are also numerous ponds around the aquarium that are great spots for watching alligators.

Lake Waccamaw State Park, Lake Waccamaw (www.ncparks.gov/lake-waccamaw
-state-park)

Lake Waccamaw State Park and the surrounding areas are good for gators.

Green Swamp Preserve (www.nature.org/en-us/get-involved/how-to-help
/places-we-protect/green-swamp-preserve)

Especially try the canals along the north end of the Green Swamp Preserve.

Merchants Millpond State Park, Gates County (www.ncparks.gov/merchants
-millpond-state-park)

This is one of the most northerly populations of alligators in their range. Not
many gators here but they can be found. You might need a canoe or kayak to
get back far enough into the wetlands to see them.

Oklahoma

There are not many alligators in Oklahoma, but there are a few places that you
have a good chance of spotting some in the extreme southeast corner of the
state.

Red Slough Wildlife Management Area, McCurtain County (www.wildlifedepart
ment.com/wildlife-management-areas/red-slough)

Alligators have been seen on Red Slough and in some of the area's wetlands,
ponds, and oxbows.

Little River National Wildlife Refuge, McCurtain County, Pine Lake (www.fws.gov
/refuge/little_river)

Broken Bow Lake, McCurtain County (www.brokenbowlake.org)

Alligators are not at all common but can be found here.

South Carolina

Donnelley Wildlife Management Area, Green Pond (www2.dnr.sc.gov/Managed
Lands/ManagedLand/ManagedLand/58)

Access this fantastic site off of Hwy. 17. A wetland preserved for waterfowl but
provides a tremendous opportunity to see large groups of adult alligators.

Savannah National Wildlife Refuge, Hardeeville (www.fws.gov/refuge/savannah)

Another site with very large numbers of alligators.

Huntington Beach State Park, Murrells Inlet, Georgetown County (www.south
carolinaparks.com/huntington-beach)

Another great spot for alligators on the South Carolina coast.

Bear Island Wildlife Management Area, Colleton County (www2.dnr.sc.gov/Man
agedLands/ManagedLand/ManagedLand/56)

Cape Romain National Wildlife Refuge, Awendaw (www.fws.gov/refuge/cape
_romain)
Look for them on Bulls Island.

Tom Yawkey Wildlife Center, Georgetown County (www.dnr.sc.gov/mlands/TYaw
keycalendar19.html)

Kiawah Island, South Carolina, Charleston County (www.kiawahisland.org)
Just southwest of Charleston, Kiawah Island has dozens of ponds, both
brackish and freshwater. Alligators can be found in almost all of them.

Congaree Creek Heritage Preserve, Cayce (www.scgreatoutdoors.com/park
-congareecreekheritagepreserve.html)

Texas

Smith Oaks Sanctuary, High Island (www.houstonaudubon.org/sanctuaries
/high-island/smith-oaks.html)
Near Houston. Elevated walkways over wetlands.

Anahuac National Wildlife Refuge, Anahuac (www.fws.gov/refuge/anahuac)
Coastal refuge in southeast Texas with lots of alligators. There's a one-way
loop drive through the marsh for great viewing opportunities.

Brazoria National Wildlife Refuge, Brazoria County (www.fws.gov/refuge
/brazoria)
Wildlife viewing by car or on trails.

Lake Texana State Park, Edna (www.tpwd.texas.gov/fishboat/fish/recreational
/lakes/texana)
Lake Texana is within the Brackenridge Recreation Complex. Lots of access to
the lake and the surrounding wetlands.

Aransas National Wildlife Refuge, Austwell (www.fws.gov/refuge/aransas)
Alligators in freshwater wetlands. Be sure to check out Jones Lake and
Thomas Slough.

Laguna Atascosa National Wildlife Refuge, Los Fresnos (www.fws.gov/refuge
/laguna_atascosa)
Great coastal refuge with tons of alligators.

Brazos Bend State Park, Needville (www.tpwd.texas.gov/state-parks/brazos
-bend)

Bentsen-Rio Grande Valley State Park, Mission (www.tpwd.texas.gov/state
-parks/bentsen-rio-grande-valley)
Up the Rio Grande valley.

Scientific Names of Non-crocodilian Species Mentioned in the Text

For the scientific names of crocodilian species, please see the chart, "Order Crocodylia," in chapter 7.

COMMON NAME	SCIENTIFIC NAME
MAMMALS	
armadillo, nine-banded	*Dasypus novemcinctus*
bear, black	*Ursus americanus*
bear, grizzly	*Ursus arctos horribilis*
bison	*Bison bison*
bobcat	*Lynx rufus*
cougar (panther)	*Puma concolor*
deer, white-tailed	*Odocoileus virginianus*
hutia, Desmarest's	*Capromys pilorides*
lion	*Panthera leo*
manatee, West Indian	*Trichechus manatus*
mink, American	*Neovison vison*
mouse, cotton	*Peromyscus gossypinus*
muskrat	*Ondatra zibethicus*
nutria	*Myocastor coypus*
opossum	*Didelphis virginiana*
otter, river	*Lontra canadensis*
pig, feral	*Sus scrofa*
rabbit, marsh	*Sylvilagus palustris*
rabbit, swamp	*Sylvilagus aquaticus*
raccoon	*Procyon lotor*

COMMON NAME	SCIENTIFIC NAME
rat, cotton	*Sigmodon hispidus*
rat, rice	*Oryzomys palustris*
rat, wood	*Neotoma floridana*
tiger	*Panthera tigris*
wildebeest	*Connochaetes taurinus*
wolf, red	*Canis rufus*
zebra, plains	*Equus quagga*

BIRDS

eagle, bald	*Haliaeetus leucocephalus*
egret, cattle	*Bubulcus ibis*
egret, great	*Ardea alba*
egret, snowy	*Egretta thula*
gallinule, purple	*Porphyrio martinica*
goose, Canada	*Branta canadensis*
heron, great blue	*Ardea herodias*
heron, green	*Butorides virescens*
heron, tricolored	*Egretta tricolor*
kite, snail	*Rostrhamus sociabilis*
limpkin	*Aramus guarauna*
moorhen, common	*Gallinula chloropus*
pigeon, passenger	*Ectopistes migratorius*
spoonbill, roseate	*Platalea ajaja*
vulture, black	*Coragyps atratus*
vulture, turkey	*Cathartes aura*

AMPHIBIANS & REPTILES

amphiuma, two-toed	*Amphiuma means*
bullfrog	*Lithobates catesbeiana*
cooter	*Pseudemys floridana* (FL), *Pseudemys concinna* (LA)
cooter, Florida red-bellied	*Pseudemys nelsoni*
cooter, peninsula	*Pseudemys peninsularis*
frog, green tree	*Hyla cinerea*
monitor, Nile	*Varanus niloticus*
monitor, Mertens' water	*Varanus mertensi*
python, Burmese	*Python molurus bivittatus*
rattlesnake, eastern diamondback	*Crotalus adamanteus*
siren, greater	*Siren lacertina*
siren, lesser	*Siren intermedia*
slider, pond	*Trachemys scripta*

COMMON NAME	SCIENTIFIC NAME
snake, eastern coral	*Micrurus fulvius*
toad, cane	*Rhinella marina*
turtle, alligator snapping	*Macrochelys temminckii*
turtle, common snapping	*Chelydra serpentina*
turtle, Florida softshell	*Apalone ferox*
turtle, loggerhead musk	*Sternotherus minor*
turtle, mud	*Kinosternon subrubrum*
turtle, striped mud	*Kinosternon baurii*
water moccasin	*Agkistrodon piscivorus*
water snake, green	*Nerodia cyclopion*
water snake, southern	*Nerodia fasciata*

FISH

bass, largemouth (black)	*Micropterus salmoides*
bowfin	*Amia calva*
carp	*Cyprinus carpio*
catfish, armored	*Hoplosternum littorale*
catfish, channel	*Ictalurus punctatus*
eel, American	*Anguilla rostrata*
gar, alligator	*Atractosteus spatula*
gar, Florida	*Lepisosteus platyrhincus*
minnow, mud	Fundulidae
mosquitofish	*Gambusia holbrooki* (FL), *Gambusia affinis* (LA)
mullet, striped	*Mugil cephalus*
shad, gizzard	*Dorosoma cepedianum*
shark	*Negaprion brevirostris*
sunfish	*Lepomis* sp.
topminnows	Fundulidae

INVERTEBRATES

ant, fire	*Solenopsis invicta, Solenopsis saevissima*
bug, creeping water	*Pelocaris* (Naucoridae)
bug, giant water	*Belostoma griseus*
clam	*Rangia* sp.
crab, blue	*Callinectes sapidus*
crab, horseshoe	*Limulus polyphemus*
crab, land	*Cardiosoma guanhumi*
crayfish (FL)	*Procambarus paeninsulanus*
crayfish, red swamp (LA)	*Procambarus clarkii*
dragonfly	*Odonata* sp.

COMMON NAME	SCIENTIFIC NAME
fly, soldier	*Odontomyia cincta* (Stratiomyidae)
katydid	Tettigoniidae
mayfly	*Ephemeroptera*
mussel, Atlantic ribbed	*Geukensia demissa*
shrimp	*Penaeus* sp.
shrimp, freshwater	*Palaemonetes kadiakensis*
shrimp, grass	*Palaemonetes intermedius*
snail, apple	*Pomacea paludosa*
snail, giant apple	*Pomacea maculata*
snail, periwinkle	*Littoraria irrorata*
spider, fishing	*Dolomedes triton*

PLANTS

cypress	*Taxodium distichum, Taxodium ascendens*
duckweed	*Lemna valdiviana*
giant reed	*Phragmites* spp.
palmetto, saw	*Serenoa repens*
saw grass	*Cladium jamaicense*
Spanish moss	*Tillandsia usneoides*
water lettuce	*Pistia stratiotes*

Index

legal protection, for alligators, 39, 229, 247–55

legs and feet, 46, 79, 80

Le Moyne de Morgues, Jacques, 28, 30

length. *See* size

life span, 203–4, 207, 211–13, 215

limpkins, 226

lizards, 43, 58

locomotion, 43, 61–63; in crocodiles, 154, 163; "high-walk," 61–62, 63; in home range, 88–89; speed, 12; "sprawling crawl," 61, 62; tail use in, 63, 64. *See also* swimming

Long, Stephen H., 35

Louis XVI (King of France), 8, 10

Louisiana, alligators and crocodiles of, 31; attacks on humans, 242; diet, 113, 114, 115; egg collection programs, 234–35, 238; habitat, 23; hide industry, 39, 249–50; hunting, 39, 249; management program, 232, 233–34, 253–54; populations, 39, 108, 241; record-sized, 210; seasonality, 98

lungs, 57, 59–61, 67

male alligators: courtship and mating behavior, 171, 173–74; differentiated from females, 206; dominance/subordinate behavior, 44, 69, 87, 221, 222, 223; "feminizing" of, 236; growth rate, 205; home range, 88, 89; parental behavior, 200; size, 205, 210; vocalizations, 222, 223, 224, 225, 227

mammals, 58, 110, 112, 113, 115, 118, 130, 155, 161

mammillary layer, 183

management programs, 231–34, 259–61. *See also* nuisance alligator control

manatees, 58, 253

marine environment, 67, 73, 74–75, 159–60

Marshall, Greg, 120

mascots, alligators as, 12, 15

mating. *See* courtship and mating behavior

mayflies, 125

Mazzotti, Frank, 133

McIlhenny, E. A. "Ned," 176, 255, 208–9; *The Alligator's Life History*, 208, 209, 218

meat: of alligators, 31, 34, 232; of crocodiles, 161, 234

melanin, 44

metabolism: anaerobic, 58–59; in desert species, 158; in embryos, 186, 188; during food deprivation, 109; temperature dependence of, 98, 102. *See also* digestion

Mexico, 16, 22–23, 39, 143, 144

Michaux, André, 8–10

migration, 21, 22, 82, 101–2

Mississippi, 16, 18, 21, 39, 207, 210

Mississippi Delta, 15

Mississippi River and Basin, 5, 9, 17, 27, 34, 122

Missouri, 104

Morelet's crocodile, 143, 152, 154–55

mortality causes, 215

mosquitofish, as prey, 110, 111–12

mouth: palatal valve, 49–50. *See also* snout; teeth

mud, entrapment in, 203

mud flat feeding, 123–24

mugger crocodile, 143, 161

mummies, 156

muscles, 43, 48, 187

muskrats, 108

mussels, Atlantic ribbed, 109

myths and misconceptions, about alligators, 12–13

Narváez, Pánfilo de, 27

nasal sinuses, 53

Native Americans. *See* indigenous people

Natural History of Carolina, Florida and the Bahama Islands, The (Catesby), 31

navigation ability, 87

Neill, Wilfred T., 22

nervous system, 50–51, 187

nest-guarding behavior, 189–92, 193, 219

nests (alligator), 185; construction and location, 78, 88, 185, 189, 192, 195; egg removal from, 186, 187; failed, 193; fire ant invasions, 195–97; opening of, 49, 197, 199, 200, 223; predation on, 189–91, 193-94, 195; restoration, 195; temperature in, 189; as turtle and snake nests, 78, 195

nests (bird), 85–87

vegetables, 116–17
vegetation, effect of alligators on, 76–78, 84–85
video recorders, 120–21
Virginia, 21–22, 104
vision, 51, 52–53, 54
vocalizations, 31, 223–24; distress calls, 200; of females, 224; of hatchlings, 194, 197, 198, 200, 201, 223; hissing, 191, 192; of juveniles, 200; of males, 222, 223–24, 225, 227
vultures, 127–28

walking. *See* locomotion
warm-blooded animals, 91–92
Washington, George, 10
water dance, 223, 224, 225, 227
water moccasins, 13, 131, 132–33
water monitor lizards, 162
water temperature, 80–81, 102–3
weight. *See* size
West African crocodile, 143, 156, 158

West African slender-snouted crocodile, 143, 158–59
wetland refuges, 247, 248, 249
Wheeler National Wildlife Refuge, AL, 17
White House, alligators in, 10–11
wildebeests, 155
wildlife refuges, 17, 18
Williams, Tim, 1–4
Windward Road, The (Carr), 127
wolves, 25, 26, 35

yacare caiman, 143, 147, 150
yearlings, prey of, 111, 112
yolk, 178, 184, 186–87, 188, 198
yolk sac, 186, 198
young alligators: dispersal, 87–88; icing response, 101; young adult, 233. *See also* hatchlings; juveniles; subadults

zebras, 155
zoos, alligators in, 213

ILLUSTRATION CREDITS

All photographs were taken by Wayne Lynch except for those on the following pages: 8, New York Public Library Digital Collections; 17, Courtesy of Dawn Witherington; 30, Used by permission of AAA Photostock / Alamy Stock Photo; 57, Courtesy of Dawn Witherington; 80, Wing-Chi Poon, Wikimedia Commons; 132, Lori Oberhofer, National Park Service, Wikimedia Commons; 134, Everglades National Park Service, Wikimedia Commons; 142 (*right*), Mark A. Wilson, Wikimedia Commons; 165, Kent A. Vliet; 186, Courtesy of Dawn Witherington; 190, Everglades National Park Service, Wikimedia Commons; 219, Courtesy of Lisa Bibko-Vanderhoop; 239 (*left*), New York Public Library Digital Collections; 239 (*right*), J. N. Wilson, New York Public Library Digital Collections.